TURKISH BOOKBINDING
IN THE 15TH CENTURY

Turkish Bookbinding
in the 15th Century

The Foundation of an Ottoman Court Style

Julian Raby and Zeren Tanindi
edited by Tim Stanley

❧

Azimuth Editions
on behalf of
L'Association internationale
de Bibliophilie

THIS EDITION IS LIMITED TO 1,000 COPIES

PUBLISHED BY AZIMUTH EDITIONS
ON BEHALF OF L'ASSOCIATION INTERNATIONALE DE BIBLIOPHILIE
AZIMUTH EDITIONS 33 LADBROKE GROVE, LONDON WII 3AY
COPYRIGHT © 1993 AZIMUTH EDITIONS LIMITED
ALL RIGHTS RESERVED. NO PART OF THIS PUBLICATION MAY BE REPRODUCED,
STORED IN A RETRIEVAL SYSTEM, OR TRANSMITTED,
IN ANY FORM OR BY ANY MEANS, ELECTRONIC, MECHANICAL,
PHOTOCOPYING, RECORDING, OR OTHERWISE,
WITHOUT THE PRIOR PERMISSION OF
AZIMUTH EDITIONS
INTERNATIONAL STANDARD BOOK NUMBER
1-898592-01-2

DESIGN BY ANIKST ASSOCIATES
PHOTOGRAPHY BY REHA GÜNAY, ISTANBUL
TYPESETTING BY AZIMUTH EDITIONS
PRINTED AND BOUND IN THE UNITED KINGDOM

Contents

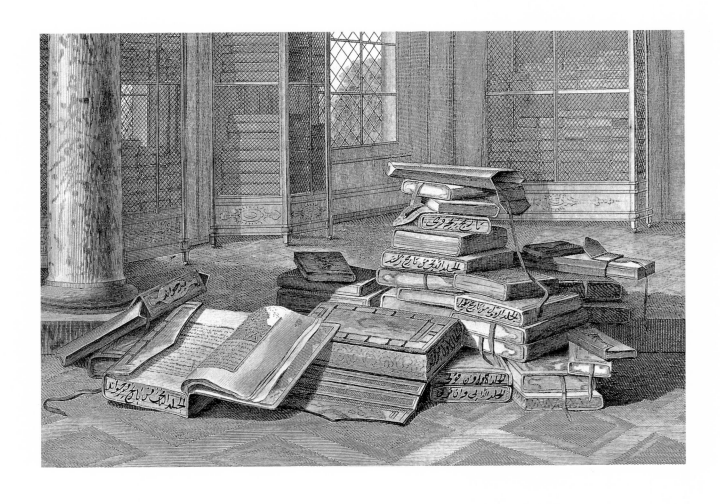

'Livres turques', after Mouradja d'Ohsson

PREFACE

The art of bookbinding is often relegated to the role of Cinderella when the various arts of Islam and even of the Islamic book are discussed.

RICHARD ETTINGHAUSEN

BINDINGS are to books as clothes are to man. Their primary function is protection, but this can be complemented, if so desired, by their use as decoration. In the Muslim world the book holds a place of special esteem, because of the importance accorded to the Koran, and the art of binding has a long and noble tradition there. Muslim craftsmen initiated advances in the techniques of bookbinding and in the format and decoration of book covers. They perfected the tanning of leather and the art of filigree, and they were the first to develop the cased leather binding, the use of pasteboards, and the techniques of gilt tooling and pressure-moulding. The Muslim world also developed the idea of the centralized, hypotactic composition, based around a central medallion or other figure, with complementary corner-pieces. Europe owed the use of floral and arabesque motifs to Muslim inspiration, as well as of rope-tools, s-tools and knot-work. Marbled paper too was introduced into Europe from Turkey. These materials, techniques, compositional principles and motifs have all become such a familiar part of the vocabulary of bookbinding in Europe that we tend to forget their origins. Yet it is not only precedence that makes the history of Islamic bindings of interest, but the skill in craftsmanship and design.

This book is not intended, though, as a general introduction to Islamic bookbinding. It concentrates instead on Ottoman bindings that date from a period of some 75 years, from the second quarter of the 15th century to the first decade of the 16th century. It has been designed to have both a narrow and a wider focus. On the one hand, it is intended as a small contribution to the history of bookbinding at a moment of great change, both in the Central Islamic Lands and in Europe. The second half of the 15th century saw an aesthetic which had been perfected in Iran in the first half of the century assume an increasing influence, particularly in Turkey, but also in Egypt and in India. That aesthetic, as Anthony Hobson has shown, was to influence the development of the Humanist binding in Italy, since it offered Humanist patrons an alternative to the Gothic style associated with monastic scholasticism.[1]

However, the study of Ottoman bindings of the 15th century serves two other purposes. Where this book differs from most previous studies of Islamic bindings is that, first, it concentrates on a relatively narrow period; second, it is based predominantly on bindings which are still attached to the manuscript for which they were made; and, third, these manuscripts are for the most part dated or datable and are associated with known patrons. We cannot hope to establish a clear idea of historical and regional variations in technique and style if we rely solely on detached bindings or on bindings whose manuscripts bear insufficient documentation. The point should be self-evident, but we can illustrate it by looking at the peregrinations, as it were, of just one binding (*figures* 27–29), which has been variously attributed to Egypt or Syria, Mesopotamia and Eastern Iran. For our part, however, we have attempted to show that it must have been made by a binder who was working for the Ottoman sultan Murad II in the 1430s.

Such a study can therefore make a contribution not only to the history of artefacts and artistic styles, but to the study of bibliophilia and libraries in the Islamic world. This is a topic familiar in a European context, but it has largely been ignored for the Islamic world until recently. The pioneering work by Turkish scholars such as Müjgân Cunbur and İsmail Erünsal on Ottoman libraries indicates how much can be learnt through a study of archival records and chronicles; a complementary approach is through the study of surviving manuscripts, and this book aims to draw attention to at least one aspect of their codicology.

The second of the wider reasons for studying Ottoman bindings of the 15th century is that they can serve as a mirror for other minor arts. The 15th century saw fundamental changes in the art of ceramics, metalwork, woodwork, textiles and carpets; these changes affected the decorative character of the objects, their techniques of production and, I would suggest, the organization of the industry. Yet, as there are almost no dated examples of these media from the 15th century, the dating of the changes has to be surmised, and the impetus behind each change must remain a matter for speculation. By contrast, numerous manuscripts survive with a rich documentation telling us when the volume was produced, by whom, for whom, and sometimes even where. This documentation allows us to chart the technical and decorative changes in the art of the book. But, as the second half of the 15th century sees an increased correspondence between the designs and motifs on bindings and those in other minor arts, the history of bindings throws light on the otherwise obscure history of those other media. The bindings cannot provide information on the technical changes that affected the other crafts, but they do suggest that centralized imperial patronage played a major role in the transformation of Ottoman art in the second half of the 15th century.

Much of the emphasis of this book is on imperial patronage, for it deals in the main with works that can be associated with three successive sultans, Murad II, Mehmed II and Bayezid II. The evidence for the three is not, however, equally abundant and in Chapter One the discussion of Murad II supported by the better-documented patronage of the bibliophile Umur Bey, the son of Timurtaş, who played an important role in sponsoring translations into Turkish and established a public library attached to his mosque. Chapter Two deals with Mehmed II, the conqueror of Constantinople and the most powerful Muslim ruler in the second half of the 15th century. During his reign Istanbul became a magnet for artists from different parts of the Islamic world, and also from Europe. Yet out of this maelstrom of artistic activity there emerged a clear and coherent style that was initiated by palace artists and which spread from the art of the book to other media. Chapter Three looks at the patronage of Bayezid II and attempts to show how his reign had a decisive and enduring effect on the development of the art of the book in Ottoman Turkey. This encompassed binding, illumination and calligraphy, and Bayezid's active role as a patron is brought out in his relationship with the most influential of Ottoman calligraphers, Şeyh Hamdullah. In short, the second half of the 15th century witnessed the emergence

of a distinctive Ottoman voice in both architecture and the minor arts, and it is bookbindings that provide the most secure documentation for the latter.

In an important article written in 1954 Richard Ettinghausen pointed out how Islamic bindings of the beginning of the 14th century seemed to reflect developments that had taken place in illumination one or two centuries previously, and he concluded, 'These bindings therefore point to the art of illumination as the pacemaker in the decorative arts and in particular in the craft of the bookbinder'.[2] One of the aims of this present study is to show how in the third quarter of the 15th century the artist-draughtsman exerted a major influence on Ottoman bookbindings, but in this case the influence was felt immediately and directly. However, the final chapter will also attempt to show that the emergence of the classical style of Ottoman bookbinding occurred when bookbinders emancipated themselves from slavish imitation of the drawn image.

This study has been a collaborative effort by the authors, and the principal chapters and the entries in the catalogue cannot be attributed categorically to a single authorship. Broadly speaking, though, Chapter One, and any pre-Ottoman material, has been the responsibility of my friend and colleague, Dr Zeren Tanındı, who has pioneered research into this area. She has also contributed most of the evidence for the textile bindings discussed in Chapter Two and in Appendices 2 and 3. Chapter Two, and Chapter Three have, though, largely been my responsibility.

Our editor, Tim Stanley, has also contributed to the body of the text. In particular, he has reworked the references given by Erünsal and others concerning the patronage of Sultan Murad II and Umur Bey, the son of Timurtaş Pasha, with interesting results, and he has added comments to a number of catalogue entries, notably cat.5, cat.18 and cat.36.

Julian Raby
Oxford 1993

ACKNOWLEDGEMENTS

ॐ

This book was commissioned by the Association Internationale de Bibliophilie, and the authors would like to thank in particular the President of the Association, Anthony Hobson, for proposing the idea, and the group of anonymous benefactors who supported the costs of publication. For a variety of reasons it has been a long time from commission to completion, and we would like to thank the members of the Association and the benefactors for their patience.

We could not have produced this book without considerable help from others. The Ministry of Culture of the Turkish Republic and the Ministry's Directorates General of Libraries and of Monuments and Museums allowed access to the Topkapı Palace Museum, the Museum of Turkish and Islamic Arts and the Süleymaniye Library in Istanbul, whose holdings are of vital importance to anyone studying Islamic bookbindings, and to the less well-known libraries and museums of Bursa and Konya.

We must also thank the many colleagues whose generous assistance has made our work possible: Ahmet Menteş, the Director of the Topkapı Museum, and the staff of the museum's library, notably Dr Filiz Çağman and Dr Banu Mahir; Dr Nazan Ölçer, Director of the Museum of Turkish and Islamic Arts, and Şule Aksoy, who is responsible for that Museum's manuscript collection; Dr Muammer Ülker, Director of the Süleymaniye Library; Salih Kütük, the Director of the Bursa Museum, Bengi Çorum, the head of the Museum of Turkish and Islamic Arts in Bursa, and Vahap Yıldız, the head of the İnebey Library there; Dr Erdoğan Erol, the Director of the Konya Museum, and Yaşar Yılmaz and Naci Bakırcı, who are responsible for the Museum's manuscript collection; Dr Michael Ryan of the Chester Beatty Library in Dublin; and Dr Eva Irblich of the Österreichische Nationalbibliothek.

Valuable advice on bindings and paper was given by the conservator Don Baker, and on the textiles by Louise Mackie of the Royal Ontario Museum, Dianne Mott of the Museum of Fine Arts in Boston, and Hülye Tezcan of the Topkapı Palace Museum. The authors owe special thanks for information and advice provided by Dr Filiz Çağman in particular, and by Professors Ernst Grube, Gülru Necipoğlu and Michael Rogers; and a debt is owed to John Carswell, whose inspiration it was to organize the exhibition of Islamic bookbindings in Chicago in 1981 that gave a new direction to the study of the subject.

We would also like to thank Gülser İlhan, Alper Bilsel and Özkan Eroğlu of the Faculty of Education of Uludağ University, who took the working photographs in Konya and Bursa. Several photographs were kindly provided by Professor Ernst Grube, but the majority of the published photographs of the items in Turkey, including almost all of those in colour, are the work of Reha Günay, who carried out his task with meticulous care.

Photographic Acknowledgements

The illustrations in this book are reproduced by courtesy of the Kültür Bakanlığı Anıtlar ve Müzeler Genel Müdürlüğü, Ankara (*figures* 1, 4, 9, 10, 12, 13, 17, 19–21, 23, 24, 26, 30, 40, 42–48, 50, 53, 55–58c, 59–61, 66, 67, 70, 71, 74, 75, 77–82, 85; cat.1, 2, 5, 8, 10, 11, 13–18, 20, 21, 24–41), the Director of the İnebey Library, Bursa (*figures* 22, 32, 33, 35, 36, 38, 41, 47; cat.3, 4), the Director of the Süleymaniye Library, Istanbul (*figures* 54, 58d, 63– 65, 68, 69, 83; cat.6, 12, 19, 23), the late Professor Süheyl Ünver (*figures* 2, 3, 7), K.Öhrnberg (*figure* 8), the Trustees of the Chester Beatty Library, Dublin (*figure* 25; cat.9), the Staatsbibliothek, Munich (*figures* 27–29), the Österreichische Nationalbibliothek, Vienna (cat.7), Edmund de Unger, Esq. (cat.22).

Figures 5, 6 are after Weisweiler 1962; *figure* 18, after Raymond 1922; *figure* 31, after Kuran 1968; *figures* 37b, 39, after Ettinghausen 1954; *figure* 61, after Sakisian 1927b; *figure* 76, after Pope & Ackerman 1938–9; *figure* 87, after Arseven, n.d.

The following photographs were taken by Reha Günay, Istanbul: *figures* 4, 13, 17, 20, 22, 30, 38, 40, 41, 44–46, 53, 55, 56, 59, 64, 68, 71, 77–80; cat.1– 6, 8, 10–21, 23–29, 32, 33, 35–41.

INTRODUCTION

B Y the beginning of the Islamic period, in the 7th century AD, the codex appears to have been the standard form of book in the territories conquered by Muhammad's immediate successors. This is certain for the Roman empire, where the codex had triumphed over the roll because of its association with the Gospels,[1] but it is far from clear what type of book was most common in the Persian empire. The earliest Islamic codices, like their Christian precursors, consisted of sheets of papyrus or parchment folded into gatherings, which were sewn together and attached to a protective binding. In the few surviving bindings of the early period two boards, either of wood or of papyrus pasteboard, were covered in a single sheet of leather, which also formed the spine, and a second piece of leather was often glued to the inside of the back cover to provide a protection for the edges of the text block.[2] The basic form of the codex was to remain unaltered, but different materials and techniques came into use, and the aesthetic principles that underlay book production underwent a number of far-reaching changes. By the mid-10th century, for example, paper had replaced papyrus as the commonest material for the text block, and papyrus production in Egypt had ceased.[3] As a result, paper eventually replaced papyrus in the manufacture of the pasteboard used for covers.

Like a modern cased binding Islamic covers were prepared separately from the text block. Binding and text block were attached with adhesive along the spine and hinges, but the spine attachment did not require great strength, as books were stored on their sides rather than on their ends (*frontispiece*). The result was a square block with none of the spine swell found on many contemporary European laced-in bindings, whose construction was integral to the text block. The most visible distinguishing feature of the Islamic binding was the pentagonal envelope flap. The leather flange formerly used to protect the edges of the manuscript was replaced, from the 11th century on, by a flap that protected only the fore edge of the book. This flap was, though, better integrated into the structure of the binding as a whole. It took the form of a

two-part extension to the back cover, being made of two pieces of pasteboard cut to shape and covered with leather, which was decorated to much the same degree and in the same style as the covers. The first part of the flap was a narrow rectangle that fitted over the fore edge, while the second came to a point on the free side and was folded under the front cover when the book was not in use, thus forming a glorified portfolio.[4]

The processes involved in the production of Islamic cased bindings have been described in considerable detail by Gulnar Bosch and Guy Petherbridge, whose account also deals with other aspects of Islamic book production.[5] However, their conclusions are not always in accord with the evidence from Turkish bindings of the 15th century. To take one example, Bosch and Petherbridge have asserted that the sewing structure most frequently found in Islamic manuscripts from the medieval period to the 20th century has two stations only,[6] but their claim was based largely on their examination of medieval Arab manuscripts,[7] and it does not hold true for Ottoman manuscripts of the 15th century. These were generally sewn at four stations with a two-ply, z-twist silk, the thread from the top and bottom stations being looped over the ends of the central fold (see Appendix 1).

Despite these variations from the model promoted by Bosch and Petherbridge, Ottoman book covers remained firmly within the Islamic tradition of cased bindings. One feature these bindings share is the weakness of their attachment to the text block: what Islamic bindings gained in elegance, they lost in durability. As a result, the covers of Islamic manuscripts have frequently become detached, and this has had two effects on the study of Islamic bookbinding.

The first is that there are sizeable collections of loose Islamic bindings in Western collections, and these have provided the data for most previous studies of the subject. While detached bindings can offer evidence on the techniques of forwarding and finishing, it is surprising how little they had been used for this purpose – with the exception of the work of Paul Adam at the turn of the century – until the major study by Bosch and Petherbridge in 1981.[8] Instead they have often been published as art-historical documents, despite the fact that in isolation they provide no evidence about provenance and dating. The result has been that attributions have been little more than guesswork, dependent either on a handful of assignable manuscripts with comparable covers or on broad art-historical assumptions. The attribution procedure often became self-referencing.

The second outcome is that over the centuries Islamic manuscripts have been rebound. This poses a danger for those who wish to study attached, rather than loose, bindings. It means that caution has to be used when attributing a single binding on the basis of the documentary evidence in the manuscript. The only safe procedure is to assemble a large enough body of manuscripts whose dates, provenance and, hopefully, patronage are certain; if these manuscripts have bindings with common characteristics it is possible to deduce art-historical conclusions.[9] Caution of this sort seems such an obvious requirement that it may be insulting to the reader to mention it, but in over a century of studies on Islamic bookbindings there have been few attempts to identify a coherent corpus of bindings attached to manuscripts with a common locale and date. Three of these studies have been on 'Persian' bindings of the 15th century; the definition, though, was still broad in terms of date and place, and the studies have largely relied on the same material.[10]

The procedure in this book has been to rely almost entirely on securely documented manuscripts, although not every manuscript offers all the information that one would ideally hope for, such as where, when, by whom, and for whom the text was copied. Nevertheless, there is a concatenation of evidence for the second half of the 15th century that allows broader conclusions to be drawn, not only about technical and art-historical developments, but also about the context of patronage.

The evidence only becomes substantial in the mid-15th century, when Ottoman scribes, illuminators and binders began to evince increased influence from Timurid and Turcoman Iran. Surviving Ottoman manuscripts and bindings before this period are few and far between, as we

shall see in Chapter One. We are therefore unable to answer with confidence the question of how much the Ottomans in the first century of their state relied on Anatolian traditions in the arts of the book, and how much on influences from abroad, whether from Iran or the Mamluk realms. The answer is complicated by the fact that the evidence for the rest of Anatolia in the 14th and early 15th centuries is patchy and problematic, especially for binding. However, the available evidence is worth summarizing for two reasons: firstly because it provides a backcloth, however rent and faded, for the developments that occurred later in the 15th century, and secondly because it illustrates the problems of method we have just outlined.

Binding in Anatolia

The Turkish presence in Anatolia began when the Saljuq Turks defeated the Byzantines at the battle of Manzikert (Malâzgirt) in 1071. During the 12th century the members of a cadet branch of the Saljuq dynasty established themselves as overlords of central Anatolia, where they continued to rule or, at least, reign until the first decade of the 14th century. However, after a Mongol army defeated Sultan Kaykhusraw II at the battle of Kösedağ in 1243, power passed first to the leading members of the bureaucracy and then, from 1278, to Mongol governors appointed from Iran. The wealth of the viziers who ruled Anatolia for the Mongols was sufficient to impress the Mamluk sultan Baybars during his invasion of Anatolia in 1277, and the resources available to them can be judged by the number of religious institutions they founded. For example, the vizier Fakhr al-Din ‘Ali ibn Husayn, known as Sahib Ata, had at least three *medreses* built, and one of these, the Gök Medrese in Sivas, was established in the same year, 1271–2, as two other *medreses* in the city, the Çifteminareli Medrese and the Bürüciye.[11]

A *medrese* was a school for higher learning run by a single master, the *müderris*. During the Middle Ages it acquired a standardized institutional and architectural form, which served to provide a secure living for reputable scholars and to subject what they taught to public scrutiny. A patron erected a building where the master might teach, and he provided endowments, known as *waqfs*, whose revenues paid for the upkeep of the building and the support of the master, the other staff and the students. The *medreses* of late Saljuq Sivas, like those of the Ottoman period, generally consisted of a lecture hall opening on to a porticoed courtyard surrounded by smaller rooms where the students lodged.

The scholastic character of Islamic higher education meant that texts played a central role in the life of the *medrese*, and the founding of *medreses* therefore entailed the production of books.[12] Moreover, there is evidence that in the late 13th century at least one *medrese* in Konya, the capital of Anatolia, functioned as a centre for the production of books, for a Koran was produced in the *medrese* of Sa‘d al-Din Kubak in that city in Rabi‘ al-Akhir 677 (October 1278); the scribe was Hasan ibn Juban ibn ‘Abdallah al-Qunawi, and the illuminator, Mukhlis ibn ‘Abdallah al-Hindi.[13] A month later, in Rajab 677 (November 1278), another scribe, Muhammad ibn ‘Abdallah al-Qunawi al-Waladi, completed a copy of the *Maṣnavī* (‘Poem in rhyming couplets’) of the great mystic Mawlana Jalal al-Din al-Rumi, and the illumination of this volume was again entrusted to Mukhlis ibn ‘Abdallah al-Hindi.[14] The colophon of the *Maṣnavī* does not state where it was copied and illuminated, although the coincidence of the illuminator suggests that it, too, may have been produced in the *medrese* of Sa‘d al-Din Kubak. However, an endowment notice on the last leaf records that it was donated to the Sufi establishment attached to the tomb of the Mawlana in Konya, by a freedman of Sahib Ata, Jalal al-Din Mubarak ibn ‘Abdallah, in the year it was produced.

Muhammad al-Qunawi’s manuscript was probably the first clean copy of the *Maṣnavī* made from the Mawlana’s own drafts, and, as this immense poem is the most highly regarded of Sufi works, it is entirely appropriate that the result was one of the finest manuscripts of the 13th century. A

manuscript of this quality presumably had a binding of an appropriate standard, but regrettably the original covers were removed, probably at the beginning of the 20th century, when it was rebound.

In the period after 1278 the political unity of Anatolia rapidly disintegrated, to be replaced by any number of small states, ruled mostly by dynasties of Turcoman origin. It was against this background that the Ottomans first emerged as the rulers of a small territory in north-west Anatolia, but for much of the 14th century they were far from being the most important of the Turcoman dynasties in the region. This role was filled by 'the sons of Karaman', who emerged from their home in the Taurus Mountains to seize control of much of the Anatolian plateau. Their possessions included the former Saljuq capital of Konya, and it was in Konya that the finest manuscripts of 14th-century Anatolia seem to have been produced. Recent research has shown that the Karamanids and the lords of Erzincan were the principal patrons of the art of the

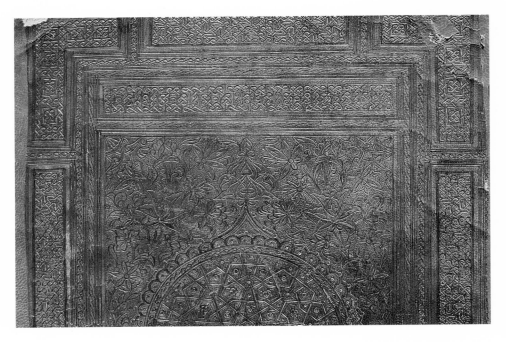

1 Front cover of a Koran,
perhaps Konya, 1315
Konya, Mevlana Museum, MS.12 (490 × 320 mm)

book in this period. Their finest manuscripts were not large-scale Korans, as was the case in contemporary Mamluk and Ilkhanid book production, but copies of the *Maṣnavī* and the *Dīvān-i kabīr* of Mawlana Jalal al-Din al-Rumi and the *Rabābnāmah* and the *Intihānāmah* of the Mawlana's son, Sultan Veled.[15] A group of manuscripts containing copies of these works, now in the Mevlana Museum in Konya, are remarkable for the quality of their illumination and their monumental dimensions, but only one has retained its original binding. This manuscript, which contains part of the *Dīvān-i kabīr*, was written by the scribe Hasan ibn 'Uthman al-Mawlawi between 2 Shawwal 768 (1 June 1367) and 1 Rabi' al-Akhir 770 (13 November 1368) and was richly decorated by an anonymous illuminator. It was made for Emir Satı, the ruler of Erzincan, who died in 1386.[16] The dark-brown leather covers, which have retained their flap, were tooled with polygonal stars and interlace, while the doublures are of leather block-pressed with a design of leaves and large blossoms. The binder has tooled his signature, in the form, *'amal-i Abū Bakr al-Mujallid al-Mawlawī al-Ḥamawī*, on the back doublure.

Another Karamanid manuscript that has retained its original binding is a two-volume Koran copied in AH 714 (AD 1314–15) for Khalil ibn Mahmud, a member of the ruling dynasty.[17] Both

volumes have covers of brown leather, with different designs on the front and back covers, one geometric, the other largely floral. The large central medallion on the front cover (*figure* 1) is divided by strapwork into a series of compartments, which have been filled with tiny rosettes and knot forms, while the field on either side of the central medallion has been filled with a floral spray that contains oversized lotus blossoms.[18] On the back cover a ten-pointed star forms the centre of an overall design of polygonal forms, which have been tooled with motifs in gilt or blue. The covers have been lined with leather which has been block-pressed with a spiral arabesque design.[19]

The use of different designs on the front and back covers was continued on Ottoman bindings until the 1460s, and the binding on the Konya Koran has several other features that relate it to Ottoman bindings of the first half of the 15th century. The small corner-pieces, for example, are in the form of quarter-rosettes reminiscent of chrysanthemums, framed by two overlapping segments

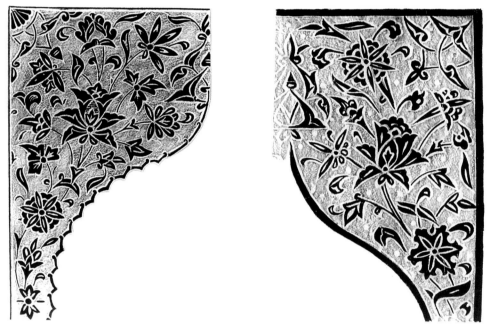

2 *left* Detail of *figure* 1
3 *right* Detail of a front cover, purportedly of Istanbul,
Süleymaniye Library, MS.Fatih 4962

of a circle and a half-ogive. This is a feature that can be found on bindings from 14th-century Iran, but it also occurs on Ottoman bindings from the 1440s and 1450s.[20] Another element in the design of the Konya binding that also occurs on several Ottoman manuscripts of the first half of the 15th century (cat. 1, cat. 2, and *figure* 27) is the wide, segmented borders filled with knotwork patterns. Here, though, narrow panels have been inserted above and below the main field.

Although these links to Ottoman covers of the second quarter of the 15th century may be due to continuity with Karamanid binding of the early 14th century, we should not discount the possibility that the covers of the Konya Koran are the product of a later rebinding. Indeed, one of the leading authorities on Ottoman bookbindings, the late Professor Süheyl Ünver, collected material which seemed to support a date in the mid-15th century, but his evidence is unreliable because he mistakenly identified his material (*figures* 2–3).[21]

The same uncertainty surrounds the covers on a celebrated copy of the translation of Dioscorides known as the *Kitāb al-Ḥashā'ish*,[22] dated Safar 626 (December 1228). The binding on the Dioscorides manuscript is of brown leather, and the front cover is decorated with a geometrical strapwork centred on ten-pointed stars. The back cover (*figure* 4) has been worked with a

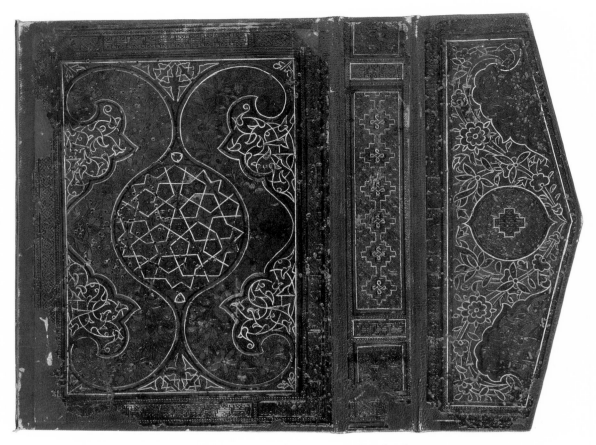

4 Back cover of Dioscorides, *Kitāb al Ḥashā'ish*,
perhaps Anatolia, 14th century
Istanbul, Topkapı Palace Library, MS.A.2127 (317 × 245 mm)

large central medallion, also filled with strapwork. The medallion is connected by curved fillets to four voluminous cresting motifs in the corners. The interstices are filled with large floral sprays, but comparable sprays on the envelope flap are easier to read, as they have been outlined in gold.[23] Similarities between the covers of the Dioscorides manuscript and those of the Koran in the Mevlana Museum, and similarities between the geometrical strapwork on the front cover and that used on several manuscripts of the 14th century, suggest that the Dioscorides binding dates from the 14th, rather than from the 13th, century.[24] Yet it must be borne in mind that the 14th-century bindings have in their turn been claimed for the mid-15th century.[25]

Konya was not, of course, the only centre where manuscripts were produced in Anatolia in the 14th century, but our information on other centres is scant and relates to bindings of more modest pretensions. A manuscript produced in Niğde in 1317 has a binding with a frame that is broader top and bottom than it is at the sides; the frame and the central roundel are filled by a basketwork design composed from bar and arc tools of ungainly size (*figure 5*).[26] Related work occurs on the spine and envelope flap of a manuscript that was copied in Ankara in Rabiʿ al-Awwal 703 (October 1303) by the scribe Ibrahim ibn Shaʿban.[27] The next manuscript known to have been produced in Ankara bears dates of 1417 and 1429, but it is altogether different in composition and its use of tools.[28] Two manuscripts divided by more than a century are hardly sufficient evidence on which to base conclusions about regional or chronological variations.

Konya continued to be a centre for manuscript production into the 15th century, and the only signed Anatolian bookbinding of the 15th century carries an inscription stating that it was the work of Muhammad al-Qaramani (*figure 6*). The manuscript to which it is attached contains several treatises, one of which is dated AH 834 (AD 1430–31).[29] Despite the obvious differences in

terms of proportions, border and field motifs, as well as quality of execution, there is one feature that links several of these Anatolian bindings: this is the discrepancy in size between the zones that frame the main field. As this feature does not occur with any regularity on bindings from other parts of the Islamic world, it may, with due caution, be taken as a diagnostic of the Anatolian tradition.[30] What is clear is that it was not a feature adopted by the Ottomans in the second half of the 15th century. A manuscript that Süheyl Ünver claimed belonged to the library of Mehmed II (*figure 7*) displays this compositional aesthetic, but there is no evidence about where or when the manuscript, and its binding, were produced.[31]

With the loss of so much information about bookbindings under the Karamanids, and so little evidence for bookbinding in other centres in Anatolia in the 14th century, it is impossible at present to build up a coherent picture of the Anatolian forebears of Ottoman bookbinding in the 15th century. For our purposes this loss may not be so great as one might expect, for it is only in the second quarter of the 15th century that there is sufficient evidence about Ottoman bindings for a clear picture to emerge, and by then the influences at work on Ottoman bindings were coming principally from two sources outside Anatolia, namely, from Mamluk Syria and Egypt and from Iran. In order to appreciate how the Ottoman tradition diverged from those of its neighbours, some consideration of bookbinding in these rival traditions is required.

Mamluk Bindings

The earliest datable examples of Mamluk bookbindings come from the end of the 13th century, and substantial numbers of dated specimens survive from the following two centuries, so that it should be possible to trace the history of the subject from the 1280s until the incorporation of

5 Front cover of a manuscript copied in Niğde in 1317
Berlin, Staatsbibliothek, MS.OR.QUART.1583 (234 × 155 mm)

6 *left* Front cover of a collection of mystical texts dated 1430, binding by
Muhammad al-Qaramani. Berlin, Staatsbibliothek, MS.OR.OCT.3285 (188 × 100 mm)
7 *right* Back cover of al-Nasafi, *Madārik al-tanzīl*,
probably Ottoman, mid-15th century
Istanbul, Süleymaniye Library, MS. Ayasofya 284 (275 × 175 mm)

Syria and Egypt into the Ottoman empire at the beginning of the 16th century. However, no comprehensive survey of this material has been undertaken, and, as a result, little is known of the development of this art form during the two centuries and more of Mamluk rule. This is certainly not the place to attempt a detailed study of Mamluk book production, but some generalizations are necessary if we are to draw out the differences between Egyptian and Syrian bindings of the 15th century and the Ottoman tradition. A survey of published material that can be dated with reasonable certainty has allowed us to make a number of observations regarding the typology of Mamluk bindings and their historical development, but at this early stage these remarks must be treated with caution. In terms of their design Mamluk bindings fall into two distinct groups, which are distinguished by the treatment of the main field. This is either filled by an all-over design or by a centre-and-corner composition, in which a central ornament, such as a medallion or pointed-oval figure, is complemented by four devices of similar form placed in the four corners of the main field.

The most common type of all-over design consists of geometrical strapwork. The strapwork systems vary considerably: some were based on a central star, while others are paratactic in structure. The polygonal compartments created by the strapwork often contained tooled knot-work motifs or similar accents, but they were sometimes worked with tiny tools that created all-over texturing. The first approach seems to have derived from a pre-Mamluk tradition and,

although it continued until at least the mid-14th century,[32] it was largely abandoned in favour of the second. The earliest example of the 'textured-ground' style appears on a manuscript dated Rajab 686 (August – September 1287),[33] but it endured into the 15th century, as examples from manuscripts produced in Cairo in 1412 and 1446 demonstrate.[34] A less common type of all-over composition consisted of broad arabesques or large floral forms such as lotuses, buds and half-palmettes reserved against a densely tooled ground.[35] The result was so impressive that it is small wonder that one example was signed by the binder.[36]

The centre-pieces in the earliest examples of bindings with centre-and-corner compositions were roundels, with or without lobed borders.[37] A variant consisted of two overlapping three-lobed devices.[38] From the late 14th century the roundels were often given fleur-de-lis-shaped pendants, attached by more or less triangular shoulders. A very elaborate version is attached to a work on Hadith produced in Cairo as early as AH 698–9 (AD 1298–1300),[39] but the most famous example is found on the bindings of a 30-part Koran that was donated to his *medrese* in Tripoli by the Mamluk amir Aytmish al-Bajasi.[40] As the amir was executed in 1400, the Koran can be dated to the end of the 14th century. The same binder must have worked for Sultan Faraj (*reg.* 1399–1412), for in 1410 the Sultan donated a 30-part Koran with very similar covers to 'his *medrese* in the desert plain' (*figure* 8).[41]

The shoulders added to these medallions brought their profiles close to that of the pointed oval device with a lobed outline that appears on a manuscript from Syria dated 1329.[42] The pointed oval centre-piece only became common in the 15th century, when it was also a feature of Iranian and Ottoman bindings. In the Iranian tradition, and increasingly in the Ottoman, the corner-pieces usually have cusped and indented outlines derived from the 'cloud-collar' cartouche (*figure* 43, for instance).[43] On Mamluk bindings, however, this type of corner ornament only appeared at a relatively late date (*figures* 10, 12; compare also *figure* 11), and for most of the period the corner-pieces that accompanied pointed-oval centre-pieces took one of two forms. The com-monest was a simple triangle, often filled with knotwork,[44] while the second type was larger and assumed a more dynamic role in the composition, as they had arrow-like forms on their hypotenuse that pointed inwards, towards the centre-piece.[45] This form of corner orna-ment does not appear to have survived into the 15th century, and from the late 14th century its place was increasingly taken by a corner-piece that consisted either of a quadrant of a circle or of overlapping quarter-circles.[46]

The inner faces of 14th- and 15th-century Mamluk bindings were often lined with pieces of leather cut from sheets ornamented with designs pressed on to them using rectangular blocks; the ground was darkened by this process, leaving the design in reserve, but it is not clear how this effect was achieved.[47] Block-pressed doublures were current in other parts of the Islamic world, including Anatolia,[48] and continued in use in Ottoman bindings until the 1450s (cat.3–5). A par-ticularly fine specimen occurs on part 20 of a 30-part Koran that was commissioned by the Emperor Öljäytü, the Mongol ruler of Iran, in 1306.[49] In this example the decoration consists of a complex arabesque scrollwork composition that is symmetrical on the vertical and horizontal axes. Most remarkably, the design appears to have been created to match the dimensions of the covers, although repairs to the edges of the doublure have obscured this: all the main elements of the design fit within the surface to be lined, and the scrollwork does not continue off into infinity but turns in on itself, at least at the base.

The high standard of this work is on a par with the generally elevated quality of the books made for Öljäytü in Iraq, and a saddler's mould published by Ettinghausen, whose design can be linked to metalwork of the mid-13th century from northern Mesopotamia,[50] suggests that the production of such block-pressed designs was well within the technical capabilities of Iraqi binders. It therefore seems unnecessary to link the Islamic tradition of block-pressed doublures

to textile production in Egypt, as Bosch has done;[51] indeed, the blocks for printing textiles were carved in relief, while those for pressing the pattern into leather were always carved in intaglio.[52] Wherever the use of block-pressed leather for doublures originated, it was certainly a widespread practice in the Mamluk period.[53] In some examples the design consists of an all-over arabesque pattern,[54] while in others arabesque and floral elements are contained within geometric strap-work,[55] and it is designs of this second kind that occur in Ottoman bindings of the 1440s and 1450s.

Other Mamluk bindings were lined with green cloth, either fabric with printed designs and inscriptions or damask,[56] whereas filigree, which was a common feature of Iranian doublures of the 15th century, is rare. A peculiarity of Mamluk bindings, however, was the use of leather

8 Back cover of part 6 of a 30-part Koran,
produced for the Mamluk sultan Faraj, about 1410
Finland, private collection (370 × 270 mm)

filigree for the centre- and corner-pieces on the outer covers, the filigree often being set against a textile backing. The practical disadvantages of using delicate filigree work on the outer covers of a manuscript do not seem to have concerned Mamluk craftsmen, and it was from their bindings that the idea was borrowed by Paduan and Venetian bookbinders in the 1470s.[57] The earliest Mamluk manuscript with a binding whose outer covers have been worked in filigree is dated 1336,[58] but, as there are no further examples of comparable date, it may be that the binding is a later replacement. Examples are known, though, from the late 14th century, and the practice became usual in the second half of the 15th century.[59]

It was in this later period that Mamluk bookbinding achieved a new degree of splendour, a development that appears to have been associated with the rise to power of Amir Qa'itbay, who became sultan in 1468 and reigned until 1496. Geometric strapwork designs continued to

be used, but despite their new brilliance they are sometimes so complex that they lack the coherence and visual clarity of their predecessors.[60] Centre-and-corner compositions were also employed. On the binding of a manuscript written for Qa'itbay in 1473 (*figures 9, 12*) the centre-piece is a pointed oval with a lobed profile, which is extended top and bottom by fleur-de-lis escutcheons, and the corner-pieces are cusped in the Iranian manner. Iranian influence is also evident in the 'cloud-collar' cartouche on the envelope flap.[61] Despite these borrowings there is no mistaking the Mamluk predilection for boldness in design and execution, with extensive use of gold outlines serving to accentuate the proportions. This is especially noticeable in the floral sprays used on the envelope flap, and in the generous treatment of the doublure, with its adipose centre-piece inset with four large leaf forms.

A typical feature is the wide, segmented inner border of the outer covers, and in this instance it has been decorated with a tool in the shape of a quatrefoil filled with a petalled cross. The same tool or one of similar design was used on at least two other manuscripts produced for Sultan Qa'itbay.[62] The narrow outer border is composed of stamps bearing a pattern of a rhomb crossed by two interlacing meander bands, and precisely the same rectangular stamp was used for the outer covers of a copy of the *Ṣaḥīḥ* of al-Bukhari that was produced for Qa'itbay ten years earlier, in 1463 (*figure 10*).[63] That the two bindings were produced in the same bindery is confirmed by the fact that the same stencil was used for the centre-pieces of both, for the outer covers of the manuscript of 1463 and the filigree doublure of the manuscript of 1473 (*figure 9*). The same binders also produced the covers for a manuscript dated 1469–70.[64]

Another binding attributable to the second half of the 15th century has previously been published as Ottoman, but there are several characteristics that confirm a Mamluk origin (*figure 11*). In the first place, the treatment of the envelope flap is close to that on the binding of the Qai'itbay manuscript of 1473, as is the overall style and density of gilding (*figure 12*).[65] Secondly, the huge proportions of the spade-like escutcheons have no parallel on work from either Iran or Turkey. Thirdly, the gold round border of the centre-piece has a meander pattern of rosettes alternating with floral buds, and buds of a similar type occur on the binding of a Koran written for Qansuh al-Ghawri before he became sultan in 1501.[66]

There is some evidence for a connection between Mamluk and Ottoman bookbinding in the first half of the 15th century, and these will be discussed in detail in Chapter One, but the connections diminished as the century progressed. It may therefore be worth summarizing some of the differences between the two traditions in the second half of the century. *Figure 12* illustrates at least one of these: the use of tools with a square or rectangular format, which were abandoned by Ottoman binders after the 1450s (cat. 4). Furthermore, Ottoman binders did not use the same stamp to decorate the centre-piece and the borders of the main field, a practice that can be seen on bindings made for both Qa'itbay and Qansuh al-Ghawri;[67] the segmented borders that were popular under the Mamluks (*figures 10, 12*) almost entirely disappeared from Ottoman binding in the second half of the 15th century; and there are very few examples of Ottoman bindings with filigree outer covers, and none are known from the second half of the 15th century.

Timurid Bindings

The changes that took place in Mamluk binding in the latter half of the 15th century appear to have been a delayed reaction to the fundamental change in the aesthetic and technical principles of the art that had occurred in Mesopotamia and Iran around the turn of the century.[68] Before that date bookbinding in these regions had shared many similarities with that in the Mamluk realm, but thereafter the Iranian tradition diverged, attaining a degree of refinement that has long been regarded as the summit of the bookbinder's art. This transformation was part of a

9 *above* Doublure of a manuscript by al-Dimyati, copied in 1473 for the Mamluk sultan Qa'itbay
Istanbul, Topkapı Palace Library, MS.A.649/1 (365 × 260 mm)
10 *below* Front cover of a *Ṣaḥīḥ* of al-Bukhari, transcribed for Qa'itbay in 1462–3
Istanbul, Topkapı Palace Library, MS.A.247/2 (435 × 315 mm)

general refinement of the arts of the book, including miniature painting, and occurred firstly under the patronage of Sultan Ahmad Jalayir, who ruled intermittently in Baghdad and Tabriz from 1382 to 1410. Sultan Ahmad had the misfortune to be a contemporary of the Central Asian conqueror Timur (*reg.* 1376–1405), and he was expropriated on a number of occasions by Timur and his immediate successors. But the Jalayirids' loss was the Timurids' gain, and calligraphers, painters, illuminators and binders who had been associated with Sultan Ahmad's court found new employment with the Timurids. Their transfer took place on three different occasions. In the first instance, some were removed directly from Baghdad to Samarqand by Timur. Others later attached themselves to the court of Timur's grandson Iskandar Sultan in Shiraz, some no doubt in the wake of Iskandar's marriage to Sultan Ahmad's daughter, and at least some of these artists would have been among the group that Timur's son Shahrukh removed to Herat after Iskandar Sultan was deposed in 1414. Finally, Shahrukh's son Baysunghur Mirza removed the remaining artists who had worked for Sultan Ahmad to Herat in 1421, following a brief period as governor in Tabriz. On this basis Baysunghur was able to establish a scriptorium in Herat in the 1420s that was the heir in terms of personnel of those of Sultan Ahmad and of his cousin Iskandar Sultan.[69]

Bindings produced for Sultan Ahmad and for Iskandar Sultan demonstrate the principal changes that occurred in Iranian bookbinding in the 15th century. One change was an increasing use of colour, which was initally restricted to the doublures but eventually found its way on to the outer covers. The use of colour was connected with the development of filigree, and the doublures of a binding on a copy of Sultan Ahmad's own *Dīvān* (collected poems), produced in Baghdad in 1407,[70] stands at the beginning of a tradition of leather filigree that was to culminate in the virtuoso doublures of the late 15th century.[71]

The invention of filigree in Iran has been credited by all 20th-century commentators to the binder Qiwam al-Din on the authority of Dust Muhammad, who wrote in 1544.[72] In fact, the term employed by Dust Muhammad was *munabbatkārī*, which the 19th-century lexicographer Steingass defined as a colloquial term meaning 'embossed, inlaid, or carved-work', while he defined the root word, *munabbat,* as 'caused to grow out or to be raised; hence ornamented in relief, embossed, carved, inlaid; raised work; embossment; inlaid-work'. In this century the term has been used to refer to relief-work such as repoussé metalwork and wood carving and stone sculpture in relief, rather than to openwork.[73] In view of this and of the fact that filigree work had been executed by binders many centuries before Qiwam al-Din's time,[74] it seems more likely that the binder was responsible for introducing the use of stamps that created relief-moulding, for the first undisputed use of stamped decoration in Iranian bookbinding occurs on two nearly identical covers, one on another copy of Sultan Ahmad's *Dīvān*, dated 1402, the other on a manuscript copied in Yazd in 1407, perhaps for Iskandar Sultan.[75] As Barbara Brend has pointed out, there are two possibilities that would explain the similarity between the bindings: either the stamps used for Sultan Ahmad's binding were in the hands of Iskandar Sultan's binder; or Sultan Ahmad's *Dīvān* of 1402 was bound or rebound in 1407. Either way, the bindings demonstrate the existence of pressure-moulding by the first decade of the 15th century.[76]

These two bindings are also the earliest examples with figurative decoration. The outer covers have a scene of a stag and a hind in the centre-pieces and rabbits in the corner-pieces, while the doublures of the manuscript of 1407 have filigree centre-pieces with a scene of two foxes.[77] Figurative decoration was to become an increasingly important feature of Iranian bindings in the 15th century, and by the middle of the century human figures had been introduced as well. It is clear that neither the Ottomans nor the Mamluks had much taste for pictorial bindings: to date no Mamluk binding of this type has been identified, and the number of Ottoman examples is very small. Nevertheless, one of the earliest bindings to include a human figure is attached to a *Khamsah* of Nizami whose frontispiece contains a dedication to Mehmed II and which was copied between

11 *above* Back cover of a detached binding,
Mamluk, late 15th century
London, Victoria & Albert Museum, inv.no.531–1983 (312 × 210 mm)
12 *below* Back cover of *figure 9*

1440 and 1443, probably in Yazd or Shiraz (*figure* 13).[78] It has been suggested that it was presented to Mehmed on his accession,[79] but this is open to doubt, for the dedicatory roundel that includes Mehmed's name was placed on the verso of the first folio, which is highly unusual, unless there are two roundels arranged as a double-page spread. In this case, the roundel had to be placed on the right-hand page because there was an earlier roundel on the recto of the second folio, which has been covered over with gold.[80]

Regardless of how this Shirazi manuscript came into Ottoman hands, it provides, in association with two other manuscripts, a useful summary of several of the most distinctive characteristics of Iranian binding of the Timurid period. The most striking of these was the figurative aesthetic. In

13 Front cover of a *Khamsah* of Nizami,
Yazd or Shiraz, 1440–43
Istanbul, Topkapı Palace Library, MS.R.862, (180 × 130 mm)

addition to human figures, the imagery used ranged from dragons and phoenixes in a pseudo-Chinese style to deer, monkeys and rabbits, which, like the foxes on the doublures of the Yazd anthology of 1407, were in a more obviously Iranian manner. The style of figure-work used on bindings was not derived from narrative painting, but from *siyāhqalamī* ('black-pen work'), the style of drawing that was used in the production of designs for all forms of decorative art. Stencils, either for direct tooling or for making a stamp, were, as we shall see, prepared by a designer who was not necessarily a practising binder.

One such stencil was used on the outer covers of the *Khamsah* of 1440–3 (*figure* 13) and again for the binding of a *Maṣnavī* copied four years later, in 1446.[81] The doublures of the *Khamsah* illustrate the skill of Iranian binders in producing minute filigree. In this instance the designs are of arabesques and floral motifs, whereas the doublure of the *Maṣnavī* of 1446 has a centre-piece with a

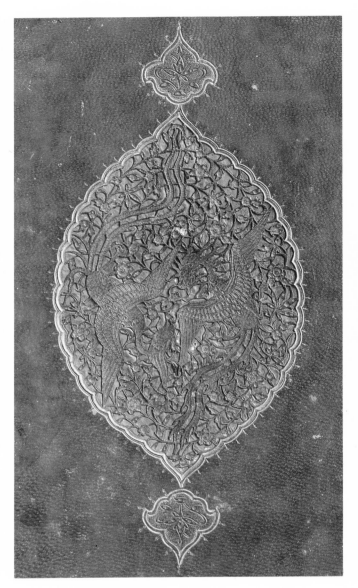

14 *left* Detail of the front doublure of a *Khamsah* of Nizami,
Shiraz, 1449–50. New York, Metropolitan Museum of Art, inv.no.13.228.3
(centre-piece, including pendants, 192 × 85 mm)
15 *right* Drawing in *siyāhqalamī*
Istanbul, Topkapı Palace Library, MS.H.2152, folio 72a (192 × 112 mm)

pair of confronted phoenixes in flight.[82] The stencil used to produce the phoenix centre-piece in filigree was used for the back cover of the same *Maṣnavī*, and, reversed, for another filigree dou-blure, on a *Khamsah* produced in 1449–50 (*figure* 14).[83] The repetition of these designs proves the roles of stencils, and it is from the Jalayirid and Timurid period that the first such decorative draw-ings survive. One of these is a sketch of two phoenixes in flight (*figure* 15) which was evidently for a centre-piece comparable in concept and size to those of 1446 and 1449–50.

The Role of the Scriptorium

In the 15th century the use of stencils was not unique to Iranian bookbinders, for we have already seen how Mamluk binders under Qa'itbay employed them (*figures* 9–10). Of course, the Iranian bindings differ from the Mamluk in the use of figural elements, which was more than a stylistic preference, for it reflected the interest in painting and design shown by members of the ruling dynasty. The involvement of royal patrons in the production of figural works of art can be docu-mented from the reign of the Jalayirid ruler Sultan Uways (*reg.* 1356–74), who learnt the art of *siyāhqalamī*.[84] Sultan Ahmad Jalayir also studied drawing, and there is evidence for the direct involvement of the Timurid prince Baysunghur Mirza, who died in 1434, in artistic production. Baysunghur is renowned as a calligrapher, not least because he designed the monumental inscription for the sanctuary façade of his mother's mosque in Mashhad.[85] But he was also the leading patron of the arts of the book in the second quarter of the 15th century, and a document datable to Ramadan 830 (June – July 1427) gives a detailed account of the activities of the artists employed in his scriptorium.[86] This document shows that, in addition to the copying, illumina-tion and illustration of some seven manuscripts, two masters were engaged in binding. Khwajah Mahmud was working on the binding of the *Rasā'il*,[87] while Mawlana Qiwam al-Din, whose role as the inventor of *munabbatkārī* has already been mentioned, was working on the covers for a *Shāhnāmah*. Another member of the scriptorium, Khwajah 'Abd al-Rahim, was creating cartoons for the binders and illuminators, as well as for tent-makers and tile-cutters. Moreover, the large group of decorative artists (*naqqāshān*) and tent-makers engaged in executing these designs also appear to have been doing so under the direction of the head of the scriptorium, Ja'far al-Tabrizi, as do the tile-cutters and decorative sculptors working on buildings to be used by the court.[88] Other objects being made under his direction included a small chest, four albums and a saddle in mother-of-pearl.

There can be little doubt that the coordination within scriptoria of all aspects of book produc-tion was the crucial factor in the development of the new and refined style of binding in Iran in the first half of the 15th century. Patrons such as Baysunghur devoted enormous resources to book production and took a personal and informed interest in what was produced, favouring the application of a pictoral approach strongly influenced by Chinese art to all aspects of design.

When we turn to Ottoman bindings, it is not until the 1460s that we see a similar degree of radical change, and, what is more, it was at this time that Sultan Mehmed II seems to have established a scriptorium on much the same lines as described above. The radical changes of the 1460s and 1470s resulted in the emergence of an identifiably Ottoman style of bookbinding, but this was soon overtaken by a reformulation of the Ottoman style in the final decades of the 15th century. Indeed, we may detect a broad shift in Ottoman binding design over the century, for fine bindings of the period before about 1460 related more to the Mamluk tradition, while by the 1490s Ottoman bookbinding was dominated by a style developed on the basis of Timurid and Turcoman models.

16 Rubbing from the outer cover of a Koran
associated with Murad II, Ottoman, 1445
Istanbul, Topkapı Palace Library, MS.Y.438 (actual size)

Chapter One

OTTOMAN BOOKBINDING BEFORE 1460

THE Ottomans, like the Karamanids before them, had their very humble origins in a band of mountainous territory on the edge of the Anatolian plateau. Their lands lay to the south of Bithynia, then still held by the Byzantines, and to the north of the part of the plateau occupied by other Turkish elements, led by lords of the Germiyan dynasty. The Ottomans rescued themselves from obscurity by expanding into Byzantine territories in Bithynia and eliminating their immediate Turkish neighbours. As their power and wealth increased, they began to attract scholars and literati to their court, but we have no way of knowing when Ottoman rulers first began to acquire secular manuscripts for their personal use. We can presume, however, that copies of the Koran and other religious works were in their possession or that of members of their immediate circle from the establishment of their state in the late 13th or early 14th century, for no group of Muslims with any claim to piety could survive without them.

The aspiration to piety of the early Ottomans is indicated by the action of the second ruler of the dynasty, Orhan Bey, after he conquered the Byzantine city of Nicaea (which thereby became Iznik) in 1331: 'He converted a great church into the Friday mosque and also turned a monastery into a *medrese,* and at the place where the Yenişehir Gate issues he built an *imaret.*'[1] Orhan's *medrese* in Iznik seems to have been the first founded in the Ottoman period,[2] but his example was followed by his sons, Süleyman Pasha and Sultan Murad I, and *medreses* soon became a standard feature of all the cities the Ottomans conquered.

As we have noted in connection with Sahib Ata's patronage of *medreses* in the 13th century,[3] the scholastic nature of the education provided by the *medrese* system meant that the text played a central role, and so the growth in the number of *medreses* created a demand for books. Something of the nature of this demand is suggested by the entry on the *müfti* Molla Fenari in the biographical dictionary of Ottoman scholars compiled by Taşköprülü-zade Ahmed Efendi in the 16th century. As well as being the first supreme *müfti* 'in the Ottoman lands', Molla Fenari was

an author of some renown and is generally considered the founder of the Ottoman *medrese* system, at least in terms of its curriculum. Even so, Taşköprülü-zade's statement that when the Molla died in 1431 he owned a library of 10,000 volumes seems to be something of an exaggeration.[4] But Taşköprülü-zade also relates that until Molla Fenari's time 'students had Fridays and Tuesdays as their rest days, but the above-mentioned Molla added Monday to them. The reason for this was that in his time the works of the scholar al-Taftazani were celebrated, and the students wished to read them. However, those books were not to be found for sale because copies of them had not been disseminated. Therefore, they needed to make their own copies, and, because they had too little time to do so, the above-mentioned Molla added Mondays to their rest days.'[5] In the *medrese* curriculum formulated by Molla Fenari the works of Sa'd al-Din al-Taftazani, who died in 1390, together with those of al-Sayyid al-Sharif al-Jurjani, who died in 1413, played an essential role: they were the filter through which the new generation of students received the wisdom of the 'ancients'. The shortage of copies of al-Taftazani's works would therefore have created a bottleneck in the expansion of higher education in Ottoman territory and had to be overcome.

Molla Fenari first came to prominence in the reign of Orhan Bey's grandson, Sultan Bayezid I (*reg.* 1389–1402). By this time, the Ottoman state had expanded its territories across the Straits and into the Balkans. The chief town of the European provinces was Edirne, situated at the junction of the Rivers Tunca and Meriç in eastern Thrace, and it was here and in the Anatolian capital of Bursa that most Ottoman *medreses* were founded. Bursa was also the burial place of every ruler from Orhan, who had the remains of his father, Osman, transferred there, to Murad II, who died in 1451. Each of these princes also established an *imaret* in the city. These institutions, whose name, interpreted literally, means nothing more than 'edifice', played an important part in the life of the empire until the mid-16th century, but their original functions eventually lapsed, and the buildings were adapted for use as neighbourhood mosques. Thus the *imaret* of Sultan Mehmed I in Bursa, also called the Green İmaret, later became the Green Mosque.[6] At the same time, the term *imaret* came to be applied to a public building used for only one of the functions of the original institution, namely, an establishment from which food was dispensed to the needy.

Early *imarets* consisted of a complex of rooms around an internal courtyard. The whole building was generally aligned on the *qiblah*, and the largest room, which was completely open to the courtyard on one side, served as a prayer hall, being equipped with a *mihrab*. İmarets provided a meeting place for Muslim mystic brotherhoods, one of whose activities was the provision of sustenance and accommodation for visitors, who were under no obligation to pay. The Bavarian Johann Schiltberger, who spent some time in the Ottoman empire after being taken captive at the Battle of Nicopolis in 1396, defined an '*emared*', one of three types of Turkish '*tempel*', as an institution where anyone could lodge and eat and drink.[7] The founder seems to have played a part in these activities on occasion, for the chronicler Aşık Paşa-zade described how, when his *imaret* in Iznik had been completed, Orhan 'was the first to share out with his own blessed hand the food that had been cooked, and, what is more, on the first night he himself lit the lamps'.[8]

While such charitable activities caught the attention of both Frankish visitors and Turkish chroniclers, other aspects of life in these institutions, including the use of books there, were less open to scrutiny. In some of the imperial *imarets* of Bursa the side rooms have retained their elaborate stucco fittings on one wall, and these include a hearth and niches of the type where books were kept, stacked on their sides.[9] But, whereas in a *medrese* the books kept in such niches would have been almost exclusively works of scholarship written in Arabic, in an *imaret* they would also have included literary compositions in Persian and Turkish.[10]

The type of bindings produced in the period before the accession of Sultan Murad II in 1421 has still to be established, partly because very few manuscripts of the period have been published, and none of these appear to have retained their original covers. An exception may be the

autograph of a work on Koran recitation, the *Kitāb al-nashr fī'l-qirā'āt al-'ashar* of Ibn al-Jazari.[11] The author began to compose the book 'in his home in Bursa' in Rabi' al-Awwal 799 (December 1396), and he finally completed it in Safar 803 (August–September 1400), which makes it the earliest manuscript known to have been produced in the city. As well as the colophon, the book also contains a dedication to 'Iskandar Bahadur Khan', who can probably be identified with Iskandar Sultan, a grandson of Timur and governor of Shiraz between 1409 and 1414.

Ibn al-Jazari was one of the many scholars attracted to Bursa in the 1390s by the growing power and wealth of the Ottomans under Bayezid I, arriving from Damascus in 1396. But in 1402 Bayezid was defeated at the battle of Ankara by Timur, and Ottoman control in both the Balkans and Anatolia was severely shaken. Ibn al-Jazari was deported by Timur to Transoxiana, where he continued to give instruction in Koran recitation. After Timur's death in 1405 the scholar travelled across Iran with the intention of making his way to Mecca, but when he reached Shiraz he was forced to accept appointment as chief cadi by Pir Muhammad, another grandson of Timur who was Iskandar Sultan's predecessor as governor of the city. Ibn al-Jazari was only able to reach Mecca in 1420, and he later returned to Shiraz, where he died in 1429.[12]

The binding of the manuscript (*figure* 17) is of purplish-brown leather and has a pointed-oval centre-piece filled with an arabesque scroll on the front cover and a roundel filled with interlaced bands on the back cover. The flap bears a lobed roundel filled with a floral design that includes a large lotus blossom and plane leaves.[13] If we combine the documentary and stylistic information provided by the book itself with what we know of Ibn al-Jazari's life from other sources, we are presented with three possibilities regarding the illumination and binding of the manuscript. The first is that Ibn al-Jazari took the book to Shiraz unilluminated and unbound, that the work was

17 Back cover of a work on Koran recitation by Ibn al-Jazari,
Bursa, 1396–1400, binding later
Istanbul, Topkapı Palace Library, MS.A.167 (260 × 160 mm)

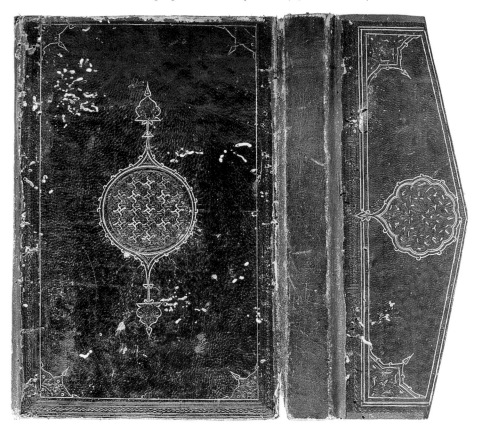

carried out there, and that the book was subsequently taken back to Turkey by some means or other, eventually entering the library of Sultan Ahmed III in the Topkapı Palace. The second is that the manuscript was illuminated and bound in Bursa, with the intention of presenting it to Iskandar Sultan, who was nearby, in Kütahya, in 1402. The plan may not have been realized, in which case the manuscript may have stayed in Bursa when Ibn al-Jazari was deported. The third is that the manuscript remained in Bursa, unilluminated and unbound, until some time in the second quarter of the 15th century, when the work was carried out in the somewhat outmoded Shirazi style still current in the Ottoman empire at that time; it must be admitted, however, that this last explanation fails to account for the dedication to 'Iskandar Bahadur Khan'.

Ibn al-Jazari's experience of Timur's invasion in 1402 seems to have been typical. Molla Fenari, for example, was led away in chains by the conqueror's forces, together with two other leading figures in the religious life of Bursa, the mystics Emir Sultan and Seyyid Natta'. All three were soon released because of their eminence, but Molla Fenari appears to have then settled in Konya, and he only returned to Bursa in 1417.[14] At the same time many less eminent citizens were deported to Central Asia. One of these was 'Ali ibn Ilyas, who, as we shall see, eventually returned to Bursa to work on the complex of buildings constructed on the orders of Sultan Mehmed I. Much of the territory Bayezid I had conquered was lost as a result of Timur's intervention, and the remainder was divided between Bayezid's sons. One of these, Sultan Mehmed Çelebi, gradually assumed control in Anatolia, and in 1413 he reunited the empire by defeating his brother Musa Çelebi, who had seized control of the Balkan provinces.

Sultan Mehmed and 'Ali ibn Ilyas

The disaster of 1402 had a profound effect on the history of Ottoman art, for it was followed by a period of intensive contact with the Timurid East. The most obvious manifestation of this contact was the appearance of decorative tilework on Ottoman buildings, but the early 15th century was also the first period for which we have evidence of the coordination of artistic production in different media by a master of the decorative arts, or *naqqāsh*. As we shall see, the first such *naqqāsh* known by name may have been a leather-worker by training, but a lack of surviving bindings means that it is impossible to say whether there was any effect on this art form.

The reunification of the empire brought a measure of stability and renewed confidence to Bursa, symbolized most notably by Sultan Mehmed's building activity there. In 1412 he had undertaken the erection of a magnificent group of buildings on the hillside immediately to the west of the city. This complex – it includes a tomb, a *medrese* and the *imaret* now known as the Green Mosque – is close in scale and construction to the complex erected by Sultan Mehmed's father, which stands nearby.[15] But its decoration marks a new departure, for, in the case of the tomb and the *imaret*, it includes extensive, elaborate and, in the context of Bursa, exotic tilework in the style then current in Timurid Samarqand: one feature is the external use of tile revetments in the manner of the brick architecture of the Iranian plateau and western Central Asia, although the buildings themselves are mostly of stone. To some extent the designs used in this tilework can be related to those employed in the decorative arts under the Timurids, including bookbinding. The most striking parallel occurs on the internal walls of the tomb, whose dado of hexagonal turquoise tiles is set with a series of enormous pointed roundels in tile mosaic (*figure* 18). The form of these roundels has been compared to those found on 15th-century carpets,[16] but they also resemble the figures used as centre-pieces on some Timurid bindings of the same period. They have palmette-shaped finials, and they are filled with an arabesque pattern that is symmetrical on its horizontal and vertical axes, and both these features occur, for example, in the central roundel on the outer covers of a manuscript copied in 1430–1 (*figure* 19). There are also parallels between

18 *left* Tile panel in the tomb of Sultan Mehmed I
in Bursa, *circa* 1420
19 *right* Back cover of a work on Hadith, Iran, probably Shiraz, 1430–31
Istanbul, Topkapı Palace Library, MS.A.645 (300 × 200 mm)

the designs used in the tilework and Ottoman bindings produced later in the 15th century. An
example is the spray of flowers rising from a vase that fills the central panel of the *mihrab* in the
tomb;[17] this can be seen as a more sophisticated version of the sprays of flowers that fill some of the
centre-pieces of cat.4 below, one of the bindings commissioned by Umur Bey, the son of Timurtaş
Pasha, who played a key role in Ottoman book culture in the decades before his death in 1461.

The craftsmen who made the tilework *mihrab* in the *imaret* signed themselves as 'the masters of
Tabriz'.[18] This city in north-west Iran was certainly one of that country's main centres of artistic
production,[19] but, although the Tabrizi craftsmen may have been responsible for the technical
aspects of tile production, they were not necessarily in overall control of the designs they exe-
cuted. Indeed, the use of designs similar to the large roundels in the tomb on, for instance, the
painted wooden ceilings over the two spaces between the main door of the *imaret* and the internal
courtyard suggest that the decorative work in all media was being coordinated from above.[20] We
know from the inscriptions on both the *imaret* and the tomb that Sultan Mehmed had placed
one of his viziers, Hacı İvaz Pasha, in charge of the construction work as a whole,[21] but an inscrip-
tion in Arabic on a stone plaque inside the *imaret* tells us that, 'The decoration [*naqsh*] of this Noble
Edifice was completed by the most needy of mankind, 'Ali ibn Ilyas,[22] in the last [ten days] of
Ramadan the blessed, *anno* 827 [17–26 August 1424]'.[23]

The 'Ali ibn Ilyas mentioned in this inscription is unusual for an artist of this period in that his
name is known from both epigraphic and literary sources and can be securely linked to extant work.
His continued fame was no doubt due to the eminence of his descendants. His son Osman Çelebi
rose to be registrar of the imperial treasury under Sultan Bayezid II, and his grandson Mahmud
became, under the pen-name Lami'i, a great master of Ottoman Turkish prose.[24] In his account of

20 *left* Mystical text copied in Bursa in 1424
Istanbul, Topkapı Palace Library, MS.A.1509 (216 × 152 mm)
21 *right* Hebrew commentary by Eliezer Comtino on Maimonides's
Guide of the Perplexed, dated 12 November 1480
Istanbul, Topkapı Palace Library, MS.G.İ.53 (239 × 169 mm)

the life of Lami'i the biographer Taşköprülü-zade provided some striking information about the writer's grandfather: he 'was from the city of Bursa, and when Lord Timur entered the city of Bursa he took ['Ali] with him, [even though] he was [only] a boy, to the land of Transoxiana. There ['Ali] learned the craft of the decorative artist [*naqqāsh*], and he was the first to produce patterned saddles [*surūj munaqqashah*] in the land of Rum.'[25]

In traditional Turkish saddles the wooden 'tree' consists of two boards laid parallel to the flanks of the horse and joined by an arched pommel and cantle; the centre of this structure is filled with a padded seat; and the whole is covered with leather, which is often decorated with stitching.[26] Some sort of decoration seems to have been the norm by the 1430s at the latest, for the Burgundian gentleman-pilgrim Bertrandon de La Broquière reported that the Turks had 'des selles moult riches',[27] and so it is difficult to take at face value Taşköprülü-zade's claim that 'Ali ibn Ilyas introduced the 'patterned saddle' a mere decade or so earlier.[28] However, if we accept Taşköprülü-zade's statement that 'Ali was trained in Transoxiana, where Timur had gathered craftsmen from the cities he had conquered, then what 'Ali may have done was to introduce a new technique for decorating saddles, or new and more sophisticated designs, or both.

We know that saddles decorated with mother-of-pearl were being produced at the Timurid court in Herat some time after 'Ali ibn Ilyas had returned to Turkey,[29] but the similarity between the decorative designs employed in the buildings of Mehmed I under this artist's supervision and those used for contemporary Timurid bookbindings suggests that 'Ali ibn Ilyas may have made designs for leatherwork. Ettinghausen has pointed out the connection between bookbinding

and leatherworking in general and has proposed that in the medieval Islamic world bindings may have been surpassed in quality by other types of leatherwork, as they seem to have been in Coptic Egypt.[30] At the same time he published two fragmentary stone moulds engraved with designs typical of the pre-Mongol period.[31] In the margin of one there is an inscription reading, 'The work of Bandar the Saddler', and this, and the shape of the panel of decoration, led him to suggest that it was used for pressing a pattern into saddle leather.[32]

'Ali ibn Ilyas's known work – the decorative programme in the 'Green Mosque' and probably that in the adjacent tomb of Sultan Mehmed – have some association with contemporary Timurid bookbinding, as we have seen. It is difficult to take the argument further, to include 'Ali's possible influence on Ottoman bookbinding, because only one binding of the first quarter of the 15th century has been identified, and its quality is too modest to allow comparison (*figure* 20), while the grandest bindings of the second quarter of the century relate more to later Mamluk work than to anything produced for the Timurids (cat.1, cat.2, *figures* 23–30). However, if we look forward to the more modest bindings produced for Umur Bey, the son of Timurtaş Pasha, during much the same period, we can see parallels with the architectural ornament produced under the supervision of 'Ali ibn Ilyas, not only in the tilework, but also in the painted decoration of the wooden ceilings in the Green Mosque, with their centre-and-corner compositions.

The institutions founded by Sultan Mehmed in Bursa must have been endowed with books as a matter of course. This was certainly the case with the mosque and *medrese* he established in Merzifon, in north-central Anatolia, in 1417, for later in the 15th century the complement of staff there included a binder, who was to be paid two silver pence a day 'for repairing the Noble Fascicules [of the Koran] and the books on jurisprudence'.[33] Sultan Mehmed also owned books for his personal use.[34] But the earliest dated manuscripts whose bindings are certainly original are from the reign of his son, Murad II.

Bursa Colophons

The first of these (*figure* 20) has already been mentioned. It contains a commentary by 'Abd al-Razzaq al-Kashani on a famous 11th-century work on Sufi mysticism, the *Manāzil al-sā'irīn* of 'Abdallah al-Ansari. It was copied by one Ahmad ibn 'Abdallah, who describes himself as the freedman of the former grand vizier Çandarlı-zade Ali Pasha, and it was completed in AH 827 (AD 1424), in Bursa. Although Bursa seems to have recovered relatively quickly from the disruption of Timur's invasion and its aftermath and maintained its importance as an economic, political and cultural centre throughout the 15th century, very few other manuscripts from this period have colophons giving the city as their place of origin. One is an anonymous copy, dated Dhu'l-Qa'dah 856 (November 1452), of a commentary on the *Maqāṣid* of Sa'd al-Din al-Taftazani, the scholar whose works were so sought after in the time of Molla Fenari (*figure* 41);[35] another contains the dictionary of Muhammad al-Firuzabadi and was copied for Sultan Mehmed II in AH 860 (AD 1455–6) by the scribe Ahmad ibn Husayn al-Misri;[36] and a third is an autograph copy of the *Jāmi' al-da'wāt* of Shukrallah al-Amasi, made in Jumada'l-Ula 868 (January 1464).[37]

We may conclude from the surnames of the scribes of two of these manuscripts that Bursa continued to attract scholars from elsewhere in Turkey (al-Amasi means 'of Amasya', in north-central Anatolia) and from other parts of the Islamic world (al-Misri means 'of Egypt'). In other respects the information these manuscripts provide is rather scant, and, considering the large number of books that survive from the second half of the 15th century, it is surprising that the colophons of so few mention that they were produced in Bursa. This should not be taken to mean that manuscripts were not produced in Bursa in any numbers, for colophons mentioning Edirne in the period before 1453 are equally rare, even though this city was the main residence of

the sultan and is known to have been a centre of literary activity.[38] The situation in the rest of Anatolia is equally obscure, for very small numbers of 15th-century bindings can be associated with important cultural centres such as Konya and Amasya (*figures* 6, 40).[39]

The leather covers on the four Bursa manuscripts were produced over a period of 40 years, and it would be dangerous to construct a typology of Bursa bindings on such slender evidence, especially since two of the examples, namely those on the commentary on the *Manāzil al-sā'irīn* of 1424 (*figure* 20) and the *Jāmi' al-da'wāt* of 1464, belong to an ahistorical class of binding, a type in which the main decorative element is a central pointed oval, a figure that is also called a mandorla or vesica (for vesica piscis).

Generic Bindings

Although ahistorical, or generic, bindings evolved only slightly over the period under consideration and therefore tell us little about major developments in the art form, they do deserve our attention, if only because to ignore them would create a false impression, namely, that all bindings produced in Turkey in the 15th century were as ambitious in scheme and as spectacular in execution as the selection of bindings described in detail below.

The covers of the Bursa manuscript of 1424 (*figure* 20) have tooled and gilded decoration and may well be contemporary. As in all such bindings, the design consists of three main elements: a plain field, a pointed-oval centre-piece and a multiple border combining fillets and tooled bands. One of the earliest examples of this type is on an illustrated copy of the *Manāfi' al-ḥayawān* in the Pierpont Morgan Library, New York, which Ettinghausen has shown was contemporary with the manuscript and therefore dates from the late 1290s.[40]

On the *Manāfi'* binding the field within the pointed oval is divided by tooled bands into three compartments, but by the 15th century the field had come to be treated as a single unit. In this connection Ettinghausen cited a Persian binding attached to a manuscript produced at Abarquh in Fars in 1424, but he underestimated the number of bindings of this type produced in the 15th century,[41] for covers with pointed-oval centre-pieces were relatively common under the Ottomans. Most appear on books that seem to have been intended for the use of scholars, a fine example being the binding of the Bursa manuscript of 1464, the *Jāmi'al-da'wāt* of Shukrallah al-Amasi, but some are attached to manuscripts with dedications to the sultan, such as a commentary on a work on logic, which bears the date 11 Muharram 877 (18 June 1472) and was made 'to be read by' Sultan Mehmed II.[42] The pointed-oval composition was common on the bindings of the Greek manuscripts prepared for Mehmed II, and a similar composition was used for the covers of a Hebrew manuscript datable to *circa* 1480 (*figure* 21).[43] One difference between the covers of the Bursa manuscript of 1424 and those of the Hebrew manuscript of *circa* 1480 is the form of pendant used. On the Bursa manuscript these take the form of a fleur-de-lis constructed from arc tools, while the Hebrew manuscript has an everlasting knot. As well as being used for pendants, this knot motif was also employed for the corner-pieces in more modest centre-and-corner compositions, as on cat.3,[44] on doublures, such as those of cat.18, and as the centre-piece on a second type of generic binding.

The history of the use of the everlasting knot as a motif in Islamic decorative art has been traced by Stöcklein, who suggested that it originated in China, where it was considered a symbol of good luck, and that it entered the Islamic world in the late 13th century, perhaps as a result of the Mongol invasions, and was applied to a wide range of artefacts, from coinage to carpets.[45] The motif was popular in Turkey in the 15th and 16th centuries, and in the 15th century it was commonly used as a centre-piece on a relatively humble type of bookbinding. In these cases it takes the form of a rhomb of knotwork and has extensions above and below, worked with an s-tool and

sometimes terminating in small knotwork pendants; such centre-pieces were usually accompanied by modest corner-pieces, often little triangles in the same type of knotwork. Although this composition was simple in conception, there was considerable variation in the quality of execution.

A rendition of this motif, with the knotwork in gold composed around four squares tooled in blue, appears on the doublures of cat.7, whose text was completed in 1455. A complex, but not quite so fine, example, which verges on basketry in its effect, was tooled in gold on the outer covers of a miscellany of three works in Arabic and Persian copied between July 1440 and March 1451 (*figure* 22),[46] whereas the example on a 15th-century Greek manuscript in the Topkapı Palace Library is dot-punched in gilt and can be considered more typical of the style.[47] Even simpler

22 Front cover of miscellany, Ottoman,
probably Bursa, 1440–51
Bursa, İnebey Library, MS.Haraçcıoğlu 640 (180 × 140 mm)

versions were used on other Greek manuscripts of the 15th century.[48] The modest character of such bindings often stands in sharp contrast to the exquisite quality of the books they enclose. This is the case with a beautifully illuminated copy of an Arabic work on medicine, which lacks a dedication to Sultan Mehmed II but was probably copied during his reign.[49] But perhaps the most marked contrast occurs in the case of an anonymous treatise on mysticism copied by Sayyid Muhammad al-Munshi al-Sultani in AH 883 (AD 1478–9). The binding has blind-tooled central knotwork rhombs that are a mere 10 mm square, but the text is a superb example of calligraphy in *ta'līq*.[50]

The available evidence is not sufficient to allow us to identify Ottoman bindings of the first half of the 15th century as the distinctive products of a particular centre of production, even in the case of Bursa and Edirne, the two principal cities of the empire. However, we do have information of another kind that permits us to associate bindings with particular patrons. In two

23 *left* Front cover of cat.1, Ottoman, probably Bursa,
circa 1435. Bursa, Museum of
Turkish and Islamic Arts, MS.207 (590 x 475 mm)
24 *right* Back cover of cat.1

instances – the patronage of Sultan Murad II and of Umur Bey, the son of Timurtaş Pasha – there
is enough of this information to allow us to identify groups of bindings and to begin a coherent
discussion of stylistic development. Other types of bindings current in the 1440s and 1450s can
be associated with named patrons, but the number of examples is too small to allow such gener-
alizations. An example is the type of binding with a centre-and-corner composition consisting
of a roundel with a wide border, similar to the borders on the pointed-oval type; the roundel has
fleur-de-lis pendants above and below, which are attached by more or less triangular shoulders.

This composition was common in Turkey only in the mid-15th century. It appears, for example,
on the covers of a Koran made for Mercan Ağa, who was probably a member of the imperial
household,[51] and on the back cover of a manuscript produced in Konya in AH 859 (AD 1454–5).[52]
It is tempting to derive this form from a similar composition used in Mamluk binding from the
late 14th century (*figure* 8). In the Mamluk examples the roundel is the dominant figure in the
composition, but it is surrounded by a lobed ogival frame with fleur-de-lis finials. In the simpler
Ottoman version, however, the frame is reduced to simple triangular shoulders above and below the
roundel, and the main similarity is the fleur-de-lis finials. This composition was used both for
outer covers, as in the case of the Koran of Mercan Ağa, and for doublures, as on cat.2 and cat.9 below.

Murad II

In later centuries Sultan Murad II was celebrated as 'the first Sultan of the Ottoman line to
compose poetry and to value and esteem poetry and poets: not only did poems of rare refine-
ment emanate from him, but during his auspicious reign this art found favour and popularity to

the utmost degree'.[53] The biographical dictionaries of Ottoman poets that were prepared in the 16th century all contain a notice on the Sultan that runs along these lines. The earliest of these writers, Sehi Bey, emphasized the Sultan's carefree disposition, 'No other emperor has been granted as many blessings as [God] granted him. He was a great drinker and a terrible rowdy, good-natured and refined …', and he quotes two lines from the beginning of one of Murad's poems, as if to confirm this:

> Saki! Bring, bring back my wine of yesterday!
> Make your tongue sing! Bring back my harp and rebec!
> While I am alive, I need this pleasure and enjoyment:
> A day will come when no-one will see my mortal form.[54]

Latifi, who wrote a decade later, in the 1540s, was keener to stress a more serious side of the Sultan's character. According to him, Murad 'used to gather scholars and poets together on two days a week and would listen to them with consideration and courtesy from beginning to end, having appointed several topics from every branch of knowledge to be the subject of debate'. The Sultan rewarded the participants, and he would show his approval 'if a wit made a good point or a pleasing jest at the right moment, or if a virtuous jurist solved some difficult legal problem'. The Sultan was also eager to encourage 'anyone in whom he sensed an atom of talent or a trace of art, so that he might be the cause of his acquiring merit and skill and the reason for his gaining knowledge and excellence'.[55]

In compiling their works the biographers were celebrating the coming of age of Ottoman Turkish as a literary language: in Murad's reign it would hardly have been possible to write such a work, as so few poets had written in Turkish up to his time. The Ottoman tradition of composing poetry in Turkish emerged at the end of the 14th century, was kept alive at the court of Emir Süleyman in Edirne and continued under Murad's father, Sultan Mehmed. Murad's interest in this literature is confirmed by an anecdote recounted by Mercümek Ahmed in the preface to his Turkish translation of the Qābūsnāmah, a famous work on statecraft: 'One day in Filibeboli [Plovdiv in Bulgaria] I entered the presence of the Emperor, and I saw that Sultan Murad … was holding a book in his hand. This stuttering weakling enquired of that sublime personage what book it was. He replied with mellifluous words, saying, "It is the Qābūsnāmah", and he continued, "It is a good book, and there are many useful hints and pieces of good advice in it, but it is in Persian. Someone has translated it into Turkish, but it is obscure: he has not phrased it clearly, so we find no sweetness in the stories in it. If [only] there was someone who could translate it clearly, so that hearts might take pleasure in its contents!" Then this weakling plucked up his courage, and when I said, "Let me, the least [of God's creatures], translate it", that pure-minded Emperor did not say, "How dare you?", but, "Make a translation right away!"' Mercümek Ahmed completed his task in 1432.[56]

The leading lyric poet under Bayezid I and Emir Süleyman was Ahmedi, and the earliest of the manuscripts that can be associated with Murad II is a copy of his Dīvān, or collected lyrics. This was copied by the scribe Ahmad ibn Hajji Mahmud al-Aqsarayi in AH 840 (AD 1436–7) and bears a dedication to the Sultan. It contains elaborate illumination,[57] but its binding is not original.[58] The same scribe copied a miscellany by the same poet in Dhu'l-Qa'dah 835 (June 1432), which retains its original binding.[59] This has different compositions on the front and back covers, which appears to have been the norm in the reign of Murad II, but it is far less ambitious than the binding of a music manuscript written for Murad three years later (cat.2, figure 30).

The binding of the music manuscript is remarkable in an early Ottoman context for the use of colour and the variety of materials and techniques employed. The light-tan outer covers and the reddish-brown doublures bear tooled decoration in gold and blue, and the central motifs on the doublures were worked in leather filigree, which has been partly gilded and set against a ground of

25 *above* Back doublure of a detached binding,
probably Ottoman, *circa* 1435
Dublin, Chester Beatty Library (795 × 550 mm)
26 *below* Front doublure of cat.1

27 *left* Front cover of the *Book of Proverbs* by al-Maydani, copied in 1206 and 1218,
the binding Ottoman, *circa* 1435
Munich, Staatsbibliothek, COD. ARAB.643 (245 × 175 mm)
28 *right* Front doublure of *figure* 27

green silk. Like that on the miscellany of 1432, this binding has different compositions back and
front – a pointed oval on the front cover, and a roundel on the back cover.

A monumental Koran in the Museum of Turkish and Islamic Arts in Bursa (cat. 1, *figures* 23–24,
26) has a binding that is very close to that of the music manuscript of Murad II. For example,
similar trellis-work patterns were employed in the leather filigree work on the doublures of
both bindings, and the filigree was set against a ground of green silk in both cases, although in
the case of the Koran the range of colour has been increased by the addition of blue and white
paint. The outer covers of both have segmented borders filled with knotwork, which was tooled
in blue and gold to create geometric patterns such as chevrons and rhombs. Although the Koran
is itself undated, its covers can be attributed to the same binder as the music manuscript and must
have been produced in about the same period.

Similar parallels can be drawn with the binding of a manuscript in Munich, which contains two
parts of a book of *Proverbs* by al-Maydani, the first dated AH 603 (AD 1206) and the second AH 615
(AD 1218). The present binding was clearly added in the 15th century, perhaps when the two parts
were bound together (*figures* 27–29).[60] There are no seals, and the later owners' notes provide no
help in identifying the provenance of the manuscript. However, the pointed oval on the back
cover is filled with a pattern identical to one employed on the music manuscript (*figures* 29–30).
The same stencil was evidently used, although the treatment of the border of the pointed oval is
different. The two manuscripts are also linked by the roundels of leather filigree that occur on
their doublures (*figure* 28).

In view of the parallels with the music manuscript, the provenance of the *Proverbs* manuscript
is clearly Ottoman, but Gratzl, when he first published it, believed it to be 'ägyptisch-syrisch'.[61]

 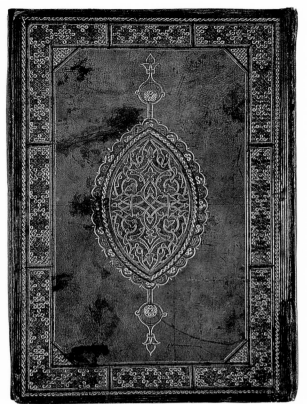

29 *left* Back cover of *figure 27*
30 *right* Front cover of cat.2, produced for Murad II in 1435
Istanbul, Topkapı Palace Library, MS.R.1726 (313 × 218 mm)

Links with Mamluk work appear at first sight to be strong, and the most impressive comparison is with a detached binding which is now in Dublin (*figure 25*). It is of enormous size (795 × 550 mm), and Regemorter claimed that it originally belonged to a Koran, also in Dublin, that was written for the Mamluk sultan Qa'itbay.[62] Both the outer covers and the doublures of this Koran have segmented borders filled with ropework tooling, partly gilded to create geometric patterns; and the long, almost sickle-like leaves and tiny rosettes in the arabesque pattern that fills the pointed ovals on the covers also occur in the central roundel on the music manuscript. In addition, the roundel on the doublures of the Dublin binding, with its knotwork fill and circular pendants, is strikingly similar to that on the front cover of the Munich manuscript. Regemorter, though, was mistaken, and there is no connection at all between the detached binding and the Koran of Qa'itbay in Dublin. In all likelihood the Dublin binding is Ottoman work from the reign of Murad II. The number of important Ottoman bindings known from this period is at present so small that it seems probable that many detached bindings have been misattributed, in particular to the Mamluks. For example, a detached binding in Chicago, published as 'Egypt or Syria, 14th century', has features that can be related to the group of Ottoman bindings described above, but it is impossible at present to say whether this binding should be reassigned to the 15th century or should even be attributed to Turkey.[63]

A complete contrast to the luxurious quality of the bindings of the Bursa Koran, the music manuscript of 1435, and the Munich *Proverbs* is provided by the covers of a 30-part Koran that was copied in Ramadan 849 (December 1445) by 'Abd al-Latif ibn 'Abd al-Qadir ibn Ghaybi al-Hafiz (*figure 16*).[64] This Koran has no illumination, and the bindings are very modest. The main feature of the tooled decoration is a central medallion with fleur-de-lis extensions above and below, and the extensions and the lobed outline of the medallions were constructed using simple arc tools

in a manner reminiscent of the Bursa binding of 1424 (*figure* 20). Most of the doublures are of unpolished European paper, but those of part 20 were made of the same block-pressed leather as a manuscript containing part of the *Mafātīḥ al-ghayb* of Fakhr al-Din al-Razi (cat.4, volume VIII). A notice in part 20 of the Koran suggests that it was once owned by Sultan Murad, and its date, 1445, places it in the period when Murad was living in retirement in Manisa, in western Anatolia.[65]

A comparison of the bindings of the two Korans identified here as having some connection with Sultan Murad II, namely, the fine single-volume example (cat.1, *figures* 23–4, 26), which was made by the same binder as Murad's music manuscript, and the less impressive 30-part copy in the Topkapı Library (*figure* 16), shows that an understanding of why a manuscript has a particular sort of binding is not dependent solely on questions of stylistic or technical evolution, for the two Korans were bound by two masters working in completely different traditions. In fact, we would only be able to appreciate the reasons for this variation if we knew for what purposes the two manuscripts were destined. It may have been, for example, that the Bursa Koran, a large, single-volume copy of exceptional quality, was meant for use in one of the grander mosques of the city, while the simple 30-part Koran of 1445 was intended for use in more private circumstances. Fortunately, we do not have to resort to such guesswork in the case of the books of Umur Bey, the son of Timurtaş Pasha, who was the patron of a remarkable public library established in Bursa in the mid-15th century.

Umur Bey, the son of Timurtaş Pasha

Umur Bey's family had been associated with the Ottoman dynasty since its earliest days, their fortunes rising with those of their lords.[66] Umur Bey's father, Kara Timurtaş Pasha, participated in the Ottomans' military campaigns from the 1320s to the 1390s and served for long periods as *beylerbeyi* of Rumelia, *i.e.* governor-general of the Ottoman territories in the Balkans and commander-in-chief of the forces whose fiefs lay there, and as a member of the imperial council, or *divan*. He was also famous for his wealth, part of which he used to create the *imaret* in Bursa where he was laid to rest after his death in 1404.

Kara Timurtaş Pasha had four sons, who all served in positions of responsibility. The eldest, Yahşı, became *beylerbeyi* of Anatolia and was killed at the Battle of Ankara in 1402. The surviving sons – Oruç, Ali (who had himself been taken prisoner at Ankara) and Umur – played a leading role in the two decades that followed, and at the accession of Sultan Murad II in 1421 all three brothers were members of the imperial *divan* at the same time. In 1423, however, Sultan Murad II removed them: Oruç was made *beylerbeyi* of Anatolia, Ali was sent to Manisa as governor of Saruhan, and Umur was dispatched on a diplomatic mission to Germiyan-oğlu Yakub Bey at Kütahya. Oruç Bey died in 1426, and Ali Bey some time after 1428, but Umur Bey lived on until 1461. By this time he must have been an old man with a wealth of knowledge and experience, for he was a source consulted by the chronicler Aşık Paşa-zade, from whom much of our knowledge of early Ottoman history derives.

After 1423 Umur Bey's name disappeared from the accounts of the chroniclers, but his activities were recorded in other sources, which show that Umur Bey, as the patron of a series of religious foundations in a number of Ottoman cities, took great care to ensure that these institutions were provided with sufficient books; he is also shown as taking considerable interest in the way these books were used. The first of these documents is the endowment deed (*waqfiyyah*) of Umur Bey's foundations and was drawn up in April 1440, with an annexe dated AH 850 (AD 1446–7). Among the acts of charity recorded was the donation of works in Arabic to Umur Bey's *medrese* in Bergama, for the use of the master and students, and of 33 books in Turkish to his mosque in Bursa, to be read by the congregation.[67]

Umur Bey's *medrese* in Bergama seems to have disappeared, but his mosque in Bursa still exists, although it has been subject to repeated repair and has lost many of its original features, including its two domes.[68] It was presumably built some time before the *waqfiyyah* was drawn up in 1440, and it was certainly in existence by 1449, when a lady called Erhundişah dedicated part of the revenue she received from a village near Bursa to supplying it with a *berat*, a large candle to stand before the *mihrab*.[69] The mosque is unique in its architectural form (*figure* 31). A porch runs the full width of the building and is supported on four antique columns with reused Corinthian capitals. It leads to two large rooms of different proportions that now make up the prayer hall. The larger of the two, that on the right, was clearly the original mosque, for the *mihrab* stands at the centre of the far wall. This room is roughly 8 m square and communicates with the smaller room on the left through a gap 2.19 m wide in the wall between them. The original function of the second room is no longer apparent,[70] but it seems reasonable to presume that it contained the mosque library to which Umur Bey donated so many books.

After 1440 Umur Bey continued to add to the mosque library on an impressive scale, so that, when an expanded version of the *waqfiyyah* was drawn up in January 1455, the total had reached at least 270.[71] In the text Umur Bey lays down that the books, whose names are recorded on the back of the document, were for the use of anyone who could benefit from them, although he does not, in fact, specify where they were to be kept; this information is supplied by a Turkish version of the same text, which was inscribed on two stone slabs set in the front wall of the mosque in March–April 1461: 'I have donated my books, together with an inventory, but they are not to be taken out of the mosque.'[72] However, one of the books donated to the mosque in this period, cat.3 below, bears an endowment notice dated 1449, which stipulated that books could be borrowed on payment of a deposit, although none was to be taken outside Bursa.[73]

In 1453 Umur Bey donated 20 books in 60 volumes to the *imaret* of his father. They included a four-volume copy of a work of Koranic exegesis, the *Tafsīr* of Abu'l-Layth al-Samarqandi, which had been translated into Turkish, and a 30-volume copy of al-Bukhari's celebrated collection of Hadith, in the original Arabic. Both of these belong to the realm of Islamic scholarship, but most of the books were works of edifying literature, such as the *Qiṣaṣ al-anbiyā'* ('Tales of the prophets') and the *Tadhkirat al-awliyā'* ('Memorial of the saints'), and there was also one volume of mystic poetry, the collected lyrics of the 14th-century Turkish poet Aşık Paşa. This information comes from a curious document which the cadi of Bursa had inscribed in one of the

31 Plan of the mosque of Umur Bey in Bursa

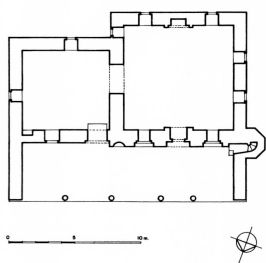

manuscripts concerned. The document, which includes an inventory, was drawn up when Umur Bey tried to revoke the donation, for what reason we do not know.[74] However, Hacı Paşa, the son of Abdullah Bey, objected, and the case went to court, where the cadi ruled that a donation by *waqf* was not revokable. As a result, it was laid down that the books were to be kept 'in the prayer hall [*mescid*] of the *imaret* of his late father'. The warden (*şeyh*) of the *imaret* was to be responsible for the books' safekeeping, taking stock of them every six months, and anyone resident in the foundation could use them, while educated persons residing elsewhere could have access to them only if someone stood surety for them. For his part, Umur Bey could make use of the books during the rest of his life, whether he was resident in Bursa or travelling elsewhere.

Umur Bey continued adding to the library attached to his mosque after 1455, for a copy of a Turkish translation of the *Lama'āt* of 'Iraqi in the İnebey Library, Bursa, contains an endowment notice dated 1456.[75] Indeed, his book-collecting activities may only have ended with his death in early August 1461, when he was buried in a tomb that still stands beyond the south wall of his mosque, not too far from his library.[76]

The manuscripts that can be associated with Umur Bey's public library are similar in quality to the Koran of 1445. They, too, have no illumination, and the five surviving bindings (cat.3, cat.4) have blind-tooled decoration on the outer covers. Different centre-and-corner compositions were used on the front and back of each binding, and, in the case of cat.4, the variations in the designs on the back covers suggest that they were executed free-hand (*figures* 32, 33). The doublures were all cut from sheets of block-pressed leather, whose use for this purpose was long-established.[77] In examples from elsewhere in the Islamic world the design pressed into the leather usually consists of an arabesque repeat pattern, but the Umur Bey doublures are of a second type, in which arabesque and floral elements are contained within geometric strapwork. The linings of two bindings (cat.3; cat.4, volume II) are ornamented with strapwork that forms eight-pointed 'stars', although the filler motifs are different in each case. Another example has tiers of stretched hexagons, some ranged vertically, and others horizontally (cat.4, volume IV, and the back doublure of volume VI).[78] The third type bears staggered rows of two types of medallion (cat.4, volume VI, front doublure). And the fourth, and most complex, design is made up of four- and three-lobed figures arranged in a scale pattern (cat.4, volume VIII). As we have seen, leather stamped with the same design was used for the doublures of part 20 of the Koran of 1445, and it is found in two other books in the Topkapı Palace Library, MS.A.3449, a music manuscript presented to Sultan Mehmed II, and MS.A.2069, a medical work.

A number of other bindings in the İnebey Library in Bursa share many features with the Umur Bey group. One is attached to MS.Hüseyin Çelebi 481, a miscellany of works by Molla Fenari, copied in AH 845 (AD 1441–2).[79] The doublures have been cut from leather block-stamped with a variation on the stretched-hexagon design, in which the vertical hexagons contain an inscription, either *'amal-i mujallid Ḥaydar ibn-i Ṭūrbagī* ('The work of the binder Haydar, the son of Turbeyi'), or *Al-'izz al-dā'im wa'l-iqbāl* ('Everlasting power and prosperity'; *figure* 36). Unlike the Umur Bey bindings, the same centre-piece – a medallion divided into compartments by strapwork and filled with interlace, rosettes, whorls and other small motifs – occurs on both covers (*figure* 35), but one register of the borders was tooled with the same design as cat.3 and cat.4, volume VIII, a four-lobed motif containing a fleur-de-lis (*figure* 34b, d). A similar tool, but slightly different in size, was used for one of the borders of cat.5, an almanac prepared for Sultan Mehmed II for the Muslim year 856 (AD 1452; *figure* 34e), and of another manuscript made for the Sultan (*figure* 34c), and the same design also appears in the border of a binding in the Staatsbibliothek in Berlin: this is attached to a miscellany of Arabic and Persian texts, the latest of which was copied in Ankara in 1429.[80] From the description provided by Weisweiler it appears that the Berlin binding has doublures of the stretched-hexagon type: in this case the only inscription

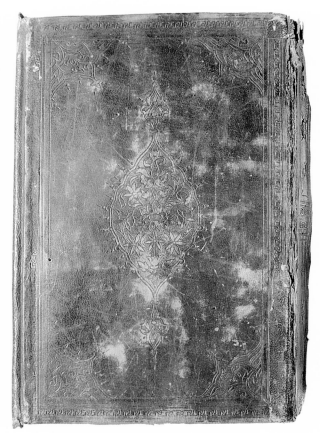 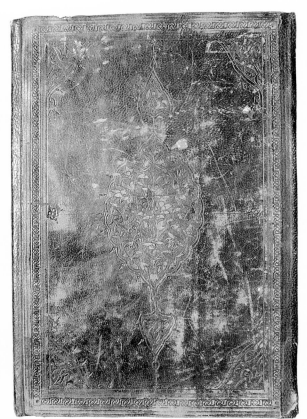

32 *left* Back cover of cat.4, volume IV, Ottoman, probably Bursa, before 1453
Bursa, İnebey Library, MS.Ulu Cami 318 (265 × 180 mm)
33 *right* Back cover of cat.4, volume VIII
Bursa, İnebey Library, MS.Genel 931 (265 × 175 mm)

used was *Al-'izz al-dā'im wa'l-iqbāl*, as in two volumes of Umur Bey's copy of the *Mafātīḥ al-ghayb* (cat.4) and another Bursa miscellany, which was probably bound in the early 1450s.[81]

Although the bindings in the 'Umur Bey' group were clearly the product of a Bursa workshop, it is possible to connect individual details of the designs with examples from the previous century produced in cities further east. One parallel is between the centre-piece on the back cover of cat.3 and that on the bindings of a 30-part Koran produced in Maraghah in north-west Iran in 1338–9.[82] In each case the centre-piece features a combination of a ten-pointed star and a decagon, although in the case of the Maraghah Koran the star and decagon are contained with-in a roundel, and the filler motifs are more elaborate (*figures* 38, 39).[83] An even stronger parallel exists between another Bursa binding, that of the Molla Fenari miscellany of 1441–2 (*figure* 35), and the covers of the final section of a 30-part Koran in Philadelphia, which was copied by Ahmad ibn 'Ali of Isfahan in 1387.[84] The centre-pieces on both bindings consist of a roundel containing a strapwork design and surrounded by a frame with a lobed and knotted profile, and in both cases the lobes of the frame are filled with a scale pattern.[85] On the Philadelphia Koran section the strapwork includes rows of five and ten pentagons, which contain five-lobed knots, and the same motif appears in some of the compartments on the Bursa binding, where the pentagons occur in sixes and twelves. The basic conception behind this type of design can be traced back at least to the bindings of the 30-part Koran, now in the National Library, Cairo, which was copied in Hamadan in western Iran in 1313, for the Emperor Öljäytü.[86]

The Bursa miscellany of 1441–2 and the Philadelphia Koran section of 1387 also have similar corner-pieces (*figure* 37a – b). These are made up of a quarter-rosette framed by two overlapping

segments of a circle and a half-ogive, a device that has been discussed in connection with the binding of the Konya Koran of 1313–14 (*figure 2*). Similar corner-pieces occur on the Ibn al-Jazari manuscript of 1400 (*figure 17*), whose binding may have been produced in either Bursa or Shiraz, and on the binding of MS. Fatih 5004 in the Süleymaniye Library, Istanbul. The corner-pieces of cat. 5 are also similar in outline, but they do not enclose quarter-rosettes, while the appearance of this device on the binding of a manuscript produced in Cairo in 1394 indicates the international character of such designs.[87]

The Süleymaniye binding is attached to an autograph copy of a work by the scholar 'Ala' al-Din 'Ali ibn Muhammad, known as Musannifek, on Koranic exegesis.[88] The manuscript was completed in AH 859 (AD 1454–5), in 'the valley of Meram' near Konya, and was subsequently donated to the 'new library' in the great complex of *medreses* and other institutions founded by Mehmed II in Istanbul. The design on the block-pressed doublures is of the stretched-hexagon type, with the inscription, *Al-'izz al-dā'im wa'l-iqbāl*, and the outer covers display similar principles of design to the Umur Bey group, but the overall quality of the binding is not as high as that of the Bursa pieces. It may, then, be a product of Konya.

From this brief survey it will be apparent that the bindings produced for Umur Bey were quite distinct in character from the group centred on the manuscript of Murad II. Umur Bey's binders used different compositions, motifs, techniques and colouring and even had a different approach to surface texture. As we have seen above, the designs of the Umur Bey bindings can be related to the tilework and painted decoration on architectural monuments erected in Bursa in the first half of the 15th century, and this suggests that a design atelier existed in the city during this period; if this is so, it would be the earliest example of such an atelier in the Ottoman empire. What is certain is that neither the Umur Bey group nor the bindings associated with Murad II owed anything to Iranian styles of the 15th century. Yet in the first half of the century Iranian binding was transformed by technical developments and new types of decoration. The technical advances included the use of pressure-moulded compositions, a more refined and elaborate form of filigree, set against polychrome backgrounds, and the increasing employment of gilt-tooling. In terms of decoration, the impact of chinoiserie was paramount, and this took both abstract and figurative forms.

Cloud-collar Bindings

The new abstract elements included a cruciform cartouche with a heavily lobed outline, a motif whose profile resembles that of the 'cloud collar' used to decorate Chinese robes from at least the Yuan period.[89] The Chinese-style cloud collar became a feature of Iranian court costume under the Timurids and Turcomans in the 15th century, and paper patterns bearing chinoiserie designs for the embroidery on such collars were produced by the decorative artists attached to their courts.[90] Drawings of this type, executed in black ink with occasional touches of gold and blue, were produced in court scriptoria as models for other forms of applied art, including book-binding, and the style was also used for decorating the margins of manuscripts.[91] In this context it seems entirely feasible that the same group of artists were responsible for the production of patterns for costumes and for book production, and it may have been by this means that the cloud-collar motif was transferred to the arts of the book. But motifs with similar profiles appeared on Chinese works of art in other media, and it is possible that the cloud-collar cartouche of the Iranian binder was derived from imported artefacts such as furniture or paintings.[92]

One of the first appearances of the motif in a Timurid context is in the illumination of a copy of the *Shāhnāmah* of Firdawsi, produced in Shiraz in about 1397,[93] and it recurs repeatedly in the illumination executed in Shiraz in the first decade of the 14th century, in the anthologies made for Iskandar Sultan.[94] At the same time the cloud collar made its appearance in bookbinding, for

34 Rubbings of details (actual size)
34a *top* Fore-edge section of flap, cat.4, volume VIII
34b *second from top* Fore-edge section of flap, cat.3
34c *centre* Border, outer cover of a work on Hadith copied for Mehmed II
Istanbul, Topkapı Palace Library, MS.A.521
34d *second from bottom* Border, back cover of cat.4, volume VIII
34e *bottom* Border, front cover of cat.5

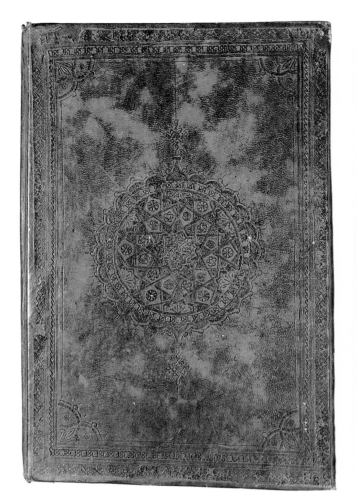
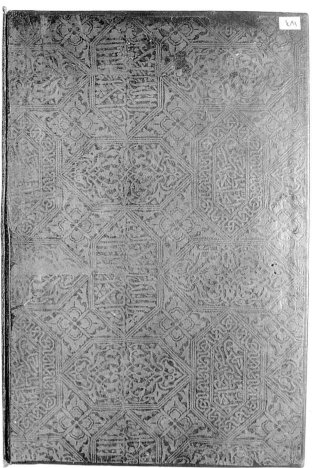

35 *left* Back cover of a miscellany, probably Bursa, 1441–2
Bursa, İnebey Library, MS.Hüseyin Çelebi 481 (280 × 185 mm)
36 *right* Front doublure of *figure* 35

37a *left* Rubbing of the corner design of *figure* 35
37b *right* Rubbing of the corner design on a Koran section dated 1387
Philadelphia, University Museum, MS.P.80

one of the doublures of an anthology produced in Yazd in 1407 is decorated with a cloud-collar cartouche in filigree, whose design includes two foxes.[95] A characteristic Iranian example without figural depictions is dated 1436 (*figure 42*).[96]

The Ottomans seem to have had little taste for figurative elements, but the non-figurative forms were clearly more acceptable, for it is possible to identify a group of bindings produced in Bursa and Edirne in the 1450s as local versions of these Timurid styles. However, the earliest occurrence of the cloud-collar cartouche on an Ottoman binding seems to be that on the back cover of a work on logic, copied by Muhammad ibn 'Abd al-Rahman al-Muslihi in Amasya in Jumada'l-Akhir 843 (November 1439; *figure 40*).[97] The front cover of this black leather binding has a centre-piece of the pointed-oval type, whereas the back cover has a cloud-collar cartouche filled with a six-pointed star and large scrolls bearing lotus blossoms and other motifs. An unusual

38 *left* Detail of the back cover of cat.3, Ottoman, 1434
Bursa, İnebey Library, MS.Ulu Cami 435
39 *right* Detail of the back cover of a Koran section, Maraghah, 1338
Dublin, Chester Beatty Library, MS.1470

feature of this binding is the use of black leather filigree for the borders of the outer cover.[98] Indeed, this use of filigree on an outer cover is so idiosyncratic in an Ottoman context – only one other example has been identified – that it is difficult to link this Amasya example to the later bindings that share elements of its design.[99]

In some of the Timurid-inspired bindings produced in Bursa and Edirne in the 1450s the centre-piece on the outer covers is a cloud-collar cartouche filled with diminutive arabesques. The earliest cloud-collar binding in this group is on the copy of a commentary on the *Maqāṣid* of Sa'd al-Din al-Taftazani, made in Bursa in 1452 (*figure 41*).[100] A second specimen (cat.7) is dated 1455, but the colophon is silent about where it was written, with the result that it has been published on several occasions as Iranian. The arabesque fillers, the outlining of the main elements in gold and the general proportions of the designs link these two bindings to cat.6, which is attached to a manuscript copied in 1453. In this example, the centre-piece is not a cloud-collar cartouche but a pointed oval with a lobed profile. The field of the oval has been divided into

sections outlined in gold, and the arabesque filler motifs have been tooled in gold or in blind in alternate compartments. A more restrained interpretation of the same aesthetic can be observed on another binding in the group (*figure* 43); this is attached to an undated manuscript in Bursa, which contains a copy of the astronomical tables known as the *Zīj-i īlkhānī* and once belonged to Sultan Bayezid II.[101] On the pointed-oval centre-piece gold was used only for the single tooled line that divides the compartments. The shape of these and the arabesque patterns used to fill them are so close to those on cat.6 as to suggest that they are by the same binder, but the other elements in the overall design are different, for the border of the *Zīj-i īlkhānī* binding is much simpler and plainer, and the gilt knotwork of the finials and corner-pieces of cat.6 have been replaced by more solid designs: palmette-shaped pendants to the centre-piece, and segments of a cloud-collar cartouche for the corner-pieces. The nature of these corner-pieces illustrates the use of proportion in the design of these covers, for they are not full quarters of the notional cartouche but have been reduced to the point where their outline touches the border, leaving as much of the central field as possible uncluttered.

That work in this elegant, lightly tooled style continued to be produced in the 1460s is shown by two bindings made of the same mid-burgundy leather and with identical designs, one on a manuscript completed in Safar 867 (November 1462), the other (*figure* 45) on one produced two years later, on 21 Muharram 869 (23 September 1464).[102] Although, like the *Zīj-i īlkhānī* manuscript in Bursa, both these books bear the seal of Sultan Bayezid II, there is no indication in either that they were ever in the possession of his father, Mehmed II. Two related bindings, one of which has no gilding, are attached to works of Molla Gurani copied in 1463 (cf. *figure* 46).[103] One of these was dedicated to Mehmed, but the book may have been a gift from the author rather than a royal commission, and it is noticeable that, when an imperial style developed under Mehmed II in the 1460s, it took an altogether different direction.

The bindings in this group may be contrasted with those produced for Umur Bey in the 1440s and 1450s in several ways. Noticeable at once is their polychromy. As a group they exhibit a greater range of colours of leather, a mid-tone burgundy being the favourite, while gold tooling, sometimes accompanied by blue paint, was employed, particularly to emphasize outlines.[104] On the inside (*figures* 46, 47) blocks of gold and ultramarine were used as a ground for the filigree decoration, which replaced the block-pressed doublures so favoured by Umur Bey's binders. The use of space and the proportions of the elements in the centre-and-corner compositions changed, so that, unlike those on Umur Bey's bindings, the centre-pieces no longer dominated the covers through size, but through shape and colour.

We know too little about Ottoman binding in the 1440s to be certain that what we may call the cloud-collar style had not already been introduced then, but there are indications that the style was relatively new in the 1450s. Bindings in the 'Umur Bey style' were still considered acceptable for manuscripts made for presentation to the Sultan, such as cat.5, an almanac for the Muslim year 856 (AD 1452–3), and block-pressed doublures similar to those used on Umur Bey's manuscripts occur on the binding for a poem written by Amin in honour of Sultan Mehmed II.[105] As a copy made for presentation to the ruler rather than as a commission executed at his expense, this manuscript may not have been in the forefront of stylistic developments. The same caveat may apply to another manuscript, the text of which was dedicated to Mehmed II, but which does not bear a dedicatory frontispiece. It has a cloud-collar cartouche outlined in gold and blue on the front cover and block-pressed doublures of exactly the same type as used on one of Umur Bey's books.[106] Such a combination of different aesthetics suggests a period of transition.

There can be little doubt concerning the source of the cloud-collar style when we consider Iranian bindings produced in the preceding decades. The binding of a *Shāhnāmah* copied in 1439 and now in the Topkapı Palace Library (*figure* 74) has the wide borders and dense and richly

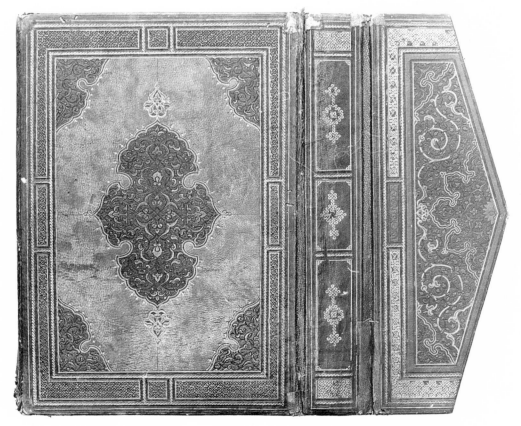

40 *top left* Amasya, 1439, back cover. Istanbul, Topkapı Palace Library, MS.A.3419 (215 × 160 mm)
41 *top right* Bursa, 1452, back cover. Bursa, İnebey Library, MS.Haraçcıoğlu 1324 (270 × 165 mm)
42 *bottom* Iran, probably Shiraz, 1436, back cover
Istanbul, Topkapı Palace Library, MS.A.255 (265 × 180 mm)

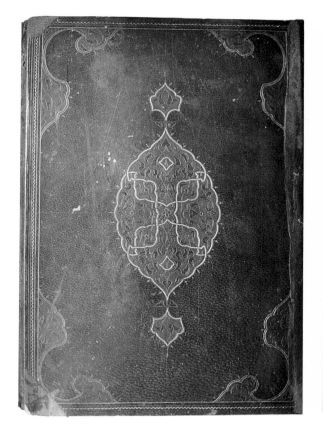

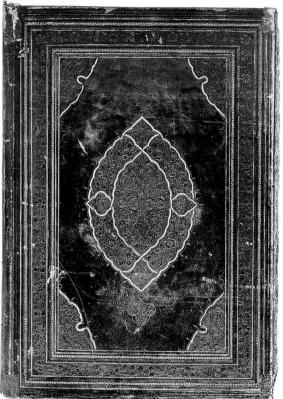

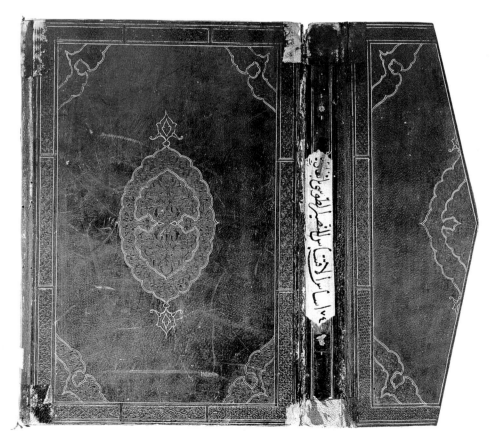

43 *top left* Ottoman, probably 1450s, front cover. Bursa, Museum of
Turkish and Islamic Arts, MS.11 (260 × 175 mm)
44 *top right* Probably Iran, 1459, back cover. Istanbul, Topkapı Palace Library, MS.A.1357 (265 × 175 mm)
45 *bottom* Ottoman, September 1464, back cover. Istanbul, Topkapı Palace Library, MS.A.3441 (265 × 175 mm)

coloured decoration that were characteristic of some Shirazi bindings of the second quarter of the 15th century,[107] but on the cover illustrated here there is already a contrast between the decorated areas and the smooth, unencumbered field. A second Iranian binding, that attached to a *Maṣnavī* copied in 1449 (*figure* 44), still has a wide border, and the central pointed oval is relatively large, but the decoration is immeasurably lighter. The oval is divided into compartments in very much the same way as the *Shāhnāmah* binding, but the only gold used was for emphasizing the outlines of the centre-and-corner composition and of the compartments within the centre-piece. This very moderate use of gold clearly relates to the Ottoman examples, as do the arabesques used to fill some of the figures and the delicacy of execution.

One feature of this type of Iranian binding and of the Ottoman cloud-collar style is the use of leather of the same colour for both the outer covers and the doublures. The doublures of the *Shāhnāmah* binding of 1439 (*figure* 48) have a central pointed oval worked in leather filigree against gold and blue grounds. In its form the oval echoes that on the outer covers (*figure* 74), having a wide border filled with a floral pattern and interrupted by four small, four-lobed figures, and a similar relationship between the filigree decoration on the doublures and the tooled designs on the outer covers can be observed on the binding of the *Maṣnavī* of 1449 (*figures* 44). The filigree work on the doublures of Ottoman examples (*figures* 46, 47, for instance) tends not to be so fine or coherent. By contrast, Iranian bindings of the 15th century exhibit such technical virtuosity and such a freedom of imagination that they have long been regarded in the West as among the greatest achievements of the binder's art. The literature on the subject has, though, always emphasized the pictorial types, while the types that inspired the Ottoman versions discussed above – that is, those without figural elements – have been all but ignored.

In the absence of other evidence, the dedications that occur in one or two manuscripts of the 1430s, 1440s and 1450s – whether dedications to the sultan or by a donor to a public library – have allowed us to build up a partial picture of the stylistic development of bindings during this period. In the 1460s the patronage of one man, Sultan Mehmed II, was clearly the main factor in generating a new style that was to characterize Ottoman bindings for 20 years. He was also the driving force in creating a whole range of side styles, including textile bindings and a single example decorated in imitation of a type of Chinese lacquer (cat.18).

46 *top left* Back doublure of a work
by Molla Gurani, dedicated to Mehmed II
Istanbul, Topkapı Palace Library, MS.A.1691 (225 × 135 mm)
47 *top right* Back doublure of *figure* 49 (270 × 165 mm)
48 *bottom* Back doublure of a *Shāhnāmah*
Iran, probably Shiraz, 1439
Istanbul, Topkapı Palace Library, MS.R.1547 (360 × 260 mm)

49 Rubbing from the flap of a binding
Ottoman, *circa* 1480
Istanbul, Topkapı Palace, MS.A.1921

Chapter Two

A New Order. The Books of Mehmed II

HIC·BELLI·FVLMEN·POPVLOS·PROSTRAVIT·ET·VRBES
'This man, the thunderbolt of war, has laid low peoples and cities'

These awesome words, which were inscribed on a medal issued in 1481, probably on news of Mehmed the Conqueror's death, summarized Europe's perception of this Sultan, who had led what must have seemed a relentless and inexorable attack on his Christian neighbours for almost 30 years.[1] In 1453 he captured Constantinople, and he then annexed the remaining outposts of the Byzantine Empire – from Trebizond in the east, to the Peloponnese in the west. In 1456 he attempted to take Belgrade from the Hungarians, and a quarter of a century later his forces were encircling Rhodes, the last great Crusader outpost, and were pressing at the gates of Italy itself, besieging Otranto in the south and making incursions into Friuli in the north. Mehmed's Muslim neighbours suffered, too, for the Sultan ousted the Karamanids and soundly repulsed the Aqqoyunlu Turcomans, his major rivals to the east.

Yet, although he went on campaign in almost every year of his reign, military exploits were not Mehmed's sole preoccupation. This was so even in the winter leading up to the final assault on Constantinople: every day at a fixed hour the Sultan, then 21 years old, would have an Arabic-speaking philosopher read to him and two doctors, one Greek-educated, the other Latin-trained, school him in ancient history, with readings from Laertius and Quintus Curtius, Herodotus and Livy, and chronicles of popes and emperors.[2] Indeed, it was the Sultan's wider interests that had laid the ground for the appearance of his portrait on the medal of 1481, for Mehmed had shown an interest in medallic portraiture throughout his reign, using his influence with Venice, Rimini, Naples and Florence to obtain the services of Italian medallists.[3]

To almost every European contemporary, however, Mehmed's diverse cultural interests were unknown. For them Mehmed was the Anti-Christ, and the sack of Byzantium meant not only the collapse of Christendom's eastern bulwark but the destruction of holy relics and Greek learning. Overwrought Western contemporaries claimed that during the sack Ottoman troops had made bonfires of the Byzantine literary heritage. Lauro Quirini, writing from Crete on 15 July 1453,[4]

– 47 –

talked of 120,000 books being destroyed even though his source, the eye-witness Isidore of Kiev, had not specified numbers but merely referred to evangelaries being trampled under foot.[5]

It was inevitable that some losses would occur after the fall of the city, but Mehmed did as much as he could to prevent wholesale destruction. The defenders had refused to capitulate, and, as the city had been taken by force, the Sultan was constrained by Muslim law to allow his troops to plunder the movable property within it for three days. But once the looting was over Mehmed rehabilitated the Greeks in the city. Their patriarchate was reestablished, 'beyond all expectation', according to one of the new patriarch's aides, and the Orthodox were allowed to retain some of their churches.[6] This leniency was clearly part of a deliberate policy, designed to regenerate a city that had long been an impoverished and depopulated ghost of its former self, and over the 30 years that followed Mehmed succeeded in turning Constantinople into one of the great capitals of the Muslim world. While doing so, he ensured that he was well-informed about the city's past, for he had *The Antiquities of Constantinople* translated into Turkish and Persian, and a copy of the Greek original was produced in his scriptorium in 1474.[7]

Nevertheless, the new dispensation that Mehmed's conquest of the city brought about was essentially Muslim in character. Islam's triumph was celebrated by the transformation of Justinian's church of Hagia Sophia into a mosque. It was manifested by the removal of the great equestrian statue that stood atop a column, 100 feet high, next to the church,[8] and in time by equipping the ancient building with a minaret. For a decade or so Hagia Sophia, or the Great Mosque of Ayasofya as it now became, was the home of the most important *medrese* in the Ottoman empire, but it was soon eclipsed by the sixteen *medreses* that Mehmed established on the site of one of Justinian's other great churches, the Holy Apostles.

These *medreses* formed part of a complex of buildings at whose heart was the Fatih ('Conqueror') Mosque and the Sultan's tomb. Initiated in the 1460s as the most ambitious architectural project that the Ottomans had ever undertaken, this great foundation was distinguished not just by the size and number of its components but by their distribution. On previous occasions building complexes of this type had been laid out in an organic fashion, with the individual components, such as the mosque, the *medrese* and the bath-house, disposed where the lie of the land allowed. In the Fatih complex the character of the hilltop site was subjugated to the demands of the builder: it was covered over by a huge platform, and the major elements were arranged in strict formality. The mosque and tomb in the centre were flanked by eight *medreses* to the east and eight to the west. This was an expression of ideal planning which may have owed its inspiration to the Italian architect and theorist Filarete,[9] and it is possible that Filarete visited Istanbul in 1466, when the project was in progress.[10] The mosque itself marked a departure, for it incorporated a dome and semi-dome within a rectangular ground-plan, heralding the development of the imperial mosques of the 16th century. In the words of one of Mehmed's courtiers, 'he constructed a great mosque on the model of Ayasofya, which, although it does not encompass all the arts of Ayasofya, found a new manner and an immeasurable beauty, and which, in its effulgence, is an expression of the miraculous white hand [of Moses]'.[11]

The foundation of the Fatih complex was of more than architectural importance, for the establishment of the *medreses* within it was accompanied by the imposition of a centralized order on the learned institutions of the empire, a change that was to be of lasting influence. Each position was assigned a rank and a salary, and the teaching posts at the *medreses* in the Fatih complex were placed at the top of a scholarly hierarchy. Most importantly, offices were reserved for those who had received a particular form of training, and a division was increasingly established between posts in the central administration, which were filled by men of servile origin who had been brought up in the imperial household, and posts held by free Muslims who had been educated in the *medrese* system.[12]

Mehmed established four principal libraries within his great foundation, but almost immediately after Bayezid II's accession in 1481 these were consolidated into a single library in the mosque, and the four librarians reduced to one.[13] Mehmed evidently endowed the libraries with a generous number of books, and it has been suggested that, where he had acquired an early copy of an important work, he would have a new copy made for himself and would give the precious original to the *medreses*.[14] For example, he had several copies of Ibn Sina's *Kitāb al-shifā'* transcribed for the imperial library, whereas the oldest copy he owned, which was made in AH 420 (AD 1029) and appears to have been checked by the author two years later, was rebound and donated to one of the libraries in the Fatih complex.[15]

As regards the imperial library, Mehmed transferred the books from the palace in Edirne to the first residence he constructed in Istanbul, which soon became known as the Old Palace. From there they were transferred to the New Palace he built in the 1460s, the present Topkapı Palace.[16] Almost nothing is known about the contents of the imperial library before the 1460s, but this decade saw a marked increase in the number of manuscripts copied for the Sultan.

The Fatih Style

Just as the Fatih complex asserted an Ottoman voice in architecture and established the foundations for the classical style of imperial Ottoman mosques, so in the 1460s a distinctive type of binding was introduced that marked the beginning of an Ottoman court style, not only in bindings but in the minor arts in general. The term 'court style' has been used in the context of Ottoman art of the 15th and 16th centuries with increasing licence over the last few years. The same may be said of the connected term *nakkaşhane*, by which is meant a centralized design studio of the type described above, in connection with the system of patronage at the Timurid court in the early 15th century.[17] In the present context, however, both terms have been adopted advisedly.

The distinctive aesthetic applied to imperial bindings by the mid-1460s, and its constituent floral style, which for convenience's sake we shall call the 'Fatih style', seem to have emerged out of nowhere, for we cannot trace them back to any of the Ottoman traditions of binding from the 1440s and 1450s so far identified. It could be argued that they were introduced by immigrant craftsmen from either Iran or the Mamluk realms, but this would be to ignore the fact that, despite influences in vocabulary and syntax, the expression is distinctly Ottoman. Furthermore, the style occurs almost exclusively on manuscripts produced for Mehmed; the few exceptions were made for his grand vizier, Mahmud Pasha. It is clear, then, that the style did not evolve but was deliberately created for an identifiable patron. At the same time, its floral motifs recur in other media: in metalwork and woodwork, and ultimately in ceramics. As with the bindings, their occurrence in these media was novel, and coincides – in the case of metalwork and ceramics – with the use of expensive materials and techniques. This suggests the dissemination of a decorative repertoire and increased financial investment, a combination that points to a centralized system of patronage based around a *nakkaşhane*.

The first feature to strike one about the Fatih style of binding is the dark leather outer covers, which range from a deep brown to black in colour and are unrelieved by gilding or blue paint. The mid-tan typical of previous Ottoman bindings, such as those produced for Umur Bey or for Mehmed himself in the 1450s (cat. 3–5), was rarely employed for outer covers in the Fatih style, while burgundy, which had been used for the cloud-collar group, was avoided entirely for outer covers. The avoidance was evidently deliberate, because a mid-tone burgundy was used for the most elaborate of the doublures in the Fatih style, while mid-tan was used for others. The intended effect was a marked contrast between the outer and inner covers. The outer covers were worked in blind, whereas the doublures had filigree centre-pieces against an intense gold ground

(cat.22).[18] As the predominant colour of illumination in the 1460s was a light ultramarine, it seems that there was a conscious colour sequence of black, to red and gold, to blue (cat.12).

The principal characteristics of Fatih-style bindings can be readily appreciated by comparing them with the cloud-collar bindings of the 1450s. The differences between the two groups were not confined to a change in the colour of the leather or the absence of gilding on the outer covers: there was an alteration in the type of centre-and-corner composition, for example, and the type, scale and tempo of the filler motifs were entirely new. The centre-pieces in the Fatih style invariably took the form of a large pointed oval or a roundel; these figures had lobed profiles, with heart-shaped knots at the cusps of the lobes.[19] The corner-pieces, too, were lobed, with the same type of heart-shaped knots at the cusps, but they were deeply indented, so that they resembled quarter-sections of a cloud-collar device;[20] in other words, in the Fatih style the cloud-collar device had been moved from the centre of the composition to the corners.

As for filler motifs, in the cloud-collar group these were predominantly arabesque and invariably small in scale. In the Fatih style, by contrast, the arabesques were larger and were subordinate to a range of distinctive floral motifs (*figure 50*). Purely arabesque compositions were very rare on outer covers, having been transferred to the doublures. An exception is the binding of a manuscript produced for Mehmed late in 1465 (*figure 61*),[21] but this is the exception that proves the rule, since the stencil used for the centre-piece of the outer covers was also employed for the filigree doublures of another manuscript (cat.11).[22]

The floral motifs of the Fatih style were lobed leaves (often with one of the lobes curled back), rosettes and lotus blossoms, and the repertory also included a snail-like cloud band (*figures 51–2*). Although the individual motifs were often highly stylized, the overall impression was one of rampant growth. This was achieved in two ways. One was to give the motifs three-dimensionality by curling the tips of leaves and making the stems cross over and under each other. The second, a marked break with tradition, was to introduce asymmetrical compositions. As the predominantly arabesque centre-pieces were rigidly symmetrical, the effect of asymmetry on the floral versions was quite considered (*figures 50–1*).

Another difference between the Fatih-style bindings and their predecessors affected the nature of the border with which the main composition was framed. In the Fatih style the corner-pieces were large enough to contain the design, and the borders were accordingly reduced to a tiny cabling composed of s-tools, framed by fillets, as on cat.20. Such minimalism was a notable departure from the die-tooled borders used on some of Umur Bey's bindings (cat.3–4, *figure 34b, d*); from the interlace or knotwork types found on the cloud-collar group (*figure 41*); and from the wide, segmented borders popular under the Mamluks (*figures 10–11*).

The treatment of the doublures in the Fatih style was also distinctive. Gone was the block-pressed leather used on the manuscripts produced for Umur Bey and for Mehmed in the 1450s (cat.3–5). Instead filigree became the norm. But Fatih-style filigree was quite different from that of the cloud-collar group, which had been heavily influenced by the Shirazi tradition. In the cloud-collar group doublures have pointed-oval centre-pieces whose arabesque designs are framed by floral borders and set against a ground of blue and gold (*figures 46–8*), whereas the finest Fatih-style filigree consists of a borderless lobed centre-piece filled with sinuous and prehensile arabesques silhouetted against a gold ground (cat.11, 22). Additional detailing was rare, but on the largest manuscript, cat.21, the size of the filigree motifs allowed for hand-tooling, the arabesques being enlivened with veins and circlets.

The intriguing aspect of this aesthetic is that it was conceived to be read as a sequence, rather than as the sum of discrete parts. As we have already noted, the outer covers were kept sombre in colour and, in the case of the floral centre-pieces, languorous in rhythm, in order to create a change of mood and pace when the book was opened. Taken by themselves, the outer covers of

Fatih-style bindings are difficult to appreciate in photographs, but, when the manuscripts are handled, glancing light brings out the decoration. This was worked by hand with a relatively broad-pointed awl, and there was therefore little relief, but in some cases a feathering tool was used, which left a small round or oval depression, usually in the centre of leaves and buds (*figure* 50), and helped to create some sense of three-dimensionality. In general, though, the Fatih style made little use of relief. It was not, so to speak, a sculptural style, like that which became common in the reign of Bayezid II, but was instead a drawing aesthetic applied to leather.

The designs were not built-up with unit tools, but traced free-hand on to the covers. They thus seem more graphic than constructed, and drawings were certainly used to produce the stencils

50 Front cover of a Koran,
Ottoman, 1460s
Istanbul, Museum of Turkish and Islamic Arts, MS.448 (402 × 289 mm)

from which the binders worked. In some instances the stencil was used for one of the covers and then reversed for the other (*figures* 51–2; *cf.* cat.13, cat.26). Thus the common Ottoman practice of using centre-pieces of different design on the front and back covers was abandoned in the Fatih-style bindings of the 1460s.

A stencil might be used on different bindings, and these were sometimes produced several years apart. For example, two copies of al-Suhrawardi al-Maqtul's *Al-mashāri' wa'l-muṭāraḥāt*, both produced in AH 871 (AD 1466–7), have identical decoration on their envelope flaps,[23] and one of them has the same centre-piece on its outer covers as a manuscript produced some two years later, in AH 873 (AD 1468–9).[24] This third manuscript bears several similarities to an undated manuscript dedicated to Mehmed II:[25] their filigree doublures and the envelope and fore edge sections of their flaps are identical. There are other examples of such relationships (see cat.11, for example), but these should suffice to prove that stencils were used repeatedly within the same

workshop. However, the use of stencils is not enough in itself to demonstrate that there was an imperial design studio under Mehmed II, comparable to that established under the Timurid prince Baysunghur, in which, it will be recalled, the artist Khwajah ʿAbd al-Rahim was recorded as working simultaneously on cartoons for binders, illuminators and tilemakers.[26] For stencils were an essential tool of binders in the 15th century, and in the Introduction we have seen instances of binders in Mamluk Egypt and Timurid Shiraz repeating the same designs on bindings, sometimes over a period of several years (*figures 9–10, 13*). But, although Mehmed's bindings could have been produced in an independent workshop, there are several strands of evidence to support the idea of an Ottoman imperial design studio or *nakkaşhane,* either within the confines of the palace or, as in the 16th century, in close proximity.

The most striking piece of evidence is an album, now in the University Library in Istanbul, that appears to contain gleanings from Mehmed's scriptorium.[27] Dubbed the Baba Nakkaş album, it bears no dedication, but its history can be deduced from its contents, compilation and provenance. Its contents consist mostly of calligraphy, some of it Timurid in origin, the remainder Ottoman. Much of the Ottoman material carries references to Mehmed or to Constantinople: it includes, for example, a poem addressed to the Sultan in AH 879 (AD 1474–5) by Ghiyath al-Din al-Mujallid, a Persian bookbinder who, as we shall see, played an important role in the closing years of Mehmed's reign. Although no item in the album is dated later than Mehmed's death in 1481, one is dated 15 Muharram 886 (16 March 1481), a mere two months before that event, and there are two poems in praise of Sultan Bayezid.[28] This suggests that it was under Bayezid II that the material was brought together in the album, possibly during a general reorganization of the Inner Treasury.[29] Before this many of the items must have been stored in loose-leaf form, for they show evidence of having been folded, and they are numbered. The present order of the items in no way corresponds to the numbers, so the numbering must have been carried out when the items were still loose.[30] The provenance of the album supports the idea that it was related to an imperial design studio or scriptorium, for it was transferred late last century to the University Library from the Yıldız Palace collection, and there can be little doubt that its ultimate source was the Topkapı Palace.

Apart from calligraphy, the album contains drawings (*figure 59*). On the opening page there is a gouache painting by a European artist of roses in a Florentine majolica jug. Both the date of the jug and the style of painting suggest a date in the third quarter of the 15th century, and this accords well with Mehmed's patronage of European artists.[31] A majority of the drawings, however, are designs, although it is not always clear for what: one could have been for a painted ceiling;[32] some, it has been suggested, were for tilework.[33] Others were clearly for book illumination and bindings.

The most explicit bookbinding item is the design for a centre-piece with arabesque decoration (*figure 53*). None of Mehmed's bindings appears to have the precise same centre-piece, but it is of an arabesque type used for filigree doublures (*figure 54*). Other bookbinding elements include several arabesque roundels, comparable to those on cat.1 and cat.18. Two drawings include typical binding motifs – the cloud-collar motif with pendant escutcheons in *figure 56* and the arabesque corner-pieces in *figure 55*. But the overall results differ markedly from any known bindings, and they may be experiments rather than preparatory models. *Figure 55* lacks the centre-piece typical of leather bindings, and it may therefore have been a design for a painted

51 *left* Rubbing from back cover of a work on rhetoric and grammar,
Ottoman, March 1467
Istanbul, Topkapı Palace Library, MS.A.2177 (actual size)
52 *right* Rubbing from front cover of *figure 51*

lacquer binding similar to cat.18, to which it bears some resemblance in the density of its design and the relative scaling of its motifs. More probably, though, *figure 55* was an idea for illumination. Its proportions – approximately 1:2 – are unusual for the text-block and binding of an Ottoman manuscript and more in keeping with rectangular panels of dedicatory frontispieces such as *figure 57*. Here the connection includes not only the proportions, but the arabesque corner-pieces and the floral decoration, although this is less elegant in the manuscript illumination than in the album drawing.

There are even connections between *figure 55* and the lacquer binding in details of the drawing: the parallel hatching and the trait of giving the leaves a thin central vein crossed at right angles by a series of short strokes. Where the designs in the album and the lacquer painting differ markedly is in the ponderation of the draughtsmanship. But this can be explained in part by the fact that the binding is painted in gold only, which does not allow for the lively contrasts of black ink contours and gold detailing.

The lacquer binding is of especial interest because it is the earliest such binding to survive from the Islamic world. It testifies to the degree of innovation during Mehmed's reign, and more than any other binding conveys a sense of the enhanced role of the draughtsman–designer. Lacquer book covers did not, however, become common under the Ottomans in the 15th century, and the technique was more often employed in Herat, three outstanding examples being dated 1482, 1492 and 1496. Several of the Timurid bindings were, like cat.18, painted in gold on a black ground, though their decoration is quite different from that of the Ottoman binding.[34]

There is no example in the Baba Nakkaş album of a design for the floral centre-piece for a binding. Nevertheless, elements in the drawings relate closely to those on bindings of manuscripts dedicated to Mehmed II. For example, the oak leaf with one lobe curled back may be compared to a leaf on the binding of a manuscript (*figures 58a–b*), and a pomegranate palmette, to one on a bind-ing of a manuscript completed in August 1466 (*figures 58c–d*).[35]

The Imperial Nakkaşhane

The association within the Baba Nakkaş album of a binding design with designs meant for other purposes (*figure 53*) suggests that we are dealing with the work of a generalized *nakkaşhane* rather than a specialist bindery. It might be countered that the association is accidental – the work of whoever compiled the album. *Figure 55*, however, would undermine such an argument, as it is connected to bindings in its details, though not in its composition and purpose, and it thus links the bindings to a larger world of design. It is the relationship with other arts that makes bindings such an important guide to the development of Ottoman minor arts in the second half of the 15th century, for numerous datable bindings survive, whereas there is not a single dated – and few precisely datable – textile, pottery or metal object from this period.

That there was a commonwealth of designs is proved by the close relationships between metalwork (especially silverware), ceramics, woodwork, illumination and bindings of the late 15th century.[36] The three-dimensional nature of the metal and ceramic objects, however, meant the connections were largely in terms of individual motifs; there is, for example, a close similarity between the central motif on one of the earliest blue-and-white fritware ceramics from Iznik – a bowl in the Musée des Arts Décoratifs in Paris – and a drawing in the Baba Nakkaş album.[37] But the influence of bookbinding extended to composition when the area to be decorated was a flat rectangle. This occurs in the case of a silver lantern from the Fatih Mosque, which, as we have seen, Mehmed II established in the 1460s.[38] The body of the lantern is a six-sided pyramid, and in the middle of each side there is a lobed centre-piece with pendant escutcheons (*figure 60*). The centre-pieces are decorated with openwork arabesques, which are arranged in a series of spirals around a

53 *left* Drawing for a filigree centre-piece
from the Baba Nakkaş album
Istanbul, University Library, MS.F.1423, folio 61b
54 *right* Back doublure,
Ottoman, probably mid-1460s
Istanbul, Süleymaniye Library, MS. Şehid Ali Paşa 1680 (348 × 220 mm)

floral centre-point. They thus recall in form and decoration filigree doublures of Fatih style manu-scripts produced in the mid-1460s, as, for example, on cat.11,[39] or the related outer cover discussed above (*figure* 61). The design was in use, then, in the mid-1460s, when the Fatih Mosque was near-ing completion, and when orders would have been made for furnishings such as the silver lantern. The panels on the lantern differ from Fatih-style bindings in two respects: one is the floral scroll which surrounds the centre-piece; the other is the manner in which segments of figures similar to the centre-piece are used to link the centre-piece to the top and bottom frames. Yet comparable features can be found in the illumination of manuscripts dedicated to Mehmed II (*cf. figure* 57).[40]

The height of the panels on the lantern – 245 mm, excluding the inscriptional borders above and below – is close to the height of several manuscripts dedicated to Mehmed II; indeed, the centre-piece on the lantern is about 140 mm high, excluding the escutcheons, and this is almost exactly the same size as the centre-piece in *figure* 61 and the related doublure of cat.11.[41] In this instance, one can well see how metalwork, binding and illumination could draw on a common

55, 56 Drawings in the Baba Nakkaş album
55 *left* folio 61a
56 *centre* folio 15a
57 *right* Detail of the frontispiece of a *Qānūn fī'l-ṭibb*
of Ibn Sina dedicated to Mehmed II
Istanbul, Nuruosmaniye Library, MS.3571, folio 1b
(area of illumination, 299 × 149 mm)

repertoire of designs and compositions, but differences in scale do not appear to have restricted the sharing of design ideas. If Baysunghur's artist 'Abd al-Rahim was able to work simultaneously on designs for bookbinders and tentmakers, there was no impediment to Mehmed's designers doing the same. It should not come as a great surprise, then, to find that there are clear correspondences between two major types of Ottoman carpets – those known as 'Star Ushaks' and 'Medallion Ushaks' – and Fatih-style bookbindings.

Star Ushaks provide the most obvious correspondence with Ottoman court bindings of the 1460s. The stars that have lent their name to the group have, on the most common variant, eight spatula-like flanges and are filled with arabesques that converge to form a central square or octagon. A filigree star of comparable design occurs on the doublures of two manuscripts dedicated to Mehmed II. Although neither manuscript is dated, there is evidence that points to a date in the mid-1460s (cat.12).[42] What is more, the doublures are in the characteristic red and gold of the Fatih-style bindings, and, while the carpets employ a wider colour scheme, there are numerous examples in which red and gold are the predominant colours.[43]

The eponymous medallions of Medallion Ushak carpets are pointed ovals in form and have pendant escutcheons. Individually they bear a general resemblance to the centre-pieces of bindings, but they are arranged in a manner quite different from that employed on book covers. The standard composition on bindings is hypotactic, with a dominant motif in the centre and subsidiary corner-pieces; that of Medallion Ushak carpets is paratactic: rows of pointed-oval medallions alternating

with rows of roundels. In many cases the structure is not readily apparent, as a single pointed-oval medallion takes up most of the field, but on a carpet the size of that in the Al-Sabah Collection – it is more than seven metres in length – the paratactic principle is evident.[44]

Despite this difference in composition, a connection can be traced between Medallion Ushak carpets and Fatih-style binding, for the internal composition of the pointed ovals on the carpets is close to that on a binding made for the Mehmed II (*figures* 62–3).[45] Four pairs of split-leaf arabesques are aligned on the diagonals to form a central 'rhomb', and four fleshy arabesques spring from the top and bottom points of the rhomb. In addition, the floral scrolls that fill the field of the carpets, between the pointed ovals and the roundels, consist of palmettes and three-lobed leaves that are close to those used in Fatih-style bindings. As for the roundels on the carpets, they can be compared in form to the dedicatory roundel in a manuscript copied for the same Sultan.[46]

Both Star and Medallion Ushak carpets continued to be produced over a very long period, and the date of the surviving carpets is little guide to the dating of the original cartoons. These, it is usually believed, were produced between 1525 and 1550. The only evidence in support of this dating is that Ushak carpets first appear in European paintings at this period. Star Ushaks appear in a painting by Paris Bordone, the *Return of the Ring to the Doge*, which was commissioned in 1534, for example, and in a portrait of King Henry VIII of England, attributed to Hans Eworth, of 1567.[47] But these paintings can only provide a *terminus ante quem*; and there is no justification for assuming that they would have been included in European paintings immediately after their introduction in Turkey, unless we can show that they were developed in the first instance as export goods. This is highly unlikely, as they represented a quantum leap, in terms of size, complexity of detail and graphic quality, from the standard export types of the 15th century, such as the 'Animal' and 'Holbein' rugs. Nor is there anything to suggest that they evolved out of these types; on the contrary, they were a new introduction.

The evidence of the bindings suggests two conclusions. Firstly, that the same artists produced the designs for the bindings and the original concept for the Ushak carpets, although it may have taken a specialist to transfer the design to a full-scale cartoon. As the bindings were imperial, it is likely that the first carpets were, too. And secondly, that, whatever the date of the extant carpets, the original designs were conceived in the mid-1460s, which is the period for which we have the most cogent parallels.[48] This was the time when Mehmed was completing his two most important architectural commissions – the Fatih Mosque and the New Palace. Both were such grand undertakings that it would have been quite appropriate for Mehmed to demand carpets of ambitious size and more graphic design than anything attempted previously. The suggestion, in other words, is that Mehmed commissioned the production of an entirely new concept of carpet. The initial investment to produce the Medallion Ushak carpets in particular must have been substantial, because they demanded larger looms, more materials, more labour and, above all, new designs and cartoons. The fact that Medallion and Star Ushak carpets became common later should not blind us to their originality in the context of the 1460s.

Until the suggestion was made that Ottoman court carpets were in existence as early as the 1460s, carpet historians were used to believing that it was only in the 1580s that carpet-weavers were installed at the Ottoman court, after Murad III had a group of them transferred from Cairo to Istanbul. But there is archival evidence that Mehmed II had court carpet-weavers,[49] and in Bayezid's reign we find no less than 18 court weavers and their apprentices engaged in producing carpets for the Sultan's new mosque in Istanbul.[50] Even if the first Medallion Ushak carpets were produced in the town of Uşak, the carpet-weavers at Mehmed's court may have advised on technical issues and may have helped in transferring the design concept to full-scale cartoons. The German bookbinder Paul Adam, writing at the turn of this century, remarked how often the designs of Islamic bindings were close to those of carpets.[51] Adam seems tacitly to have assumed

58a *top left* Detail from *figure* 59
58b *top right* Detail from *figure* 51
58c *centre left* Detail from *figure* 59
58d *centre right* Detail from the fore-edge section of
the flap, Ottoman, 1466
Istanbul, Süleymaniye Library, MS.Damad İbrahim 826
59 Drawing in the Baba Nakkaş album, folio 61a

that the relationship between the two media was direct, but this ignores the role played, as we have just argued, by a central studio or *nakkaşhane*.

A third strand of evidence in support of the claim that there was such a studio under Mehmed ii concerns the artist after whom the Baba Nakkaş album has been named.

Baba Nakkaş

The nickname Baba Nakkaş has a double ring, because the word Baba, which literally means 'Father', is used with affection and reverence for elders in general and Sufi shaykhs in particular. Baba Nakkaş, whose proper name was Mehmed, appears to have deserved his nickname on both counts: like his father, Şeyh Bayezid, and two of his grandsons, Şeyh Mustafa and Derviş Mehmed Çelebi, he was a Sufi shaykh;[52] and he earned respect and eminence at court, presumably for his artistic skills. The favour he earned at court is illustrated by the grant to him in Ramadan 870 (April–May 1466) of the village of Kutlubeyköy, which lay north-east of Çatalca, 'in the district of Istanbul'. Baba Nakkaş provided the village, which came to be known as Nakkaşköy, with a wooden mosque, a bath-house and a fountain, and almost a decade later, in June 1475, he was able to convert the village into a *waqf*, for the support of these institutions.[53] The introduction to the deed establishing the *waqf* refers to the artist as Baba Nakkaş and describes him as 'the exalted master, the intimate of the sublime presence (of the Sultan), the possessor of manifest perfection and unalloyed merit'.[54]

Baba Nakkaş would hardly have worked in isolation, and his name suggests that he had a following. Indeed, one of the witnesses to the deed of 1475 was another artist, Qasim ibn 'Abdallah al-Naqqash. Whether Baba Nakkaş came to be regarded as a father figure primarily on account of his spiritual qualities or of his artistic abilities, or whether the two went hand in hand, we cannot tell. A body of students, disciples or apprentices – call them what you will – would not necessarily, though, have formed a *nakkaşhane* on the model of Baysunghur's scriptorium. Such a *nakkaşhane* implied centralization in respect of personnel, pay and commissions. The *hane* of *nakkaşhane* also implies a building, and the frequent assumption is that this was attached to the palace. *Nakkaşhane* is, however, a modern locution, and a dedicated building, or part of a building, should not be taken as a necessary condition for what was first and foremost an administrative institution. Commissions could therefore have been executed outside the palace without jeopardizing central control over payments and artistic direction.

Some of Mehmed's manuscripts were certainly produced outside Istanbul: one was copied during the Bosnian campaign of 1463,[55] others were produced in Edirne, and one was transcribed in Mecca.[56] Later, too, there are examples of work being carried out in dispersed locations: in the 1550s, for example, the room for the scribes working on the illustrated history of Süleyman's reign, the *Sulaymānnāmah*, was partitioned, but it was situated in the house of the book's author, Arifi, not in the palace.[57] Nevertheless, by the 16th century the court designers had been allocated their own atelier, for a document of 1527–8 refers to the painters' workshop (*kārkhānah-i naqqāshān*) above the imperial menagerie.[58] This was a reference to a two-storey Byzantine church near the Hippodrome, the lower storey of which was given over to lions and other beasts, the upper storey, to court painters. (The association is surprising, but perhaps all the inhabitants of the building were regarded as intractable as each other.) There is no record that the upper storey was allocated to artists in the 15th century, but the building appears to have been converted into a menagerie by Mehmed ii, and it is conceivable that it was Mehmed who first allocated the upper storey to the painters.[59] Whatever the location of the work, it is clear that there was some form of centralized administration for court artists, at least late in Mehmed's reign. This is proved by a document of 1478–80, which lists a number of designers (*jamā'at-i*

naqqāshān), who included two binders – Muhyi'l-Din ibn Baylawan and Sinan.[60] The evidence of preparatory drawings and finished artefacts supports the notion of artistic centralization, while the figure of Baba Nakkaş suggests an artistic mentor at the centre of this institution.

Little is known for certain, however, about Baba Nakkaş's origins or his art. According to the 17th-century travel writer Evliya Çelebi, Baba Nakkaş was of Central Asian, Uzbek, origin and executed architectural decoration, such as the painted designs within the gatehouse of the Old Palace in the centre of Istanbul and in Bayezid II's Council Chamber in the New Palace. He also describes him as a 'boon companion' of Bayezid II. It is perfectly possible that Baba Nakkaş's career as courtier and artist continued into Bayezid II's reign (1481–1512), for we do not know when he died. It is possible, too, that the gatehouse of the Old Palace and the Council Chamber of the New Palace, both of which were originally constructed by Mehmed II, were restored under his son, but there is no proof to this effect. It therefore seems likely that Evliya Çelebi mis-identified the Sultan and that his comments should apply to Mehmed II. Evliya Çelebi is no more reliable when he says that Baba Nakkaş was the first to introduce painting to the Ottoman lands.[61]

Baba Nakkaş's work as a mural painter would not have precluded him from working on minia-tures and illumination. According to the report about Baysunghur's studio, all the painters, which must have included the miniature painters discussed earlier in the report, were involved in painting tent-timbers,[62] and, to take a later Ottoman example, several of the leading miniature painters of the late 16th century, including Nakkaş Osman, were employed in decorating a newly erected pavilion in the palace in 1591.[63]

Evliya Çelebi may have been misinformed about Baba Nakkaş's Uzbek origins, but if he was from Central Asia it would help to explain the Timurid influences that emerge in the Fatih style of the 1460s, and also the 16th-century legend that Timurid artists came to Istanbul during his reign.[64]

Timurid Sources and Jerusalem Scribes

Although it was claimed above that the Fatih style was an Ottoman creation, this does not mean that it was a creation *ex nihilo*, and the main source for the style appears to have been the court art of the Timurids. The essential repertoire of motifs in the Fatih style occur in Timurid work of the first half of the 15th century, and some of these motifs had already made their way to Anatolia from the Timurid realms in Iran and Central Asia at the beginning of the century, to judge by the tilework in the Green Tomb in Bursa (*figure* 18).[65] We can compare, for example, the margin illu-mination in two manuscripts, a *Khamsah* of Nizami produced in Herat for Shahrukh, the son of Timur, in 1431,[66] and a treatise on death and the afterlife copied for Mehmed II.[67] The motifs and composition are similar; indeed the meander of the central rinceau follows an almost identical rhythm. But whereas the Herati work is polychrome and was executed in opaque watercolour, the Ottoman illumination was worked in gold, with black details. Watercolour was more tractable than gold leaf, and the Herati artist could play with highlights, tonal variation and colour con-trasts to bring out a host of details denied to the Ottoman artist by his medium. The difference between the two examples extends beyond the colouring, however, because the Ottoman drawing is more rounded and dispenses with the frilled edges to the leaves and rosettes that give the Timurid drawing a more restless air.[68]

However, on almost no Timurid or Turcoman bindings of the 15th century so far published has this flora been exploited in the manner of Mehmed's bindings.[69] A binding of Timurid origin that shows many of the same traits as Mehmed's books, but at a considerably earlier date, occurs on a copy of the *Qaṣīdat al-Burdah* written for Shahrukh's grandson Sultan 'Abdallah in the last ten days of Shawwal 848 (February 1445).[70] It has black outer covers, doublures in a medium tan and narrow borders that consist of a simple s-tool band and fillets. The lobed, pointed-oval

60 *left* Side panel from a silver lantern from the Fatih Mosque.
Probably mid-1460s
Istanbul, Museum of Turkish and Islamic Arts, inv. no. 167
(height of panel, 245 mm)
61 *right* Back cover of a copy of al-Tusi's *Taḥrīr al-Majastī*
dedicated to Mehmed II and dated November 1465
Istanbul, Millet Library,
MS.Feyzullah 1360 (252 × 149 mm)

centre-piece of the outer covers has floral decoration that includes the characteristic oak-leaf
with one of the lobes folded over.[71] One difference from the Fatih-style bindings, however, is the
use of gilding to highlight the contours of the centre-piece.[72]

The use of Timurid-style flora in a lobed pointed oval can be documented on an Ottoman
binding as early as 1452, but in other respects this binding belongs to the cloud-collar group of
the 1450s and is quite distinct from the Fatih-style bindings of the 1460s and 1470s.[73] Conversely,
there is a binding, on a manuscript dated 19 April 1458, which anticipates the Fatih style in finish
and colouring – in particular the use of brown-black for the outer covers and burgundy for the
doublures – but not in the details of its centre-piece.[74] The manuscript, which is not expressly
dedicated to Mehmed II, evidently stands at the beginning of the Fatih style, but it is particularly
important for the information it yields.[75] The end of part I of the text has a colophon that says
that the volume was written, illuminated and bound by Shihab al-Din al-Qudsi (*figures 64–5*).
Shihab al-Din is thus one of the few documented binders of the period whose work can be
identified.[76] His surname indicates that he was from Jerusalem, but little is known about manu-
scripts from this region in the mid-15th century. There is nothing to suggest, however, that this
was a style imported from the Mamluks. Indeed, the style of the *naskh* and the illumination are
Ottoman, and it seems more likely that Shihab al-Din was one of the first exponents of a style
developed within the Ottoman court.

One other work by Shihab al-Din al-Qudsi is known.[77] The copying of the text was completed in 1472, and the manuscript bears a dedication to Mehmed II. The binding is a typical example of the Fatih style, even though the execution is not of the highest standard: it has black outer covers, decorated in blind with a floral centre-piece, and burgundy doublures with a filigree centre-piece comparable to *figure 54*.[78] The floral elements on the outer covers have even been worked with a feathering tool comparable to those used on bindings produced for Mehmed II in the 1460s.[79] The evidence, then, points to Shihab al-Din being a member of an imperial scriptorium-cum-bindery.

Shihab al-Din al-Qudsi was not the only scribe working for Mehmed II who was from Jerusalem: a Shams al-Din al-Qudsi is known to have produced at least three manuscripts in the 1460s and 1470s.[80] Other scribes with Mamluk connections are documented working for the Ottomans in the 1450s,[81] but in general Mamluk influence on the Ottoman art of the book in the 1460s and 1470s was restricted. There seems, however, to have been some Mamluk connection in the treatment of filigree doublures in the Fatih style. *Figure 66* illustrates the doublure of an undated medical manuscript copied by Şeyh Hamdullah for Mehmed II, probably in the late 1470s,[82] while *figure 67* illustrates the filigree outer cover of a manuscript written for the Mamluk sultan Qa'itbay in AH 889 (AD 1484),[83] the use of filigree outer covers being largely a Mamluk phenomenon. On both bindings the silhouette effect of the filigree is achieved by the use of small-scale arabesques against a spacious gold ground. As the Mamluk example postdates the Ottoman, the Mamluks may have been indebted to Turkey in this respect rather than *vice versa*, but the exchange of ideas and techniques in bookbinding can only be established when more is known about Mamluk bindings of the 15th century.

The finest leather bindings produced for the court in the 1460s and for most of the 1470s were in the Fatih style, which relied exclusively on centre- and corner-piece compositions. All-over designs of geometrical interlace, of the type familiar from Mamluk bindings, were rare in the extreme. Two exceptions are bindings with star-polygon designs. The two share a common geometrical approach, gilding of the outlines of the polygons, and the use of gold dot-punches. But the geometrical compositions vary, because the two manuscripts are of differing sizes. The larger volume has a central row of three dodecagonal stars,[84] whereas the design on the smaller volume, which was dedicated to Mehmed II and produced in 1468, is based on a single decagonal star.[85]

Two Peaks in Patronage

Mehmed II's demand for books was evidently high, for 90 manuscripts containing dedications to him have so far been identified. This is a far larger number than can at present be associated with any other Muslim imperial patron, but it may seem a small number compared with, say, Bessarion's gift of almost 1,000 manuscripts to the Republic of Venice in 1467.[86] Indeed, it represents only an average of three volumes a year over the 30 years of his second reign, from 1451 to 1481.[87] It must be borne in mind, however, that Mehmed did not have the volumes in his private library marked in any special way, either with notations or a seal impression, and so it is impossible to tell how many other manuscripts he owned, apart, that is, from the 90 with frontispiece dedications. Mehmed's son, Bayezid II, had the imperial library inventoried and the manuscripts stamped with his seal (see Chapter 3), and it is perfectly possible that many of the manuscripts that bear Bayezid's seal originated in Mehmed's library, and we may therefore presume that the total of 90 manuscripts errs very much on the side of caution.

That this is so is indicated by a number of manuscripts that do not contain dedications to the Sultan but for which there is other evidence associating them with him. Such is MS.Ayasofya 2639, whose text is by 'Ali Qushchi, an author patronized by Mehmed, and whose decoration is

62 *left* Central field from a Medallion Ushak Carpet, 16th or 17th century
Formerly in the Palazzo Salvadore, Florence
63 *right* Centre-piece from the outer cover of a work on Hadith
dedicated to Mehmed II, *circa* 1465
Istanbul, Süleymaniye Library, MS.Fatih 2571M

typical of Mehmed's reign. But the only documentation the manuscript contains is the impression of Bayezid II's seal.[88] The same is true for older manuscripts, which often contain no indication of when they came into Ottoman hands beyond Bayezid's seal. Appendices 2 and 3 include several manuscripts that were copied in the 13th and 14th centuries, but which the Ottomans had rebound in the second half of the 15th century. It seems likely that this rebinding was ordered by Mehmed, and when further evidence comes to light it will be possible to add them to the total.

It must also be borne in mind that Mehmed's bibliophilia was not a constant phenomenon; changes in the intensity of his demand for books are suggested by the dates of the manuscripts with dedications to him. The highest incidence of such manuscripts occurs in the mid-1460s, and there appears to have been something of a lull in the early 1470s, whereas patronage was resumed in the last six years of his reign (see Table 1). The incidence of dated manuscripts fits well with the periods when Mehmed rested from campaign and spent his time in cultural pursuits. This applies especially to the mid-1460s.

Throughout the winter of 1464 he saw to the building and decoration of his New Palace. In the spring of 1465 he realized that the army was disaffected at the prospect of yet another campaign, and he gave them leave. His decision may have been influenced by his own health, for he was seriously ill that summer, suffering from gout and obesity.[89] The rest enabled him to devote his

TABLE I

1.	Topkapı Palace Library, MS.B.309	AH 856 (AD 1452)
2.	Topkapı Palace Library, MS.A.3279	AH 857 (AD 1453)
3.	Süleymaniye Library, MS.Fatih 5004	AH 859 (AD 1454–5)
4.	Süleymaniye Library, MS.Süleymaniye 1009	AH 860 (AD 1455–6)
5.	Süleymaniye Library, MS.Ayasofya 2557	AH 863 (AD 1458–9)
6.	Süleymaniye Library, MS.Ayasofya 3587	5 Safar 863 (12 December 1458)
7.	Topkapı Palace Library, MS.A.306	AH 864 (AD 1459–60)
8.	Süleymaniye Library, MS.Damad İbrahim 1066	AH 865 (AD 1460–61)
9.	Süleymaniye Library, MS.Turhan Valide 116	AH 866 (AD 1462)
10.	Süleymaniye Library, MS.Turhan Valide 304	AH 8676 (AD 1462–3)
11.	Süleymaniye Library, MS.Ayasofya 2382[90]	12 Rabi' al-Awwal 867 (5 December 1462)
12.	Süleymaniye Library, MS.Şehzade Mehmed 88	Dhu'l-Qa'dah 868 (July 1464)
13.	Süleymaniye Library, MS.Ayasofya 2448	AH 869 (AD 1464–5)
14.	Topkapı Palace Library, MS.A.2097	AH 869 (AD 1464–5)
15.	Topkapı Palace Library, MS.A.3278	AH 869 (AD 1464–5)
16.	Millet Library, MSS Feyzullah 1359, 1360	AH 869 (AD 1464–5)
17.	Süleymaniye Library, MS.Ayasofya 2480	AH 869 (AD 1464–5)
18.	Süleymaniye Library, MS.Şehid Ali Paşa 1240	20 Dhu'l-Hijjah 869 (13 August 1465)
19.	Topkapı Palace Library, MS.A.2254	20 Shawwal 869 (15 June 1465)
20.	Topkapı Palace Library, MS.A.1297	AH 869 (AD 1464–5)
21.	Süleymaniye Library, MS.Şehid Ali Paşa 1754	AH 869 (AD 1464–5) and AH 870 (AD 1465–6)
22.	Süleymaniye Library, MS.Turhan Valide 48	21–30 Muharram 870 (14–23 September 1465)
23.	Süleymaniye Library, MS.Turhan Valide 81	AH 871 (AD 1466–7)
24.	Süleymaniye, Library, MS.Turhan Valide 210	19 Safar 871 (1 October 1466)
25.	Süleymaniye Library, MS.Amca Hüseyin Paşa 77	AH 871 (AD 1466–7)
26.	Topkapı Palace Library, MS.A.3296	1–10 Dhu'l-Hijjah 871 (4 July–13 July 1467)
27.	Süleymaniye Library, MS.Damad Ibrahim 826	Muharram 871 (13 August –11 September 1466)
28.	Topkapı Palace Library, MS.A.3220	12 Rabi' al-Awwal 871 (22 October 1466)
29.	Süleymaniye Library, MS.Şehzade Mehmed 101	AH 872 (AD 1467–8)
29.	Süleymaniye Library, MS.Şehzade Mehmed 67	22 Muharram 872 (23 August 1467)
30.	Süleymaniye Library, MS.Ayasofya 1930	1–10 Muharram 872 (2–12 August 1467)
31.	Topkapı Palace Library, MS.A.3213	Jumada'l-Ula 872 (January 1467)
32.	Süleymaniye Library, MS.Süleymaniye 353	AH 873 (AD 1468–9)
33.	Topkapı Palace Library, MS.A.1672	24 Rabi' al-Akhir 873 (11 November 1468)
34.	Süleymaniye Library, MS.Fatih 4080	AH 874 (AD 1469–70)
35.	Süleymaniye Library, MS.Şehzade Mehmed 58	Safar 875 (30 July –27 August 1470)
36.	Topkapı Palace Library, MS.A.3210	20–30 Dhu'l-Hijjah 875 (9 June–19 June 1471)
37.	Süleymaniye Library, MS.Ayasofya 3626	AH 876 (AD 1472)
38.	Topkapı Palace Library, MS.A.3437	AH 877 (AD 1472)
39.	Süleymaniye Library, MS.Ayasofya 2383	AH 880 (AD 1475–6)
40.	Süleymaniye Library, MS.Ayasofya 2008	Dhu'l-Hijjah 880 (April 1476)
41.	Topkapı Palace Library, MS.A.2005	14 Safar 881 (8 June 1476)
42.	Museum of Turkish and Islamic Arts, MS.2031	AH 881 (AD 1477)
43.	Topkapı Palace Library, MS.A.3267	Rabi' al-Akhir 882 (July–August 1477)
44.	Süleymaniye Library, MS.Esad Efendi 2494	AH 883 (AD 1478–9)
45.	Süleymaniye Library, MS.Ayasofya 2415	AH 883 (AD 1478)
46.	Süleymaniye Library, MS.Ayasofya 3839	Muharram 886 (March 1481)

energies to architectural and cultural projects during the whole of 1465. As his Greek eulogist Kritoboulos of Imbros wrote, 'as was his custom, he did not neglect his efforts for the City [Constantinople], that is, for its populace, giving diligent care to buildings and improvements. He also occupied himself with philosophy, such as that of the Arabs and Persians and Greeks, especially that translated into Arabic. He associated daily with the leaders and teachers amongst these, and had not a few of them around him and conversed with them. He held philosophical discussions with them about the principles of philosophy, particularly those of the Peripatetics and Stoics'.[91] By the later 1460s and early 1470s, however, he was involved in several arduous campaigns, against Albania in 1467, Karaman in 1468, Negroponte in 1470 and the Aqqoyunlus in 1473. By contrast, 1474 was a year without important military undertakings, and the Sultan spent much of that year, and the winter of 1474–5, in Istanbul. By the summer of 1475 he was again seriously ill, but by the spring of 1476 he was campaigning in Wallachia. Between late 1478 and May 1481, when he died a few days after leaving the capital for yet another campaign, he remained in Istanbul and indulged his cultural interests. These included sending invitations to Venetian and Florentine artists, and it was at this time that Gentile Bellini spent almost a year and a half in Istanbul.[92]

The chronology presented here appears to fit reasonably well with the incidence of dated manuscripts, and we cannot, therefore, take a provisional average of three manuscripts a year as any indication of either the overall, let alone the peak, demand for binding work at Mehmed's court.

Textile Bindings

Bindings in the Fatih style varied in their degree of elaboration, but, as they were worked free-hand, they must have been time-consuming to produce. During the booms in Mehmed's demand for new bindings, this must have presented something of a problem, and one answer was to make bindings that were appropriately luxurious, yet required less finishing. The answer was found in textile bindings.

Textile bindings had been made in previous centuries in the Islamic world – the earliest reference to such a binding is from 10th-century Iraq, and the earliest surviving examples are 14th-century Mamluk.[93] But there is no parallel from the Islamic world for the extraordinary number of textile bindings that were produced for the Ottoman court in the second half of the 15th century. That they were court manuscripts is proved by the presence on all of them of the seal of Bayezid II, although it seems likely that most, if not all, were produced under Mehmed: many contain dedications to this Sultan; none predate his reign; and only one (cat.25) has a dedication to Bayezid. Even this one dedication does not seem to be original, for it has been tampered with, and there is little doubt that the manuscript was originally intended for Mehmed himself.

The textile bindings fall into two main categories, those covered with striped or plaid tabby (see Appendix 2), and those with velvet covers (see Appendix 3). The dated specimens suggest that the two categories may be attributed, respectively, to the 1460s and to the mid- to late 1470s. There are 34 known bindings covered with tabby textiles. Of these, 18 bear dedications to Mehmed and 12 have dates in the 1460s; one lone specimen (Appendix 2, no.23) was produced in the 1470s, more precisely in 1474. The earliest example has a text completed in 1460, but most of the dated examples are from the period 1465–7. Few of the colophons in these manuscripts state where they were produced: only one, that of 1474, mentions Istanbul, while two others were copied in Edirne (Appendix 2, nos 1–2). It is possible, therefore, that the tabby bindings were mostly produced in Edirne, while the Fatih-style leather bindings were produced in Istanbul.[94]

A greater number of velvet bindings have been identified, 49 in all. Of these 16 are on texts that were definitely copied in the second half of the 15th century: seven bear frontispiece dedications to Mehmed II; an eighth bears the altered dedication to Bayezid (cat.25; Appendix 3, no.7);

64, 65 Muhammad al-Razi's *Nuzhat al-Mulūk*.
Copied and bound by Shihab al-Din al-Qudsi, April 1458
Istanbul, Süleymaniye Library, MS.Fatih 3645 (317 × 216 mm)
64 *left* front cover
65 *right* folio 86b

a further seven have colophons with 15th-century dates, all of them falling within Mehmed's reign; and the last of the group (Appendix 3, no.10) carries neither date nor dedication, but is by a scribe who produced several works for Mehmed. The dating range of this group – between January 1475 and January 1481 – is extremely narrow.[95]

The number of manuscripts with Ottoman dedicatory frontispieces may seem too low to justify the claim that all the velvet bindings were produced for the Ottoman court. But the proportion of these velvet bindings that are securely documented as Ottoman – 16 out of 49 – is depressed by the fact that many of the manuscripts are earlier copies, several bearing dates in the 13th or 14th centuries. This is especially true of those bound in green velvet, of which cat.26 is a typical example. Regardless of when the texts they contain were copied, all the manuscripts with velvet bindings appear to have been bound or rebound for the Ottoman imperial library in the last quarter of the 15th century. This can be argued on several counts. Firstly, all the volumes are closely related codicologically. Secondly, all of those with dedications were made for Ottoman patrons, unless they are of much earlier date, such as the Ilkhanid copy of Ibn Sina's *Qānūn fi'l-ṭibb* (Appendix 3, no.23). Thirdly, all the named copyists from the 15th century were scribes who are known to have copied other manuscripts for Mehmed II, with the exception of the scribe of no.27, who is otherwise unknown. Indeed, these copyists were the most important scribes working for Mehmed in the latter part of his reign and include the illustrious Şeyh Hamdullah. The only important scribe who worked for Mehmed in the last five to six years of his reign but who is not

represented among the manuscripts with velvet bindings is Sayyid Muhammad al-Munshi, to whom we shall refer later. Fourthly, every manuscript, bar cat.25, bears Bayezid's seal, indicating that it was in the imperial library in the early 16th century at the latest, and the one rogue example – cat.25 – was also in the Ottoman palace, but in the Sultan's Privy Chamber rather than the imperial library.[96]

Although all the velvet bindings appear to have been produced for Mehmed's court, they were not necessarily all meant for the Sultan's personal use; indeed, there appears to be a correlation between the type of velvets used for the bindings and the status of the manuscript. Green velvet was mostly used for older manuscripts. The texts they contain are often anthologies, and they were written in a small, usually vocalized, script. These manuscripts tend to lack any embellishment, and their text areas are often unframed: the gold that features in most of the books written for Mehmed ii, whether for illumination, text frames or details of text, is almost entirely absent. The relative simplicity of the presentation and the variety of the texts included within a single volume suggest that these books may have been intended for teaching purposes, rather than as prestige library products. The manuscripts with green velvet bindings therefore contrast with those with red velvet covers, which are the only ones to have imperial dedications. The contrast can be explained by the fact that the cost of the dyes used made red velvets the most expensive. In this context it is worth noting that two of the red velvet bindings are brocaded with gold (cat.24–25), and that the manuscripts of both have imperial dedications. It would be wrong, though, to think that only the most elaborate velvets were used for texts with illuminated dedications. An undated manuscript (Appendix 3, no.49) is outwardly unpretentious, with a plain, dark-brown velvet cover and simple edging of dark, brown-red leather, but inside there is some of the most sumptuous illumination in any of Mehmed's books, and calligraphy to match.

As there are no tabby or velvet bindings that can be dated to the reign of Murad ii or that of Bayezid ii,[97] the implication is that textile bindings were Mehmed's whimsy. He evidently liked the striped and plaid tabbies enough to have a kaftan made of the material.[98] Mehmed also appears to be holding a handkerchief of this material in the famous portrait that shows him smelling a rose.[99] It is a curious fact, however, that the tabbies cease when the velvets start. The last of the dated tabby bindings is on a manuscript completed June–July 1474,[100] while the dated velvet bindings begin in January 1475. To judge from this evidence there was no overlap in the two types of binding, although there is one manuscript, unfortunately undated, for which velvet has been used for the outer covers, and tabby for the doublures (Appendix 3, no.48).

Why, we might ask, was there a change in the type of textile used? Several explanations suggest themselves. One is that the change was forced on the Ottomans, because the supply of these striped and plaid tabbies ceased. It is possible, for example, that the workshops that produced the tabbies were destroyed, but until it is established where the tabbies were made this remains extremely hypothetical. It is worth pointing out, though, that one of the factors that led to the war between the Aqqoyunlu Turcomans and the Ottomans in 1473 was Uzun Hasan's attack on the city of Tokat, which was one of the main centres in Anatolia for the silk trade from the east.[101] An alternative explanation is that the Ottomans increased their use of velvets in the 1470s, and that the adoption of velvet for bindings was a by-product of this development.[102] This would not, however, explain why velvets replaced tabbies for bindings, for velvets had long been in use at the Ottoman court. Mehmed's father, Murad ii, for example, was described in the 1430s as wearing a kaftan of crimson 'pile-on-pile' velvet,[103] and velvet was available in sufficient quantities in the early 1470s for it to be distributed to the Ottoman troops before the eastern campaign in late 1472.[104] It seems likely, then, that the reason for the change was more a matter of taste than supply, and that the concept of velvet bindings was introduced from Europe, where they were considered items of great luxury. Their status there can be gauged from the fact that most, if not all, the bindings

66 *left* Doublure of a copy of Husayn ibn Ishaq's *Kitāb al-Masā'il*
made by Şeyh Hamdullah for Mehmed II,
circa 1475–80
Istanbul, Topkapı Palace Library, MS.A.1996 (227 × 138 mm)
67 *right* Back cover of a manuscript
copied for Sultan Qa'itbay in 1484
Istanbul, Topkapı Palace Library, MS.A.2829 (320 × 215 mm)

produced for the English monarch Henry VII (*reg.* 1485–1509) are believed to have been in velvet, while the great bibliophile Matthias Corvinus of Hungary (*reg.* 1458–90) also had numerous manuscripts bound in velvet.[105]

Velvets could only be employed for outer covers, for they were too thick to be used to line the binding. For this reason most of the velvet bindings have leather doublures, but an interesting development took place in the last two years of Mehmed's reign, when silk lampas of differing designs was used on several manuscripts with velvet outer covers. Four are lined with variants of the same striking design (Appendix 3, nos 1, 3–5; cat.27, 29). On stylistic grounds this lampas must surely be Ottoman, but the origin of the lampas used for cat.30 is more problematic.

Why such accomplished lampas-weave textiles should have appeared on Mehmed's bindings only in the last few years of his reign is puzzling, but it is possible that the court sponsored the development of the Ottoman textile industry in the 1470s in the same way that it sponsored the development of the carpet industry in the 1460s. Evidently, by the very beginning of the 16th century it was considered that the products of Mehmed's reign had been of superior quality, for the composer of an edict of 1502, aimed at controlling prices in the textile industry, commented on the decline in standards since Mehmed's day: the amount of dye used, the thread counts, the loom widths and the standard lengths had all been reduced.[106]

The Ottomans continued to produce textile bindings on occasion in the 16th century and later, and they were sometimes used for important book projects, such as the copy of the *Nuṣratnāmah*

produced in about 1585, which had embroidered velvet covers,[107] or the *Sūrnāmah* of Vehbi, which was illustrated by Levni for Sultan Ahmed III between about 1721 and 1730, and which had outer covers lined with a striped silk cloth.[108] Nevertheless, no large group of Ottoman textile bindings has so far been identified to rival those produced in the second half of the 15th century. While the introduction of velvet bindings in the last six years of Mehmed's reign points, it would seem, to European influence, a rival influence from the East was making itself felt, not only in bookbinding, but in all aspects of the art of the book.

Influence from Turcoman Iran

This influence came from Iran, predominantly from the Turcoman-held cities of Shiraz, Isfahan and Tabriz. It manifested itself in the adoption of a harder sizing for the paper, which allowed for a higher burnish (see Appendix 1), and a more brilliant style of illumination was also adopted, with a lavish use of gold. We can identify three main phases in the illumination of Mehmed's manuscripts. The first was strongly influenced by Shirazi work of the first half of the 15th century in its use of a spindly floral decoration executed in white or gold against an ultramarine ground.[109] In the second phase Ottoman court artists created an orginal style of illumination that was used for Fatih-style manuscripts of the 1460s. This style made extensive use of ultramarine in various intensities (cat.11–2), often as an overall ground, but the flora was distinct in form and colouring from that of the Shiraz style. The style that came to dominate in the third phase, in the latter part of the 1470s, substituted gold for blue as the main ground. The gold was used in several tones, with differing levels of burnish that produced a contrast between matt and lustrous finishes. Once domiciled in Istanbul, this style developed into the characteristic manner used for the illumination of manuscripts under Bayezid II (cat.41).

A fine example of this style of illumination occurs in one of the last books produced for Mehmed.[110] The rosette in the dedicatory frontispiece has three tones of gold,[111] while the head-piece at the beginning of the text has a ground of matt, silvery gold. Against this background an abundance of florettes have been rendered in a much-extended palette, ranging from orange to blue, emerald green, black, yellow, red and lilac. A diagnostic feature of the style is the use of tiny tear-drop forms, shaped like the eye of a needle, as accents on the lobes of leaves and rosettes; in this manuscript each of the 'eyes' is in a different colour. Another characteristic is the tendency to reduce the size of the borders.

The basis of the style was developed in Iran, and it appears to have reached the Ottomans via the Turcomans, when Mehmed profited from his defeat of the Aqqoyunlus in 1473 by removing artists to Istanbul. A marked increase in Turcoman influence in the Ottoman art of the book in the latter part of Mehmed's reign is apparent from the stylistic changes that took place in Ottoman illumination, but it can be confirmed from the surnames of the scribes who worked for Mehmed. Calligraphers from Iran such as 'Ali ibn Fathallah al-Ma'dani al-Isfahani and 'Ata'allah al-Tabrizi (cat.13) had been working for the Sultan before 1473, but after this date Iranian scribes came to dominate the production of royal manuscripts.[112]

Mehmed's victory in 1473 may serve as a convenient marker, but it should not be taken as definitive, not least because the earliest of Mehmed's manuscripts in which the Turcoman style of illumination occurs is dated AH 876 (AD 1471–2), almost two years before his defeat of Uzun Hasan.[113] Mehmed's victory seems, however, to have confirmed the Turcoman contribution to the Ottoman art of the book, and at least one of the scribes who made their presence felt after 1473 was captured during his campaign of that year. Whether the others were also captured at the same time or were attracted to Istanbul by the increased lustre of Mehmed's reputation and the prospect of liberal patronage remains to be established.

Table 2 is a listing of the scribes who produced manuscripts which have both precise dates and frontispiece dedications to Mehmed. The list exludes autograph works by scholars and concentrates primarily on those who worked as professional scribes. Since it also excludes undated manuscripts dedicated to Mehmed, it does not show all the known works of the scribes listed, nor does it include a scribe such as Şeyh Hamdullah, who copied several undated manuscripts for Mehmed (cat.23). What it does reveal, though, is the contribution towards the end of his reign of two Iranian calligraphers, one from Shiraz, the other from Isfahan. (Another Iranian scribe, who began working in Istanbul in the 1470s and rose to be one of Bayezid's court scribes, was Muhammad al-Badakhshi, but no work by him expressly dedicated to Mehmed has so far been discovered.)[114]

Sayyid Muhammad, who was from Shiraz, worked as a scribe and epistolographer in Mehmed's chancery, whence he styles himself 'al-Munshi al-Sultani'. According to the early 16th-century Ottoman historian Idris Bitlisi he had been the *nişancı* of the Aqqoyunlu ruler Uzun Hasan and

TABLE 2

1.	'Abd al-Latif ibn Darwish Bayazid	AH 857 (AD 1453) Topkapı Palace Library, MS.A.3279
2.	Ahmad ibn Husayn ibn 'Ali al-Misri	AH 860 (AD 1455–6) Süleymaniye Library, MS.Süleymaniye 1009
3.	Dawud ibn Mawlana Ibrahim ibn Khwajah Dawud al-Isfahani, known as al-Madji	AH 866 (AD 1462) Süleymaniye Library, MS.Turhan Valide 116
4.	'Ali ibn Fathallah al-Ma'dani al-Isfahani	12 Rabi' al-Awwal, 867 (5 December 1462) Süleymaniye Library, MS.Ayasofya 2382[115]
5.	'Abd al-Wasi' ibn Hasan al-Lahsawi	20 Dhu'l-Hijjah 869 (13 August 1465) Süleymaniye Libray, MS.Şehid Ali Paşa 1240
6.	Wali ibn Yusuf al-Qastamuni	20 Shawwal 869 (15 June 1465) Topkapı Palace Library, MS.A.2254
7.	'Ali ibn Fathallah al-Ma'dani al-Isfahani	AH 869 (AD 1464–5) Topkapı Palace Library, MS.A.3278
8.	Dawud ibn Mawlana Ibrahim Khwajah ibn Dawud al-Jamarlaqi al-Isfahani	AH 871 (AD 1466–7) Süleymaniye Libray, MS.Turhan Valide 81
9.	Shams al-Din al-Qudsi	19 Safar 871 (1 October 1466), Süleymaniye Library, MS.Turhan Valide 210
10.	Ahmad ibn Akhi Tuy al-Marzifuni, known as Ahmad al-Sultani	AH 871 (AD 1466–7) Süleymaniye Library, MS.Amca Hüseyin Paşa 77
11.	Yusuf ibn Ilyas	Dhu'l-Hijjah 871 (July 1467) Topkapı Palace Library, MS.A.3296
12.	Mahmud ibn Ahmad al-Kharparti	Muharram 871 (August–September 1466) Süleymaniye Library, MS.Damad Ibrahim 826
13.	Yusuf ibn Ilyas	Muharram 872 (August 1467) Süleymaniye Library, MS.Ayasofya 1930
14.	'Ali ibn Fathallah al-Ma'dani al-Isfahani known as Sabri	Jumada'l- Ula 872 (November–December 1467) Topkapı Palace Library, MS.A.3213
15.	Bali al-Katib al-Sultani	AH 873 (AD 1468–9) Süleymaniye Library, MS.Süleymaniye 353
16.	Ahmad ibn 'Ali Maraghi	24 Rabi' al-Akhir 873 (11 November 1468) Topkapı Palace Library, MS.A.1672 (cat.18)

17.	Ahmad ibn Ishaq al-Qudsi	Safar 875 (July–August 1470), Süleymaniye Library, MS.Şehzade Mehmed 58
18.	Shihab al-Din al-Qudsi	AH 876 (AD 1471–2) Süleymaniye Library, MS.Ayasofya 3626
19.	Yusuf ibn Husayn al-Siwasi	AH 877 (AD 1472–3) Topkapı Palace Library, MS.A.3437
20.	Shams al-Din al-Qudsi	15 Ramadan 879 (23 January 1475) Topkapı Palace Library, MS.A.3195
21.	'Ali ibn Fathallah al-Ma'dani al-Isfahani, known as Sabir	AH 880 (AD 1475–6), Süleymaniye Library, MS.Ayasofya 2383
22.	Mansur [...] Amasi	Dhu'l-Hijjah 880 (April 1476), Süleymaniye Library, MS.Ayasofya 2008
23.	Sayyid Muhammad al-Munshi al-Sultani	Rabi' al-Awwal 881 (July AD 1476), Richmond-upon-Thames, Keir Collection
24.	Ghiyath al-Din al-Mujallid	AH 881 (AD 1476–7), Istanbul, Museum of Turkish and Islamic Arts, MS.2031 (cat.33)
25.	Sayyid Muhammad al-Munshi al-Sultani	Rabi' al-Akhir 882 (June–July 1477), Topkapı Palace Library, MS.A.3267
26.	Ghiyath al-Mujallid al-Isfahani	AH 883 (AD 1478–9), Süleymaniye Library, MS.Esad Efendi 2494
27.	Ghiyath al-Mujallid al-Isfahani	4 Dhu'l-Qa'dah 884 (17 January 1480), Süleymaniye Library, MS.Ayasofya 4009
28.	Sayyid Muhammad al-Munshi al-Sultani al-Shafi'i al-Shirazi	Muharram 886 (March–April 1481), Süleymaniye Library, MS.Ayasofya 3839

was among those captured at the battle of Başkent in August 1473.[116] An Aqqoyunlu document in the name of Uzun Hasan dated 1471 is perhaps in his hand, for it is in a variant of the elaborate chancery script known as *ta'līq* that was his speciality.[117] It was almost certainly through Sayyid Muhammad's influence that this script entered into Ottoman chancery practice, and that a related form of script, *dīvānī*, came to be used for Ottoman *fermans*.[118] One of the earliest Ottoman examples of a document written in *ta'liq* is dated January 1474, and in all probability was composed and written by Sayyid Muhammad.[119] His earliest signed work for the Ottomans is a manuscript produced for Mehmed in July 1476 (cat.22); this is followed by another dated AH 882 (AD 1477) and by one, without a dedication, dated AH 883 (AD 1478–9). Sayyid Muhammad evidently continued in imperial service, because he completed a work dedicated to Sultan Bayezid in Ramadan 893 (August–September 1488).[120]

The second and, for our present purposes, the more interesting, of these two scribes is Ghiyath al-Din al-Isfahani, who signed himself 'al-Mujallid' (the Bookbinder) in several of his colophons.[121] As a calligrapher he specialized in *nasta'līq*, and his efforts were accomplished if unremarkable (*figure* 68). No other bookbinder appears to have been as active as a scribe in this period (his signed work covers the years from 1474 to perhaps as late as 1502), while his bindings represent a major shift in technique and aesthetic that heralded the style of Bayezid's reign and the shift to the classic style of binding which dominated in the 16th and 17th centuries.

Ghiyath's *nisbah* suggests that he was from Iran, although it is possible that he used it to indicate that his family was originally from Isfahan, while he himself had been brought up in Ottoman Turkey. But as the style of Ghiyath al-Din's bindings marks a change from the Ottoman tradition and evinces considerable influence from Iran, it seems likely that he moved

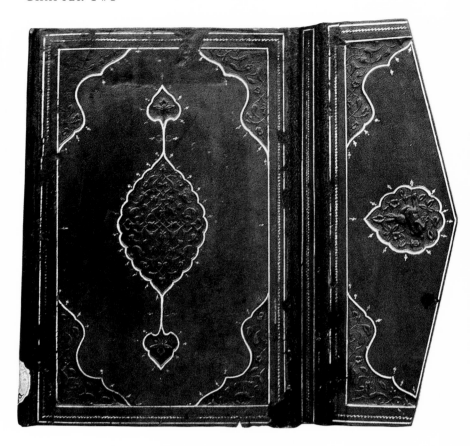

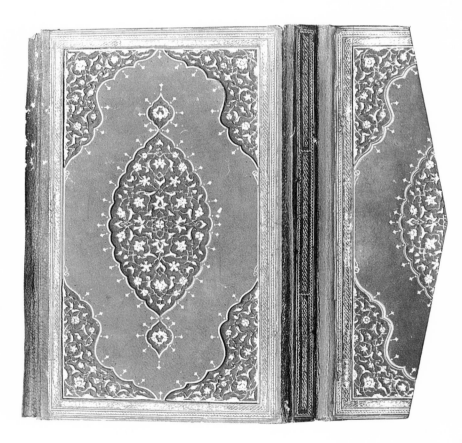

to Turkey from Iran, presumably in his maturity, bringing with him skills he had learnt in his native country. The earliest dated work by him so far known is a poem addressed to the Sultan, which he composed in Constantinople in AH 879 (AD 1474–5). It reads,[122]

> O king, may your luck and fortune always be good;
> may your night be the Night of Power, may your morning be Bayram !
> May the enemies of your magnificence have a short life in this world;
> may a hundred of their lives be added to your life every moment!
> May the length of your life in this world,
> upon the throne of fortune, be as long as the fame of your justice!
> May your adversary,
> like the fly trapped in the spider's web within the cave of grief,
> turn to skin and bone, because of the workings of fate.
> If the offering of a poor man's prayer is too trifling,
> may it be accepted by the One Lord, for the king's sake!

This poem may have been one of the means by which Ghiyath al-Din brought himself to the notice of the Sultan, in which case it suggests that he had not been long in the Ottoman capital. If he did arrive in AH 879, his success was almost immediate, for he was soon executing works for the Sultan and for Prince Cem.

Although our interest in Ghiyath al-Din is as a scribe and binder, he was also trained as a doctor. In an undated manuscript, he recorded in the colophon that the manuscript was completed 'by the hand of the poor slave, Ghiyath the Physician, … known as the Binder'.[123] His medical interests are confirmed by the text, which was a commentary on Galen,[124] and several other texts he copied were medical in character.[125] If his medical expertise extended to chemistry, it may help explain how he was able to improve the surface quality of the leather he used in his bindings, for, as Martin Levey has shown, there was a close connection between alchemy, pharmacology and bookbinding in the Muslim world.[126] Ghiyath al-Din's work as a scribe was not confined, however, to medical texts, for he copied a work by the poet Jami for Mehmed's son Prince Cem (figure 68) and the Dīvān of the poet Qabuli, who was originally from Shirvan in Azerbaijan, but who succeeded in gaining imperial Ottoman patronage, first at the court of Prince Bayezid in Amasya and later at Mehmed's court in Istanbul.[127]

Eight manuscripts signed by Ghiyath are known (see Table 3).[128] Regrettably, not all of these provide information on his skills as a bookbinder. The earliest dated example, the Dīvān of Qabuli, which he copied in AH 880 (AD 1475–6) was rebound in the 18th century, though the front flyleaf preserves the impression of the manuscript's original filigree doublure.[129] The next dated manuscript comes from the year AH 882 (AD 1477–8) and has a binding of crimson voided velvet; its doublures are of black leather, with a simple, blind-tooled roundel for a centre-piece. Evidently, it was not Ghiyath al-Din's prowess as a bookbinder that was being exploited in this instance, but, presumably, his familiarity with the medical text by al-Jurjani that the book contains. This was not the only textile binding used on a text copied by Ghiyath al-Din, as a manuscript dated AH 883 (AD 1478–9) has beige silk on its outer covers, and paper pastedowns on the inner.[130]

68 *top left* The *nasta'līq* hand of Ghiyath al-Din al-Isfahani from a work by Jami
copied and bound by him for Cem Sultan, 1480
Istanbul, Süleymaniye Library, MS.Ayasofya 4009, folio 2a (318 × 134 mm)
69 *top right* Back cover of *figure 68*
70 *bottom* Back doublure of a copy of 'Attar's *Manṭiq al-ṭayr*,
dedicated to Prince Yusuf Bahadur Khan, Turcoman, *circa* 1470–80
Istanbul, Topkapı Palace Library, MS.E.H.1511 (200 × 120 mm)

71 Drawing from the Baba Nakkaş album, folio 13a

The remaining bindings, such as cat.31, are all pressure-moulded. The use of pressure-moulding represents an important departure for Ottoman bindings, for such work became increasingly common under Bayezid II. Cat.31 is not dated, but a volume with a binding in a similar technique was produced in 1475, although, in this case, the names of neither the scribe, the binder nor the patron were given.[131] An unusual feature of cat.31 is that it has differing centre-pieces on the front and back covers, though in both cases they take the form of pointed ovals with floral and arabesque designs. The centre-piece on the front cover (*figure 73*) provides clear confirmation of Turcoman influence, because it is close in composition and motifs to the centre-piece on the binding of an undated copy of the *Manṭiq al-ṭayr* produced for a Prince Yusuf Bahadur Khan (*figure 70*). He is perhaps to be identified with Uzun Hasan's cousin Yusufchah Mirza who was captured by the Ottomans in 1472, sent to Istanbul, and subsequently ransomed.[132] In fact, the correspondence between the two centre-pieces is so close that it raises the question as to whether Ghiyath al-Din had been working for the Aqqoyunlu court. If so, he may have been taken prisoner along with Yusufchah Mirza in 1472, or, like Sayyid Muhammad al-Munshi, in 1473. An alternative possibility is that he was a member of the entourage of Uzun Hasan's son Ughurlu Muhammad, who rebelled in 1474 and fled to the Ottomans after his defeat in 1475. Ughurlu Muhammad had previously been governor in Isfahan, the home city of Ghiyath al-Din, and the date that the Prince fled to Istanbul fits well with the date of Ghiyath al-Din's poem to Mehmed.

The motifs on another undated binding by Ghiyath al-Din are more akin to those of the Fatih style, but the binding prefaces developments under Bayezid in two respects: the reduced size of

72 Rubbing from the front cover
Ottoman, 1480
Istanbul, Topkapı Palace Library, MS.A.2062 (actual size)

its motifs, and the use of all-over gilding for the ground of the pressure-moulded areas.[133] The doublures of this manuscript have pointed-oval centre-pieces worked in filigree and set against a blue ground, a trait of other work by Ghiyath al-Din, such as cat.33 and the manuscript he produced for Prince Cem. Although the arabesque design bears some resemblance to that of a Fatih-style binding (*figure 54*), the use of a uniform blue ground is distinctive.

Two of the bindings – cat.33 and that of the manuscript made for Prince Cem – have some animal decoration, which is enough in itself to suggest that Ghiyath al-Din received his training as a bookbinder in Iran. For, although representations of animals or humans were common on bindings there, figurative representations were almost unknown in Ottoman bookbinding of the second half of the 15th century. Indeed, only two other examples have been identified (see Chapter 3). The figurative decoration on the binding of Prince Cem's manuscript is restricted to

TABLE 3: WORKS BY GHIYATH AL-DIN[134]

1.	Istanbul University Library, MS.F.Y.1423, fol.20a[135]	AH 879 (AD 1474–5); dedicated to Mehmed II
2.	Süleymaniye Library, MS.Ayasofya 3958	Constantinople, AH 880 (AH 1475–6)
3.	Museum of Turkish and Islamic Arts, MS.2031 (cat.33)	Dhu'l-Qa'dah 881 (19 February 1477)
4.	Süleymaniye Library, MS.Ayasofya 3696[136]	Constantinople, AH 882 (AD 1477–8)
5.	Süleymaniye Library, MS.Esad Efendi 2494	Constantinople, AH 883 (AD 1478–9)
6.	Süleymaniye Library, MS.Ayasofya 4009	4 Dhu'l-Qa'dah 884 (17 January 1480)
7.	Topkapı Palace Library, MS.Y.830 (cat.31)	undated
8.	Süleymaniye Library, MS.Ayasofya 3557	undated

a single rabbit on the envelope flap (*figure 69*); but one of the covers of cat.33 is decorated with a landscape that includes a large tree in bloom, foxes, deer and an ibex. Unfortunately, some scrupulous soul, offended by the animals, has taken a knife to them, removing both the leather and the relief pasteboard beneath and leaving only a ghost of the composition. The other outer cover was worked with an arabesque design and this has survived unscathed. The landscape scene derives from the Turcoman tradition and is unparalleled among Ottoman bindings. Ghiyath al-Din's work was innovative, too, in technique, because the entire landscape design has been pressure-moulded from a single panel stamp, which makes it by far the earliest use of panel stamping on an Ottoman binding.[137]

Ghiyath al-Din achieved rapid and impressive success as a scribe and bookbinder for the Ottoman court. His work helped establish pressure-moulding as an essential process of finishing, with the result, as we shall see in Chapter 3, that the major bindings produced for Sultan Bayezid all made use of the technique. The Ottomans proved, however, to be selective in the innovations that they adopted, and, despite his general success, Ghiyath al-Din failed to stimulate a move towards panel stamping or pictorial bindings in Turkey.

The Pomegranate Style

The introduction of pressure-moulding did not necessarily displace the Fatih style, but one of its last dated appearances is on cat.22, which is dated July 1476. The prospect of competition may have encouraged the artists who had been responsible for the Fatih style to ring the changes, and in the last few years of Mehmed's reign they responded by modifying it. The leather used was similar in type and colour to that used for the Fatih style – black-brown outer covers and burgundy

or light-tan doublures – and the decoration, which was exclusively floral, was not stamped, but tooled free-hand using stencils. As the most recurrent motif in this style was a pomegranate, the style will be referred to – with due originality – as the 'Pomegranate style'.

It had three distinguishing features. One was the complete absence of outlines for the centre- and corner-pieces; the second was its fleshy, almost voluptuous, floral motifs; and the third was its broad treatment, with minimum detailing and often no stippling for the background. It thus contrasted with Ghiyath al-Din's work, which used small-scale motifs and emphasized the contours of the centre- and corner-pieces by the use of moulding. The contrast was so marked that it may have been deliberate.

Three bindings in the Pomegranate style have so far been identified. Two of them have colophons that state they were produced in Constantinople, one in Safar 885 (12 April–10 May 1480; *figure 72* and page 224),[138] the other in Muharram 886 (2–31 March 1481).[139] The third manuscript must be of similar date,[140] as the same stencil was used for its doublures and those of the manuscript of March 1481, even though the volumes are of different sizes; in both instances the stencil used on the front doublure was reversed for use on the back doublure. The designs on the front covers of the two manuscripts are similar in style, but there are differences in details. None of these manuscripts bears a dedication, but that dated March 1481 was copied by the imperial scribe Sayyid Muhammad al-Munshi al-Sultani.[141]

A drawing in a comparable style – it comes closest in its rendering to the work on the binding of the manuscript of March 1481 – occurs in the Baba Nakkaş album (*figure 71*), which helps confirm that this was a style developed in the imperial studio. Yet, like its predecessor, the Fatih style, it may have drawn inspiration from developments in Iran.[142]

A binding related to the Pomegranate style is decorated, not with leaves and pomegranates, but a most striking rendition of a Chinese cloud band (*figure 49*).[143] It bears neither date nor dedication but shares with the Pomegranate style the same broad treatment and the greater sense of freedom that came with abandoning the frames around the centre- and corner-pieces. It therefore seems reasonable to date this binding to 1480–81. Cloud bands were to become a standard element in the vocabulary of Ottoman bookbinding in the 16th and 17th centuries, yet these are etiolated specimens compared to the bands on this binding, which have a charge that recalls the cloud bands on the silk used to line cat.28. What is more, cat.28 is dated to the end of March 1481, the month in which Sayyid Muhammad al-Munshi completed the volume bound in the Pomegranate style.

Conclusion

Mehmed the Conqueror has been alternatively portrayed as a Humanist prince who was imbued with the spirit of Renaissance enquiry but who happened to wear a turban, or as a Muslim despot who consorted with Greek and Italian scholars and acquired Greek and western manuscripts for the sole purpose of learning about the latest advances in technology and cartography, advances which he used to augment his dominions.[144] The most extreme version of the anti-Humanist view was adopted by Franz Babinger, who also argued that Mehmed took an interest in ancient heroes such as Alexander the Great and Julius Caesar solely because he saw them as practical exemplars of military excellence.[145] Likewise, there are two opposed interpretations of why he took an interest in the tenets of the Orthodox church; for some this was part of his reestablishment of the Byzantine empire, for others, callous *realpolitik*.[146]

The practical and materialistic argument seems at first to be supported by the fact that many of the European books that Mehmed received were devoted to three areas – geography, military science and medicine.[147] One of the leading Greek scholars at his court, George Amiroutzes, for

example, translated Ptolemy's *Geography* into Arabic, and created a single map of the world from the separate maps in the manucript.[148] Amiroutzes pioneered advances in spherical trigonometry, and he said himself that he saw the purpose of this work as contributing 'audacity cum prudence' to the sultan's actions.[149] It is misleading, though, to assess Mehmed's intellectual interests solely on the basis of the Greek and Latin manuscripts that he acquired. Amiroutzes, for example, conducted his work on Ptolemy in the summer of 1465, and, however pragmatic that project, he also gave lessons to the sultan on Stoic and Peripatetic philosophy. Mehmed's practical and speculative interests are not as mutually exclusive as Franz Babinger seems to imply. The sultan gave time and commitment to both, as his interest in the work of Ibn Sina (Avicenna) demonstrates.

In 1466, and again in 1467, the sultan made several requests to the Rectors of Ragusa for copies of Latin commentaries on the *Canones* of Ibn Sina, which, as the requests specify, were for the Sultan's Jewish Italian physician, Jacopo da Gaeta.[150] The interest in Ibn Sina's medical work at Mehmed's court is also shown by the fact that several copies of his original text, the *Qānūn fi'l-ṭibb,* were transcribed for Mehmed. Two of these are prestige copies, and, though neither are precisely dated, they can be attributed, on the evidence of their illumination and bindings, to the 1460s (*figure* 57).[151] The request to Ragusa may have been prompted by the Sultan's recent ill health; yet at much the same time copies were produced of Ibn Sina's philosophical-theological works, such as the *Kitāb al-Ishārāt wa'l-tanbīhāt* (Table 2, nos 4, 7) and the *Kitāb al-Shifā'*.[152]

Of the 90 books with frontispiece dedications to Mehmed 20 are on philosophy, and a further five on logic, a high proportion that testifies to his speculative interests. These are also indicated by the debates he organized, often with the encouragement of his grand vizier, Mahmud Pasha. One leading participant was the scholar Hocazade, who visited the Sultan in search of patronage and succeeded in being appointed as his personal tutor. A debate on the subject of the single nature of God (*tawḥīd*) lasted eight days, and Hocazade was judged to have triumphed over his opponent, Molla Zeyrek, and was given Molla Zeyrek's *medrese* as a reward.[153] This debate probably took place before the building of the Fatih mosque and its *medreses* and may in some way have been connected with the treatise on Christianity that Mehmed commissioned from the Orthodox patriarch, Gennadios.[154] Later, possibly in AD 871 (AD 1466–7), Mehmed organized a debate between Hocazade and Ali Tusi on the *Incoherence of the Incoherence*, a work in which Ibn Rushd (Averroes) had countered al-Ghazali's attack on the *falāsifah* ('the philosophers').[155] Central to al-Ghazali's criticism was his claim that philosophical reasoning lacks the strictness of mathematical reasoning, whereas the Aristotelian position of Ibn Rushd was that logic cannot be accused of lacking strictness.[156] It is remarkable that Mehmed initiated a debate on the work of Ibn Rushd, a scholar better known in the West than he was in the Muslim world, and that he was prepared, as we have seen, to study Greek philosophy with a Greek tutor, Amiroutzes. From the available evidence it seems that Mehmed was attempting to revivify the cause of the *falāsifah*, which had withered after the attack by al-Ghazali in the 11th century.

Ibn Rushd, like Thomas Aquinas and Maimonides, believed that man's rational quest for happiness would find fulfilment in knowledge of God,[157] and it is surely no coincidence that a Greek translation by Demetrio Cydonio of Thomas Aquinas' *Summa contra Gentiles,* was produced in Mehmed's scriptorium, and that a copy of the Hebrew version of Maimonides' *Guide of the Perplexed,* produced in 1480, entered the imperial library (*figure* 21).[158] Mehmed was also in contact with Greek scholars such as Gennadios and George of Trebizond who argued the Aristotelian cause, but he was interested, too, in Neo-Platonism, rescuing what he could of the *Laws* of the great 15th-century Byzantine proponent of Neo-Platonism, Georgios Gemistos Plethon, a work which Gennadios had attempted to have destroyed. Again it is perhaps no coincidence that an Arabic translation of Plethon's work, including his *Compendium Zorastrorum et Platonicorum*

Dogmatum, his collection of the *Chaldaean Oracles,* and a *Hymn to Zeus,* can be dated on codicological grounds to Mehmed's reign.[159]

There has been no detailed study of Ottoman intellectual history during Mehmed's reign, but any such study will need to take into account the imperial library. Bindings can provide a criterion for dating Mehmed's manuscripts, from which it may be possible to discern trends in his interests. It is intriguing, for example, that in the 1470s at least two copies of the fundamental work of Illuminationist philosophy, al-Suhrawardi al-Maqtul's *Ḥikmat al-ishrāq,* were produced for him, and it would be intriguing to know if his interest in Illuminationism was a feature of his later years,[160] following a phase more influenced by Aristotelianism in the 1460s. If such a development did indeed take place, it would have coincided with a change in the style of manuscript illumination in the 1470s towards one more in the Turcoman manner, with a heavy use of several tones of gold, a visual aesthetic that successfully expressed – providentially or by design – the Illuminationist theme.

A further question that arises is whether Mehmed's speculative interests were related to a concept of the state in which Mehmed played the role of the philosopher-king. Mehmed's Greek eulogist, Kritoboulos, described the sultan's ambition for empire: for this, he said, Mehmed was well-suited not only physically and spiritually, but because 'his learning and his fine knowledge of all the works of the ancients aided him. For he studied to the limit all the wisdom of the Arabs and Persians, and whatever Ancient Greek works had been translated into Arabic and Persian – I refer particularly to the works of the Peripatetics and Stoics – making use of Arab and Persian tutors who were the most dedicated and knowledgeable in such matters.'[161]

73 Rubbing from the front cover of cat.31,
by Ghiyath al-Din al-Isfahani

Chapter Three

BAYEZID II AND THE ORIGINS OF THE CLASSICAL STYLE

IN the varying traditions of Ottoman imperial portraiture Sultan Bayezid II is often depicted dressed in green (the colour associated with the Prophet Muhammad), with a grey beard and, in many cases, holding a book.[1] Although the series of imperial portraits in which Bayezid was depicted in this manner only became popular from the last quarter of the 16th century, the image of pious maturity they offered was current in Bayezid's own time. The Sultan was referred to as Veli ('friend of God') and Sofu ('the Sufi') by the contemporary poet Necati, for example,[2] and the epithet Veli also occurs in contemporary inscriptions, such as those on the gravestones of Ahi Durmuş Baba, a Mevlevi dervish from Khorasan who became the Sultan's water-carrier and died in 1505, and of Katib Sinan, the clerk of the imperial kitchens, who died in 1510.[3] The earliest example of this usage is in the foundation inscription of Bayezid II's mosque in Foča in Bosnia, which is dated AH 906 (AD 1500),[4] and this indicates that the pious image was promoted by the Sultan himself. Indeed Bayezid's preoccupation with religious matters, and his close relationships with Sufi brotherhoods in particular, influenced his patronage of the arts, including the art of the book.

Bayezid in Amasya

Bayezid was born in December 1447 or January 1448, and in 1454, at the tender age of six, he was instated as governor of Amasya, a town in northern Anatolia and capital of the province of Rum. When an Ottoman prince was sent out to rule an appanage in Anatolia in this way, he was accompanied by an entourage whose structure mirrored that of his father's court.[5] The general direction of the prince's upbringing was the responsibility of his *lala*, who was the equivalent, as it were, of the grand vizier. But his grounding in the academic disciplines essential to a cultivated Muslim's formal education was entrusted to tutors. In Bayezid's case several of these were

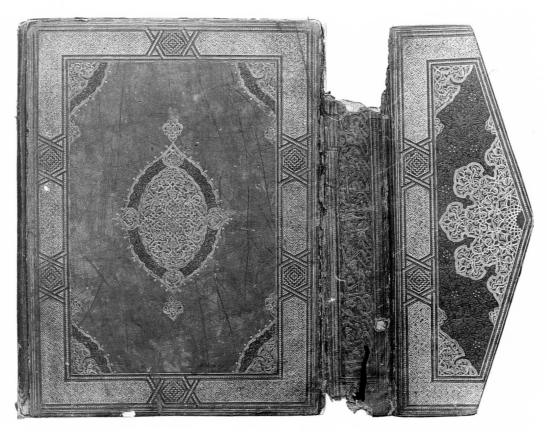

74 Back outer cover of a *Shāhnāmah*,
dated March 1439, Iran, probably Shiraz
Istanbul, Topkapı Palace Library,
MS.R.1547 (360 × 260 mm)

scholars from Amasya itself, and some, such as Qasim ibn Yaʻqub al-Amasi, went on to act as tutors to the prince's son and successor in Amasya, Prince Ahmed.[6] Amasya is also known to have been the home of other scholars, such as Şerefeddin Sabuncuoğlu, who composed a major work on surgery, a copy of which was dedicated to Mehmed II in 1465.[7]

The roll call of scholars and literati who were active in Amasya in the third quarter of the 15th century, not to mention the city's many eminent calligraphers, who, as we shall see, included the great Şeyh Hamdullah, makes it evident that the city was a cultural centre of importance, and we may therefore presume that it was a thriving centre of book production. For the moment this must remain a presumption, for, as in the case of other important cultural centres of Anatolia in the 15th century, few books produced in Amasya have so far been identified.[8] The dearth of evidence is equally true for Bayezid's library. He was governor of Amasya for 27 years, between 1454 and 1481, only a little less time than he was sultan in Istanbul, yet a mere two books with contemporary bindings can be associated with his period in Amasya. The compensation, though, is that one of them (cat.32) is among the most intriguing Ottoman bindings of the 15th century, not only because it is one of the few with figurative decorations, but also because it juxtaposes ideas derived from Iran with an Ottoman tradition of some 40 years earlier.

The manuscript, a compendium of commentaries on the *Maqāṣid* of al-Taftazani, was copied for Prince Bayezid between January and March of 1477. The front cover has a lobed pointed-oval centre-piece, filled with arabesque work and framed by a wide border, which is interrupted by four tear-drop shapes. This composition is reminiscent of a style of binding associated with Shiraz in the mid-century, an example being the covers of a *Shāhnāmah* dated 1439 (*figure 74*).

However, the Amasya binding of 1477 is distinguished by the treatment of the field between the centre- and corner-pieces. Each spandrel is occupied by a sinuous dragon that is being attacked by three monkeys, one of whom pierces the dragon through the head with a sword.

By the mid-15th century dragons and monkeys had become the standard denizens of decorative drawings in Iran,[9] first appearing on bindings attached to manuscripts made for Ibrahim Sultan, the governor of Shiraz between 1414 and 1435,[10] and for Baysunghur and Shahrukh in the 1430s (cf. *figures* 13–15).[11] The formal antithesis of two similar animals in the Chinese tradition was transformed in Iran into an aggressive confrontation:[12] the fight could be between animals of the same or different species, between, for example, two ducks, or a lion and a *qilin*. More complex combats, between a variety of creatures, became possible when the concept was transferred from the confines of a medallion to 'rectangular' settings, such as whole-page drawings, book covers, or the margins of manuscripts. The monkeys in these scenes often adopt an aggressive stance, but they rarely engage in, so to speak, hand-to-hand combat. There is one design, evidently for the margin of a manuscript, where monkeys are in close combat with a dragon,[13] but there is no published example of monkeys brandishing swords. This suggests that the Amasya monkey and dragon combat is a somewhat free Ottoman interpretation of an Iranian concept, rather than the work of an emigré craftsman from Iran.

That this is the case is borne out by the work on the back cover and the doublures. On the back cover the knotwork finials to the central medallion recall the knotwork on cat.6, whose text was completed in August 1453, while the dense floral scroll that fills the field is a distant echo of that used on the Bursa Koran (cat.1), which is attributable to the second quarter of the 15th century. A much stronger link with the Bursa Koran is provided by the doublures: these are

75 Back cover of a work on astrology
dedicated to Bayezid II, dated January 1475, probably Amasya
Istanbul, Topkapı Palace Library, MS.A.3314 (285 × 165 mm)

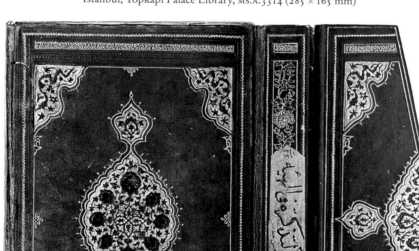

decorated with a pointed-oval centre-piece worked with a filigree diaper design, picked out in gold against a green and blue ground (*cf. figure* 26).[14]

The other dedication to Bayezid is in a commentary by Fathallah Shirvani on Nasir al-Din Tusi's *Tadhkirah al-nāṣiriyyah*, completed in Ramadan 879 (January–February 1475).[15] The binding (*figure* 75) is aesthetically unprepossessing, in part because the stamps were designed for a volume that was not as tall, and the binder extended the field by adding two gilt borders, one above and one below. This means that the scribe probably chose the size of his text block without consulting the binder at the outset, which, in turn, suggests that the scribe and the binder were not working together in a scriptorium, as would have happened when a scholar presented a book to a prince of his own accord. This was surely the case here, as the manuscript is an autograph of a learned commentary. If the binding does indeed date from the mid-1470s, it provides evidence that several features which were to become standard in Ottoman binding in the 16th century were pioneered not in the scriptorium of Mehmed II in Istanbul, but further east, in Amasya: it is one of the earliest instances of pressure-moulding in Ottoman bookbinding, and certainly the earliest known in which a gold ground was used for the sunken panels; furthermore, the corner-pieces have thin 'Chinese cloud scrolls', which were to be an important motif in Ottoman bookbinding from the reign of Sultan Bayezid on. All three of these features appear to be of Iranian inspiration: the cloud scrolls, for example, are first documented on the binding of a manuscript produced for the Qaraqoyunlu prince Pir Budaq in 1459.[16]

Two further manuscripts, neither of which are dated, may possibly have been produced in Amasya during Bayezid's time as governor. One is a fragmentary Koran which has long been acknowledged to have some of the finest illumination of any 14th- or 15th-century manuscript. Portions of the Koran are now in the Chester Beatty Library in Dublin and the Gulbenkian Museum, Lisbon, but neither contains any documentation.[17] When it was first published, just before the First World War, F. R. Martin claimed that the book was copied for Bayezid II.[18] The Ottoman attribution has never been questioned, but the dating has caused problems, for both the layout and the use of pale foliage as a background to the script on the opening pages of text recalls work of the 14th century from Shiraz. Eric Schroeder, citing these and other details, 'shrewdly suspected', in his own words, that Martin had mistaken the name and titles of Bayezid I (*reg.* 1389–1403) for those of Bayezid II.[19] If this were the case, we would have an example of the art of the book of the very highest quality from a period of which we know very little. Certainly, the manuscript cannot date from the sultanate of Bayezid II (1481–1512), for it bears no relationship to work of this period, such as cat.37–41, but an alternative is that it dates from when Bayezid was in Amasya. The error in attribution presumably stems from the assumption that the title 'Sultan Bayezid' referred to his later years, whereas in fact he would have been addressed in this form even as a prince.

The opening pages of text have a central panel framed above and below by tall bands of Kufic; the panel contains lines of cursive script set in *abrī* clouds against a floral background. This layout was common in the 14th century, but it continued in use into the following century in both Iran and Ottoman Turkey.[20] It occurs, for example, in the Bursa Koran (cat.1), and there are connections between the Bursa Koran and the 'Bayezid' Koran in terms of individual motifs, although their colouring is quite distinct. Two other features suggest a date in the third quarter of the 15th century. One is the style of the Kufic, which is tall and spindly, with broken profiles and right-angle returns to many of the hastae of the letters. This form of Kufic was practised in Timurid Iran in the first half of the 15th century, and became common under the Ottomans in Mehmed II's manuscripts.[21] The other is the flora that was used to embellish the opening lines of text, for it bears similarities to the so-called Baba Nakkaş style.[22] The associated binding, whose present whereabouts are unknown, was tooled in blind and gold, with lobed centre- and

corner-pieces set within a broad frame segmented into cartouches with pointed ends and octagons; the cartouches are filled with inscriptions, and the octagons between them with knot-work (*figure 76*).[23] The division of the frame recalls that on a binding of the *Shāhnāmah* of 1439 (*figure 74*),[24] and the foliage within the corner-pieces is also in a Timurid style. What is clear is that the binding of this Koran reveals few links with bindings produced at Mehmed's court.

If the documentation for the Koran remains unconfirmed, that on another manuscript that may be associated with Bayezid is disputed. This is the copy of the *Khamsah* of Nizami that was produced in AH 849 (AD 1445–6) for the Timurid princess 'Ismat al-Dunya, who was married to

76 Detached outer cover
from a Koran said to have been made for Sultan Bayezid II
Present whereabouts unknown (263 × 182 mm)

Muhammad Juki, the brother of the bibliophile Baysunghur. The majority of the miniatures are of Timurid origin, but two are subsequent additions. One depicts Bahram Gur slaying the two lions that guard the crown of Iran; the other, Alexander journeying to the Land of Darkness. These additions display a strong European influence, in dress, figure style, colouring, shading and even, as Eleanor Sims has shown, in composition.[25] More than one scholar has recently suggested that these miniatures were added in Turcoman Tabriz, but such an attribution ignores the fact that many of the figures are shown wearing the tall felt hat of the Ottoman Janissaries, and the red version worn by the Solaks; and that the gateway in the background of the Alexander scene has twin flanking towers with conical roofs, remarkably like the Middle Gate of the Topkapı Palace. There can be little doubt, then, that the miniatures were added when the manu-script was in Ottoman hands.[26] What makes this relevant for the history of Ottoman bookbind-ing is that there is a gold-tooled inscription on the spine of the outer covers which reads, 'For the

Sultanic Bayezidian library' (*li-rasm al-khizānah al-sulṭāniyyah al-bāyazīdiyyah*). There is a possibility, then, that the original manuscript and the bulk of its paintings were produced in Herat for 'Ismat al-Dunya, and that the Ottoman prince Bayezid had it bound at the same time that the miniatures were added.

Several features of the binding suggest that it was Ottoman and that it predates Bayezid's accession to the throne. Firstly, the outer covers, which are in a mid-burgundy leather with fine gold-tooling, bear differing centre-pieces – a cloud-collar motif on the front and a lobed pointed oval on the back (*figures 77–8*). Secondly, the cloud-collar motif, filled with small-scale arabesques, recalls the centre-piece on cat.7, which was produced in 1455. Thirdly, the tooled borders on the doublures are almost identical to those used on cat.6 and cat.7. Fourthly, the doublures have a very simple triangle of knotwork for their corner-pieces, a feature that is rare on 15th-century bindings from Iran, but which occurs on numerous Ottoman examples from the mid-century (cat.6–8). And, fifthly, there is another link with cat.8 in the use of knot-work for the border of the outer covers, gold-tooled in parts to create the effect of a sequence of rhombs; the similarity, however, is in concept rather than precise details.

It is obviously dangerous to extrapolate on the basis of so few bindings, particularly when one was on a volume presented to Bayezid by its author, and two others are of disputed date or provenance. Nevertheless, there is nothing in the available evidence to suggest that there was a distinct style of binding associated with Bayezid's court in Amasya. Nor is there evidence that the style of binding so characteristic of the manuscripts dedicated to Mehmed II in the 1460s and 1470s influenced work outside the capital, even at the princely courts. This reinforces the claim that the bindings made for Mehmed II were produced in a court scriptorium, and it also means that Mehmed's bindings should not be regarded as representative of general trends in Ottoman binding in the second half of the 15th century. There must have been skilled binders who worked outside the court tradition of Mehmed II, and cat.32 illustrates the point.

We cannot be certain that there was no contact at all on an artistic level between Bayezid's court in Amasya and the sultan's in Istanbul. But relations between father and son were strained in the 1470s. Mehmed reprimanded Bayezid for his drug taking, and a letter survives in which Bayezid expresses regret to his father.[27] Mehmed also took severe objection to some of the prince's companions, and in 1478 he moved against three of them; one was executed, but the other two, apparently forewarned by Bayezid, succeeded in escaping.[28] By contrast, Mehmed's relations with his younger son, Cem Sultan, seem to have been more trusting and intimate. In December 1474, following the death of Prince Mustafa, Cem assumed the governorship in Konya, where his court, like that of Bayezid, attracted scholars and poets. Cem was also a poet in his own right, and while he was in Konya he collected his own verse into a *dīvān* and translated Khwajah Salman's Persian romance, *Jamshid and Khurshid*, into Turkish, dedicating it to his father.[29] One manuscript, a copy of a work by the Persian poet Jami,[30] demonstrates both Cem's interest in poetry and his closer contacts with his father's court. Its connection with the Prince is indicated by a neatly written inscription on folio 114b stating that the book belonged to 'the most steadfast of [God's] servants, Cem, the son of Mehmed, the son of Murad', with the generous prayer, 'May God grant forgiveness to him and to all believers in every land'.[31]

What makes the book of particular interest is that the scribe, and one can assume the binder, was Ghiyath al-Mujallid al-Isfahani, who, as we have already seen, worked for Mehmed II in Istanbul. The covers are of a dark-burgundy leather, and both have pressure-moulded oval centre-pieces filled with arabesques, while the envelope flap bears a pear-shaped cartouche occupied by a seated rabbit. On every page there is an illuminated triangle which encloses mostly floral (*figure 69*) and some animal decoration, executed in gold outline.[32] The colophon is dated Dhu'l-Qa'dah 884 (January 1480), but while it gives the scribe's name it does not state where it

77 Back cover of a *Khamsah* of Nizami, Herat, 1445– 6,
the binding inscribed in the name of Sultan Bayezid
Istanbul, Topkapı Palace Library, MS.H.781 (245 × 165 mm)
78 Back doublure of *figure 77*

was written. It may have been produced in Konya, but we have no record of where Ghiyath was working in AH 884, only that he was in Istanbul in the preceding two years.[33] It seems more likely, though, that the volume was written and bound in Istanbul and sent to Cem in Konya, because the dedicatory oval at the front of the book is blank, which is not what one would expect if the manuscript had been produced at Cem's own court. Either way, the book illustrates a degree of artistic contact between Cem and Mehmed that cannot be documented for Bayezid.

The choice of subject-matter for the two Ottoman miniatures added to the *Khamsah* of 'Ismat al-Dunya – Bahram Gur slaying the two lions that guard the crown of Iran (an act he undertook before claiming the throne), and Alexander journeying to the Land of Darkness to visit the hermit Khidr at the source of life – may have been prompted by lacunae in the original manuscript, with no intention of conveying a political message. But even if this was so, the two miniatures may serve as a metaphor for the events of 1481. For in that year Bayezid laid claim to the crown of the Ottoman empire, and, with an eye on the distant gates of the Topkapı Palace, made nefarious contact with the leading Halveti dervish in Amasya. The Halvetiye brotherhood claimed to have been founded by the Iranian mystic 'Umar al-Khalwati, who had been born in Gilan and died in Tabriz, probably in AH 800 (AD 1397). It owed its organization, however, to a second master, Shaykh Yahya Shirvani, who is said to have had some 12,000 followers.[34] Shaykh Yahya sent out representatives (*khalīfahs*) to different parts of the Islamic world, and one of these, Pir Ahmed of Erzincan, was largely responsible for the successful propagation of the movement in Anatolia. In fact, Pir Ahmed was so successful that, following the death of Shaykh Yahya in AH 868 or 869 (AD 1463–5), the headquarters of the brotherhood moved to Amasya.[35]

The reason for Bayezid's initiative was that in April 1481 he had received news that the grand vizier, Karamani Mehmed Pasha, had recommended to the Sultan that the throne pass to Prince Cem, and that Bayezid be eliminated.[36] According to Yusuf Sinan, a prominent member of the Halvetiye who wrote during the reign of Murad III, Bayezid, on receipt of this news, sent a message through his head gatekeeper, the future Koca Mustafa Pasha, to the head of the Halvetiye in Amasya, Muhammad Jamal al-Din al-Aqsarayi, known as Çelebi Efendi.[37] Çelebi Efendi's reply was that he could do nothing against the grand vizier, since he was protected by an amulet prepared for him by Şeyh İbn-i Vefa, who was an opponent of the Halvetis and an adherent of the Sultan and of Prince Cem, but that there was an alternative plan, which would become apparent in 20 days. Twenty days later, on 3 May 1481, Sultan Mehmed died, as he was setting out on another campaign.

Popular belief had it that Mehmed had been poisoned. This is supported by circumstantial evidence, which also suggests that Bayezid's Halveti associates were implicated. In the aftermath of Mehmed's death there were riots in Istanbul, during which Karamani Mehmed Pasha was eliminated.[38] Bayezid moved so fast in response to the news of Mehmed's death that it would appear that he was forewarned. When Karamani Mehmed Pasha despatched two messengers, one to Bayezid, and one to Cem, Cem's was detained by the *beylerbeyi* of Anatolia, a supporter of Bayezid's cause. Within eight days of Mehmed's death Bayezid had mobilized his troops in Amasya, and he reached the capital on 19 May.[39] By pre-empting his brother he gained the crucial advantage in the war to come. The final piece of evidence is that Bayezid paid for the building of a large mosque complex in Amasya, which, it is said, had been requested by the Halveti shaykhs Çelebi Efendi and Pir Hayreddin Hıdır Çelebi in return for the help they had given Bayezid.[40] Once he was established on the throne Bayezid acceded to their request and had his son, Sultan Ahmed, the new governor of Amasya, construct the mosque.[41]

It is ironic, when the evidence for Bayezid's patronage of the art of the book in Amasya is so jejune and ill-assorted, that it was a group of Amasya scribes, many of them members of the Halvetiye, who transformed the course of Ottoman calligraphy during his reign in Istanbul.[42]

Historical records testify to the scope of Sultan Bayezid's interests, and his personal involvement in the patronage of literati and calligraphers, and in the organization of the imperial library, while extant artefacts demonstrate how a coherent style was developed, which encompassed all the arts of the book – from calligraphy to illumination and binding. For the first time there are sufficient archival records to provide an insight into the workings and institutional framework of court patronage.

Bayezid in Istanbul

According to the Venetian *bailo* Andrea Gritti, Bayezid interested himself in poetry, philosophy and theology, and was particularly curious about astrology, cosmography and the mechanical arts.[43] His interest in things mechanical found expression in his invitation to Leonardo to build a bridge across the Bosphorus,[44] while his interest in astrology and astronomy is borne out by the numerous books dedicated to him on the subject,[45] and several astronomers and astrologers were attached to his court. The best known of these was Mirim Çelebi, who acted as a tutor to Bayezid, probably after he became sultan.[46]

Bayezid's generosity to scholars, poets and literati emerges vividly from palace account books for the years 1503 to 1512,[47] which include lists of imperial 'acts of beneficence' (*in'ām*). The scale on which Bayezid dispensed sums of money, often accompanied by a robe of honour, is remarkable, for hardly a day passed without such a gift being made, and the number made each day was particularly high before each of the major feast-days. Retainers were paid to the nobility; alms were given to the pious and deserving; spies, buffoons and palace servants were rewarded for their services; and others were recompensed for the gifts they had made to the Sultan, among them writers, artists and craftsmen. These groups included a number of individuals who were attached to the court on a continuing basis, receiving a regular retainer. Indeed, there has been a tendency in recent years to interpret the Ottoman system of court patronage merely on the basis of the published lists of the regular payments made to calligraphers, painters and others. As a result the system has been seen as centralist and dirigiste, but Michael Rogers has rightly pointed out that an artist who was listed on a pay-roll did not necessarily have to work within the confines of the palace grounds.[48] In fact, the annual retainers paid to these court artists may have been deliberately calculated at a relatively low rate, so as to enhance the importance of the gift-and-reward system: if an artist or craftsman was on an annual retainer of 2,000 *akçe*, for example, it was obviously an enormous incentive if he stood to receive 1,000 or 1,500 *akçe* for a fine piece of work, and the system thus encouraged competition and initiative.

Poets and other writers were among the most frequent recipients of *in'ām*: no less than 13 poets received presents on a regular basis before each of the major feast-days, for example,[49] and they were frequently rewarded on a one-off basis. We may take the three months Rajab, Sha'ban and Ramadan 909 (20 December 1503–17 March 1504) by way of an example. On 5 Rajab two poets, Alaeddin the Tailor and Saili received, respectively, 1,500 *akçe* for a *qaṣīdah* and 2,000 *akçe* for a book. On 3 Sha'ban the writer Fethullah received 1,500 *akçe*. On 17 Sha'ban, Hüseyin of Amasya was given 3,000 *akçe* and a robe of honour as a reward for presenting the Sultan with a book. Ten days later the poet Keşfi received 500 *akçe* for a poem.[50] On 9 Ramadan the author Veled-i Leng received 3,000 *akçe*, and on 29 Ramadan he received a further 2,000 *akçe* and a robe of honour.[51] On 18 Ramadan a scholar called Muhyiddin received 2,000 *akçe* for making a commentary on the works of Muslim and al-Bukhari. And on 25 Ramadan Mehmedşah, son of Mevlana Muhyiddin, the chief justice of Rumelia, was given 2,000 *akçe* and a robe of honour for a *qaṣīdah*. What is more, on 29 Rajab, 7,000 *akçe* had been paid to the scribe Şeyh Hamdullah, perhaps the most famous of all Ottoman calligraphers.[52]

Between mid-December 1503 and March 1504, then, Bayezid received at least eight manuscripts. In the same period rewards were given to a swordsmith, who had presented a sword and a dagger; to an armourer, who presented a musket; and to Sayyid Ahmad Maghribi, who had brought an engraved ewer and tray.[53] Not all the gifts were rewards for the presentation of a particular item: this was the case with the 5,000 *akçe* and the robe of honour Mirim Çelebi received on 1 Ramadan.[54] But when the reward was in response to a gift that the Sultan had received, his generosity could be out of all proportion to the value of the gift: on 20 Rajab, for example, 2,000 *akçe* were given to a dervish who had brought an apple.[55]

The gift-and-reward system was not by any means the only source of Bayezid's books: he probably also acquired them by purchase and as gifts from abroad, and he certainly received some as the result of his own commissions. Information on purchase is the least secure, but on 4 Ramadan 909 (20 February 1504) Sultan Bayezid gave 'alms' to a bookseller by the name of Sofu,[56] which suggests some activity of this sort. The issue of princely gifts from abroad is neatly raised by a copy of Shams al-Din Muhammad Assar Tabrizi's poem *Mihr u Mushtarī* (*figure 79*). The copy, whose colophon is dated 18 Ramadan 887 (31 October 1482), was dedicated to Bayezid II.[57] It contains 11 miniatures, all in the style of Shiraz, while the scribe, Na'im al-Din al-Katib ibn Sadr al-Din, was one of the most active calligraphers in Shiraz in the last quarter of the 15th century, to judge from 14 known manuscripts that bear his signature.[58] There is nothing to suggest that Na'im al-Din ever visited Turkey, and it is much more likely that the manuscript was sent as a gift to Bayezid, following news of his accession. The question is, who sent the gift?

The quality of this manuscript is superior to that of most other Turcoman Shiraz manuscripts of the period, and it might be thought that a commercial environment such as the Shirazi ateliers would have been inimical to such work; after all, a 16th-century visitor to Shiraz, Budaq Qazwini, recounted how 'in every house in the city the wife is a scribe, the husband a painter, the daughter an illuminator, and the son a binder: thus any kind of book can be produced within one family. Should one want a thousand books they could all be produced within a year.'[59] Ivan Stchoukine assumed that the *Mihr u Mushtarī* was sent as an imperial gift from the Aqqoyunlu ruler Sultan Ya'qub to Bayezid.[60] But he relied on the common and erroneous assumption that quality was a prerogative of Islamic courts. There is, however, no reason why a scriptorium in Shiraz should not have ventured to send a manuscript to the new Ottoman sultan of its own accord, just as artists did in Istanbul.

For his own commissions Bayezid seems to have relied to a large extent on scribes working for him on a regular basis. Of course, the court employed a number of official scribes who worked at one remove from the Sultan, drawing up ledgers and copying out decrees. According to a register that was compiled at some time between 1494 and 1511, there were 20 scribes and apprentices working for the state treasury and a further five working for the imperial council.[61] It is clear that, although these men, and other scribes working within the state bureaucracy, were primarily engaged in administrative tasks, they did produce manuscripts from time to time. On 21 Jumada'l-Ukhra 909 (11 December 1503), for example, a scribe called İlyas, who was a member of the Janissary corps attached to the Palace, presented the Sultan with a Koran he had copied himself, and for which he received a substantial reward of 4,000 *akçe*;[62] but İlyas had presumably copied the Koran as an independent initiative rather than as an imperial commission.

For the regular production of manuscripts Bayezid had a separate staff of eight copyists, known as the 'scribes of the imperial books' (*kātibān-i kutub-i khāṣṣah*). These scribes appear to have enjoyed a relatively high status, for they were paid a monthly wage, rather than receiving an allowance every three months, as did the majority of the artists and craftsmen.[63] This high status was also reflected in the much higher rate at which they were paid: according to the register of 1494–1511, the aggregate of the scribes' annual salaries was 45,612 *akçe*, an average of 5,701 *akçe*

per person, while the 22 designers (*naqqāshān*) received an average of 3,250 *akçe* per annum, and the nine binders, an average of 2,516 *akçe*. We must bear in mind, however, that the total number of binders may have included their apprentices, whom we know from a more detailed register of 1526 were paid at much lower rates.[64] In AH 920 (AD 1514–15) the number of these 'scribes of the imperial books' had dropped to four. The decline may have been fortuitous, but it is possible that the demand for manuscripts was less under Selim I than it had been under his father: this explanation is supported by the small number of manuscripts so far identified that bear dedications to Selim.[65] The decline in the number of royal copyists has a parallel in the reduction in the

79 Detail from front outer cover of
a copy of *Mihr u Mushtarī*,
Shiraz, 1482, dedicated to Bayezid II
Istanbul, Topkapı Palace Library, MS.A.3563
(complete cover 212 × 122 mm)

overall number of craftsmen on the palace pay-rolls: in the register of *circa* 1494–1511 the roster, which included craftsmen with a wide variety of skills, from bakers and furriers to goldsmiths and surgeons, totalled 360 persons,[66] while in 1514–15 the number had fallen to 308.[67] This may reflect a higher level of patronage under Bayezid.[68]

We know little about how these 'scribes of the imperial books' operated, but they do not seem to have been obliged to reside at court, as is made clear by the case of Muhammad al-Badakhshi. Muhammad's surname indicates that he was originally from Badakhshan, high in the Pamirs, and this is confirmed by a colophon in which he stated that he 'belonged to the country of Badakhshan'.[69] He was already in Istanbul by the mid-1470s. He produced two manuscripts, almost certainly in Istanbul, one in May 1474,[70] the other in June or July 1475.[71] By the 1490s, at the latest, he was copying manuscripts with dedications to Bayezid: one in Istanbul in AH 898

(AD 1492–3),[72] another in AH 904 (AD 1498–9).[73] To judge from these four examples he specialized in *nasta'līq* script, and a comparison between the hands shows a marked improvement in execution between the 1470s and the 1490s. By July 1503 Muhammad al-Badakhshi was the shaykh of the *imaret* of Emir Sultan in Bursa,[74] but he was also one of the imperial manuscript scribes, for, three days after he had received 'alms' of 2,000 *akçe* and a robe of honour from the Sultan in recognition of his position in Bursa, he received a further 3,000 *akçe* and another robe of honour as a reward for a book which he had copied.[75] This was not the end of his entitlements, because he was also one of the astrologers on the palace pay-roll, and on 15 Rajab 909 (3 January 1504) he received 4,000 *akçe* and yet another robe of honour.[76]

The example of Muhammad al-Badakhshi illustrates how an artist registered on the palace payrolls might combine several activities and live not in Istanbul, but in Bursa; the court's demands on his time cannot have been too great, and his allowance must have been more in the nature of an honorarium than of a salary. In view of this, and in view of the fact that we do not even know for certain the names of most of the other 'scribes of the imperial books', it is impossible to estimate how many manuscripts they produced in a year.[77] The output must, however, have been sufficient to warrant Bayezid having nine bookbinders on his payroll.

Bayezid's Binders and Their Work

No names are given for the nine binders mentioned in the document of *circa* 1494–1511, but it appears from kitchen accounts for the year AH 895 (1489–90) that the senior binder was called Sinan, as he authorized the purchase of 300 *akçes*' worth of pasteboard, paper and glue.[78] He may well be the same Sinan who was listed as a binder in a document from AH 883 (AD 1478), late in Mehmed II's reign.[79] From rewards given in February and March of 1504 we learn the name of a further five of Bayezid's binders: Mustafa ibn 'Abiri, Alaeddin, Yusuf, Ahmed and Hüdadad. Mustafa was given 1,000 *akçe* on 11 Ramadan 909 (27 February 1504);[80] 18 days later Alaeddin and Ahmed both received 1,000 *akçe*, which was among the higher emoluments given to 51 craftsmen on that day; and on the same day Yusuf and Hüdadad received 500 *akçe*.[81] As yet, though, these binders are no more than names, for there is no evidence to identify known bindings as their work (see Appendix 4).[82]

In general, the bindings of Bayezid's reign continued the technical innovation in countersunk stamped decoration that had been introduced towards the end of Mehmed's reign. The compositions consisted predominantly of lobed pointed-oval centre-pieces with corresponding corner-pieces, but there were several notable changes from the bindings of Mehmed's reign. One was a change in proportions, which applied not only to the centre- and corner-pieces, but also to the motifs that they enclosed. The move, in general, was away from the often dense decoration of earlier Ottoman bindings, towards a greater appreciation of space and textural contrasts.

In other respects, too, the accession of Bayezid II was accompanied by a break with the immediate past. The Fatih style of the 1460s was abandoned, as was the Pomegranate style introduced in the last few years of Mehmed's reign, and the use of textiles in bindings declined. Crimson velvet bindings seem to have disappeared soon after 1481, and the same may have been the case with green velvet bindings, but none are precisely dated. Textiles were not abandoned altogether, for green satin was used to line the covers of a manuscript copied in 1506,[83] but no textile bindings are known on manuscripts with dedications to Bayezid (see Appendix 3) – the exception proves the rule in the case of cat.25, whose dedication was deliberately altered. What is clear is that textile was no longer in regular use for the covering of royal manuscripts, and that it was in leather bindings that the major developments of the period took place; these changes were to influence the course of Ottoman binding throughout the 16th and 17th centuries.

In terms of the material itself, there was a change in both colour and handling. The colour scheme that had been characteristic of Mehmed's court bindings of the 1460s – black outer covers and burgundy doublures – was not entirely abandoned, as cat. 40 and several other manuscripts show,[84] but there was a greater preference in Bayezid's reign for outer covers in red leather (cat. 34–5).[85] On occasion burgundy was used for both the outer and inner covers.[86] An undated manuscript which bears a dedication to Bayezid has a binding that provides a fitting commentary on the change; it reverses the colour scheme of Mehmed's reign, with red used on the exterior, and black on the doublures.[87] Greater emphasis was placed on the finish of the leather. The outer covers were often highly burnished, with the result that the grain of the skin was almost snuffed, and the leather took on a high sheen. As we shall see, this became an important part of the aesthetic. As regards technique, there was increased use of stamping. The aesthetic was prefaced in the latter part of Mehmed's reign by works such as cat. 31, and the technique was well established by 1490 (cat. 34, 39).[88]

From the point of view of decoration, we should differentiate between bindings of relatively modest ambition, such as cat. 39, and prestige productions on which no expense was spared (cat. 37, 40–1). For convenience's sake we shall call the prestige bindings 'extra bindings', and the more modest productions 'standard bindings', although it must be remembered that we are dealing here almost exclusively with bindings on manuscripts with dedications to Sultan Bayezid, and that 'standard' in this context still refers to covers of considerable technical and artistic accomplishment. There is also a danger in allowing the technical virtuosity of the extra bindings to blind us to the fact that they are few in number, and that it was decorative developments in the standard bindings that were to have the most influence on the majority of later Ottoman bindings. Between them, though, these standard and extra bindings – and the manuscripts they enclose – established the canons for later Ottoman book production.

Standard Bindings

A striking feature of the standard bindings of Bayezid's reign was the extensive use of gold, for, although gilt outlines had been used in the cloud-collar style of the 1450s, gilding was a relatively rare feature in bindings produced for Mehmed himself (cat. 20). During Bayezid's reign, however, gilding came to be employed not only for outlines, but also for the sunken field of the corner- and centre-pieces. Gilding and stamping complemented each other. On a technical level, the gold ground did not have to be tooled, as was the case with gilded outlines: the area to be moulded was lined with gold leaf before the stamp was applied, so that the fixing of the gold and the moulding were achieved in a single process.[89] On a practical level, the sunken field helped preserve the gold from abrasion. And on a visual level, the gold ground had the effect of lending a greater sense of relief to the raised motifs, which remained in blind.

The earliest dated Ottoman example of a gold-ground centre-piece appears to be on the binding of a manuscript produced for Bayezid in 1474 (*figure 75*), while a binding with a complete panel-stamp and gilt ground was produced by Ghiyath al-Din al-Mujallid in 1477 (cat. 33), but the aesthetic did not become common until slightly later (cat. 35–6). When and where the idea originated has never been established, although Oktay Aslanapa briefly stated that central medallions with a gold ground were characteristic of Turcoman, but not of Herati, bindings.[90] Persian precedents include bindings on manuscripts produced in 1459, 1476, 1478, 1483, and 1485; in this last example the same stamps were used as for the binding of 1476, which was made for the Aqqoyunlu Turcoman prince Khalil.[91]

Another shift that took place in Bayezid's reign was towards polychromy. This was an ever increasing feature of bindings in Iran,[92] but the Ottomans were cautious in their adoption of it.

As cat.39 demonstrates, blue might occasionally be used on outer covers as a ground colour for centre- and corner-pieces. More commonly, though, it was used to accompany gold as a parti-coloured ground for filigree panels on the doublures, as it had been on occasion during Mehmed's reign (cat.21); an innovation of Bayezid's reign was to introduce green as a third colour, as, for example, on a manuscript dated AH 906 (AD 1500).[93] This use of parti-coloured grounds for the filigree harks back, in concept though not in detail, to the cloud-collar style of the 1450s, and the same can be said of other features of Bayezid's manuscripts, such as the burgundy outer covers and the greater sense of space.

Bayezid's reign saw important modifications to the decoration of bindings. The overall effect was more sparse than it had been previously; both arabesques and floral motifs became reduced in scale, creating a cool and delicate feel, quite different from the hothouse profusion of the designs of Mehmed's period (figure 80). The reduction in size also applied to the cartouches, though cat.39 is an extreme instance. The greater sense of lightness was helped by making the borders less prominent in height and elaboration, so that they were often little more than tiny s-tool guilloche bands, flanked by fillets. Emphasis was thus cast on the centre-pieces, and in some instances the corner-pieces were virtually dispensed with (cat.34; cf. figure 80). A sparseness that had often characterized Ottoman doublures had now found its way to the outer covers. In these cases the undecorated area assumes a positive function. It is no longer just the interstice between fields of decoration, but a space in which the voice of the ornament can be heard.

Extra Bindings

The technique of pressure-moulding was used in the 1490s and the first decade of the 16th century for several bindings that are amongst the masterpieces of the craft (cat.37–8, 40–1). The depth of moulding was up to 2mm (cat.37), and was achieved by building up the pasteboarding around the areas that were to be countersunk (see Appendix 1). The motifs stood up proud from the sunken ground, which required deep intaglio carving in the matrices used for the moulding. The variation in height lent surface movement in a way that had not been seen before in Islamic bindings, and the effect was emphasized by the variation in texture. They also differ from the contemporary 'standard' type in that their designs are far from sparse. It is not that the central stamp is oversized, but that they have generous corner-pieces and especially wide borders. The undecorated area is small, yet the plain leather has been so highly burnished, and there is such a strong textural contrast between the highly reflective, raised field and the minutely stippled ground of the sunken panels, that the plain areas play a more dynamic role than their limited surface area might suggest.

The craftsmen evidently perceived their pressure-moulding to be virtuoso, because they used it for the doublures as well. This was quite an unusual treatment, and in the case of cat.37–8 and cat.41, the difference between the outer covers and the doublures shows a subtle shift in colour and proportions. In contrast to bindings in the Fatih style, in which the outer covers were usually floral or floral-cum-arabesque, in Bayezid's extra bindings it was customary to have purely floral centre-pieces on the doublures. Broadly speaking, though, the doublures mirrored the exteriors.

The doublures of cat.38, however, seem more like pressure-moulded renderings of filigree doublures, in their use of parti-coloured grounds, and a cartouche set into the oval centre-piece. The influence here was, ultimately at least, from Iranian bindings (figures 81–2),[94] and a further influence from Iran is seen in the segmented borders of cat.41, in particular the separation of the long cartouches on the outer covers by roundels. Indeed, in general, in their crisp pressure-moulding, and the shape and proportions of their centre- and corner-pieces, these Ottoman bindings reflect developments in bookbinding under the Turcomans in Iran (figure 70), but the Ottoman

80 Back cover of a work on morals and politics
copied by Muhammad ibn al-Shaykh Ibrahim al-Halabi
for Bayezid II in 1511
Istanbul, Topkapı Palace Library,
MS.A.2493 (245 × 165 mm)

examples have a grandness of conception and a competence of execution that is difficult to match.

As with the standard bindings the decorative motifs are generally smaller and less varied in size than the motifs on Fatih-style bindings. None of Bayezid's extra bindings, however, make use of a gold ground: gold was confined to outlines. On a binding with a gold-ground centre-piece such as cat.35, the motifs are reserved in blind and the effect is one of silhouette. On cat.37, by contrast, the motifs have each been outlined in gold, and even internal detailing on the rosettes and arabesques has been picked out in gold. The result is more graphic, and there is a clear relationship between the type of motifs used on the binding and those used in the illumination inside the manuscript. Even on cat.38 and cat.41, where the contours of the motifs are not picked out in gold, the relationship is obvious, particularly in the way in which rosettes and leaves have been indented with a thin tear-drop shape that resembles the eye of a needle. The same type of 'eye' is a hallmark of Ottoman illumination during Bayezid's reign and derives from the Turcoman style of illumination introduced into manuscript decoration in the last decade of Mehmed's reign.

Indeed, just as pressure-moulding was introduced at the end of Mehmed's reign and then became a normal feature of Ottoman bookbinding, so the Turcoman style of illumination became standard in prestige manuscripts, though the leading practitioner, Hasan ibn ʿAbdallah, was not from Iran, but probably a *devşirme* recruit trained in the Palace scriptorium.[95] One of the most notable developments was to use contrasting matt and shiny gold,[96] and to juxtapose zones of gold and of a dark and intense ultramarine, whose quality and hue differs markedly from that used on manuscripts produced for Mehmed in the 1460s and early 1470s (*cf.* cat.12 and 41).[97] The play between areas of gold and ultramarine was to be a standard feature of Ottoman

illumination throughout the 16th century, even though modifications were introduced in the compositions and filler motifs. The impact of this was not merely aesthetic, but financial. Although there are no records for the production costs of prestige manuscripts under Bayezid, an account of the expenses incurred in the production of Korans for the Süleymaniye Mosque between 1552 and 1556 clearly demonstrates that illumination was the most expensive element in the process.[98] This was in part due to the cost of materials, but calligraphy and illumination also called for a higher number of craftsmen. The project involved eight illuminators, three principal scribes and 13 lesser scribes, but only four bookbinders.

Bayezid and Şeyh Hamdullah

As a patron of the art of the book, Bayezid is best known for his relationship with the calligrapher Şeyh Hamdullah, which is conventionally portrayed as an ideal encounter between an artistic genius and an enlightened patron. Indeed, it seems that the Sultan did more than provide Hamdullah with a stipend and award him specific commissions, for he is credited with providing the impetus for the development of the Şeyh's own style. According to the account preserved in later biographical works, Hamdullah was born in Amasya, probably in 1436,[99] and he seems to have lived there for the greater part of his life. It was in Amasya, too, that he taught calligraphy to one of Bayezid's sons, and possibly to Bayezid himself.[100] After Bayezid's accession Hamdullah moved to Istanbul, where Bayezid gave him a studio, which is said to have been in the imperial quarters of the palace.[101] The Sultan made sure that the calligrapher was well-paid: he awarded him the revenues from two villages near Üsküdar, and he provided another fief for the support of the Şeyh's *mührezens*, the craftsmen who burnished his paper.[102] Hamdullah is also said to have received a salary of 30 *akçe* a day. As this was equivalent to the salary of the second tutor to the Ottoman princes, it was perhaps assigned to him in his function as the Sultan's tutor in calligraphy.[103] At the same time he was paid for specific commissions, such as the design of the calligraphic panels for the *mihrab* and dome of Bayezid's mosque in Istanbul.[104] The traditional account of the relationship also emphasized its personal character: the Sultan is said to have visited Hamdullah regularly, holding his ink-pot on occasion and adjusting the pillows at his back.[105] Bayezid's association with Hamdullah was criticized by religious scholars, who complained that the Sultan spent too much time with him and gave him excessive privileges.[106] Bayezid countered these deprecations by assembling a group of scholars and showing them a Koran by the Şeyh. When they all admired it and praised the Şeyh, Bayezid asked them if he should place the Koran on the top or bottom of a pile, and they replied that he should place it on top.[107]

Other sources provide a more factual and contemporary picture of imperial favour, although none has yet been studied systematically. One is the colophons Hamdullah placed at the end of the manuscripts he copied. In the colophon of one Koran, for example, Hamdullah describes himself as 'head of the scribes',[108] which may indicate that he was the head of the 'scribes of the imperial books'. Archival records confirm how highly Bayezid valued Hamdullah's work. As we have seen, on 29 Rajab 909 (17 January 1504) the calligrapher received 7,000 *akçe*, as well as a robe of honour, in recognition of a Koran that he had presented to the Sultan.[109] It seems highly likely that the Koran for which the calligrapher received this reward was cat. 40, which is dated AH 909 and bears a dedication to Bayezid II on folio 371b. The wording of the dedication (*bi-rasm tilāwat ...*, 'to be read by ...') suggests that the Koran was meant for the personal use of the Sultan and was not produced for donation to the mosque he was building in Istanbul at the time, and this is supported by the fact that the manuscript seems never to have left the Topkapı Palace.

Every aspect of the manuscript – the paper, the calligraphy, the illumination and the binding – is of the highest quality. This is remarkable in a book that was a presentation piece rather than the

81 Filigree doublure used as outer cover of *figure* 70, Turcoman, *circa* 1470–80
Istanbul, Topkapı Palace Library, MS.E.H.1511 (200 × 120 mm)
82 Back doublure of cat.38, Ottoman, 1496
Istanbul, Topkapı Palace Library, MS.E.H.72 (280 × 186 mm)

product of an imperial commission, and it is not clear whether the cost of the basic materials and of having the manuscript illuminated and bound was borne by the calligrapher or the court. The more likely alternative is that Hamdullah alone – or more probably in collaboration with the illuminator Hasan ibn ʿAbdallah and the unknown binder – bore all the costs in the expectation of a substantial return. In market terms it would have been a speculative venture, but for Hamdullah the risk would not have been especially high, as he had received sufficient encouragement from Bayezid to be sure that he would be well-rewarded.[110] From the court's point of view such a system would have had the advantage of instilling a sense of competition, with the artists paid largely on results. It would also have reduced the cost of stockpiling materials and the possibilities for pilfering, which, if Mustafa Âli's account of such problems in the later 16th century is to be believed, would have imposed a substantial liability on the sultan.[111]

If Bayezid was little more than a passive recipient in the case of cat. 40, the traditional account of his relationship with Hamdullah suggests that he also had a more active role, establishing the standards, and the artistic direction, that Hamdullah should pursue. One day, apparently, the two men were discussing the work of the most important calligrapher of the 13th century, Yaqut al-Mustaʿsimi. Bayezid did not think that Hamdullah's work was on a par with Yaqut's and suggested that Hamdullah was insufficiently acquainted with Yaqut's work. He therefore had seven examples brought from the imperial library, saying that it would be excellent if he could improve on just one of Yaqut's scripts. Şeyh Hamdullah, we are told, closeted himself away,[112] and when he emerged he had, to everyone's amazement, improved all of Yaqut's six scripts. Even if this story were proved to be a complete fiction, it would still be of great importance, since it formed a central part of an account that dominated the way in which the Ottomans regarded the history of their calligraphy. The mythopoeic tendency extended to Hamdullah's other talents: he was depicted not only as an artist of exceptional talent but as a man of great piety and a sportsman of superhuman strength, not to mention his talents as a tailor.

Hamdullah's piety is almost tangibly transmitted in the long invocations in his colophons, and the prayers and *fālnāmahs* that he included at the end of his Korans. Undoubtedly, too, Hamdullah was a sportsman of skill and power. Bayezid extended the archery ground of Ok Meydanı on the northern side of the Golden Horn and made Hamdullah head of the dervish lodge that he established there. One of the earliest stone markers set up on the archery ground commemorates a record shot by Şeyh Hamdullah in AH 911 (AD 1505), just after he produced cat. 40.[113] We can only marvel, though, at the calligrapher's alleged ability to swim the Bosphorus from Üsküdar to Saray Point with his legs crossed under him and his portfolio in his mouth, and to proceed straight to the Palace to give a calligraphy lesson.[114]

The story of how Bayezid encouraged Hamdullah to improve on the work of Yaqut allowed a euphuistic symmetry to be drawn between the two calligraphers. Yaqut had six famous pupils, for example, while Hamdullah was credited with seven.[115] Hamdullah was referred to as 'the *qiblah* of the scribes', a title previously accorded to Yaqut. And both Yaqut and Hamdullah were said to have been experts in the six scripts. The comparison was made more explicit by later authors, who called Hamdullah the 'Yaqut of Anatolia', and Amasya the 'Baghdad of Anatolia'. To complete the circle, Yaqut was even said to have been born in Amasya.

For all its importance in the later history of Ottoman calligraphy, the legend of Bayezid's relationship with Şeyh Hamdullah did omit important aspects of the scribe's work. One is that Hamdullah was already working as a scribe for the court before Bayezid's accession, having copied at least two medical books for Mehmed II (cat.23).[116] It is not stated in the colophons of either manuscript where they were copied, and it is conceivable that Hamdullah produced them in Amasya. However, the bindings are of a type associated with Mehmed II, which suggests that at the very least the manuscripts were finished in Istanbul. Hamdullah may, on the other hand, have

worked for a time in Istanbul during Mehmed's reign. In either case it is clear that his career was not as exclusively dependent on Bayezid as later historians of calligraphy would have us believe.

A second aspect of Hamdullah's work that has been almost entirely overlooked relates to his being a Sufi and to his connections with the Halveti brotherhood in particular. In fact, there is no evidence that Hamdullah was ever an actual member of this brotherhood: his father, Mustafa Dede of Bukhara, had been a shaykh of the Suhrawardi brotherhood,[117] and the calligrapher, who was an influential shaykh in his own right,[118] apparently changed his allegiance from the Suhrawardiyyah to the Naqshbandis. Nevertheless, there is a good deal of circumstantial evidence that he was closely associated with the Halvetis, and this association must have played a key role in perpetuating the tradition he had founded and in promoting his reputation.

One connection is provided by three of his pupils, who were also his relatives. These were his cousins Mehmed Cemal (Cemali Çelebi) and Muhyiddin Cemal and their nephew Abdullah Çelebi of Amasya. All three belonged to the Cemali-zade family, a branch of which had settled in Amasya and provided a series of shaykhs of the Halvetiye, including Çelebi Efendi and Shaykh Jamal al-Din Ishaq al-Qaramani.[119] The combination of kinship with the Şeyh and membership of the Halvetiye also characterizes many of the calligraphers working in the tradition established by Hamdullah during the reign of Sultan Süleyman. No less than 32 of his pupils were recorded as active at this time, and they included 12 of his relatives.[120] Further work is required, though, before it is clear whether the high incidence of Halveti calligraphers was a social phenomenon, or whether Halveti philosophy placed a premium on the written word.[121]

Hamdullah's move to Istanbul after Bayezid's accession seems to have coincided with the establishment of the headquarters of the Halvetiye brotherhood in Istanbul in the late 1480s.[122] As we have seen, Sultan Bayezid owed much to his Halveti associates for the help that they had given him in gaining the throne. He repaid the debt not only by constructing the mosque complex in Amasya in the mid-1480s, but by inviting Çelebi Efendi to establish his order in Istanbul in about 1489–90.[123] As a base the brotherhood was given the church of St Andrew of Crete, and its refurbishment as a dervish lodge was entrusted to the same Koca Mustafa Pasha who had transmitted Bayezid's fateful message to Çelebi Efendi in 1481.[124] Once the lodge was established, Bayezid himself is said to have taken part in Sufi rituals there.[125]

Further evidence that Hamdullah was closely associated with the Halvetis can be gleaned from his behaviour following Bayezid's abdication and the accession of his son, Selim I, in 1512. For Hamdullah chose this moment to retire from Istanbul, taking up residence in a village on Mount Alemdağ, where he had often gone into spiritual retreat before.[126] As he would have been at least 76 at the time, the Şeyh's retirement may seem unsurprising, but it is is said that he refused even to set foot in Istanbul. This suggests a more potent motive behind his move from the capital.[127] What is more, Hamdullah's attitude changed abruptly upon the succession of Selim's son, Süleyman, in 1520. Almost immediately after Süleyman's arrival in Istanbul, Hamdullah returned to the city, where he met the new Sultan. Süleyman wished to commission a Koran from the Şeyh, but, to his deep disappointment, Hamdullah refused on the grounds that he was too old, and recommended his cousin, Muhyiddin Cemal.[128] The grounds for the refusal seem to have been genuine, for Hamdullah died soon after.

Hamdullah's retirement during Selim's reign may have been linked to the new Sultan's inimical relations with the Halveti brotherhood, whom he distrusted on several counts: in the first place, their patron, Koca Mustafa Pasha, was implicated, he believed, not only in the death of his grandfather, but also that of his uncle Cem, and the grand vizier had furthermore conspired to secure the throne for Selim's brother, Ahmed.[129] Secondly, the order had close affiliations with the Shi'i Safavid order, which had now taken over control of Iran, and which Selim was determined to destroy. As a result, Selim ordered the execution of Koca Mustafa Pasha and the

destruction of the Halveti lodge he had helped to set up. Selim was thwarted in his second line of attack by the new head of the brotherhood.[130]

The relationship between Sultan Bayezid and the Şeyh thus operated on several different levels, and Bayezid's patronage was to have a lasting influence on the Ottoman arts of the book.

The Imperial Library

Bayezid's great interest in books extended beyond his role as a patron, for he expended effort in reorganizing the sizeable collection of books he had inherited from his father. We know that the imperial library was systematically catalogued in Bayezid's day from several strands of evidence. The first is circumstantial: all the contents of the Inner Treasury, which included the personal library of the Sultan, appear to have been reordered at this period. Secondly, we have the evidence of librarian's notes and stamps in the books themselves. And thirdly, there is the existence of a detailed inventory of the manuscripts.

An inventory of the contents of the Inner Treasury may have been drawn up on an annual basis, in January or February. In a register drawn up in 1496 objects are listed as being stored both upstairs and downstairs: they ranged from robes to rhinoceros horns, swords, bed sheets and books, including Korans in Kufic attributed to 'Ali, but there seems no obvious logic to why particular items were stored above or below ground.[131] Another treasury register, dated 10 Sha'ban 910 (17 January 1505), lists the contents of the treasury room by room, and refers to chests filled with manuscripts.[132] The arrangement of items in these registers suggests that between 1496 – or more probably 1502, to judge from a further register – and 1505 a degree of order had been imposed on the contents.[133] None of these inventories, however, gave an itemized listing of the books.

A general reorganization of the Inner Treasury may have been the occasion when the library was catalogued, for a separate register of the entire imperial library was drawn up in 1505.[134] This list is as yet unpublished, but it is likely to prove of prime importance for our knowledge of how the imperial library developed.[135]

Other evidence for reorganization comes from the books themselves. There are, as we have seen, numerous books that contain dedicatory frontispieces to Mehmed II, but none carry Mehmed's seal, regardless of whether they are still in the library of the Topkapı Palace or have found their way to other collections. Yet in almost every instance they bear, on the first and last pages, the seal of his successor, Bayezid II.[136] Bayezid's seal is also found on manuscripts of earlier date. There is no published list of these, but they include important illuminated and illustrated works, such as the Dioscorides of AD 1288 (*figure 4*), a 14th-century Arabic evangeliary,[137] and the late 13th-century *Manāfi' al-ḥayawān* that is now in the Pierpoint Morgan Library.[138]

In addition to the seal, the manuscripts carry inscriptions at the beginning, either on the fly-leaf or at the top of the opening page, above the dedicatory illumination (*figure 83*). The inscription usually consists of nothing more than the title and subject of the work, and sometimes the numbers of folios. Such information was designed to make identification easier and to provide a means for the librarian to control the books. The inscriptions are written in a *riqā'* hand that it is difficult to date, but there is evidence from several manuscripts that the notes were inserted during Bayezid's reign. To take a single example, cat.6 has an additional note giving the title and stating that, 'Its owner is Sultan Bayezid, the son of Muhammad Khan – May his reign last for ever!'[139] Others, such as cat.10, have an inscription stating that the manuscript was 'one of the books of Sultan Bayezid'.

The most intriguing additional note is to be found in a manuscript now in the Süleymaniye Library, but formerly in the Ayasofya Library, to which it was donated by Sultan Mahmud I. It was therefore previously in the Palace library, and it bears the seals of Bayezid II. It also has the

typical note giving the title and subject in *riqā'* script. What makes it important is that a second inscription identifies the note as being in 'the noble hand of Sultan Bayezid' himself (*figure* 83).[140] If the identification is correct, it shows that Bayezid was personally involved in the cataloguing and organization of the library.

The onus of cataloguing cannot have fallen on Bayezid's shoulders alone, and contemporary documents mention a 'curator of the imperial books'.[141] At one stage this post was filled by the Mawlana 'Utufi who received a reward for presenting a book to the Sultan on 16 Jumada'l-Ukhra 909 (6 December 1503).[142] The idea that the sultan should have taken a personal and painstaking interest in the contents of the library should not, however, surprise us. It is related that Bayezid's successor, Selim I, perused 'the exquisite books at the imperial treasury' one by one.[143]

The importance of Bayezid's organization of the library can be gauged from the fact that many of the manuscripts in the imperial library bear his seal alone: the books in the imperial library were only stamped again when they were being permanently removed from the Palace or transferred to another building within it, such as the new library Ahmed III established in the third court.[144] Transfers out of the Palace happened when the books were being donated to charitable institutions, as when Süleyman gave volumes to the *medrese* he had founded in memory of his son Şehzade Mehmed, or when Mahmud I established the Ayasofya Library.[145]

The emphasis in this chapter has been exclusively on Bayezid's personal manuscripts, and little has been said about other libraries. This should not be taken to mean that activity was restricted to the imperial library and scriptorium. Bayezid is believed to have established a library in the palace school at Galatasaray, for example,[146] and he founded a library at his mosque and hospital complex in Edirne.[147] Libraries were also founded by his subjects. At least four libraries were established in Istanbul during his reign, and others are known to have been set up in Afyon, Amasya, Bursa, Edirne, İnegöl, Kandıra, Manastır, Manisa, Prizren and Salonica. In Amasya, for example, Ahi Yusuf, the son of Junayd of Tokat, who wrote cat.32, donated numerous books to the mosque he had built next to his house.[148]

Equally, the palace scriptorium was not unique, but information on other centres of production is scant. One of the most important, though, appears to have been attached to the household of Firuz Bey. Following the death of Firuz Bey several of his slaves, including a binder by the name of İsmail and a painter called Ahmed, were enrolled on the palace roster and were recorded among the *ehl-i hiref* in 1526.[149]

Conclusion

Most of the surviving manuscripts with dedications to Bayezid date from the 1490s and the early 16th century, whereas the 1480s proved something of a barren decade. The early 1480s were a turbulent period of civil war, and it should not surprise us if Bayezid was unable to maintain the momentum of patronage his father had achieved in the last years of his reign. There were discontinuities that suggest that Mehmed's scriptorium underwent substantial change. As we have noted, neither the Fatih style nor the Pomegranate style are found on bindings made for Bayezid, and there are no textile bindings on manuscripts made in his name, with the problematic exception of cat.25.

Changes in personnel among the designers and binders could have caused a disruption in styles, but the evidence for craftsmen working under Mehmed and Bayezid is too scant to prove that there was any large-scale change.[150] Bayezid does not, in other words, need to be cast in the role of culprit in the demise of the styles, and materials, that had characterized the bindings of Mehmed's reign, even if he is said to have disposed of Mehmed's European paintings.[151] The Fatih style had become increasingly uncommon on bindings from the mid-1470s, and its absence after

83 First folio of a manuscript formerly in the imperial library,
with the oval seal of Bayezid II and
a note in his hand at the top.
The round seal in the centre is that of Sultan Mahmud I,
followed by his endowment notice
Istanbul, Süleymaniye Library, MS.Ayasofya 981

1481 may be due to nothing more suspicious than natural death. The Pomegranate style was an innovation of the last two years of Mehmed's reign, and it may not have taken firm enough root to survive for long.

In contrast to the picture of disruption in the craft of binding during the passage from Mehmed's reign to Bayezid's, there was a clear continuity of approach in illumination. In Bayezid's reign there was a development not of the illumination style that had accompanied the Fatih style of binding, but of the gold-ground style of the latter part of Mehmed's reign that was inspired by Turcoman illumination. The approach to binding characteristic of Bayezid's reign also derived from an Iranian approach introduced in the mid-1470s.

The fundamental change in the aesthetics of bookbinding under Bayezid was due to the fact that the binders changed their source of inspiration. The designs of both the Fatih style and the Pomegranate style seem to have originated with designers: they were drawings transferred to leather. This graphic approach changed under Bayezid to a more sculptural idiom with the

triumph of pressure-moulding. The technique had already been introduced late in Mehmed's reign through the work of binders such as Ghiyath al-Din (*figure 73*). It was a bookbinder's vision, rather than the vision of a designer working on paper, that came to dominate.[152]

The aesthetic contribution of Bayezid's reign to Ottoman bookbinding was considerable. The influence of the standard bindings was, understandably, the most widespread. Burgundy leather outer covers were to become the norm, as was the composition of a lobed centre-piece; cyma corner-pieces, too, became common, as did the use of minimal borders, and a gold ground for the countersunk panels. These features were to define not only the extra, but also the 'generic', or jobbing, bindings of the 16th and 17th century.[153] In the course of the 16th century changes occured in the motifs used in the centre- and corner-pieces, and the so-called 'saz leaf and rosette' style became ubiquitous on Ottoman bindings,[154] while another common motif in the 16th century was that of clouds, the earliest occurrence of which was on the manuscript of 1474 produced for Bayezid (*figure 75*).[155] They also occur on the binding of a manuscript produced in Bursa in 1512 (*figure 84*), which usefully epitomizes the changes that had taken place in Ottoman standard bindings by the end of Bayezid's reign.[156]

The adoption of panel stamping encouraged continuity. Once the matrices were made, the transfer of the design to the covers was a mechanical process that promoted uniformity. The decoration of front and back covers became identical, and the same stamps were repeated on different bindings. The uniform result contrasted with the characteristic method of finishing in the first half of the 15th century, when the use of multiple tools had made it possible to vary the combinations, and encouraged variety from front cover to back cover, from binding to binding.

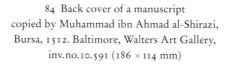

84 Back cover of a manuscript
copied by Muhammad ibn Ahmad al-Shirazi,
Bursa, 1512. Baltimore, Walters Art Gallery,
inv.no.10.591 (186 × 114 mm)

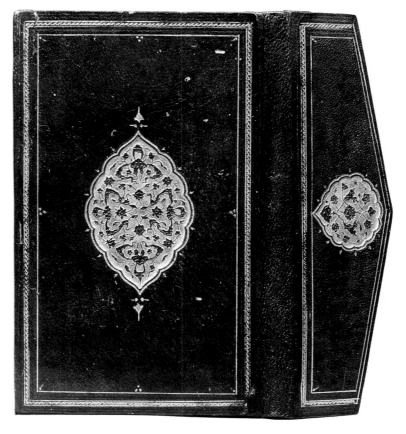

The contribution of Bayezid's reign to the art of the book thus encompassed calligraphy, illumination, and the style and techniques of binding. There seems even to have been an influence in terms of content. From Bayezid's reign there survive numerous copies of the sixth *sūrah* of the Koran, the *Sūrat al-anʿām*, bound as an independent volume. Several were produced by Şeyh Hamdullah, others by Fazlullah Nakkaş. Separately bound copies of the *Sūrat al-anʿām* were so common in later centuries that there may seem nothing surprising about their production in Bayezid's reign. But a survey of the Topkapı Palace manuscripts reveals not a single Ottoman example that was copied prior to Bayezid's reign, and, lest the phenomenon be assumed to be the result of Iranian influence, only one that has been attributed to 15th-century Iran.[157] Where and why the practice began deserves further investigation, but it is worth noting that Hamdullah announced his arrival in Istanbul by sending Bayezid specimens of a prayer book and of the *Sūrat al-anʿām* through one of the Palace gatekeepers. The sultan recognized them at once as the work of the master, despite the fact that they were unsigned.

The influence of Bayezid's reign extended beyond the mere technical and aesthetic to embrace the institutional, for Bayezid is said to have established the guild of binders.[158] It was appropriate, if not indeed intentional, that the booksellers' market was, and still is, situated next to Bayezid's mosque in Istanbul.[159]

In terms of binders working for the Palace, Bayezid's reign saw the beginning of a family tradition that was to dominate for almost the next century and a half (see Appendix 4). One of the binders who worked for Bayezid, a man called Ahmed, played a literally seminal role in the history of the imperial bindery, as at least five generations of his family, a total of 16 persons, are recorded in the pay-rolls of Palace binders; his great-great-grandsons are the last to be recorded with certainty, in AH 1033 (AD 1623). His sons, grandsons and great-grandsons were to hold the highest positions in the hierarchy of the corps of Palace binders, and the influence of this family was exerted not only through its direct members but their apprentices as well.

CATALOGUE

CATALOGUE

Single-volume Koran

Anonymous and undated copy
Probably produced in the second quarter of the 15th century
Bursa, Museum of Turkish and Islamic Arts, MS.207

ࢹ

THIS monumental Koran is probably the finest Ottoman manuscript to survive from the period before 1460. Its binding is remarkable for the density of the decoration, for the intensity of the colouring, and for the variety of materials and techniques employed. The outer covers (*figures* 23, 24) are of blackish-brown leather, and their entire surface is covered with tooled decoration. The central figures and the corner-pieces were once picked out in orange-gold and blue paint, but this has largely disappeared, except on the flap.

The doublures (*figure* 26) are of burgundy leather and are decorated both with areas of filigree and with tooling in blind, in gold and in blue. The filigree is mostly of gilt leather and has been lined with green cloth, and the pattern has been further enhanced by painting this cloth light or dark blue in the case of the front doublure and white or light or dark blue in the case of the back doublure.

The manuscript is undated, and it is not known from which foundation in Bursa it entered the Museum, but there are close parallels between its binding and that of cat.2 below, a music manuscript made for Sultan Murad II in 1435.[1] Both bindings have a pointed oval at the centre of the front cover, and a roundel with two circular pendants on the back cover. In the case of the Koran, these figures are surrounded by a floriated scroll, which is repeated on the field of the flap of the music book, and the outer covers on both manuscripts have wide, segmented frames filled with knotwork, which was partly gilded so as to create a series of rhombs.

There are also similarities between the doublures: those of the music manuscript are much less elaborate, but in both instances the main features are central roundels or pointed ovals filled with the same type of trellis-work filigree against a ground of green silk. Another link is that the arabesque pattern used in the roundel on the inside of the flap of the Koran resembles that employed in the frontispiece of the music manuscript. On this basis the binding of the Koran may be attributed to the same

period as that of the music manuscript, namely, the second quarter of the 15th century.

The use of centre-pieces with different outlines on front and back covers was standard in Ottoman bindings until the 1460s, when it was rapidly abandoned in favour of employing the same composition on both covers. The same feature occurs on a detached binding in the Chester Beatty Library, Dublin (*figure* 25).[2] Regemorter erroneously associated this binding with a single-volume Koran that was made for the Mamluk Sultan Qa'itbay (*reg.* 1468–95), but, in view of this and other similarities, such as the segmented frame filled with partly gilded knotwork, it is possible that the Dublin binding is also Ottoman work of the second quarter of the 15th century. A similar pattern of knotwork can be seen in the borders of a pair of detached covers in Chicago, which have been attributed to Egypt or Syria in the 14th century, but which should probably be reassigned to the 15th century; where exactly they were produced remains to be established.[4]

A definite Mamluk parallel can, however, be cited for the use of filigree for the centre-pieces of the doublures. The outer covers of MS.4168 in the Chester Beatty Library, which was made for Sultan Qa'itbay,[5] have the same sort of trellis-work filigree in the centre- and corner-pieces as appears on the doublures of the Bursa Koran. In addition, some of the spaces in the trellis work were filled with blue, as they are on the Bursa Koran.

The Outer Covers

The pointed oval centre-piece and lobed and pointed corner-pieces on the front cover (*figure* 23) are filled with a spiral arabesque scroll, while the central roundel on the back cover (*figure* 24), to which two circular pendants with palmette-shaped finials are attached by short stems,[6] and the quarter-circle corner-pieces are filled with a pattern of interlaced fillets that form hexagonal and six-pointed compartments. These compartments, the cusps along the edges of the centre- and corner-pieces and the

pendants are filled with knotwork. The fields of the two covers are filled with a floriated scroll, and the background has been stippled using a fine, blunt tool, so that there is a strong contrast in texture between the background and the design, as on the flap of cat.2.

The outside of the flap has a central roundel with a lobed outline. The corner-pieces are similar in shape to those on the front cover, and they are filled with the same arabesque scroll as the central roundel. The fore-edge section of the flap is decorated with three rectangular panels that are filled with a pattern of partially gilded knotwork. Two smaller rectangular panels have been placed at right angles at the top and bottom.

The Doublures

The front doublure (*figure* 26) has a central roundel filled with a geometric pattern in filigree, which consists of two sets of trellis-work, one perpendicular and the other diagonal. The triangular corner-pieces are filled with the same design, but the colours are reversed. The L-shaped corner panels of the border have gold and blue tooled knotwork like that in the borders on the covers.

The back doublure has a pointed oval centre-piece, which, with the top left and bottom right corner-pieces, is filled with the double trellis-work pattern seen on the front doublure; but the other two corner-pieces are decorated with a simpler, chevron pattern. Elements of both these patterns occur in the more complex filigree design that fills the entire border. The central roundel on the inside of the flap contains a spiral arabesque pattern in filigree, while the main field is overlaid with the double trellis-work design, also in filigree.

Text block 558 pages, 590 × 475 mm, the text area, 370 × 280 mm, unframed, with nine lines of script: lines 1, 5 and 9 in *rayḥān*, the rest in *naskh*; line 5 in gold outlined in black, the rest in black.
Paper Thick, polished Oriental paper, the colour varying between cream, ochre and pink; the back flyleaf is of Oriental paper, but the front flyleaf is a later European replacement.
Illumination The first four pages of text (folios 1b–3a) have elaborate frames, with oversize panels containing inscriptions in stylized Kufic above and below the text; the two lines of script on these pages are set within *abrī* clouds, surrounded by fine pink hatching and stems bearing rosettes and leaves on a pink ground, with the occasional triple-dot motif (*cf.* the margins of the first page of text of cat.2 below); *sūrah* headings are in white *thulth* against arabesque and floral scrolls in gold on a dark-red ground; groups of ten verses are marked by roundels containing the number written in gold Kufic against a red ground, groups of five verses by pear-shaped ornaments that contain the number written in gold against a red ground.
Sewing In signatures of eights, using two strands of two-ply, z-twist silk in sewing pattern A; black thread used top and bottom, yellow in the centre; the headbands are in black and cream, the latter perhaps faded yellow.
Published Tanındı 1990–1, p.148, figs 23–7.

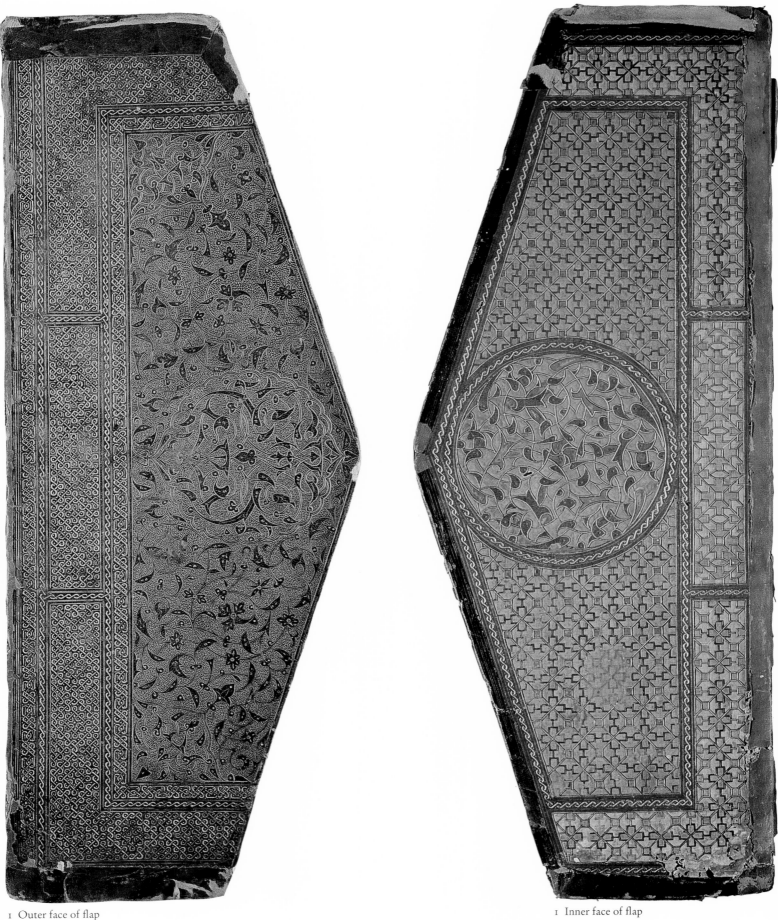

1 Outer face of flap 1 Inner face of flap

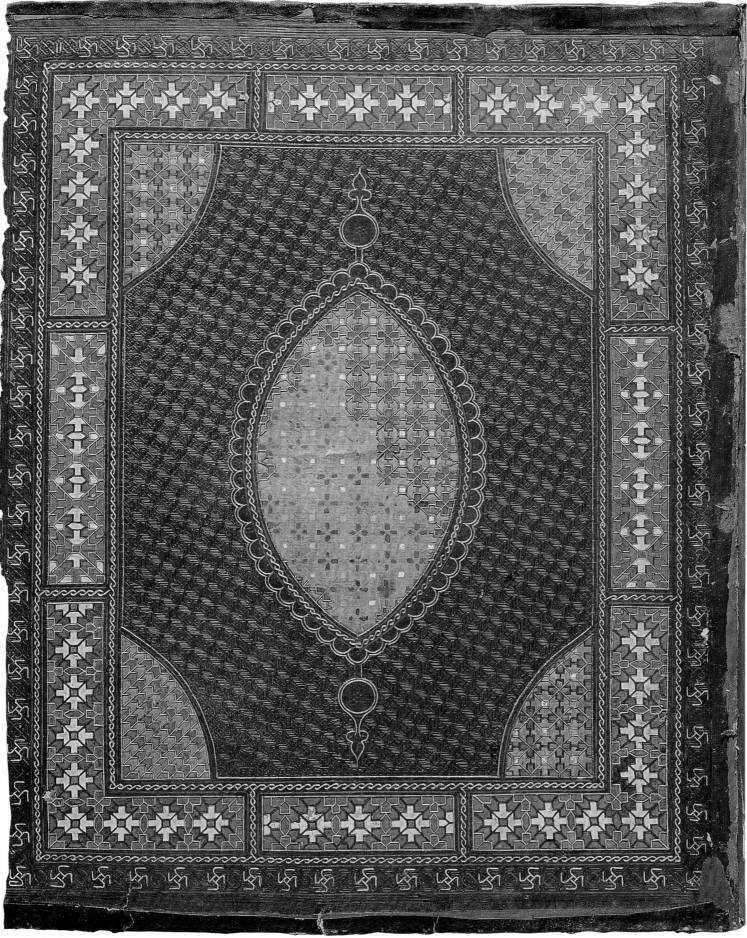

1 Back doublure

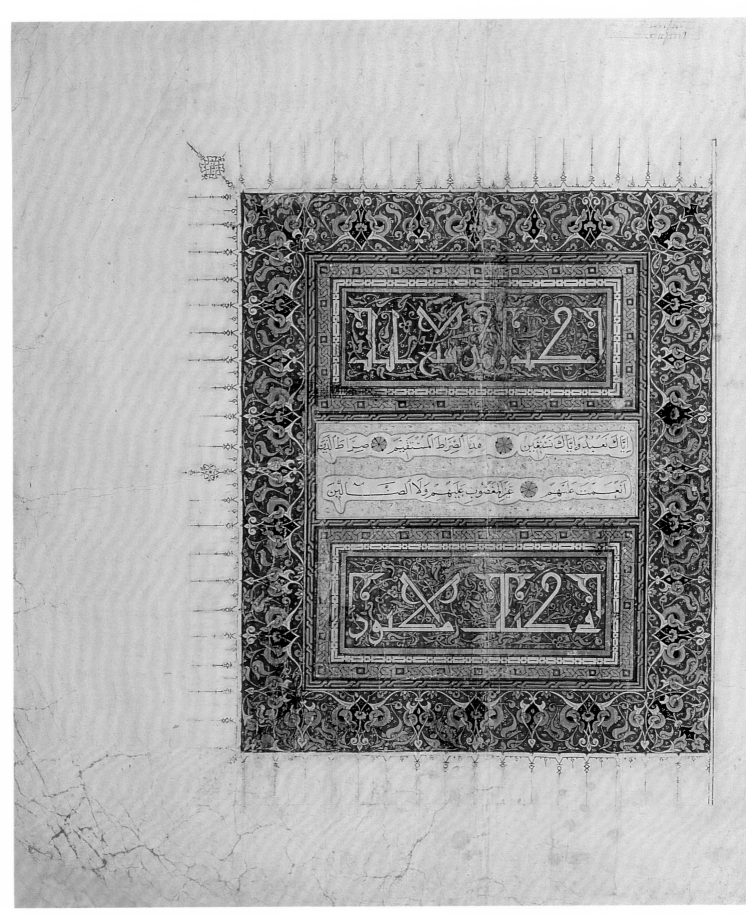

1 Folios 1b and 2a

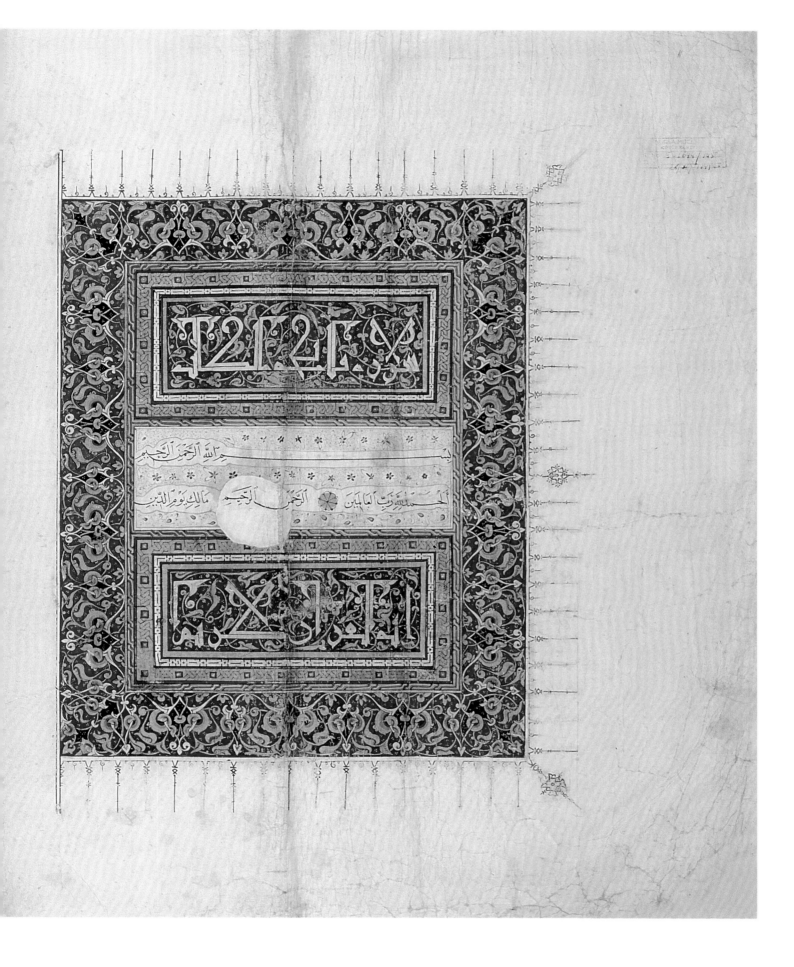

2

Maqāṣid al-alḥān of ʿAbd al-Qadir al-Maraghi

Copied by Muhammad ibn Muhammad ibn Ilyas
and completed on 14 Jumada'l-Ukhra 838 (15 January 1435)
Produced for Sultan Murad II
Istanbul, Topkapı Palace Library, MS.R.1726

ঽ৶

THE *Maqāṣid al-alḥān* ('Purposes of the notes') is a work in Persian on musical theory composed by ʿAbd al-Qadir ibn Ghaybi al-Hafiz al-Maraghi, who died in AH 839. This copy was prepared in the year before the author's death, and its illuminated frontispiece (folios 1b–2a) includes an inscription stating that it was made 'for the library of the great sultan, the mighty emperor, the helper of the warriors for the faith, the raider among those devoted to religion, the treasure among sultans, the refuge of the afflicted, the shadow of God upon the earth, the sultan, son of the sultan, Sultan Murad Khan, son of Mehmed Khan, son of Bayezid Khan, son of Murad Khan, son of Orhan', that is, for the library of Sultan Murad II. The manuscript also bears the seals of Sultan Bayezid II (*reg.* 1481–1512) and Sultan Ahmed III (*reg.* 1703–30).

The binding, which has recently been restored, is of light-tan leather and bears tooled designs, enhanced with gold and blue paint. The wide borders are divided into rectangular and L-shaped segments that are filled with knotwork set against a ground worked with tiny needle-point dots. The knotwork has been tooled partly in gold, partly in blue, and partly in blind,[1] so as to create patterns of chevrons, rhombs or other figures. The small, triangular corner-pieces are decorated with gold interlace.

The large central motifs have scalloped borders and pairs of pendants consisting of a short stem, a roundel and a palmette-shaped finial. The centre-piece on the front cover is a pointed oval in form and is filled with an arabesque pattern that is symmetrical on both the horizontal and vertical axes; the background was worked with fine stippling. The centre-piece on the back cover is a roundel; the arabesque it contains is of a similar type, but it is symmetrical only on the vertical axis.

The main decorative feature on the outside of the flap is a sub-triangular form with a lobed outline and palmette-shaped finials. This triangle is also filled with an arabesque pattern, but, whereas the main field on the front and back covers is plain, here it is decorated over-all with a delicate floriated scroll. Decoration of this type fills all the fields on the covers of the Bursa Koran (cat.1 above), and it also fills the main fields on some 14th-century Anatolian bindings, such as the two-volume Konya Koran of 1314–15 (*figure* 1). In some Mamluk bindings of the same period floral scrolls fill the main field around filigree centre-pieces,[2] while in some 15th-century Mamluk examples the scrollwork is confined, as here, to the flap (*figures* 11–12). Decoration in this style also occurs on a group of bindings thought to have been produced in Shiraz in the first half of the 15th century, a magnificent example being the composition on the envelope flap of a copy of Firdawsi's *Shāhnāmah* dated 1439 (*figure 74*).

The doublures are of reddish-brown leather. They have simple tooled borders and corner-pieces, and the centre-pieces have tooled outlines, borders and palmette-shaped pendants; again the tooling is picked out in gold and blue. The roundels at the centres of the front and back doublures and the sub-triangular figure on the inside of the flap are filled with complex geometric patterns executed in filigree of gold and reddish-brown leather, all very similar to the trellis-work filigree of cat.1. The pattern was backed with silk, which is a light blue-green on the front doublure and the inside of the flap and dark green on the back doublure.

The craftsman responsible for this binding also produced a binding for an undated Ottoman Koran, which has been wrongly attributed to the second half of the 15th century on the basis of its calligraphy and illumination. The outer covers of this Koran bear roundels similar in shape to those on the doublures of cat.2, with identical pendants but a different central pattern; the border design is built up with the same tools used for the border of the envelope flap of cat.2; and there is a comparable use of gold and blue highlights, though the blue now survives only on the flap of the Koran.[3]

The fine binding of cat.2 is matched by the illumination. The two panels that make up the frontispiece on folios 1b–2a contain two different designs, a feature that has a parallel in the use of different centre-pieces on the front and back covers. The characteristically Ottoman composition on folio 1b

2 Front cover

has as its main feature a large roundel whose centre is filled with arabesque scrolls in gold on a blue ground.[4] In contrast, the ogival cartouche in the centre of folio 2a has a shape that can be paralleled on Chinese porcelain; and it contains the inscription in gold which states that the manuscript was produced for Sultan Murad II.

The roundel on folio 1b is surrounded by a field decorated with floral sprays rendered in gold on a black ground, and the same ornament, enhanced with coloured dots, fills the bands on either side of the central device on folio 2a,[5] while it is rendered in dark red on an orange field in the corners of the illuminated heading on folio 2b.

The opening pages of text, on folios 2b–3a, are surrounded by an elaborate frame. The text itself is set in *abrī* clouds against a pseudo-marble ground in red and gold, and the margins outside the frame are filled with floral sprays in black against a red-dotted ground. This type of floral spray is also found in some

of the centre-pieces of cat.4 below, and similar floral decoration was used to fill the interlinear spaces on the first two pages of text in the Bursa Koran.

Text block 79 folios, 313 × 218 mm, with a text area, 228 × 142 mm, set within a frame of blue and gold rules, the gold having black outlines, and containing 21 lines in a poor *nasta'līq* hand, in black, with gold, red and blue details.

Paper Thick, soft, polished, cream Oriental laid paper, with the laid lines running parallel to the spine, eight or nine to the centimetre, and chain lines in groups of three, the distance between each line being about 10mm, and the distance between each group about 47 mm.

Illumination Described above.

Sewing Modern; the old sewing seems to have been in signatures of eight; sewing pattern B, the thread a white, two-ply, z-twist, z-spun silk.

Published Çağman 1983, no.E.2; Leiden 1986, p.317; Karatay 1961a, no.279; Tanındı 1990–1, figs 5, 29.

2 Detail of folio 1b

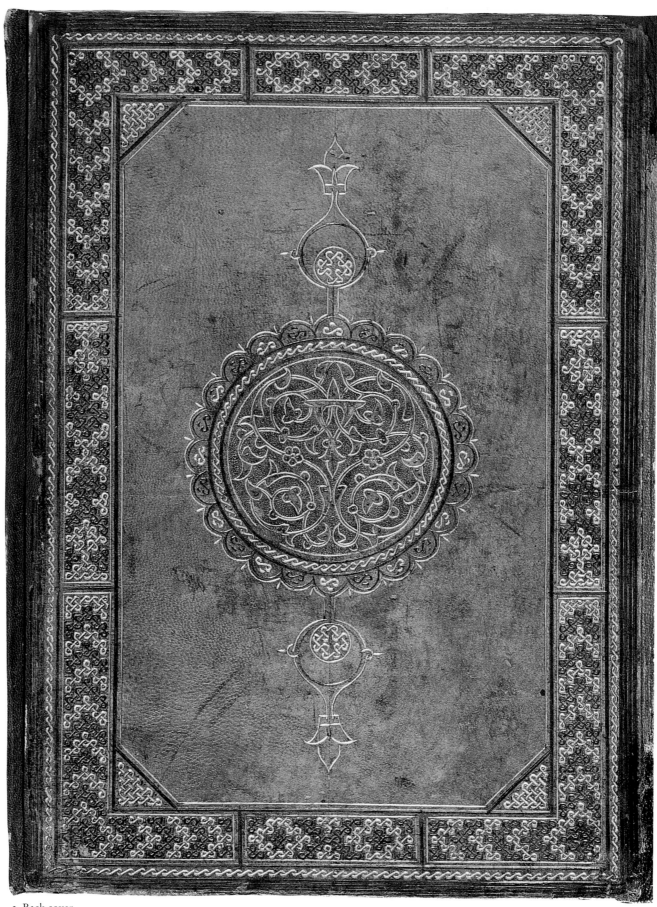

2 Back cover

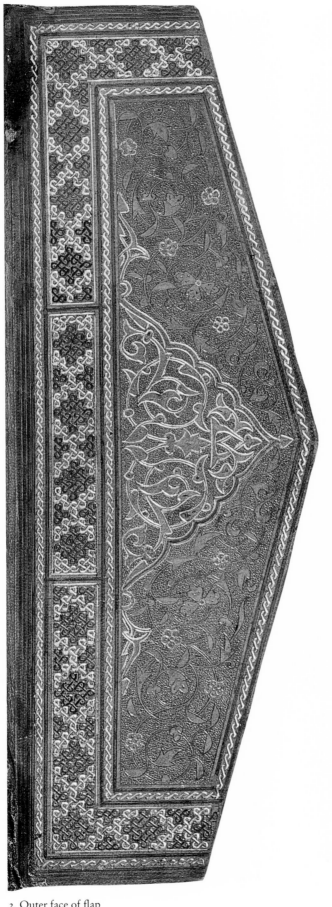

2 Outer face of flap

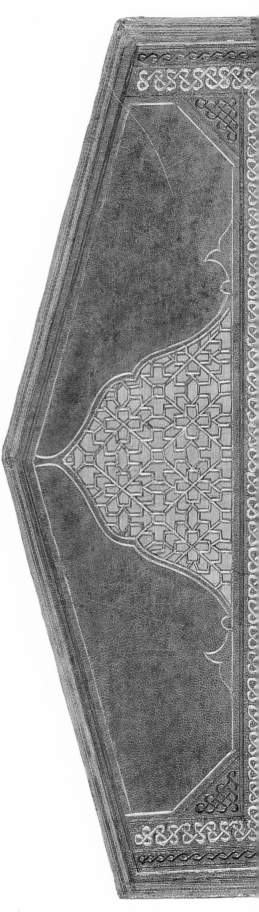

2 Back doublure

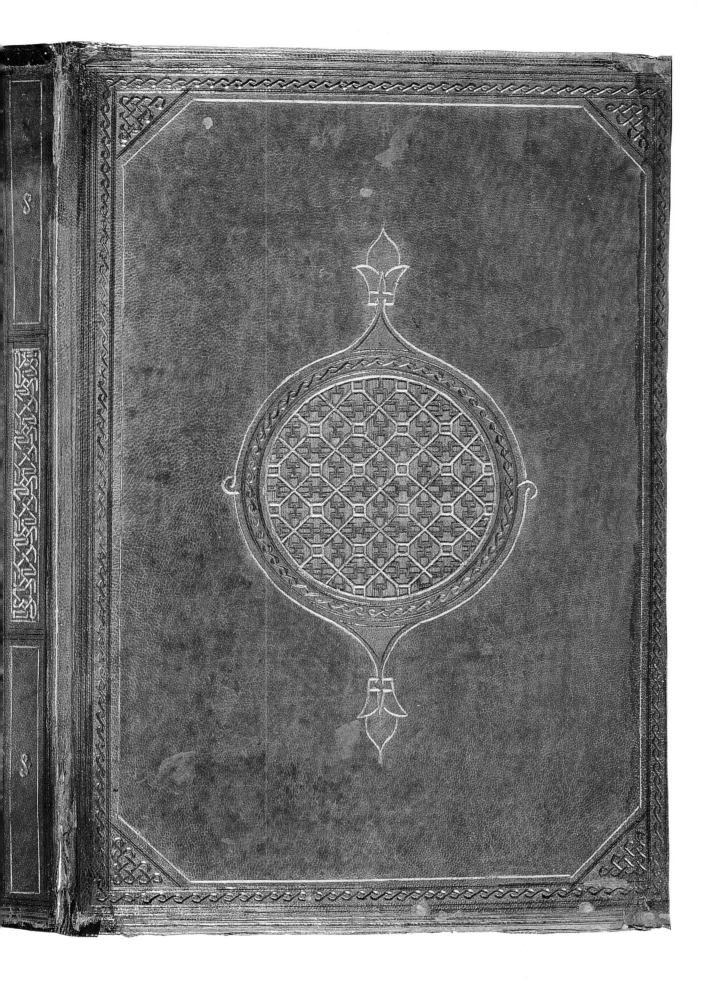

3

Tarjamah-i Tafsīr-i al-Lubāb of Musa al-Izniqi

Autograph copy of volume II completed during
the last nine days of Rabiʿ al-Akhir 838 (25 November–2 December 1434)
Acquired by Umur Bey, son of Timurtaş Pasha, before 1449
Bursa, İnebey Library, MS.Ulu Cami 435

۞

THE book to which this binding is attached forms part of a translation into Turkish of a 14th-century Koran commentary in Arabic, the *Lubāb al-taʾwīl fī maʿānī al-tanzīl*; it is the second volume of the work, covering *sūrahs* III to XI of the Koran.[1]

An endowment notice on folio 1a, of Ramadan 853 (October–November 1449), records the donation of the manuscript by Umur Bey, the son of Timurtaş Pasha, to the public library he founded in his mosque in Bursa.[2] Umur Bey stipulated that 'they are to keep it safe and not to give it to anyone before receipt of the value from him;[3] and it is to be placed in the above-mentioned mosque located in Bursa, and it is not to be taken away to any other city.' The act of endowment was witnessed by a large group of people, who included 'the writer of these words' Hasan, the son of Ahmed, his son, Abdurrahman, and Mevlana Sinan, the imam at the mosque. Two of them reappeared four years later as witnesses in the endowment inscriptions of cat.4, as Mevlana Abdurrahman, the son of Hasan Fakıh of Karahisar, and Mevlana Sinan, the son of Ahmed.

The translator, Abu'l-Fadl Musa ibn Hajji Husayn ibn ʿIsa al-Izniqi, wrote a work on ethics and was responsible for Turkish versions of at least four other works in Arabic.[4] One of these was dedicated to Sultan Mehmed I, and another was made at the orders of Umur Bey. In encouraging translation work of this kind, Umur Bey and other patrons of the 1420s and 1430s, who included Sultan Murad II himself, made an important contribution to the development of Ottoman Turkish as a literary language.

The binding of this manuscript is of reddish-brown leather with tooled decoration. The tool used for the border – a fleur-de-lis set within a four-lobed figure – occurs on several bindings produced in Bursa in the first half of the 15th century (*figure* 34b), while the modest, triangular corner-pieces are filled with a pattern resembling basketry. The centre-piece on the front cover consists of a roundel filled with interlaced bands and surrounded by eight large lobes whose centres have been worked with a fish-scale pattern. Six of the lobes have looped outlines,

but those at the top and bottom are attached to pendants composed of interlaced bands forming an 'everlasting knot'. On the back cover the centre-piece is formed by a strapwork design which combines a ten-pointed star with a decagon, at the centre of which is a rosette.

The fore-edge section of the flap (*figure* 34b) bears a strapwork pattern in which 12-sided cartouches interlock with lozenges, and the compartments formed by the strapwork are filled with 'everlasting knots' or stippling. The main part of the flap has a central medallion filled with interlace.

The doublures are of light-brown leather which has been block-pressed with a strapwork composition in which pairs of diagonal bands intersect to form five small compartments arranged in a saltire formation. These 'saltires' alternate with large eight-pointed stars, at the centre of which is a rosette with eight petals. The design which surrounds the rosette alternates, horizontal row by horizontal row, between a leafy scroll and an arabesque pattern. The compartments in the 'saltires' have been worked with a floral design that runs between them, as though it were under the strapwork. The same composition, but with different filler motifs, occurs on the doublures of another manuscript that is associated with Umur Bey (see cat.4, volume II).

The star and saltire pattern can be traced back to 13th-century tilework found at Kubadabad in Anatolia,[5] and also occur on 14th-century tiles from Kashan in Iran.[6] The earliest surviving example of its use in the arts of the book is on the binding of a Mamluk or Ilkhanid manuscript attributed to the end of the 13th century,[7] and it can be seen in the frontispieces to two manuscripts made for the Ilkhanid vizier Rashid al-Din, who was executed in AD 1318.[8]

Text block 381 folios, 270 × 175 mm, the unframed text area, 190 × 120 mm, with 19 lines of *naskh*; no illumination.
Sewing In signatures of eights, using a white z-twist flax thread.
Published Tanındı 1990–1, p.144, figs 2, 3.

3 Back cover

3 Back doublure

4

Mafātīḥ al-ghayb of Fakhr al-Din al-Razi

Anonymous and undated copies of volumes II, IV, VI and VIII
Acquired by Umur Bey, son of Timurtaş Pasha, before 1453
Bursa, İnebey Library, MSS Ulu Cami 315, 318 and 324 and MS.Genel 931

৯৪

THESE four manuscripts form part of the *Mafātīḥ al-ghayb* ('Keys to the hidden'), a detailed commentary on the Koran, written in Arabic by Fakhr al-Din al-Razi (*circa* 1150–1209), one of the most celebrated of Islamic theologians and exegetists.[1] Volume II of this copy covers *sūrah* II, verses 36–165; volume IV, *sūrahs* V–VII; volume VI, *sūrahs* X–XIV; and volume VIII, *sūrahs* XIX–XXIV.[2]

It appears that these four volumes were part of a set donated by Umur Bey, the son of Timurtaş Pasha, to the library of his mosque in Bursa, for two of the volumes (VI and VIII) contain an endowment notice in Arabic that reads: 'The great lord, Umur Bey, son of the late Timurtaş Bey, made an inalienable gift of this book in anticipation of a reward from God and in order to please Him. Abdurrahman, the son of Hasan Fakıh, Sinan, the son of Ahmed, and Hacı Ali, the son of Oğuz were witnesses to [the act, which occurred] in the year 857 (AD 1453).'[3]

The bindings of all four volumes are clearly the work of the same master, and the four manuscripts were presumably bound at the same time, perhaps when Umur Bey was preparing to donate them to the library of his mosque. The outer covers are of tooled brown leather, and the doublures were cut from sheets of brown leather that had been impressed with a variety of designs. Only in the case of volume VIII does the flap survive.

The Outer Covers

Different centre-and-corner compositions were used to decorate the front and back covers of all four manuscripts: the main element on the front is a central roundel, while the centre-piece on the back is a pointed oval. Individual motifs were reserved against a stippled ground, which increased the density of the decorated areas and heightened the contrast with the plain field. The borders are composed of multiple fillets and tooled chains of interlace, but the back cover of volume VIII has a border similar to those of cat.3 and cat.5 (*figure* 34).

The centre-piece on the front cover of volume II is unusually large, so that its pendants touch the upper and lower borders. Its main component is a roundel filled with a rotating design of arabesque scrolls.

Around it a wide band of floral scrollwork is framed by a scalloped and looped border. The corner-pieces on the front cover are quarter-sections of a pointed oval device with a scalloped border and are filled with a symmetrical arabesque composition.

The lobed pointed-oval centre-piece on the back cover is filled with a floral spray with curving stems, which rises from a calyx and has a large composite blossom at its centre. The two palmette-shaped pendants are filled with a fragment of the same spray, while the corner-pieces, which contain a symmetrical arabesque composition, are defined by a sinuous line which is interrupted by a pointed extension. The respective compositions on the front and back covers of the other extant volumes are similar to those of volume II with only minor variations (*cf. figures* 32–3).

The Doublures

The doublures of volume II have been block-pressed with the same strapwork pattern of star and saltire forms as those of cat.3, but the filler motifs are different: the form of rosette in the stars alternates, horizontal row by horizontal row.

The doublures of volume IV have an overall design of six-sided figures – rectangles with pointed ends rather than equilateral hexagons.[4] These are arranged so that they alternate on the horizontal and vertical axes. The vertical hexagons have been worked with two alternating designs – a symmetrical arabesque pattern and a floral spray. The horizontal hexagons either contain a rosette with eight petals or are inscribed in *thulth* with the Arabic benediction *Al-'izz al-dā'im wa'l-iqbāl* ('Everlasting power and prosperity!'). The interstices are ornamented with a large rosette.

The back doublure of volume VI bears the same design as the doublures of volume II, whereas the front doublure has been block-pressed with a composition whose basic elements are two circular devices. The first is a roundel defined by a beaded band. Its field has been worked with beaded bands interwoven with stems bearing palmettes and half-palmettes. The second type, which is larger, has a notched outline and palmette-shaped extensions above and below; at its centre is a rosette with four two-lobed

and four pointed petals, surrounded by a complex pattern of interlaced arabesques. The spaces between the circles are filled by a linear pattern of leafy stems bearing rosettes with six petals.

The pattern with which the doublures of volume VIII were pressed is dense and complex, and it covers too large an area to be seen on any one doublure in its entirety. It is composed of four-lobed figures, but all except the one at the very centre of the pattern overlap, so that they appear as three-lobed forms arranged in a scale pattern. These forms are defined by narrow bands with knots at the points where the lobes meet,[5] and they are filled with a variety of designs. One is an arabesque scroll; the second has a similar scroll organized around a large, composite lotus blossom; the third is a floral pattern that includes a rosette with alternating pointed and lobed petals; and the fourth has elements of this floral pattern and a roundel with an invocation in Arabic, which begins *Yā qayyūm!* ('O Self-Subsisting One!').

The four-lobed medallion at the centre of the design can only be seen in the upper left-hand corner of the front doublure. The medallion contains a double roundel whose centre is inscribed twice with the words *'amal-i mujallid* ('work of a binder'), written in *thulth*. Another inscription, *Yā kāshif al-ḍarr 'an Ayyūb fī'l-saq[am]* ('O Thou who removed the harm from Job in his affliction!'), has been arranged in the surrounding circle with the tops of the letters nearest the roundel. Two registers below this complete medallion there is a row of gaps in the pattern which are filled with one of two designs. The first is a double roundel with the phrase *ṣāḥibuhu Ḥasan* ('its owner is Hasan') inscribed twice in the centre, and another phrase in Arabic, which includes a reference to the *bayt al-naml* ('dwelling of the ants'), in the surrounding circle; the second inscription is also written twice, with the heads of the letters pointing outwards. The second

design is a rhombus of floral forms with a rosette of alternating pointed and lobed petals at its centre.

The only one of the three invocations that has been read with certainty derives its force from a passage in the Koran (XXXVIII, 41–4), where the relief provided to Job by God is described. The invocation referring to the 'dwelling of the ants' is a reference to another part of the Koran (XXVII, 15–19), in which special favour was shown to Solomon.

Doublures with this intricate form of decoration also occur on three manuscripts in the Topkapı Palace Library: the first is part 20 of a Koran, copied in 1445 and associated with Sultan Murad II;[6] the second is a copy of the *Risālah fī 'ilm al-mūsīqī* ('Treatise on the science of music') of Fath Allah Mu'min al-Shirwani, which was presented to Sultan Mehmed II;[7] and the third contains a medical text, the *Taqwīm al-ṣiḥḥah* ('Rectification of health') of Ibn Butlan.[8] But in none of these four cases do the contents of the manuscript match the invocations on the doublures, with their references to marks of favour shown by God to ancient prophets.

Volume II 207 folios, 268 × 178 mm, with a text area 185 × 125 mm; in signatures of tens, using a cream flax thread; headbands now missing.
Volume IV 287 folios, 275 × 185 mm, with a text area 215 × 140 mm; in signatures of tens, using a pinky flax thread at six stations; headbands are yellow.
Volume VI 229 folios, 265 × 180 mm, with a text area 200 × 125 mm; in signatures of tens, using a three-ply cream flax thread with a z-twist.
Volume VIII 203 folios, 265 × 175 mm, with a text area 205 × 125 mm; sewing and headbands renewed.
Volumes II, VI and VIII have 27 lines of *naskh* to the page, while volume IV has 25.
None of the volumes has any illumination.
Published Tanındı 1990–1, pp.144–6, figs 4, 8–11, 14, 15a–b, and pl.IVa–b.

4 Front cover of volume II

4 Back cover of volume II

4 Front doublure of volume VI

4 Back doublure of volume II

4 Back doublure of volume VIII

4 Back doublure of volume VI

5

Almanac produced for Sultan Mehmed II

Copy made by Muhammad ibn Mustafa ibn Sunbul
Produced for Sultan Mehmed II in AH 856 (AD 1452–3)
Istanbul, Topkapı Palace Library, MS.B.309

❧

DURING the 15th century it appears to have been the practice for the court astrologer to prepare for the sultan an almanac for each year of the Muslim calendar. This example belongs to a group of seven that begin with a chronological list, which gives the dates of events in the form 'it is so many years since'. The earliest of these was made for Sultan Mehmed I and is for AH 824 (AD 1421–2), the year of his death, while the latest was compiled for his grandson Sultan Mehmed II and is for AH 858 (AD 1454–5).[1] These chronological lists seem to have been the main form of court historiography during this period, and they were an important source for the chronicles composed towards the end of the 15th century, although errors had crept into the chronology as the lists were recopied each year.[2]

The rest of the manuscript contains a series of tables of astrological information and omens of various kinds. Some of this information could be used to foretell future events, but most was collated with lists of actions that should or should not be performed at times determined by the conjunctions of heavenly bodies, the phases of the Moon, the houses of the zodiac, the months of the year, the occurrence of dreams etc.[3]

The binding of the almanac for AH 856 is of levant-grain leather of a dark red-brown colour, lined with paper. The borders (see also *figure* 34e) were blind-tooled with three different designs between four sets of multiple fillets: the outer register contains the same combination of fleurs-de-lis and four-lobed figures that occurs in the borders of some of the bindings made for Umur Bey, the son of Timurtaş Pasha, but on a slightly larger scale (*figure* 34b, d); the middle register consists of a double band of strapwork, knotted at regular intervals; and the inner register has a chain with s-loops. The corner-pieces consist of overlapping segments of a circle, filled with stippling (*cf. figure* 37), and the outer covers are each decorated with a large central roundel with a lobed border and two star-shaped pendants. Strapwork divides the field of the roundels into a large number of small compartments. These are filled with stippling, small rosettes, knot motifs or circlets, with the exception of the central compartment, in the form of a ten-pointed star, which contains a blossom with four pointed petals and four small, round petals, set against a stippled ground.

The same roundel was used on the flap, but without the lobed border and pendants. Otherwise the size of the roundel was not adjusted to fit within the narrower field of the flap, and it touches the borders on either side. Above and below the roundel the field has been filled with floral scrollwork of considerable elegance, set against a stippled ground and outlined in gold. Indeed, the amount of gold employed on the flap contrasts with its sparing use for outlines on the outer covers. In this respect, this binding is closer to Mamluk examples than Persian.

The corner-pieces and the borders of cat.5 have parallels in bindings on two earlier manuscripts that appear to have been rebound in the 14th or 15th century. The earlier of the two is a Koran dated AH 536 (AD 1176), now in the Yusuf Ağa Library, Konya.[4] The second is a celebrated copy, made in December 1228, of the *Materia medica* of Dioscorides, in the Arabic translation known as *Kitāb al-Hashāyish*. The flap of its binding (*figure* 4) was worked with a more refined version of the border tool.

Text block 27 folios, 12.5 × 31 cm, with the text written in *naskh* and *ta'līq* within tables in a variety of formats; headings are in red.
Paper Soft, medium-cream laid paper with a low burnish, the laid lines running parallel to the spine, four or five to the centimetre, and the chain lines running at right angles to the spine in groups of three: the three lines, all very faint, are about 10 mm apart, and the sets of three are about 40 mm apart.
Illumination The dedication was recorded in a long inscription set within a large illuminated medallion (diameter 180 cm) on folio 1a; the blue is matt and uneven, and the gold is yellow, but the surface quality is that of Mamluk work.
Sewing The brevity of the text has led to an uneven number of leaves in some signatures, but they were mostly sewn in eights at two pairs of sewing stations, using two parallel strands of two-ply, z-twist pink silk; there are no headbands.
Published Atsız 1957; Karatay 1961b, no.1636.

5 Back cover

6

Dīvān of Fakhr al-Dīn al-ʿIrāqī

Anonymous copy made in Edirne and
completed during the last ten days of Rajab 857 (28 July – 6 August 1453)
Istanbul, Süleymaniye Library, ms.Fatih 3844

≈

THE author of this *Dīvān,* or collected poems,
Fakhr al-Dīn Ibrāhīm ibn Shahriyār al-ʿIrāqī is
a celebrated author of the school of Illuminationist
philosophy. He was originally from Hamadan but
went to Multan to study under Bahaʾ al-Dīn Zaka-
riyya. On failing to be accepted as Bahaʾ al-Dīn's
successor, he left for Konya where he wrote his major
work, the *Lamaʿāt* ('Flashes'; *cf.* cat.33). From Konya
he went to Cairo, and then to Syria, where he died in
AH 688 (AD 1289–90).[1]

The covers belong to a group that contains what
are, in technical terms, the finest bindings produced
by the Ottomans in the 1450s. The tooling was lightly
but crisply executed. In terms of materials they mark
a departure in the smoothness of their leather, and
the broader range of colours: the leathers were no
longer tan, but included burgundy and olive-brown.
Polychromy was achieved by the use of gold and
blue paint, and another characteristic was the use of
filigree centre-pieces on the doublures, set against
gold and blue grounds. Above all, the group demon-
strates a sense of lightness; the centre- and corner-
pieces have been reduced in proportion, leaving a
greater area of plain field, while the small-scale motifs
and fine gold outlines enhance the sense of delicacy.

The high technical and aesthetic quality of this
group does not seem to have assured it imperial
patronage. This volume was written in the former
Ottoman capital of Edirne a mere two months after
Mehmed II's conquest of Constantinople, but, like
other manuscripts with this type of binding, there
is no indication it was made for the Sultan. How-
ever, it did enter the imperial library at a relatively
early date, for it bears the seal of Mehmed's son,
Sultan Bayezid II.[2]

The two outer covers, which are of olive-brown
leather, are decorated with different designs. The
front cover bears an oval centre-piece, which is gen-
tly lobed, and has finials in the form of elaborate
strapwork knots. Such knotted strapwork was not
common on 15th-century Ottoman bindings, though
it occurs on a Koran of 1455 (cat.9) and on a binding
produced in Amasya in 1477 (cat.33). The borders are

tooled with an interlace design identical to that used
on cat.7. Comparable borders, corner-pieces and a
triangular version of the centre-piece are used to dec-
orate the outer face of the envelope flap. The tools
used for the borders have been used to decorate the
lobed pointed-oval centre-piece on the back cover.

The doublures are of medium-tan levant-grain
leather. The front doublure is decorated with a small
lobed roundel with a whorl design of arabesques
in filigree against a predominantly gold ground,
though there are three areas of ultramarine near the
centre of the roundel. There are no corner-pieces,
and the border is a series of blind fillets, framed by
gold fillets. The back doublure is simply decorated.
The borders are similar to those on the front dou-
blure, and the centre-piece is a rhomb of interlace,
much of it made using s-tools. The rhomb has single-
line extensions above and below, also made using s-
tools. The inner face of the envelope flap bears a small
roundel filled with a filigree design of arabesques
that are slightly different from those used on the
front doublure, and are set against a gold ground.

Text block 130 folios, 227 × 146 mm, with a text area,
156 × 94 mm, set within a red frame and containing
17 lines of unvocalized *nastaʿlīq* in black ink, with
details in red, arranged in one or two columns.
Paper Polished, cream, medium-thin gauge, Oriental
laid paper with four or five laid lines to the centi-
metre, running at right angles to the spine, and no
visible chain lines.
Illumination The beginning of the text is marked
by a panel containing an inscription in white *thulth*
and floral sprays in gold against a blue ground; the
sprays, which have no outline, are in the Shirazi
'waterweed' style.
Sewing In signatures of eights, using a two-ply, z-
spun, z-twist white silk in sewing pattern A; the
headbands are in alternating vertical stripes of pink
and green silk.
Documentation Impression of the seal of Bayezid II
with a confirmatory note; and the seal and endow-
ment notice of Mahmud I (*reg.* 1730–54).

6 Front cover

7

Tāj al-ma'āthir of Sadr al-Din al-Nishapuri

Anonymous copy completed during the last ten days of
Jumada'l-Ula 859 (9–18 May 1455)
Vienna, Österreichische Nationalbibliothek, MS.A.F.70

❧

THE *Tāj al-ma'āthir* ('The crown of great deeds') was written by Sadr al-Din Muhammad ibn Hasan al-Nizami al-Nishapuri and is concerned with the reign of the first independent Muslim ruler of Delhi, Qutb al-Din Aybak (*reg.* 1206–10), and the first year of the reign of his son, Sultan Iltutmish (*reg.* 1211–36). The original patron of the manuscript is unknown, but it bears the seal of Sultan Bayezid II. In 1749 it was purchased by Etienne Legrand, the French dragoman in Cairo.

The binding is of dark brown leather and is close to cat.6, both in the refined quality of the workmanship and in the use of gilding to enhance part of the design. The centre-piece on the front cover is a variation on the 'cloud-collar' cartouche: the two lobes at the sides have been subdivided by deep, palmette-shaped indentations, while the lobes at the top and bottom are simpler in form. This central figure has complex, palmette-shaped pendants, and its field is divided by a strapwork frame. This frame, the main outline of the centre-piece, the pendants, and the arabesque pattern that fills the outer section of the field were tooled in gold, while the arabesques in the inner section of the field are in blind, and the small knotwork motif at its centre is in gold. The design is set off by the fine stippling of the background.

The knotwork corner-pieces, tooled in gold and in blind, are relatively small in comparison to the fine centre-piece. Although he noted the unusual relationship between the centre-piece and these diminutive triangles of knotwork, Gottlieb, followed by Gratzl, considered the binding to be 'in the manner of Samarqand'. However, the person who catalogued the binding for the London exhibition of 1976 proposed an attribution to Turkey in the 15th century on the grounds that the triangular corner-pieces did not seem Persian in character. In fact they are all but identical to those of the binding on MS.Süleymaniye 1009, a copy of al-Firuzabadi's dictionary produced in Bursa in 1455–6. The same corner-pieces and the same border, whose knotted interlace and fillets are partly gilded and partly in blue, appear on the back cover. The pointed-oval centre-piece is very similar to that on the back cover of cat.6, although the pendants are of the 'everlasting knot' type. Like the borders and corner-pieces, this central design seems rather archaic when compared to the centre-piece on the front cover, which is in the most advanced style for Ottoman bookbindings of the 1450s.

The flap does not appear to be original, as a wider flap has left traces on folio 1a. However, it was probably added before 1749, as there is no such mark on the note pasted on to this page by Etienne Legrand. The doublures are of light-brown leather, with a border of two gold fillets. In the centre there is an interlace motif of the 'everlasting knot' variety, partly gilded, and partly blue.

Text block 307 folios, 272 × 180 mm, the text area 183 × 105 mm, with 19 lines of *ta'līq*, in one and two columns, gold border and guard stripes outlined in black, illumination.
Illumination Head-piece with *basmalah* in white Kufic on gold ground; heavily restored.
Sewing Modern restoration of 1921.
Published Flügel 1865, II, no.951; Gottlieb 1910, no.30, pl.7; Gratzl 1939, pp.1979, 1994, pl.956; London 1976, no.565; Duda 1983, pp.28–9.

7 Front cover

8

An atlas of the Balkhi school

Anonymous and undated copy
Produced for Sultan Mehmed II, probably in the 1450s
Istanbul, Topkapı Palace Library, MS.A.2830

❧

THE work this manuscript contains has often been erroneously identified as the *Ṣuwar al-aqālīm* ('Representations of the climes') of al-Balkhi, who died in AD 934. Al-Balkhi was famous for being equally competent in the religious sciences and 'philosophy', a rare achievement, and he is reported to have been the author of about 60 books, which also included the *Maṣāliḥ al-abdān* (see cat.23). The *Ṣuwar al-aqālīm*, which was primarily a commentary on a set of maps, has not survived, and the present manuscript appears to belong to an anonymous recension of both maps and text attributed to another 10th-century Muslim geographer, al-Istakhri – the version known as 'Istakhri II'. In this recension the 21 maps were less geometric, the text more polished than in 'Istakhri I'. The maps, which lacked a base projection and were treated as separate entities rather than sections from a larger sheet, consisted of a world map and maps of the Mediterranean, the Indian Ocean, the Caspian Sea and 17 provinces of the Islamic realm.[1] In this copy the maps follow the formal tradition established in the 10th century, but they are decorated in the Shiraz style, with gold 'waterweed' motifs; the seas are depicted in a dull ultramarine, and occasional fish have been added in gold outline.

The outer covers, which are in a mid-burgundy leather, bear a lobed centre-piece of the 'cloud-collar' type, while the corner-pieces are quarter-segments of a different but related figure; all are filled with an arabesque design, set against a stippled ground. The borders contain a pattern of diaper knotwork, which was highlighted in gold, as were the profiles of the corner- and centre-pieces and the arabesque designs. The inner edges of the gold profiles have been outlined in blue, and blue touches have been added to some of the elements within the centre-piece. The flap bears a variation of the same composition, but here the main field was worked in blind with a floral scroll against a stippled ground. The fore-edge section of the flap is divided into five panels of unequal size, which are filled with a band of gold interlace.

The touches of blue are not enough to alter the basic red-and-gold palette of the outer covers, but polychromy is a marked feature of the inner covers, which are in a dark grey-brown leather. The centre-piece is a lobed roundel of leather filigree, with a design of arabesques and escutcheon cartouches, which radiate from a central eight-pointed star. The star has a blue ground, and the ground of the escutcheons alternates between blue and blue-green, but the majority of the centre-piece has a gold ground. The corner-pieces are in the form of small triangles of knotwork, gold-tooled, and the borders consist of numerous blind fillets between two tooled in gold.

Although this volume is not dated, it bears a dedication to Mehmed II, and several features suggest that it belongs to the early part of his reign. It relates to Ottoman bindings datable to the 1450s in the use of burgundy leather with gold and blue tooling, a cruciform cartouche with arabesques, a knotwork diaper border, and a multi-coloured filigree doublure. In addition, the floral scrollwork in blind that fills the field of the flap is reminiscent of the work on the flap of cat.2, a manuscript dedicated to Murad II. The illumination and the phraseology of the dedication also suggest an early date. On folios 1b–2a the opening pages of text are enclosed within a broad, rectangular frame, filled with arabesques. The colouring – blue, gold and orange – and the style of the decoration are in a Shirazi idiom of the 1440s, and very similar work occurs in a manuscript dated 1442, which also has a dedication to Mehmed II but was certainly produced in Shiraz.[2] Another feature rare in Ottoman manuscripts of the 1460s and 1470s is the manner in which the text on folios 1b–2a has been set in *abrī* clouds with red outlines, against a background of brown cross-hatching. The dedication, on folios 0b–1a, is set within cartouches in the middle of two facing roundels. It was written in white *thulth* and takes a form otherwise not seen on books dedicated to Mehmed: *khudima li-ḥaḍrat al-sulṭān al-ʿādil / Sulṭān Muḥammad ibn Murād Khān ʿazza naṣruhu* ('Service was rendered to the

presence of the noble sultan, Sultan Mehmed, the son of Murad Khan – May his victory be glorified!').

Although the weight of evidence favours a dating in the 1450s, a note of caution is called for. A related binding occurs on an illustrated copy of the *Khamsah* of Nizami produced for the Timurid princess 'Ismat al-Dunya (*figure 77*).[3] The binding is likely to be an Ottoman replacement, perhaps put on when two miniatures were added in a style heavily influenced by Europe, for the fore-edge section of the flap was inscribed *bi-rasm al-khizānah al-sulṭāniyyah al-bāyazīdiyyah* ('For the library of Sultan Bayezid'). This presumably refers to Sultan Bayezid II, and, although the binding was probably produced for him while he was still a prince, it suggests that the style represented by these two bindings continued into the 1460s or 1470s at least.

Text block 149 folios, 318 × 214 mm, the text area, 203 × 132 mm, is set within a thin gold frame outlined in black, with an outer guard stripe in blue, and 15 lines of partly vocalized *naskh* in black ink, with details in red and gold.

Paper Polished, soft, cream, Oriental laid paper of medium gauge, with about eight laid lines to the centimetre, running at right angles to the spine, and chain lines in groups of three, about 7 mm apart, each group about 5 cm apart.

Illumination Discussed above.

Sewing Signatures of tens, using a two-ply, z-twist, z-spun blue silk in sewing pattern A; the headbands in cream and blue, but heavily repaired.

Published Karatay 1962–9, no.6524; Tayanç 1953; Binark 1965–6, pl.460 (fol.1b); Çığ 1971, pl.II (inside cover); Tibbetts 1992.

8 Back cover

8 Back doublure

9

Single-volume Koran

Copy made by Muhammad ibn Ghaybi in Rajab 859 (March 1455)
Dublin, Chester Beatty Library, MS.1504

❧

Few Ottoman Korans from the 1450s and 1460s have so far been identified, and this is one of the most lavish in terms of its illumination and binding. The organization of the page, with a central line of larger script, outlined in gold and flanked by lines of small *naskh*, also occurs in the Koran written by Ahmad al-Hijazi in Edirne in AH 856 (AD 1452), although this Koran also has lines in a large *muḥaqqaq* hand at the top and bottom, at least on the opening pages.[1] The system of multiple scripts was abandoned in later Korans, such as cat.21, and does not occur in the work of Şeyh Hamdullah and his school.

The edges of the burgundy leather outer covers have recently been restored. There is a large centre-piece, consisting of two pointed ovals with lobed outlines, one set within the other. The inner figure has complex strapwork knots as finials, and the same type of knots link its outline with that of the outer oval, at the sides; a similar motif replaces the main indentation of the 'cloud collar' corner-pieces. All the outlines and knots were tooled in gold, as were the leaves and arabesques that fill the centre- and corner-pieces. The wide border is filled with gold-tooled knotwork, but the pattern lacks the clarity of design seen, for example, in the borders of cat.1.

A distinguishing feature of this binding is the large knots in the centre-and corner-pieces. Comparable knots occur on another Ottoman binding of this period (cat.6), but they were not a common feature on Ottoman covers of the second half of the 15th century. They reappear on the binding of a manuscript produced in Amasya in 1477 (cat.32), but this work has several features in a retrospective style.

The decoration of the doublures recalls that used on several Ottoman manuscripts attributable to the 1430s and 1440s, because the centre-piece takes the form of a roundel with finials and shaped shoulders, though in the present case the roundels are filled with knotwork in blind, rather than trellis-work, as on cat.2 (*cf. figure* 28).

No other work by the scribe Muhammad ibn Ghaybi has so far been identified, and he is not mentioned in the standard biographies of Ottoman calligraphers. An ʿAbd al-Qadir ibn Ghaybi al-Hafiz al-Maraghi was an author during the reign of Murad II (see cat.2), but it is not known if scribe and author were related. An unassuming 30-part Koran was copied in Ramadan 849 (December 1445), probably for Murad II, by the latter's son, ʿAbd al-Latif ibn ʿAbd al-Qadir ibn Ghaybi al-Hafiz (*figure* 16).[2]

Text block 513 folios, 292 × 192 mm, the text area, set within a gold frame and containing nine lines of text, of which lines 1, 5 and 9 are in *thulth*, and lines 2–4 and 6–8 are in *naskh*.
Illumination The opening pages are heavily illuminated, with two rectangular panels above and below the text containing pointed cartouches inscribed with the titles of the *sūrahs* and the verse counts. The entire text block is surrounded on all but the inner side by a broad frame, which encloses a repeat pattern of stiff arabesques painted in gold and red against an ultramarine ground.
Sewing Modern.
Published Arberry 1967, no.188; James 1980, nos 70, 107.

9 Front cover

Sharḥ adab al-qāḍī of al-Khashshaf

Copy made by Abu ʿAli ibn Khalil
and completed on 17 Ramadan 870 (3 May 1466)
Istanbul, Topkapı Palace Library, MS.A.1017

❧

THIS is a copy of a 9th-century Arabic work on Hanafi jurisprudence, entitled 'Commentary on the judge's decorum'. It has a binding of light tan leather, and the front and back covers are decorated with a similar composition: a pointed oval with a lobed margin at the centre, sub-triangular corner-pieces whose shape was derived from the 'cloud-collar' cartouche seen on the flap, and a floral meander scroll in the border. However, the filling of the centre-pieces differs, which is a relatively uncommon feature of Ottoman bindings of the 1460s.

The design within the centre-piece on the front cover is asymmetrical and has bold floral motifs in a style associated with books that bear dedications to Mehmed II, motifs such as a feathery lotus blossom and an oak-leaf with one lobe folded over. The design of the centre-piece on the back cover is symmetrical on two axes, and uses a quite different flora, which consists mostly of small leaves and buds.

The light colouring of the leather, the shallow tooling, the use of a densely stippled ground, and of both blue and gold outlines are all features that differentiate this binding from the typical court product of the period, such as cat.11. They lend the binding a somewhat old-fashioned character. Other retrospective features are the polychromy of the doublures, which are in a mid-burgundy, with filigree centre-pieces set against a blue and gold ground; differing centre-pieces for the front and back doublures – a lobed oval on the front, and a roundel on the back; and the use of a rope tool in the middle of the edges of the main field.

In colouring and design the volume relates to certain Ottoman bindings of the 1450s, and there are elements, such as the rope-tool border used on the fore-edge section of the envelope flap and the thin knot-tool used to frame the doublures, that recall the work on cat.8. The ultimate inspiration, however, was from Iranian bindings such as those on MSS R.862 (cf. figures 13) and R.1547 (figure 48) in the Topkapı Palace Library; even a small detail – the cuir ciselé technique used on the corner-pieces – is more typical of Iranian than Ottoman work.

Text block 235 folios, 265 × 170 mm, the text area, 180 × 106 mm, with 27 lines of densely written, unvocalized *naskh* in black ink.

Paper Polished, cream Oriental paper of medium gauge, with about seven or eight laid lines to the centimetre, running at right angles to the spine; there are very faint chain lines about 12 mm apart, which are arranged in groups of three.

Illumination The first page of text (folio 1b) is framed on four sides with a wide border in ultramarine, a deep, orangey gold, and touches of red.[1] Folios 2a –8b contain an index of chapters written in gold, concluded by a cruciform cloud-collar motif flanked by flowers. A similar motif in ultramarine, filled with gold arabesques and flanked by Shiraz-style floral sprays in gold and orange, is set in an almost square panel beneath the tapering colophon on folio 235b.

Sewing Signatures of tens, using a two-ply, z-twist blue cotton in sewing pattern A; the headbands of green silk, with a small leather headcap.

Documentation There are two impressions of the seal of Bayezid II (folios 1a and 235b), a note on the title and subject of the text in Bayezid's own hand (folio 1a), and a note on the flyleaf recording that it was one of Bayezid's books (*min kutub Sulṭān Bāyazīd*).

Published Karatay 1962–9, no.3434.

10 Back cover

10 Front doublure

Two Commentaries on the Grammar of Sibawayh

Copy made by 'Umar ibn 'Uthman ibn 'Umar al-Husayni
Produced for Sultan Mehmed II, *circa* 1460–5
Istanbul, Millet Library, MS.Feyzullah 1983

THIS manuscript comprises two commentaries on the Arabic grammar of Sibawayh: the *Sharḥ kitāb Sibawayh* of Abu Sa'id Hasan ibn 'Abdallah al-Sayrafi occupies folios 1–490a, and the *Sharḥ abyāt kitāb Sibawayh* of Shaykh Abu Sa'id al-Isfahani, folios 491a–552a. According to the illuminated panels at the beginning of both texts they were copied 'to be read by' (*bi-rasm muṭāla'at*) Sultan Mehmed II.

The outer covers are of dark-brown levant-grain leather, and front and back bear the same design. The centre-pieces take the form of lobed pointed ovals, with heart-shaped knots at the indent of each lobe, and wide, wing-like finials. They are filled with a composition of arabesques and lotus flowers that is symmetrical on two axes. The design is worked in blind, and the ground of the oval has been neatly stippled in more or less regular horizontal rows. The corner-pieces are decorated in similar fashion, while the border is a diminutive s-tool cable, in blind.

The exact same centre-piece was used for the outer covers of two other undated manuscripts dedicated to Mehmed II: one contains a work on jurisprudence,[1] the other is the second volume of a literary romance, the *Sīrat 'Antar*.[2] The centre of some of the floral buds on the Sibawayh binding has been impressed with an oval tool in several sizes, which left a feather-like motif with a central stem and radiating striations. The same tools were used on the *Sīrat 'Antar* binding. Other leaves have been impressed with either an arc or a circular tool that had radiating lines. These, too, were used for the *Sīrat 'Antar* binding, though perhaps a little more lightly, and for an undated manuscript with a dedication to the grand vizier Mahmud Pasha,[3] as well as for cat.21.

The first volume of the *Sīrat 'Antar* is dated 1466, and this supports the dating of the bindings in this sub-group to the mid-1460s on stylistic grounds. The binding of volume II of the *Sīrat 'Antar* binding, for example, has a doublure comparable with – but, it must be stressed, not identical to – that of cat.13, which was produced for Mehmed II in Istanbul at the beginning of March 1467.

The envelope flap of the Sibawayh binding has a fore-edge section inscribed in *thulth*.[4] The flap itself is especially elaborate, as the entire field is occupied by large-scale lotus flowers, and oak leaves whose tips have been folded over. In the centre there is a pear-shaped medallion with a lobed and knotted profile like the figures on the outer covers. All the work was executed in blind against a ground stippled in more or less regular rows, and the same feathering tools have been used as on the outer covers. The use of an all-over composition on the envelope flap was a characteristic of the bindings in this group, and two of these are dated, one to AH 869 (AD 1464–5),[5] and the other to August or September 1466.[6]

The doublures are of mid-burgundy leather, and the filigree centre- and corner-pieces have arabesque work against a gilded paper ground, enlivened with groups of three tiny dots. In size and design the centre-piece is close to that used on the front cover of a manuscript dated between 21 and 30 November 1465 (*figure* 61).[7]

Text block 552 folios, 350 × 210 mm, the text area, 246 × 135 mm, set within a gold frame, with outer guard stripes in blue and gold and an inner stripe in gold, and containing 45 lines of a tiny, vocalized *naskh* in black ink, with details in red and gold.
Paper Polished, cream, soft Oriental laid paper of medium gauge, with about eight laid lines to the centimetre, running at right angles to the spine.
Illumination Double-page frontispieces precede the two works. In addition, small motifs such as cloud bands, executed in gold with thin black outlines, are interspersed throughout the text.[8]
Sewing In signatures of tens and twelves, using blue and green silk; headbands are in red and white silk.
Documentation Traces of an erased seal impression, probably that of Bayezid II, and the intact impression of the seal of Feyzullah Efendi, dated AH 1112 (AD 1700–1), on the first and last folios.
Published Sakisian 1927b, fig.8; Ünver 1946, pl.32; Öz 1953, p.22; Istanbul 1953, no.1; Tayanç 1953.

11 Folio 2a

11 Back cover

11 Back doublure

Al-nihāyah of Majd al-Din ibn al-Athir

Anonymous and undated copy
Produced for Sultan Mehmed II, *circa* 1465
Istanbul, Süleymaniye Library, MS.Süleymaniye 1025

❧

THIS work, the *Nihāyah* of Majd al-Din ibn al-Athir (1149–1210), is a dictionary of the less common words and meanings used in the Hadith, the reported sayings and deeds of the Prophet Muhammad.[1] The outer covers of this copy are of black leather and have blind-tooled decoration. At the centre of the composition there is a large pointed oval with a lobed profile, whose fleur-de-lis pendants have wing-like extensions. This centre-piece carries a composition of arabesque and floral scrolls that is symmetrical on two axes.[2] Comparable motifs are used for the corner-pieces, and the border is an s-tool cable framed by fillets, all in blind. The tooling is not as deep as that on cat.21, for instance; in this respect it is closer to the tooling on the binding of a manuscript which was completed during the first ten days of Rabi' al-Akhir 870 (21–30 November 1465) (*figure* 61). In comparison to cat.11 there was limited use of heated tools to create concave detailing in the motifs, and there was no use of the striated and feathery tools that are such a distinctive feature of bindings in the sub-group to which cat.11 belongs. The envelope flap of the binding is missing.

The doublures are in burgundy leather and are decorated with centre- and corner-pieces that contain filigree arabesques against a plain gold ground. The centre-piece takes the form of an eight-lobed figure with deep indentations between the lobes and quasi-triangular pendants, and the corner-pieces almost mirror the profile of the centre-piece. The border is minimal: a blind s-tool cable between fillets.

An identical doublure can be found on another undated manuscript in the Süleymaniye Library (MS.Şehzade Mehmed 28), which was also made for Sultan Mehmed II, and both bindings may be attributed to the mid-1460s on the basis of the illuminated frontispiece of the *Nihāyah* manuscript, for this is very close to the frontispiece of cat.13, which was completed in AH 871 (AD 1467).

Each half of the double-page frontispiece has a centre-and-corner design set within a rectangular frame; the centre-pieces are pointed ovals, and the corner-pieces are quarter-cartouches of the 'cloud-collar' type. The oval on folio 1b contains the dedication to Mehmed II, that on folio 2a, the name of the author and the title of the work. Although the detailing differs from that used on the outer covers, especially in the case of the border of the two centre-pieces, the general composition is the same, which illustrates the close connection between illumination and bookbinding in this period. The colouring, which is predominantly blue, with black, white, and earth colours such as burnt sienna and burnt ochre, is typical of the 1460s. An illuminated head-piece in the same colouring and style, with a *basmalah* in white Kufic against a blue ground, occurs at the top of folio 2b.

The doublures of this manuscript, and those of MS.Şehzade Mehmed 28, are of especial interest because their centre-pieces relate in their red and gold colouring, their form and their decoration to the star designs on the so-called Star Ushak carpets. This relationship suggests that the original design for Star Ushaks should be attributed to the 1460s rather than to the 1520s or 1530s, as previously believed.[3]

Text block 367 folios, 354 × 252 mm, the text area, 248 × 169 mm, set within a gold frame, with an outer guard stripe in blue and an inner stripe in gold, outlined in black. It contains 27 lines of unvocalized *naskh*, with little inter-word spacing, in black ink, with details in gold, and letters in the margin in red.
Paper Polished, cream, medium gauge, Oriental laid paper with about eight laid lines to the centimetre, running at right angles to the spine.
Illumination Discussed above.
Sewing Signatures of tens, using a green silk in sewing pattern A; the headband is of cream silk.
Documentation Impressions of the seals of Bayezid II and Süleyman I, the latter accompanied by a brief endowment notice.
Published Raby 1986, fig.14.

12 Front doublure

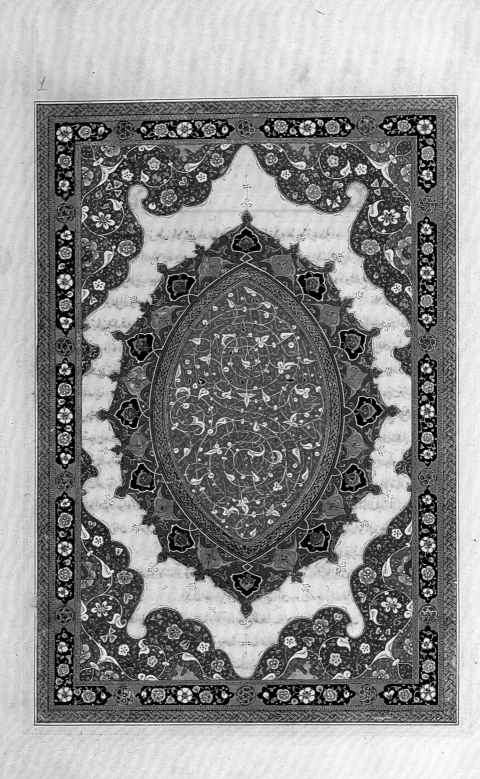

12 Folios 1b–2a

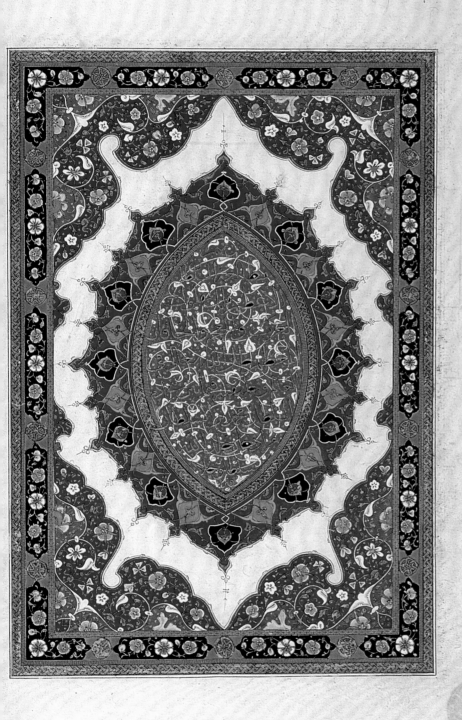

13

Al-wāfiyah of Rukn al-Din al-Astarabadi

Copy made at Constantinople by 'Ata'allah ibn Muhammad al-Tabrizi
and completed during the last ten days of Rajab 871 (26 February – 7 March 1467)
Istanbul, Topkapı Palace Museum, MS.A.2177

❧

THE *Wāfiyah* of Rukn al-Din al-Astarabadi was a commentary on the *Kāfiyah* of 'Uthman ibn al-Hajib, and both works were widely used for teaching the principles of rhetoric in the Ottoman *medrese* system. 'Ata'allah ibn Muhammad al-Tabrizi, the scribe who made this copy, had earlier produced a calligraphic tour-de-force for Mehmed II – a scroll over one and a half metres long that was written in the eight principal scripts, in a variety of sub-types and sizes, and with a range of conceits, from plaited *hastae* to figurative calligraphy in the form of a lion and a bird.[1] 'Ata'allah's name appears on the scroll alongside the date – 4 Rabī' al-Awwal 862 (20 January 1458) – and, though it is not expressly stated that he was the calligrapher, his activity as a scribe is proved by the present item. The scroll was not a functional document: it was evidently intended to impress the Sultan, and perhaps 'Ata'allah, recently arrived from Tabriz, produced it to gain imperial patronage.

The outer covers are of a dark brown, almost black, levant-grain leather, blind-tooled with a similar composition back and front. There is a lobed centre-piece, with knots at the indent of each lobe, and large wing-like pendants. The corner pieces are similarly lobed and knotted, and have deep indents. All the elements have been filled with large floral motifs typical of the Fatih style, and the oak-leaf in the middle of the centre-piece finds an almost precise parallel in the so-called Baba Nakkaş album (*figures* 58a–b). Similar motifs occur on a binding of a manuscript that was completed some six months after the present item, on Sunday 23 August 1467.[2]

The design of the centre-piece on the back cover is the reverse of that on the front, indicating that the binding was probably hand-tooled from a stencil, and not stamped (*figures* 51–2). All the work is in blind, and the main decorated areas have grounds of dense stippling, done with an awl in more or less regular horizontal rows. The fore-edge section of the envelope flap has a narrow floral meander scroll in a more spikey style than that of the front covers.

The doublures are of levant-grain, mid-burgundy leather, with centre- and corner-pieces in filigree against a ground of gold paper. The centre-pieces bear an arabesque and floral composition that is symmetrical on two axes. They thus contrast with the asymetrical centre-pieces of the outer covers.

Text block 194 folios, 265 × 166 mm, with a text area, 189 × 107 mm, set within a gold frame. An outer guard stripe in blue and an inner guard stripe in gold contain 17 lines, in one column, of partly vocalized *naskh* in black ink, with details in red and gold inks.
Paper Thin, hard, polished Oriental laid paper, with about eight laid lines to the centimetre, running parallel to the spine; there is no sign of chain lines.
Illumination The double-page frontispiece (folios 1b–2a) is very similar to that of cat.12.
Sewing Signatures of tens, using pink silk in sewing pattern A; the headbands are of pink and cream silk.
Documentation There are impressions of the seals of Bayezid II and Ahmed III, and of another seal that has been gilded over.
Published Karatay 1962–9, no.7761.

13 Back cover

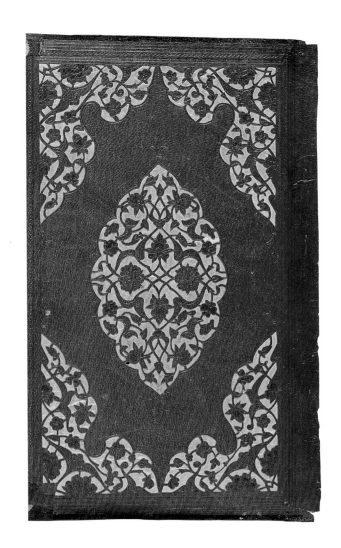

13 Back doublure

14

Al-Mulakhkhaṣ of Mahmud al-Chaghmini

Copy made by Yusuf ibn Ilyas in AH 871 (AD 1466–7)
Produced for Sultan Mehmed II
Istanbul, Topkapı Palace Library, MS. A.3296

THE *Mulakhkhaṣ* of al-Chagmini is an astro-
nomical work of the pre-Mongol period (al-
Chagmini died in 1221), and this copy was made 'to
be read by' Mehmed II in the last nine days of Safar
871 (2–10 October 1466), according to the colophon
on folio 38a.[1] The *Mulakhkhaṣ* is accompanied in this
manuscript by the commentary upon it by al-Sayyid
al-Sharif al-Jurjani,[2] which the same scribe com-
pleted in the first ten days of Dhu'l-Hijjah of the
same year (4–13 July 1467), according to a second
colophon, on folio 167b.

The evidence for Ottoman textiles of the 15th cen-
tury is scant. This makes the bookbindings associ-
ated with Mehmed II of especial importance, for they
provide dating evidence for tabby weaves, voided
and brocaded velvets and lampas weaves. The largest
group are the tabby weaves (see Appendix 2). Of
the 14 types eight are on bindings either dedicated
to Mehmed or datable to his reign. Most are from the
mid-1460s, but they range in date from 1461 to 1474:
they thus cease to be found on bindings at the very
moment when velvet bindings begin to occur.

In each case the same textile has been used to line
the outer covers and the doublures, with leather con-
fined to the edges of the textiles, the spine and the
inner face of the envelope flap. The leather is usually
decorated with blind fillets; in the case of cat.14–16,
there is also a blind-tooled everlasting knot in the
middle of the inner face of the envelope flap.

Cat.14 and cat.16–17 have impressions of the
seals of Sultan Bayezid II – in the case of cat.16 there
are only traces – and of Sultan Ahmed III, and a
note that is in Bayezid's hand giving the title and
subject of the work.

For the silk used here, see Appendix 2, type 6.

Text block 167 folios, 219 × 140 mm, with a text area,
93 × 58 mm, set within a thin gold frame with black
outlines and containing 13 lines of a diminutive, un-
vocalized *naskh* in black ink.
Paper Polished, cream Oriental laid paper, with
barely visible laid lines, almost nine to the centime-
tre, running parallel to the spine; no chain lines.
Illumination An oval cartouche on folio 1a contains
the title and name of the author in gold against an
ultramarine ground, with details in similar colour-
ing to cat.12; an unframed inscription above this,
written in gold *thulth* against the plain paper, con-
tains the dedication to Mehmed II.
Sewing Signatures of tens, using red silk in sewing
pattern A; the headbands are in red and blue silk.
Published Karatay 1962–9, no.7057.

15

Part of the Kitāb al-shifā' of Ibn Sina

Anonymous copy of the 1460s
Istanbul, Topkapı Palace Library, MS.A.3445

THIS volume contains the section on logic from
Ibn Sina's great philosophical work, the *Kitāb
al-shifā'*. Although it bears neither date nor dedica-
tion, it can be attributed to the 1460s because the
textile used to line the covers is of a type which was
used for two dated manuscripts, one from AH 869
(AD 1464–5), the other from November 1466 (see
Appendix 2, type 7).

Text block 201 folios, 308 × 197 mm, with an un-
framed text area, 208 × 112 mm, which contains 45
lines of a diminutive, unvocalized *naskh* in black
ink, with gold details, such as chapter headings.
Paper A thin polished cream Oriental laid paper, with
about seven laid lines to the centimetre, running
parallel to the spine.
Illumination None.
Sewing Signatures of 14s, using a two-ply, z-twist
green silk in sewing pattern A.
Published Karatay 1962–9, no.6666.

16

Ḥawā'ish 'alā Sharḥ al-Ishārāt of Nasir al-Din al-Hilli

Anonymous copy completed on 12 Rabi' al-Akhir 871 (21 November 1466)
Produced for Sultan Mehmed II
Istanbul, Topkapı Palace Library, MS.A.3220

THIS manuscript contains the notes (ḥawā'ish) of Nasir al-Din al-Hilli on the commentary (sharḥ) of Nasir al-Din al-Tusi on the Ishārāt, a philosophical work of Ibn Sina (Avicenna). Ibn Sina's work was evidently held in high regard at Mehmed's court.

Each face of the binding is covered with a panel of a striped silk textile (see Appendix 2, type 3), except for the inside of the envelope flap. The textile is a warp-faced tabby in structure, and the pattern consists of alternating dark-red and blue warp stripes. Brown-black leather has been used for the spine, to edge the panels of textile and to line the inner face of the envelope flap, which is decorated with a blind-tooled everlasting knot, about 5 mm square.

The volume opens with a double page of illumination (folios 0b–1a), in the form of two oval cartouches, painted in the typical palette of the 1460s

(cf. cat.12). One (folio 0b) contains a dedication, which notes that the manuscript was made 'to be read by' Sultan Mehmed,[3] while the other contains the title of the work and the name of the author.

Text block 259 folios, 245 × 140 mm, the text area, 153 × 79 mm, set within a gold frame and containing 23 lines of partly vocalized *nasta'līq* in black ink, with details in gold.
Paper Similar to that of cat.14.
Sewing Signatures of tens, in sewing pattern A, using blue silk in the centre, and red silk top and bottom; the silk headbands have red and white vertical stripes.
Illumination In addition to the frontispiece there is an illuminated headpiece on folio 1b.
Published Karatay 1962–9, no.6662; Tayanç 1953; Öz 1953, p.21; Tanındı 1985, pp.29–30.

17

Two Philosophical Works of al-Suhrawardi

Anonymous copy completed during
the middle ten days of Rabi' al-Akhir 865 (24 January – 2 February 1461)
Produced for Sultan Mehmed II
Istanbul, Topkapı Palace Library, MS.A.3377

LIKE cat.15 above, this manuscript contains the work of a Muslim philosopher, in this case the 12th-century theosophist Shihab al-Din al-Suhrawardi. His *Kitāb al-mashāri' wa'l-muṭāraḥāt* occupies folios 1a–306b, and his *Ḥikmat al-ishrāq* is on folios 307a–352b (cf. cat.26 and 29). The colophon on folio 352b, which is written in a gold *thulth*, says that the book was written for the treasury of Mehmed II and gives the date of its completion.

The same silk textile has been used for the outer covers and the doublures and for the outer face of the envelope flap (see Appendix 2, type 8). There is no decoration of the leather elements.

Text block 352 folios, 260 × 148 mm, with a text area, 178 × 91 mm, set within a thin gold frame with black

outlines and containing 21 lines of a partly vocalized *nasta'līq* in black ink, with details in gold; the script is small in scale, with a relatively large interlinear spacing of just under half a centimetre.
Paper Similar to that of cat.14.
Illumination A roundel on folio 1a contains the title of the book in white *thulth,* set in *abrī* clouds against a gold ground, the clouds cross-hatched in red; the border has a dull ultramarine ground filled with a floral meander scroll; on folio 301b there is gold floral decoration with black outlines, similar to that in Süleymaniye Library, MS.Fatih 2571M.[4]
Sewing Signatures of eights, using thin white silk in sewing pattern A; the headbands, of thick white silk, are in a chevron pattern.
Published Karatay 1962–9, no.6693.[5]

14

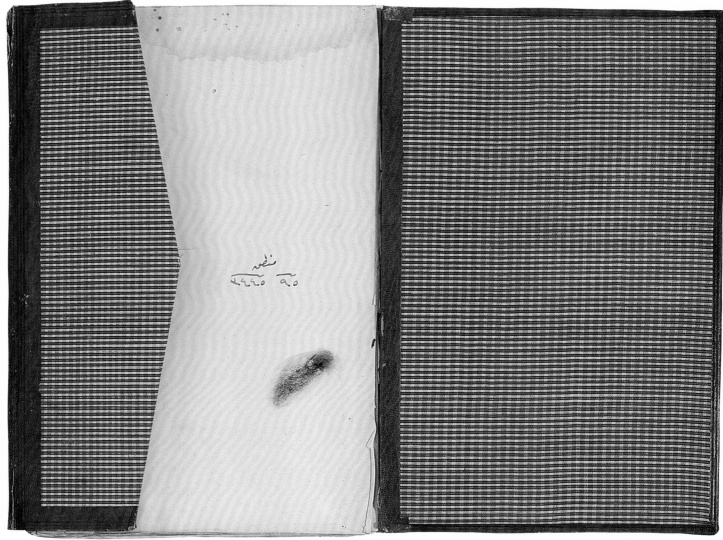

15

16

17

Al-fawā'id al-ghiyāthiyyah of 'Adud al-Din al-Iji

Copy made by Ahmad ibn 'Ali Maraghi and completed
on 24 Rabi' al-Akhir 873 (11 November 1468)
Produced for Sultan Mehmed II
Istanbul, Topkapı Palace Library, MS.A.1672

੬෧

Tʜɪs manuscript contains a famous work on rhetoric by 'Adud al-Din al-Iji, who died in 1355. The dedicatee, from whose name the title of the work was derived, was Ghiyath al-Din Muhammad, the son of Rashid al-Din and minister to Sultan Abu Sa'id from 1328 until his execution in 1336.[1]

The splendid covers are an early example of an Islamic binding decorated with lacquer painting. Islamic lacquer was produced by combining painted designs with a lustrous varnish, and the lacquer decoration of this binding was applied to a leather-covered pasteboard base: the medium-tan leather of the base can be seen where the lacquer has chipped off.

It will be apparent that Islamic lacquer had no technical connection with the lacquer of eastern Asia, not least because the sap of the lacquer tree was not available in the Middle East. But the use of gold motifs on a black ground suggests that the painter responsible for the decoration of this binding was influenced by the general aesthetic effect of some Chinese lacquerware.[2] The same can be said of other Islamic lacquer bindings of the later 15th century that are presumed to have been made in Herat. Like the present example, these have black grounds and are usually decorated in gold.[3]

The doublures of the *Fawā'id* manuscript are of burgundy leather, which provides a startling contrast to the black and gold exterior, but the decoration is very restrained. The centre-pieces consist of a tiny everlasting-knot motif with s-tool cable extensions above and below, and there are delicate borders of gold fillets enclosing an s-tool cable framed by blind fillets. The inside of the flap is ornamented in a similar manner.

On the covers the framework of the design (the borders and the outlines of the centre-pieces) consists of black bands defined by single or double gold fillets. The central figure on the upper and lower covers is a pointed oval with palmette-shaped knot-work finials. The field within the figure is filled with a rotating pattern of scrolling tendrils set with leaves and flowers. The flowers include large rosettes with five wide and five pointed petals. There are also a series of large, composite, lotus-like blossoms, the largest of which sits at the centre of the composition.

The same rosettes and blossoms occur in the floral scrollwork that fills the surrounding field. In this case the pattern is roughly symmetrical along the horizontal and vertical axes, and the rosettes have been placed on either side of the centre-piece, at the narrowest points, and the large 'lotuses' in the middle of the four spandrels. The main body of the flap is decorated with symmetrical floral scrolls on either side of a central roundel, which is filled with a rotating arabesque design on a field set with tiny triple-dot motifs.

Text block 37 folios, 271 × 167 mm, with a text area, 168 × 91 mm, set within a gold frame, with an outer guard stripe in blue and an inner guard stripe in gold, and containing 11 lines of vocalized *naskh* to the page, written in black and gold, with wide interlinear spacing.

Paper Medium-thick, cream, Oriental laid paper, with about seven barely visible laid lines to the centimetre, running at right angles to the spine; chain lines are arranged in groups of three, with about 10 mm between each line and about 45 mm between each group, but they are not visible on every page.

Illumination An oval cartouche on folio 1a contains the dedication to Sultan Mehmed II; it has the brilliant colouring typical of the 1460s, though the lack of borders and the narrowness of the oval is unusual. The text is in gold *thulth* against an ultramarine ground, enlivened with groups of three dots and orange arabesques. There is an illuminated headpiece on folio 1b.

Sewing Signatures of tens, using a two-ply, z-twist pink silk in sewing pattern A; the headbands are now missing.

Documentation Impression of the seal of Bayezid II and a note in his hand on the title and subject of the work, and an impression of the seal of Ahmed III.

Published Karatay 1962–9, no.8150; Çağman 1983, no.E.3; Tanındı 1984b, pp.223–4 and fig.1; Tanındı 1990–1, fig.6, pl.va.

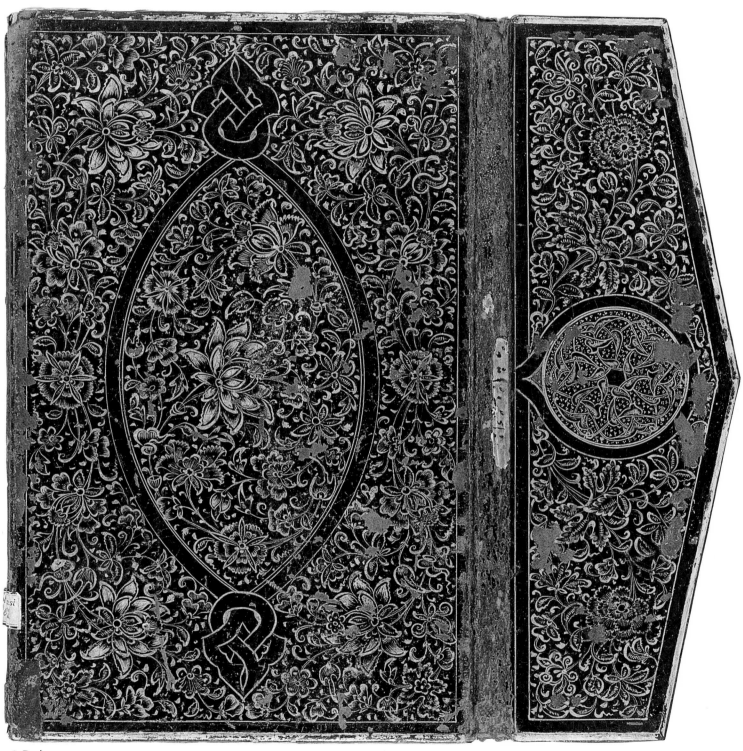

18 Back cover

Ra's māl al-nadīm of Ahmad ibn 'Ali ibn Bani

Anonymous and undated copy
Produced for Sultan Mehmed II, probably in the mid-1470s
Istanbul, Süleymaniye Library, MS. Turhan Valide 234

٭

THIS manuscript contains a 12th-century collection of historical anecdotes, whose title means the 'Stock-in-trade of the boon companion',[1] and was made 'for the library of' Sultan Mehmed II, according to the dedication on folio 1a. The binding is one of a small group with gilded outlines that also includes cat.20 below, copied in 1474. On this basis the binding of this manuscript may also be ascribed to the mid-1470s.

The outer covers are of black leather with lightly tooled decoration. The outlines of all the motifs, except for the arabesque scrollwork in the centre-pieces, have been highlighted in gold with, for the most part, double lines. The oval centre-pieces are lobed, with a knot between each lobe, and the corner-pieces are indented. These figures and the wide inner border are filled with a combination of floral and arabesque scrollwork, and the whole composition is framed by a narrow outer border, in which a cable motif worked in gilt with an s-tool runs between blind fillets.

The design on the envelope flap is an enlarged version of the left-hand half of the main centre-and-corner composition, with the double scroll-work of the centre-piece extended into the point of the flap. On three sides it is surrounded by the simple cable border that appears on the outer covers, and also on the doublures.

The doublures are of mid-burgundy leather. Each has a pointed-oval centre-piece with a lobed and indented profile. These are filled with arabesque filigree and have outlines, projecting rays and fleur-de-lis pendants in pale blue. The ground to the filigree is predominantly gold, with small areas in blue, and the gold has been pricked with small groups of triple dots. The corner-pieces are similar in all but their profiles, which are segments of a 'cloud-collar' figure.

The illumination of this volume is of a standard far below that normally found on books produced for Mehmed II, which suggests that it was not commissioned by the Sultan himself but was made as a presentation copy. On folio 1a there is a narrow oval cartouche with a blue border. It contains the title of the work and a dedication to the sultan, written in a clumsy gold *thulth* against an unpainted ground. Above the text on folio 1b there is an illuminated cartouche containing a *basmalah* in gold *muhaqqaq*. The script appears on a blue ground, which is set with arabesque scrollwork in white and a *semé* of white dots. The cartouche is surrounded by a rectangular frame, and the fields between the two are filled with spindly floral sprays on a black ground; the sprays are in gold and have no outline.

This style of 'waterweed' decoration in gold, though usually set against a blue ground, was typical of Shiraz in the first half of the 15th century. It had been transmitted to Turkey by the time that the illumination in cat.2 above was executed, presumably in the mid-1430s, and its influence continued well into the reign of Mehmed II.[2] A fine example decorates an undated copy of the *Sirat 'Antar* prepared for this Sultan,[3] and lesser versions are found in manuscripts made for him in the 1460s.[4] However, this illumination seems retrograde in a manuscript produced in the 1470s not only in terms of its style, but in the quality of the pigments, especially the matt ultramarine, and the use of orange for the details of the arabesques.

Text block 212 folios, 264 × 182 mm, with an unframed text area, 157 × 96 mm, and 17 lines of unvocalized *naskh* in black ink, with details in red.

Paper Soft, cream, polished Oriental laid paper of medium gauge, with laid lines running parallel to the spine, about eight to the centimetre; there is acid migration from the ink which has stained much of the text area.

Illumination See above.

Sewing Signatures of tens, at eight sewing stations, using red silk in the centre and two-ply, z-twist, yellow silk top and bottom; the headbands are in a chevron design in yellow and red silk, the red now badly faded.

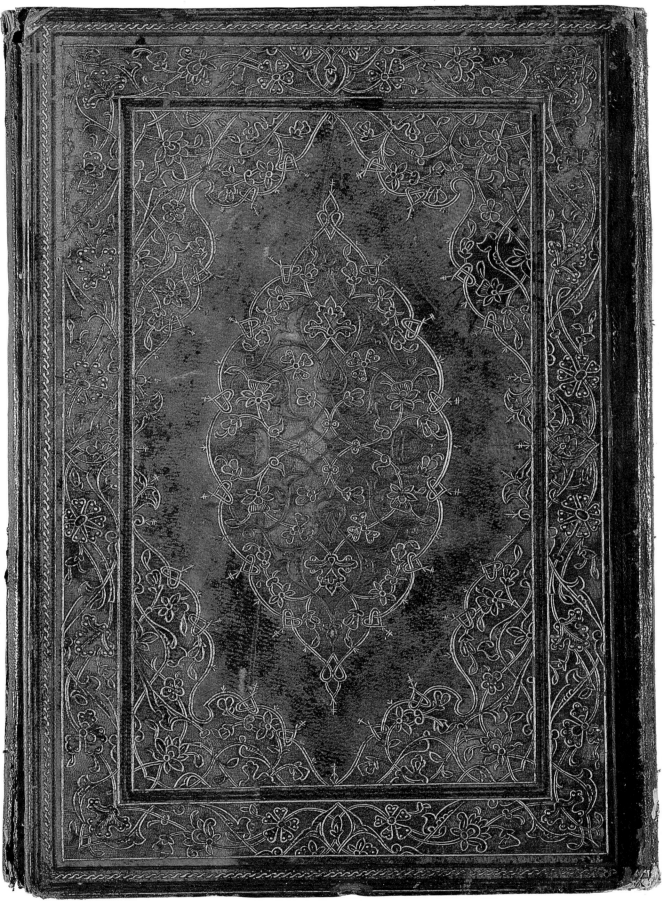

19 Front cover

20

Ghurar al-aḥkām of Molla Hüsrev

Autograph copy completed on 15 Dhu'l-Qaʿdah 878 (3 April 1474)
Dedicated to Sultan Mehmed II
Istanbul, Topkapı Palace Museum, MS.A.1032

꿎

THE *Ghurar al-aḥkām* is an Arabic work on Hanafi jurisprudence by Muhammad ibn Faramurz ibn ʿAli al-Tarsusi, commonly known as Molla Hüsrev. Molla Hüsrev held a number of important judicial posts under Mehmed II, but at one point, apparently offended by not being given pride of place next to the Sultan at a planned feast, Molla Hüsrev left Istanbul to live in Bursa. The date of this incident is not clear, but the dedication on this manuscript may help to date their reconciliation. On his return from Bursa to Istanbul, the Molla was appointed chief *müfti* of the empire.[1]

The outer covers of the manuscript are of black goatskin, tooled and painted in blue and gold, and both bear the same design of a pointed-oval centre-piece with a lobed profile and small fleur-de-lis finials; the corner-pieces are segments of a 'cloud-collar' motif. The centre-piece contains a combination of floral and arabesque scrollwork, which is symmetrical on the horizontal and vertical axes, and fragments of the same pattern fill the corner-pieces. The narrow border consists of an s-tool cable motif in gold, which is set between groups of fillets tooled in gold and in blind. The same border and the same corner-pieces appear on the exterior of the flap, whose centre is occupied by a roundel with lobes that decrease in size towards the point on the fore-edge side.

The doublures are of burgundy morocco, and the 12-pointed figure at the centre of the main field, the sub-triangular corner-pieces and the roundel on the flap have all been worked in filigree. The complex series of lobed and pointed figures into which the areas of filigree have been divided is expressed by the alternation of gold and blue grounds.

The overall design of the outer covers is a variant of one used on bindings made for Mehmed II in the 1460s and 1470s, such as cat.11 and cat.21. It differs in the generous use of blue and gold, which are employed here as an infill for the flowers and arabesques, as well as to emphasize the outlines.[2] These colours had been used for outlining motifs on several groups of bindings produced in the 1450s and

1460s in which a strong influence from Iran can be detected, but few of these are attached to manuscripts dedicated to the Sultan. Many of them have doublures with filigree designs against a blue and gold ground in a style quite different from that introduced under Mehmed II in the 1460s (*figure 46–7*).[3] The filigree doublures of the present item are more elaborate in design and more expertly executed even than those of cat.10, but they are closer to them in spirit than they are to the doublures of manuscripts in the Fatih style, such as cat.22.

Several of the manuscripts that use gold and blue for outlines can be associated with Bursa, and it is possible that the present item was also produced there. This would help explain why it differs from work associated with Istanbul in this period, and why it contains several somewhat 'old-fashioned' features – the use of flax for sewing the gatherings, the small triangles of knotwork, tooled in gold and blue, placed in the middle of each side of the main field, and the bands of similar knotwork running above and below the entire composition.

Text block 159 folios, 252 × 175 mm, with a text area, 157 × 89 mm, set within a blue and gold frame and containing 13 lines of poorly formed *nastaʿlīq* in black ink, with details in red and gold.
Paper Polished, cream Oriental paper, whose gauge ranges from medium to thin.
Illumination Folio 3a bears a pointed oval medallion with a gold ground on which appear green arabesques and a dedication to Mehmed II in white *thulth*, and the beginning of the text on folio 3b is surmounted by an elaborate illuminated headpiece. The wording of the dedication is not paralleled in other dedications to Mehmed II, and may have been composed by Molla Hüsrev himself.
Sewing Signatures of tens, using two-ply, z-twist white flax in sewing pattern A; the headbands worked in diagonal stripes of red and yellow silk.
Documentation Seal of Bayezid II.
Published Karatay 1962–9, no.4048; Çağman 1983, no.E.5; Tanındı 1990–1, fig.21.

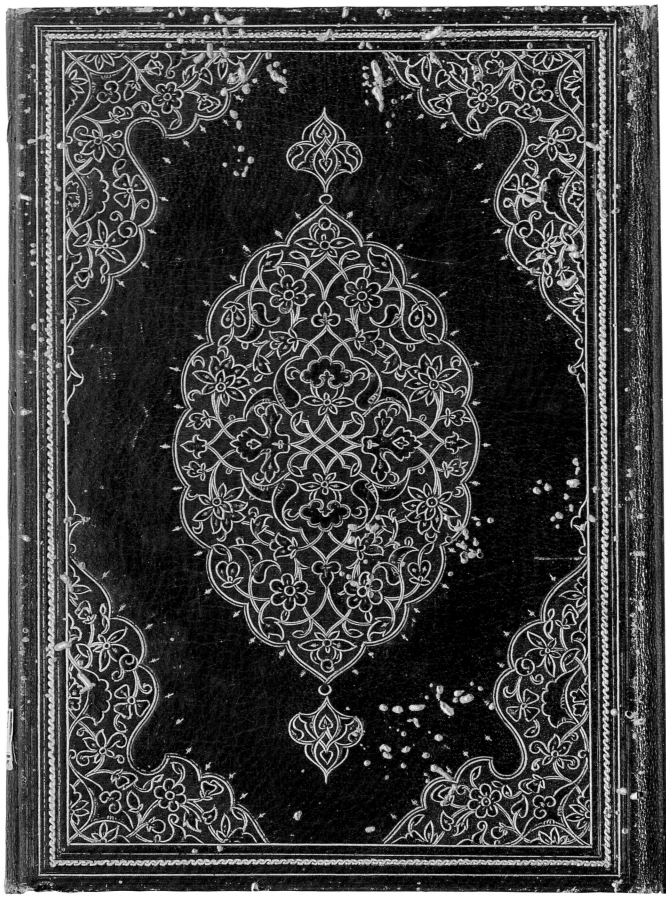

20 Back cover

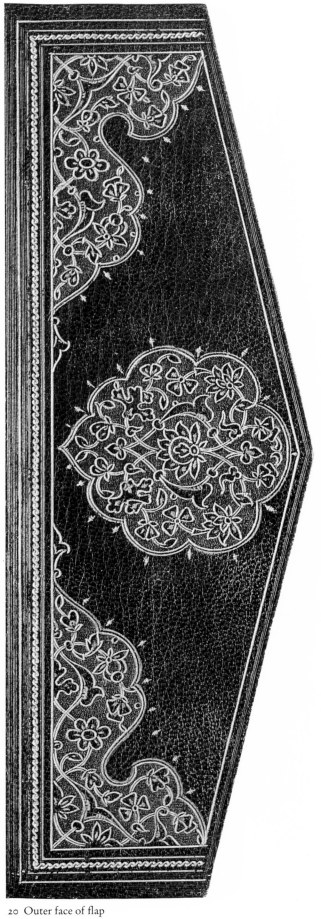

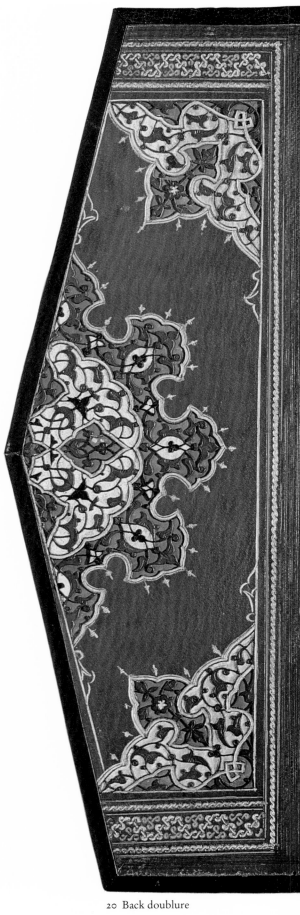

20 Outer face of flap

20 Back doublure

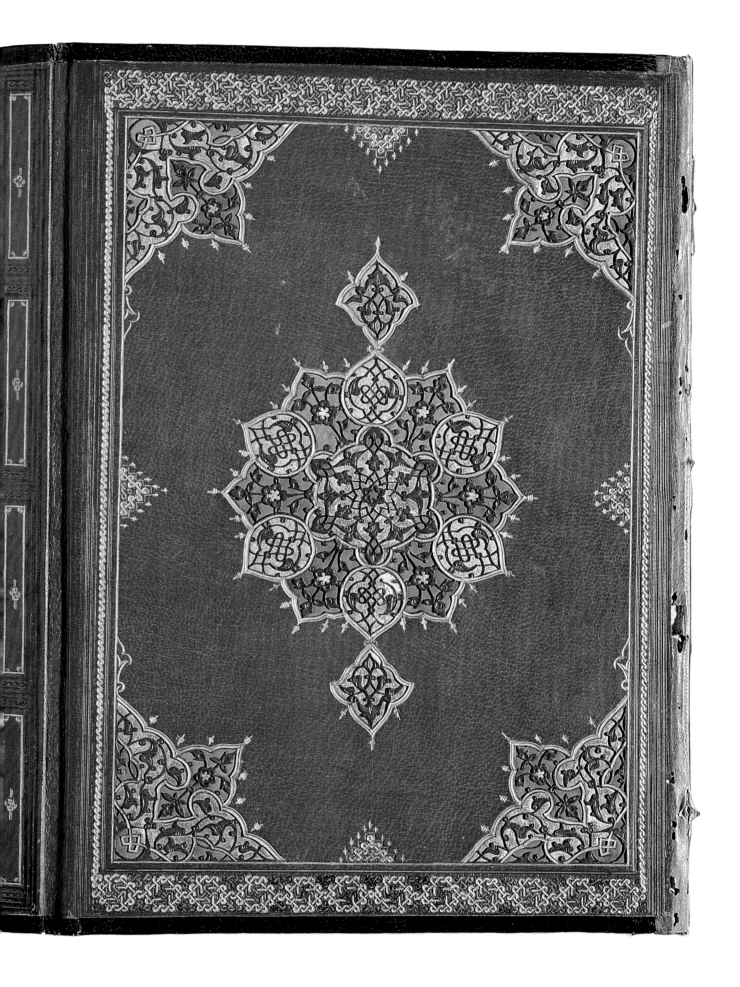

Single-volume Koran

Anonymous and undated copy
Probably produced for Sultan Mehmed II, *circa* 1465–70
Istanbul, Museum of Turkish and Islamic Arts, MS.448

❧

Tʜɪs is the most impressive Koran, and also the largest manuscript, to survive from the reign of Mehmed II. The scarcity of Korans of 'imperial quality' from his reign contrasts strongly with the number from the reign of his son Bayezid.[1] This was a prestige copy, with the text written in gold in a style of script, *thulth ashʿar*, used for the text of Korans in the Zangid and Mamluk periods. By the 15th century, however, it was normally reserved for the titles of *sūrahs*.[2] The illumination is especially rich in colouring and variety, while the composition of the frontispiece anticipates that used for a Koran copied by Şeyh Hamdullah in 1499 (cat.41). There is no evidence to prove for whom this Koran was made, but it is likely to have been the Sultan himself, as it appears to have been kept in the Topkapı Palace for several centuries.

The outer covers are of a black levant-grain leather, now so abraded that the colour has gone from parts of the front cover, and most of the back cover (*figure* 50). The covers are worked in blind with the same design of a lobed pointed-oval centre-piece, which is filled with a composition of arabesques and miscellaneous motifs that is symmetrical on two axes. The corner-pieces are similarly lobed and decorated. The border is filled with a single meander floral scroll; small, flowered stems spring from the scroll, but without forming an interlace. The envelope flap has a similar border and corner-pieces, and a lobed roundel, pointed at one end, in the centre. Additional interest is given to the design by deep circular depressions and small arcs with feathering. The same tools were used on several bindings that were produced for Mehmed II and are datable on stylistic grounds to the 1460s, though none of the manuscripts is precisely dated (cat.11).

As on many of the bindings produced for Mehmed II, there is a contrast between the motifs used for the centre-pieces of the outer covers and those used on the doublures. The filigree design of the doublures, which is identical front and back, consists of arabesque leaves only, and there are none of the floral elements found on the covers.

The volume bears no dedication page, and it opens with a single-page of illumination; the facing page is evidently missing. The composition is of pairs of lobed oval cartouches laid in four rows one above the other. The cartouches are set at angles of 45 and 315 degrees. The colour range is broad, with an ultramarine ground, orange, light-blue, terracotta, light-green, pink, white, yellow and red. The effect is made livelier by the use of different colours for the details of the flowers and other motifs. During Bayezid's period the polychromy was more controlled (cat.41).

Text block 34 folios, 406 × 275 mm, with a text area 272 × 175 mm, set within a gold frame edged in black, with an outer blue guard stripe, and containing 11 lines of vocalized *thulth ashʿār*, that is, *thulth* in gold with black outlines; the script is densely packed: the gold vocalization is large, and, though the interlinear spacing is generous, there is little space between the words.

Paper Hard, thick, cream Oriental wove paper with a high burnish.

Illumination As well as the frontispiece described above, there is illumination on folios 2b–3b, with the first two *sūrahs* set within rectangular frames, and the central panels of text in *abrī* clouds against a ground of pink cross-hatching. *ʿAshr, ḥizb, juzʾ* and *sajdah* marks were written in the margins in a gold *thulth* with black outlines, which is slightly larger than the script of the main text; they are not surrounded by illuminated cartouches. *Sūrah* headings are set in a rectangular panel within the text frame. The title of the *sūrah* is in *thulth* within a cusped cartouche. The panels have gold plaited borders.

Sewing Gathered in signatures of eights, sewn at eight stations, using s-twist cream flax in the centre, and a thin, two-ply, z-twist, z-spun pink silk for the shorter lengths, top and bottom; the headband is in blue and pink two-ply, z-twist, z-spun silk.

Documentation It bears an impression of the seal of Bayezid II on folio 334b and was presumably kept in the Topkapı Palace, until it was donated to the library of Ayasofya by Sultan Mahmud I. It was transferred from this library to its present location in the early part of this century.

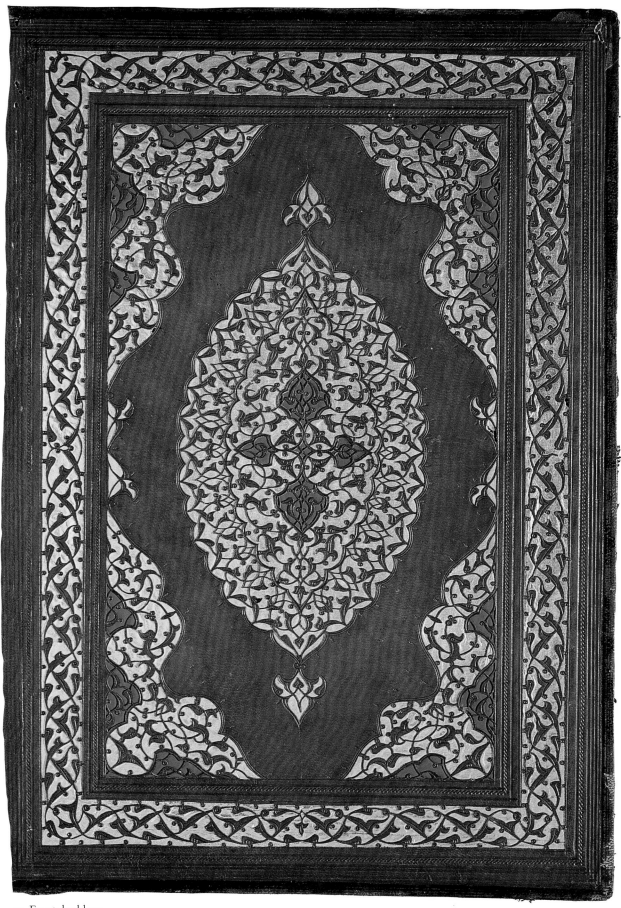

21 Front doublure

The Farā'id-i Ghiyāthī of Yusuf ibn Muhammad Ahl al-Jami

Copied for Mehmed II
by Sayyid Muhammad ibn Sadr al-Din al-Munshi al-Muhsini
in Rabi' al-Awwal 881 (July 1476)
Richmond-upon-Thames, Keir Collection

❧

THIS manuscript contains a collection of exemplary letters (*inshā'*), ranging from imperial correspondence to letters of condolence. The text was originally dedicated to the Timurid ruler Shahrukh, the son of Timur, in AH 834 (AD 1431). This copy was, appropriately, produced by an Iranian chancery calligrapher who was also a *munshī*, that is, a man skilled in the epistolary arts.

Sayyid Muhammad al-Munshi worked originally for the Turcoman ruler Uzun Hasan, but was captured by the Ottomans in 1473, when Uzun Hasan was soundly defeated at the battle of Başkent. He produced several manuscripts for Mehmed and worked for the Ottoman court until at least 1488, when he wrote a manuscript for Bayezid II.[1]

Sayyid Muhammad was a fine exponent of the convoluted script known as *ta'līq*. This script appears to have been developed for use in chancery documents, and Sayyid Muhammad seems to have played an important role in introducing this script into Ottoman chancery practice, where it developed into the hand known as *dīvānī*. Sayyid Muhammad was also one of the first to employ *ta'līq* in manuscripts, and this fine example is one of several from the closing years of Mehmed's reign.[2]

The outer covers are in a brown-black leather, lightly worked in blind, with a narrow pointed-oval centre-piece and lobed and indented corner-pieces.

The centre-piece bears a design of flowers and arabesques that is symmetrical on two axes, and its ground is lightly stippled. The burgundy leather doublures have a centre-piece consisting of a lobed roundel and pendant escutcheons, all filled with delicate arabesques against a gold ground enlivened with groups of four dots.

Text block 209 folios, 313 × 195 mm, with a text area 187 × 116 mm, set within a blue frame and containing 11 lines of *ta'līq* script in black ink, with details in red and chapter headings in gold *thulth*, outlined in black.

Paper A polished, cream Oriental laid paper that is hard and thick, with eight or nine faint laid lines to the centimetre running parallel to the spine.

Illumination A roundel on folio 1a gives the title of the book and a distinctively styled dedication to Mehmed II. It has a silvery-gold ground with floral and arabesque details in light ultramarine, white, ochre, lilac blue and green. The head-piece on folio 1b has a *basmalah* in gold against a gold ground.

Sewing Both the sewing and the headbands have been renewed.

Documentation There are no seals visible, but there is a faint oval impression on folio 209b, which was presumably made with the seal of Sultan Bayezid II.

Published Robinson & others 1988, p.22, no.PT1.

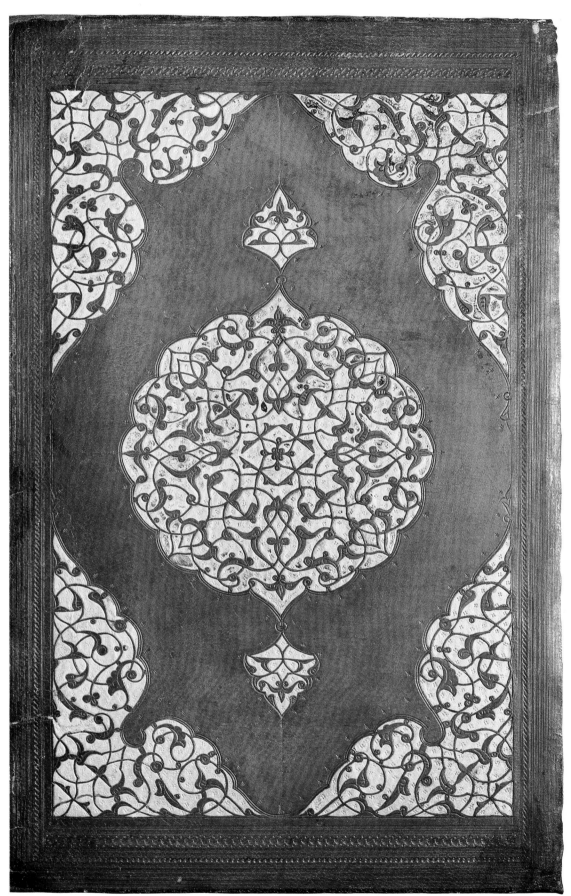

22 Back doublure

The Maṣāliḥ al-abdān of Aḥmad al-Balkhi

Copy made by Şeyh Hamdullah
Produced for Sultan Mehmed II, *circa* 1478
Istanbul, Süleymaniye Library, MS.Ayasofya 3740

ẻ♠

THE work contained in this volume is, with the *Kitāb ṣuwar al-aqālīm* (see cat.8), one of the two works attributed to al-Balkhi. This copy is in a format known as a *jung,* in which the text block is oblong, and the text has been written parallel, rather than at right angles, to the spine. The format was often used for poetical anthologies produced in Iran in the 15th century,[1] but it was unusual for Ottoman books of the period.

The outer covers are lined with a velvet that is now lake in colour, but was perhaps originally more crimson. The velvet is voided down to the satin ground with a design of pomegranates within an oval frame. The textile is edged in black leather, blind-tooled, and with an s-tool cable between fillets. The burgundy leather doublures have a lobed pointed-oval centre-piece with escutcheon pendants, worked in filigree against a predominantly gold ground, with touches of blue. The gold ground has been pricked with a *semé* of three small dots. The blind-tooled border is similar to that on the outer covers.

Although it is not dated, this volume evidently comes from the end of Mehmed's reign. Firstly, the velvet is similar to that used for a manuscript now in the Süleymaniye Library (MS.Ayasofya 3696), which was copied in Constantinople by Ghiyath al-Mujallid al-Isfahani and completed on 3 Dhu'l-Hijjah 882 (8 March 1478; see Appendix 3). Secondly, the illumination compares in style and colouring to that of another manuscript in the same library (MS.Ayasofya 3389), a copy of the *Kitāb jawharāt al-sharaf* of Tahir ibn ʿAbdallah ibn ʿAli ibn Ishaq. The text of this work was copied by Sayyid Munshi al-Sultani in Constantinople in Muharram 886 (2–31 March 1481).[2]

The scribe of cat.23 was Şeyh Hamdullah, who was to become the most famous of Ottoman calligraphers.[3] According to Müstakim-zade, Hamdullah was born in Amasya in AH 840 (AD 1436–7), and he would therefore have been in his mid-forties when Mehmed II died in 1481, by which time he must have produced numerous works. Yet tradition associates him almost exclusively with his great patron, Sultan Bayezid, and three of his best known works are Korans produced during this Sultan's reign (cat.38, cat.40, cat.41). However, this manuscript, together with an undated medical manuscript also dedicated to Mehmed II,[4] prove that Hamdullah had already received imperial patronage before the accession of Sultan Bayezid.

Şeyh Hamdullah has not here used the long sublinear extensions that were so characteristic of his later *naskh*. Whether this was because they were a later development in his style, or because he considered them inappropriate in a volume with such a narrow text frame, is not clear.

Text block 140 folios, 285 × 152 mm, with a text area 210 × 100 mm, set within a gold frame, with a black outline and an inner gold guard stripe, also outlined in black, and containing 15 lines of fully vocalized *naskh* in black ink, with details in gold.

Paper Polished, cream Oriental laid paper, the barely visible laid lines running at right angles to the spine.

Illumination A dedicatory frontispiece in the form of an oval with pendants contains the title and the name of the author, written in white *thulth* against a gold ground and interspersed with sprays of arabesques in green, and the first page of the text is crowned by a head-piece in which there is extensive use of contrasting tones of gold; gold has also been used as a ground for flowers in a wide palette: red, orange, blue, green, beige, brown and pale lilac.

Sewing Both the sewing and the headbands have recently been renewed.

Documentation Impressions of the seals of Bayezid II, Ahmed III and Mahmud I, the last accompanied by an endowment notice.

Published Istanbul 1953, no.72 (colophon); Ünver, n.d., fig.11 (medallion on flap).

24 Back doublure 24 Back cover

24

Dustūr al-ʿāmil fī wajaʿ al-mafāṣil of Masʿud al-Hasani

Anonymous copy completed on 14 Safar 881 (8 June 1476)
Produced for Sultan Mehmed II
Istanbul, Topkapı Palace Library, MS.A.2005

૨▲

IN 1476 Mehmed II suffered from a severe attack of gout, and this Persian text on the treatment of pain in the joints must have been welcome.

The tiny volume is covered with part of an Italian crimson velvet that bears an elaborate voided and brocaded design. The structure of the velvet remains to be determined, though it may have a satin ground. The brocading was executed with a thread of gilt metal, wrapped around a silk core. The metal appears to be of a thicker quality, and the wrappings less evenly spaced, than on cat.25. Yellow has been used as a core to heighten the gilt effect where spaces occur between the metal wrappings. The brocading wefts are bound in twill, creating z diagonals.

It is not easy to find close parallels for this velvet, and the style has some affinities with velvets depicted in paintings of the Netherlandish School in the mid-15th century (see Appendix 3).

The textile is edged with leather, which is dark-brown, almost black, in colour and has a border of s-tool cabling framed by fillets. The doublures are of levant-grain leather of a light, matt burgundy colour and are simply decorated in blind: there is a border of fillets, and, in the centre, a small rosette with radiating lines, six millimetres in diameter, is flanked by four minuscule fleur-de-lis tools at the cardinal points. Part of the same tool has been used to decorate the point of the inner face of the main section of the envelope flap, and a small version of the same rosette occurs on the inner face of the fore-edge section. A similar tool, but of different size, was used by Ghiyath al-Din al-Mujallid for cat.31.

Text block 141 folios, 178 × 127 mm, with a text area, 113 × 65 mm, set within a blue and gold frame and containing 11 lines of forward-sloping, unvocalized *naskh* in black ink, with details in red.

Paper Polished, cream, medium-thick, Oriental laid paper, with about five laid lines to the centimetre running at right angles to the spine.

Illumination On folio 1a there is a small plain-edged roundel with an ultramarine ground and a plaited border in gold, in which the dedication was recorded in gold *thulth* with accompanying white arabesques. On folio 1b there is an illuminated head-piece.

Sewing Signatures of eights, in sewing pattern A, using a thickish red silk in the centre and a white silk of very thin gauge top and bottom; the head-bands consist of diagonal stripes of red and blue silk.

Documentation Impressions of the seals of Bayezid II and Ahmed III.

Published Karatay 1961a, no.273; Ünver 1942, p.2; Ünver 1952, fig.16; Baylâv 1953, pp.54–6, fig.60–62; Tayanç 1953.

The Talkhīṣ al-muḥaṣṣal of Nasir al-Din al-Tusi

Anonymous and undated copy
Purportedly made for Sultan Bayezid II
Istanbul, Topkapı Palace Library, MS.A.1890

ﺀﻪ

THIS volume, which contains the abbreviation by Nasir al-Din Tusi of Fakhr al-Din al-Razi's work on theology and philosophy, is not dated, but the frontispiece bears the name and titles of Sultan Bayezid II. The style of the frontispiece is, however, precisely that used in books dedicated to Mehmed II.[1] This would appear, at first sight, to suggest that the work was copied and bound early in Bayezid's reign, following in the tradition of the last item.

The title of the work and the name of the author are set inside an oval cartouche, and are written in gold *thulth* against an ultramarine ground, interspersed with white arabesques, much in the style of cat.24. This cartouche is enclosed within a rectangular gold frame, with broad horizontal panels above and below.[2] It is these panels which contain the dedication to Bayezid, and they are executed in similar fashion to the title. But the dedication has been tampered with: the ultramarine ground around the names of both Bayezid and his father, Mehmed, is slightly different in colour, and Bayezid's name is written in a cramped fashion. It seems likely, then, that this volume originally bore a dedication to Mehmed that was altered following Bayezid's accession.

There is no certainty, though, that it ever entered Bayezid's library, because it does not bear his seal, nor is there the typical note in Bayezid's hand giving the title and subject of the work. There is, however, a note on the flyleaf that reads, *Oda'dan çıkan arabî* ('Arabic [book] that came out of the Chamber'); this suggests that the book was not kept in the Inner Treasury but in the Has Oda (Privy Chamber), which would explain why it was not sealed and annotated by Sultan Bayezid.[3]

The binding has been faced with a crimson velvet with metal brocading. The metallic thread consists of what may be strips of silver-gilt wrapped around a yellow silk core, and every third warp of the satin ground binds this metallic thread in twill, producing pronounced crimson s diagonals. The technique here is quite different from that of cat.24. Where this velvet was produced still remains to be established, although there are some similarities to European brocaded velvets of the first half of the 15th century (see Appendix 3).[4]

The volume is edged with black leather, which is decorated with blind fillets, tiny s-tool cabling and one gold-tooled fillet. The doublures are of a matt mid-burgundy leather and carry no decoration.

Text block 175 folios, 228 × 130 mm, with a text area, 127 × 69 mm, set within a blue and gold frame and containing 23 lines of an unvocalized *nasta'līq* of indifferent quality, in black ink, with details in red and gold.

Paper Thin, cream, polished Oriental laid paper, with about six barely visible laid lines to the centimetre running parallel to the spine.

Illumination In addition to the frontispiece that is referred to above, there is an illuminated head-piece on folio 1b.

Sewing Signatures of tens, in sewing pattern A, using a yellow-green, two-ply silk, which is of thin gauge and tightly plied, in the centre and a pinkish-white silk top and bottom; the headbands were sewn in a chevron pattern in red and gold.

Documentation On folio 1b there is an impression of the seal of Ahmed III, while a large, round seal has been obliterated with gilding.

Published Karatay 1962–69, no.4798, where he mistakenly gives the shelf-number as A.1980 and claims that the dedication is to Mehmed II.

24 Back cover

25 Back cover

Four philosophical works of al-Suhrawardi

Anonymous and undated copy
Bound in the late 1470s
Istanbul, Topkapı Palace Library, MS.A.3266

ða

THE works of the 12th-century theosophist, Shihab al-Din al-Suhrawardi, appear to have been popular at Mehmed's court (*cf.* cat.17). Suhrawardi is often referred to as *shaykh al-ishrāq* ('the master of illumination'), for he is regarded as the founder of the Illuminationist school of philosophy. He is also known as *al-maqtūl* ('the executed'), as he was put to death by the son of Saladin in 1191.

This volume, which contains Suhrawardi's four most important philosophical tracts, is covered with a green voided velvet with cinquefoil medallions that enclose, and are topped by, a pomegranate motif (see Appendix 3, nos 36–42). Neither the pomegranate nor the medallion is, though, as striking as the equivalent motifs on the crimson velvets used for the bindings of some of Mehmed II's manuscripts. The edging of the binding is in medium- to light-tan leather, blind-tooled with a series of fillets and small s-tool cabling.

The doublures of this binding are in a mid-burgundy leather typical of books produced for Mehmed II, and they carry as a centre-piece a lobed pointed-oval cartouche in blind that is filled with floral elements in the Fatih style. The same cartouche is used on the back doublure in reverse, indicating the use of a stencil. The remainder of the decoration is very simple, with blind fillets for the border, and triangular knotwork for the corner-pieces.

Unlike those with crimson velvet covers, none of the manuscripts that have green velvet bindings is dated during the reigns of Mehmed II or Bayezid II, and none bears illumination or dedications to either of these patrons, while a few are earlier copies that have been rebound. As with the present volume, their texts are often anthologies (in this case by a single author), and they were written in a small script, usually vocalized, in an unframed text area, and with none of the use of gold for frames, illumination or details of text that is usual in books written for Mehmed II. Several, such as MS.A.2755, also in the Topkapı Palace Library, have extensive marginal glosses, and indeed parts of the last half of this manuscript have been crossed out.

The relative simplicity of the presentation, and the variety of the texts within a single volume suggest that the books may have been intended for teaching purposes rather than as prestige library products. The same does not seem to have been the case with the crimson velvet bindings, several of which occur on manuscripts that have imperial dedications and were written by leading scribes, such as Şeyh Hamdullah (cat.23). This is understandable since crimson was the most expensive textile dye in this period.

The present item, however, is the largest of the manuscripts with green velvet bindings. It was written on paper that is heavier, better-sized and more heavily burnished than most in the group, and it is written in a stately, unvocalized hand. Yet, as it lacks a dedication, and the book titles are written in a style that lacks any elaboration, there is no need to believe that it was intended as a personal copy for the sultan.

Text block 145 folios, 355 × 225 mm, the unframed text area, 262 × 133 mm, containing 33 lines written in a neat *naskh* hand, in black and red ink; there is no illumination.
Paper Medium-thick, polished, cream, Oriental laid paper, with about seven laid lines to the centimetre running at right angles to the spine, and no visible chain lines.
Sewing Signatures of tens, in sewing pattern A, using a two-ply, z-twist white silk.
Documentation Impressions of the seal of Bayezid II and two different seals of Ahmed III: his *waqf* seal on folio 1a, his almond-shaped seal dated AH 1115 on folio 2a.
Published Karatay 1962–9, no.6690.

26 Front cover

27

The Taqwīm al-siyāsah of al-Farabi

Anonymous and undated copy of *circa* 1480
Istanbul, Topkapı Palace Library, MS.A.2460

❧

THIS work on politics, commonly known as the 'Sayings of Plato', is one of four manuscripts covered with voided crimson velvet and lined with different versions of a pink and yellow-green silk that is the most important surviving example of 15th-century Ottoman silk-weaving (see Appendix 3, nos 1, 3–5). The designs on the silks consist of oval frames arranged in staggered rows. The figures within these frames alternate row by row between a cusped and lobed 'medallion' and a fleur-de-lis motif. The fleurs-de-lis are filled with arabesque leaves, while the 'medallions' have a central stem of paired arabesques, from which spring sprays of floral buds. The entire design was executed in tabby weave in a yellow-green silk against a pink satin-weave ground.

The velvet used for the outer covers of these four books was not all from the same bolt of cloth. The specimen used to cover the present item was used for one other of the group (MS.A.2022), as well as for cat.28, which is lined with a different textile. This velvet has two levels of pile, and there are voided areas in the form of small, pomegranate-like motifs; the contrasting levels of pile were used to create the bracket pattern that frames the 'pomegranates'.

The present item is of similar size to cat.28, cat.29 and MS.A.1863, and all of them have the same black leather edging on both the outer covers and the doublures. This edging has been blind-tooled with fillets framing a tiny s-tool cable. All the books were written in a sturdy *naskh* in black and red ink, with no frame. They do not, however, all appear to have been written on the same paper, a point which deserves further investigation.

Text block 183 folios, 248 × 164 mm, with a text area, 155 × 82 mm, containing 15 lines of vocalized *naskh* in black ink, with details in red.
Paper Well-burnished, hard Oriental laid paper of medium thickness, with about eight laid lines to the centimetre running parallel to the spine; there has been acid migration, perhaps from the black ink, so that the paper has turned brownish in parts.
Illumination There is no illuminated decoration, but the title and the author's name were written in large gold *thulth*, outlined in black, in five unframed lines on folio 1a; there is a *basmalah* in similar style, also without a frame, on folio 1b.
Sewing Signatures of tens, in sewing pattern A, using z-twist white silk; no headbands are visible.
Documentation It bears impressions of the seals of Bayezid II and Ahmed III, and a note on folio 1a in Bayezid's hand.
Published Karatay 1962–9, no.6927; Tanındı 1985, p.31.

27 Back cover

27 Back doublure

28

Al-bashā'ir al-nāṣiriyyah of Qadi Zayn al-Din

Anonymous copy completed during
the last ten days of Muharram 886 (22–31 March 1481)
Istanbul, Topkapı Palace Library, MS.A.3438

❧

THE crimson velvet used for the outer covers of this manuscript, which is a work on logic, is the same as that used for two other manuscripts in the Topkapı Palace Library, one of which is cat.27 (see also Appendix 3, nos 1–3). The similarity between the bindings extends to the black leather edging to the textile panels. Yet, whereas cat.27 is lined with an Ottoman silk of the 15th century, the inner faces of this binding are lined with a patterned silk whose date and provenance are uncertain.

The silk has a golden-brown satin-weave ground, and the pattern was woven in tabby with a blue weft. The main motif, arranged in staggered rows, consists of a six-petalled rosette framed by Chinese-style cloud-bands. Around this, scrolling rinceaux have been organized into six tight circles, each of which encloses a second type of rosette with eight petals.

The same textile was used for the doublures of the binding of an autograph anthology by Muhammad bin Sayf al-Din Aydemir, which he copied in Baghdad in Shawwal 705 (16 April –14 May 1306).[1] But it seems probable that the covers of the anthology are the result of a rebinding about 1481, for one must otherwise conclude that the Ottomans used a silk of the early 14th-century to bind the *Bashā'ir al-nāṣiriyyah*.

As regards provenance, it has been suggested that the textile is Chinese.[2] In terms of motifs, the cloud-bands are no indication that this was a product of the Far East, for cloud-bands began to appear with increasing regularity in Iranian painting and illumination in the 15th century, and were – in various guises – to become a common feature in Turkish decoration in the 16th century.[3] One of the earliest, and most remarkable, appearances of the motif in Ottoman art is on a binding that can be attributed

to the latter part of Mehmed II's reign (*figure 49*). The rosette and short feathery leaf anticipate the motifs found on some Iznik tiles and pottery of the 16th century.[4] It is therefore conceivable that the silk was an Ottoman product, but the question of provenance will doubtless only be settled through analysis of the fabric's structure.

The inner face of the fore-edge section of the envelope flap is covered with a medium-tan levant-grain leather and is decoratd with three cartouches with rounded ends, each enclosing a small blind-tooled 'everlasting knot', with s-tool extensions above and below. This manuscript is of very similar size to cat.29, which was produced less than three months earlier.

Text block 244 folios, 250 × 170 mm, the unframed text area, 160 × 91 mm, containing 15 lines of unvocalized *naskh* in black ink, with details in red.
Paper Cream, burnished, medium-thick, Oriental laid paper, with about seven laid lines to the centimetre, running parallel to the spine; there is acid migration in the text block, evidently from the black ink, and the paper has turned brownish.
Illumination There is no illuminated decoration, but the title and the name of the author are written in red ink in three lines of *naskh* on folio 1a, and there is a small *basmalah* in black ink at the top of folio 1b.
Sewing Signatures of tens, in sewing pattern A, using a thin, two-ply, z-twist green silk; the headbands have oblique stripes in red and yellow silk.
Documentation The volume bears impressions of the seals of Bayezid II and Ahmed III, and a note on the title and name of the author, in Bayezid's hand, on folio 1a.
Published Karatay 1962–9, no.6771; Tanındı 1985, pp.30–1.

28 Front cover

28 Back doublure

29

The Sharḥ Ḥikmat al-ishrāq of Quṭb al-din al-Shirazi

Anonymous copy completed
during Shawwal 885 (December 1480–January 1481)
Istanbul, Topkapı Palace Library, MS.A.3236

❧

THE text of this volume is a commentary on the famous *Ḥikmat al-ishrāq* of Shihab al-Din al-Suhrawardi. At least three copies of al-Suhrawardi's original text were written for Mehmed II: the earliest was cat.17, dated AH 865 (AD 1461); the second was completed in Rabi' al-Akhir 882 (July–August 1477), by Sayyid Muhammad al-Munshi al-Sultani;[1] while the third is undated but can be assigned to the 1470s on the basis of the style of *ta'līq* script in which it was written.[2] A fourth copy (cat.26) was probably produced in his court scriptorium, but it is not expressly dedicated to him.

The binding is covered with an Italian crimson velvet with two levels of pile and voiding for fine details of design. The structure of the velvet appears to be similar to that of cat.28. The same velvet was used for the covers of several other manuscripts in the Topkapı Palace Library (see Appendix 3, nos 4, 5).

The doublures are lined with a silk of the same pattern as that used for cat.27, but the colour scheme differs and it is executed in a tabby weave in a darker green silk against a paler pink, satin-weave ground. Both the manuscripts have similar edging in black leather, decorated with blind-tooled fillets framing a narrow s-band cable.

Text block 672 folios, 248 × 162 mm, the unframed text area, 158 × 83 mm, with 15 lines of partly vocalized *thulth-naskh* in black ink, and details in red.

Paper Cream, burnished Oriental laid paper of medium thickness, with about seven laid lines to the centimetre, running parallel to the spine; there is some foxing, and acid migration in the text block.

Illumination There is no illuminated decoration, but the title and the name of the author were written in red ink in six lines of *thulth-naskh* on folio 1a, and there is a *basmalah* in gold, with black outlines, at the top of folio 1b.

Sewing Modern, the volume crudely restored on the spine and the inner face of the fore-edge section of the flap with a plain, reddish-brown leather.

Documentation Impressions of the seals of Bayezid II and Ahmed III, as well as a note on the title and name of the author in Bayezid's hand on folio 1a.

Published Karatay 1962–9, no.6701; Mackie 1989, fig.11.

29 Back cover

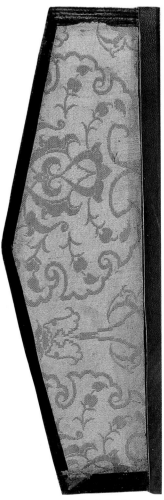
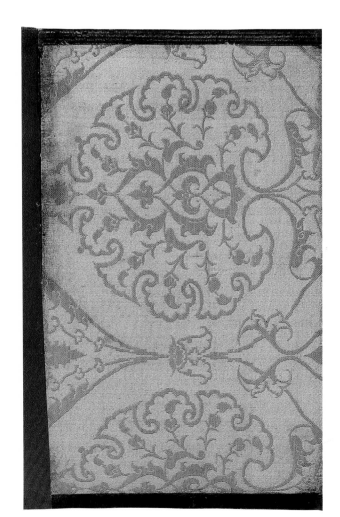

29 Back doublure

The Makhzan al-asrār of Nizami

Copy made by Razi in AH 885 (AD 1480–81)
Istanbul, Topkapı Palace Museum, MS.R.880

ॐ

THE text of this Persian literary manuscript ends with a brief prayer written in four lines of gold *ta'līq*, outlined in black. Below this there is a small signature in black *riqā'* script, *Raqamahu al-faqīr Rāḍī* ('Poor Razi wrote it'), and, to the left, *Fī 885* ('In 885'). Razi is otherwise unknown as a scribe, but he was capable, as this volume proves, of an accomplished, large-scale *nasta'līq*.

The binding was once covered with a brownish-gold silk: only the cloth on the envelope flap survives, but the design has left an impression on the outer covers. This silk has a self-coloured design of opposed s-forms, the ends of which terminate in five-lobed leaves. The s-forms are set obliquely and join up with adjacent s-forms, leaving a space filled with an eight-pointed star, each point of which has a fleur-de-lis extension.

Even more remarkable is the fabric with which the binding was lined. In this compound silk, white wefts form the designs in tabby weave on black and white stripes, separated by red, which are in satin weave. The white stripes carry a frieze of three-lobed leaves framed by feathery fronds. The wider type of black stripe contains a rectangle with a double-pointed medallion laid on its side; the medallion is filled with arabesque leaves and is set against a maze pattern. Flanking the rectangle are areas of a diaper net design, with eight-pointed stars linked by thin oblique lines and knots. The rhombs between the stars contain a cruciform motif. Between each of these wider bands are two inscriptional bands containing a repetition of the phrase *al-sulṭān al-malik*

al-'ādil ('The sultan, the just king'). Where the silk was produced is still a mystery, but there are some similarities with textiles that are believed to have been produced in the Mamluk empire in the 14th century.[1]

The book has been edged with a red-brown leather, blind-tooled with a small s-tool cable framed by fillets. The same leather has been used to edge the doublures and to line the inner face of the fore-edge section of the flap.

Text block 77 folios, 262 × 162 mm, the unframed text area, 168 × 98 mm, with 15 lines of unvocalized *nasta'līq* written in two columns in black ink, with headings in gold, outlined in black; there are five blank folios at the beginning and eight at the back.

Paper Medium-thick, cream, burnished Oriental laid paper, with about eight laid lines to the centimetre, running parallel to the spine.

Illumination There is no illuminated decoration, but folio 1a bears the title and the name of the author written in red ink, in two lines of *nasta'līq*, and there is a *basmalah* in gold *nasta'līq*, with black outlines, at the top of folio 1b.

Sewing Signatures of eights, in sewing pattern A, using a two-ply, z-spun, z-twist cream silk; the headbands have largely disappeared.

Documentation On folio 1a there is a note in the hand of Bayezid II, giving the title and the name of the author, as well as impressions of the seals of Bayezid II and Ahmed III.

Published Tanındı 1985, pp.33–4; Karatay 1961a, no.475; Mackie 1989, fig.12.

30 Front doublure

Horoscope of Sultan Mehmed II

Copy made in Istanbul by Ghiyath al-Din al-Mujallid al-Isfahani
circa 1475–80
Istanbul, Topkapı Palace Library, MS.Y.830

❧

GHIYATH al-Din al-Mujallid al-Isfahani was not only the scribe of this manuscript, but also its binder. Because of this dual role, and because he always mentioned it in his colophons, Ghiyath al-Din is the best documented binder working under Mehmed II. It is probable that he came to Istanbul relatively late in Mehmed's reign, perhaps in AH 879 (AD 1474–5). Eight manuscripts by him have so far been identified, and they are varied in technique and quality (Chapter Two, Table 3). He was one of the first binders to use high-relief pressure-moulding, and the first to use a panel-stamp with figurative decoration (cat.33). The proportions of the lobed centre-piece, and the small-scale floral motifs, distinguish his work from the style hitherto favoured by Mehmed's binders. Ghiyath al-Din was therefore responsible for introducing Iranian techniques and aesthetics that were to transform the course of Ottoman bookbinding (*figures* 70 and 73).

The outer covers of this item are brilliantly executed; the pressure moulding is not particularly deep, a little under 1 mm, but the modelling is crisp, and the ground is well stippled for textural contrast. The doublures, by contrast, are less impressive. They are in black levant-grain leather. A gold fillet frame creates an inner panel, set back about 1.7 mm from the edges of the cover. There is a narrow pointed-oval centre-piece, and triangular corner-pieces with a shaped extrusion along the hypotenuse, all worked in filigree against a gold ground. The rendering is somewhat cramped, and compares unfavourably with the filigree-work on cat.22.

Text block 264 folios, 249 × 173 mm, the unframed text area, 140 × 93 mm, with 9 lines of unvocalized *nasta'līq* script in black ink, and details in red and turquoise.
Paper Medium-thick, cream, burnished, Oriental laid paper with some foxing, and acid migration in the text block; there are about seven laid lines to the centimetre, running parallel to spine.
Illumination There is no dedicatory frontispiece, but a head-piece at the beginning of the text consists of the *basmalah* in gold *thulth*, outlined in black, without a frame.
Documentation With the impression of the seal of Bayezid II and a note in his hand which gives the title of the book and calls blessings on his father and grandfather.
Sewing Signatures of eights, in sewing pattern A, using a green two-ply, z-twist silk thread for the top and bottom pairs and a red z-twist silk, in the centre; headbands missing.
Published Karatay 1961a, no.246.

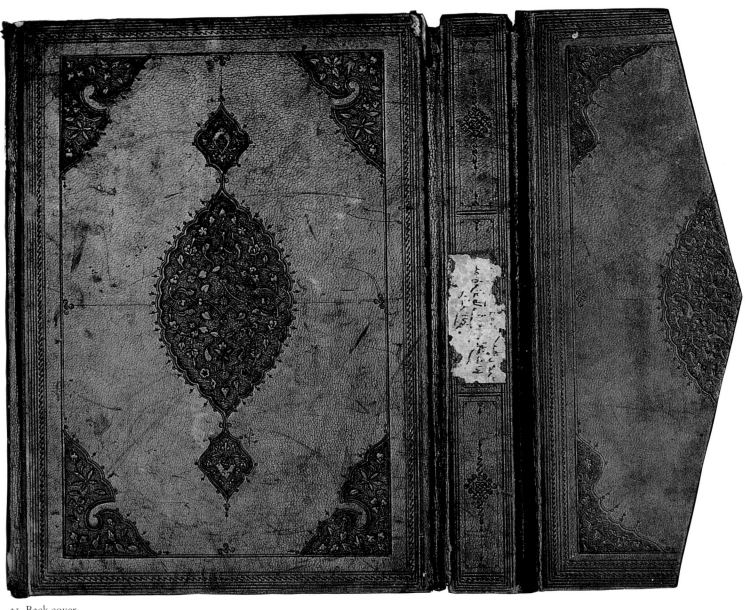

31 Back cover

32

Commentaries on the Maqāṣid of al-Taftaẓani

Copy made in Amasya by Junayd al-Toqati in AH 881 (AD 1477)
Produced for Prince Bayezid
Istanbul, Museum of Turkish and Islamic Arts, MS.1820, formerly MS.3265

❧

THERE are only a handful of Ottoman figurative bindings of the 15th century, and the decoration of the front cover and envelope flap make this the most elaborate example.

In the colophon the copyist gives his name as Junayd al-Toqati and states that he was the master of the *medrese* of Atabey Gazi in Amasya, popularly known as the Safi Medrese; that he wrote the work at the command of Prince Bayezid, whose court was in the same city; and that he began the task in the month of Shawwal 881 (17 January–14 February 1477) and finished it during the last ten days of Dhu'l-Qa'dah of the same year (6–16 March 1477).

The front cover, which is of a medium-brown leather, has a gently lobed centre-piece. The middle of this is filled with arabesques, while a running floral scroll occupies its wide border; the border is punctuated by four lobed 'tear-drops', and the finials end in escutcheons. The corner-pieces are an adaptation of the profile of the centre-piece and escutcheon finials. The most remarkable element of the binding, though, is the filling of the spandrels between the centre- and corner-pieces.

Each of these is occupied by the same arrangement of three monkeys in combat with a Chinese-style dragon: one of the monkeys pierces the dragon through the head with a sword. Monkeys were one of the most popular motifs in Iranian figurative bindings of the 15th century, one of the earliest occurrences being on a binding for a manuscript produced for the Timurid ruler Shahrukh in 1438, but there is no published example in which they are in combat with a dragon.[1]

The binding is lightly tooled, with painted gold details and touches of blue. Contrast in texture is provided by juxtaposing plain areas with areas that have the finest of stippling, done with a needle. The heads of the monkeys have been worked with a small crescent tool in blind. The border of the outer front cover is narrow, and segmented, with alternating panels of knotwork and interlace made up of two principal tools – one in the form of a swastika, the other in the form of a rhomb.

The outer face of the envelope flap gives the best idea of the original condition of this binding, as the gilding, the blue paint used to define the cusped frames, and the stippling are all in fine condition. Here there is a symmetrical arrangement of a phoenix fighting a lion, while a bird on the ground, another in flight, and a strange basilisk – with a fox's head, two legs, wings, and a dragon's tail – look on.

The design of the back cover is abstract. The centre-piece takes the form of a gently lobed roundel that has been filled with interlocking swastika tools; it has finials on four sides, which extend into elaborate knot-forms. The corner-pieces mirror the central roundel, while the interstices are filled with floral scrollwork, part blind, part gilded, against a ground of very fine stippling. An inscription on the fore-edge section of the flap gives the title of the book.

The doublures are of a similar leather and colour to the outer covers, but both front and back doublures bear an identical composition. The centre-piece is a lobed pointed oval with extended finials, whose hafts are punctuated by small roundels. The corner-pieces are similarly treated and take the form of cusped triangles with finials. All the elements, except for the finials, are executed in filigree against a ground painted in dark-green, blue and a now much darkened red. The centre of each oval is filled with a diaper mesh overlaying rows of cruciform and L-shaped motifs. A larger version of the pattern is found on the inside of the envelope flap.

This unusual binding juxtaposes elements derived from Iran with others derived from an Ottoman tradition of some 30 years earlier. The doublures immediately recall those of the Bursa Koran (cat.1) in their use of diaper meshwork with thin gold filigree outlines against a polychrome ground. The profile of the corner-pieces also harks back to those on the flap of the Bursa Koran. The floral scrollwork on the back cover appears to be a descendant of that used on the Bursa Koran, but a more telling connection is the use of the same combination of swastika and rhomb tools.

The use of differing designs on the front and back covers had been abandoned at least a decade earlier by the binders working for Mehmed II, and the use of gold and blue for outlines was more typical of bindings from the 1450s. It would be an injustice, however, to suggest that this was no more than a retrospective production: it was, in an Ottoman

context, breaking new ground in its adaptation of the chinoiserie repertoire of Timurid and Turcoman Iran, but it appears to have been a provincial experiment with no influence on what was being produced in Istanbul. Figurative bindings never exerted the appeal for the Ottomans that they held in Iran, and the only examples from the 15th century all appear to have been produced at about this time, as cat.33 illustrates.[2]

Cat.32 was produced for Prince Bayezid while he was provincial governor in Amasya. During this period his father wrote complaining about his excessive use of opium, and it is tempting to see the demonic character of the figures as an expression of Bayezid's tastes at this time.[3] Certainly, it contrasts strongly with the sobriety of the bindings produced for him later.

Text block The manuscript is unpaginated, but there are 515 pages according to the Museum registers.[4] Each page measures 265×175mm, with a text area, 176×102mm, set within a thin gold frame outlined in black and containing 25 lines of poorly formed, unvocalized *nasta'līq* in black ink, with details in gold and blue.

Paper Polished, cream Oriental laid paper, with about six laid lines to the centimetre and chain lines in groups of three, each group 25 mm across and spaced 40mm apart. The front endpaper and penultimate back endpaper are European,[5] and there are a few pages of a thin, brown, polished Oriental paper with no visible chain or laid lines; this paper is so brittle that it has lost its edges.

Illumination The book opens with an illuminated roundel in dark blue with the title of the work in white *thulth*. Each chapter begins with an illuminated panel in the Shiraz style, with the number of the chapter in gold *thulth* against a white ground, and ends with a tapering colophon, flanked by a floral composition in gold with blue details.

Sewing Signatures of 20, in sewing pattern A, with a tightly-spun two-ply cream silk; the red silk headband at the top has probably been renewed, while the headband at the bottom is missing, although there are remains of the leather pad around which it was sewn.

Documentation The manuscript bears the seal of Bayezid II at the front and back, as well as an endowment inscription of Selim II. It was transferred to its present location from the library of Selim II in Edirne.

Published Sakisian 1934, p.150, note 2.

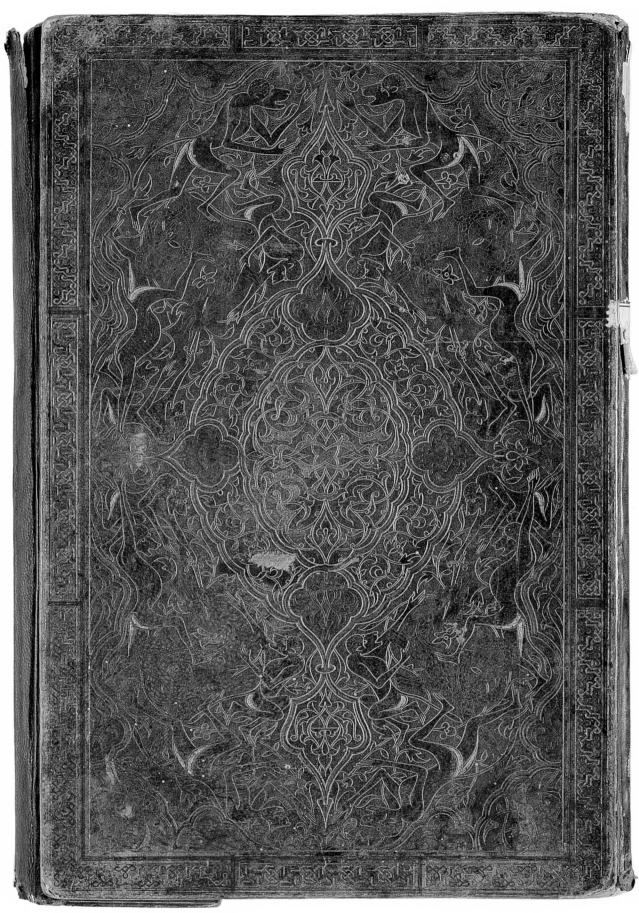

32 Front cover

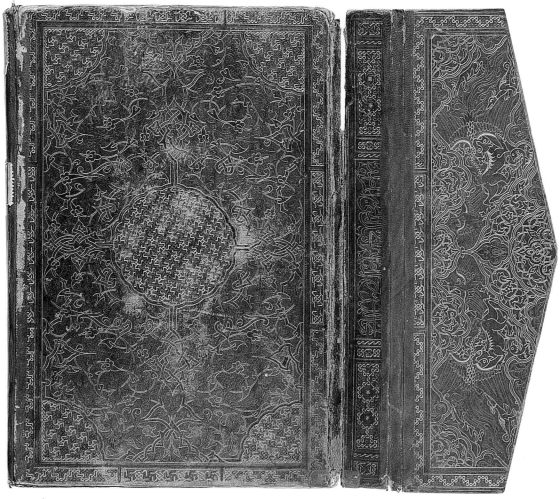

32 Back cover

32 Back doublure

33

Al-Lamā'āt of Fakhr al-Din al-'Iraqi

Copy made in Istanbul by Ghiyath al-Din al-Mujallid and completed
on 5 Dhu'l-Qa'dah 881 (19 February 1477)
Istanbul, Museum of Turkish and Islamic Arts, MS.2031, formerly MS.1501

THIS is the most famous work by the 13th-century mystic poet Fakhr al-Din al-'Iraqi (see cat.6). Its character is best summarized in the words of the late 15th-century poet, Jami, who found the *Lama'āt* contained 'graceful phrases and charming suggestions, verse and prose combined together and subtleties in Arabic and Persian intermingled wherein the signs of [human] knowledge and [superhuman] gnosis were apparent, and the lights of rapture and ecstasy manifest, so that it would awaken the sleeper, cause him who was awakened to apprehend secret mysteries, kindle the fire of Love, and put in motion the chain of Longing.'[1]

This is the only known Ottoman binding of the 15th century on which a panel-stamp with figurative decoration was used, and it was the work of the influential binder Ghiyath al-Din (see cat.31).

The front cover and the outer face of the envelope flap are badly damaged, and this may have been done deliberately, to remove their figural decoration. The front cover evidently consisted of a landscape composition dominated by trees and rocks, and it included three deer, two foxes and what appears to have been a rabbit.[2] This type of decoration was derived from chinoiserie drawings that were popular in 15th-century Iran, and an ultimate Chinese influence is apparent in the cloud-scroll in the top right-hand corner.[3] The border is a diminutive guilloche, made of s-tools and small gold dots. The ground of the main field is filled with stippling, which was executed with a pointed tool in very regular vertical rows.

The envelope flap has a composition of two foxes, one of which is chasing two deer that are fleeing to the left. The leftward movement is emphasized by the two geese flying in that direction. The outer face of the fore-edge section of the flap has a pressure-moulded inscription which records that the book was produced for the library of Sultan Mehmed. The placing of this information on the binding is unusual on books made for Mehmed II, for it is normally conveyed in an illuminated panel at the front of the book.[4]

The back cover is decorated with arabesques and lotus-flower scrolls, set against a gold ground of highly regular lines of fine stippling. Movement has been imparted to the design by making the arabesque leaves lighter than the lotus flowers and buds, and by varying the colour of the rinceaux.

The doublures, which are of medium-red levant-grain leather, are decorated with a lobed pointed-oval centre-piece with finials, and cusped corner-pieces, worked in filigree against a ground painted in ultramarine.[5] The corner- and centre-pieces are filled with arabesques and outlined in gold; the filigree leather is left in the same colour as the main field but has been worked in blind. The inner face of the fore-edge section of the flap has a Persian inscription of gilded leather set into the red field. The envelope flap has similar corner-pieces to the covers, with a lobed cartouche in the centre.

Text block 75 folios, 184 × 117 mm, with a text area, 96 × 55 mm, set within a thin gold frame outlined in black and containing 9 lines of partially vocalized *nasta'līq*, in black ink, with details in gold and blue.
Paper Thick, hard, cream, polished Oriental paper, with rag inclusions, but no sign of laid or chain lines; the flyleaves are of thick Oriental paper, dyed green on the cover side.
Illumination There is no frontispiece, but at the top of folio 1b there is an illuminated panel in the Turcoman style, executed in a silvery gold, partly stippled, and in ultramarine, light apple-green, orange, a milky coffee-brown and white.
Sewing Signatures of 12, in sewing pattern A, using a red silk; the headbands have a chevron pattern in red and yellow silk.
Documentation The volume does not bear the seal of Bayezid II, usually found on books dedicated to Mehmed II, but there is an inscription with the title and subject of the book that may be in Bayezid's hand. It also bears an impression of the pear-shaped endowment seal of Reisülküttab Mustafa Efendi, which is dated AH 1154 (AD 1741–2); the manuscript was transferred from the Aşir Efendi Library to its present location on 31 March 1330 (13 April 1914).
Published Sakisian 1927b, p.142.

33 Back cover

34

Shāhnāmah az guftār-i Malik-i Ummī

Copy made by Darwish Mahmud ibn 'Abdallah Naqqash, *circa* 1485
Istanbul, Topkapı Palace Library, MS.H.1123

୬

THE illustrated verse chronicle that this manu-script contains gives a sympathetic account of the early career of Sultan Bayezid II and is one of a number of Ottoman historical works that conclude with his successful campaign against Moldavia's Black Sea ports in the summer of 1484.[1] This was the first occasion on which the Sultan had taken the field against an external foe since the death of his father in 1481 and the subsequent struggle for the succession with his brother, Cem, and it provided the chroniclers with an opportunity to present Bayezid with updated accounts of earlier Ottoman con-quests or to compose new works devoted to his reign.

Until the reign of Bayezid II Ottoman history in written form seems to have been of little interest to the court, and the only historical material of this type presented to the sultan on a regular basis appears to have been the chronological lists pre-pared each year and included in almanacs such as cat.5 above. The chronicles ending in 1484 mark a distinct change in attitude, and these works and the histories that Bayezid commissioned during the years that followed became the basis of a version of early Ottoman history that remained standard until the fall of the empire in the 20th century. At the same time, a parallel normative process was under way with regard to the arts of the book, so that in later centuries the classical account of Ottoman history initially developed in the reign of Bayezid II was presented in codices whose aesthetic principles had been established in the same period.

This illustrated copy is not an autograph, to judge by the errors made by the scribe, such as *Shīrān-shāh Farrukhyasār* for *Shīrvānshāh Farrukhsiyar* (folio 84b), but the general quality is not high enough for it to have been commissioned by the Sultan.[2] We must therefore presume that the author had the manuscript made for presentation to the Sultan, to whom the text is dedicated (folio 13b). The text ends with the arrival of ambassadors from the Mamluk sultan of Egypt (folio 91a) soon after the end of hos-tilities with Moldavia, and as the year 1485 marked

the beginning of a long war between the Ottomans and the Mamluks, it is unlikely that this manuscript was prepared any later.

The outer covers are in a dark reddish-brown leather, with snuffed grain. The central rhombs and the triangular corner-pieces have lobed and pointed profiles and are filled with arabesque and floral work, which also fills the lobed roundel on the flap. All these figures were lightly pressure-moulded, and the sunken areas were gilded, leaving the relief motifs in blind against a gold ground stippled in neat rows. Additional details, such as the fleur-de-lis finials and the s-tool cable motif in the simple bor-der, have been gilt-tooled by hand.

The doublures are light-burgundy in colour and have a lobed oval centre-piece with arabesques in filigree against a ground that is partly gold and partly blue. The filigree centre-piece on the back doublure has been turned by 180 degrees, indicat-ing that the design was worked from a stencil.

The manuscript contains seven miniatures, of which one is original; the rest were added later, in a cruder style. Given that the copyist's name includes the term *naqqāsh*, we may presume that he was the author of the one original miniature.

Text block 98 folios, 244 × 150 mm, the text area, 150 × 85 mm, with 11 lines of unvocalized *nasta'līq* in black ink, and the section headings in red, the text arranged in two columns within a gold frame, outlined in black and with outer guard stripes in blue and black.
Paper Medium weight, polished, cream Oriental laid paper, with numerous floccular inclusions; there are about eight laid lines to the centimetre, running parallel to the spine.
Illumination The head-piece on folio 1b has arab-esques in gold and orange and white *nasta'līq*, set against gold, green and ultramarine grounds.
Sewing The headband and sewing, which is in eights, are modern.
Published Tanındı 1990–1, p.147.

34 Back cover

35

Al-siyāsat al-mulūkiyyah of al-Sarakhsi

Anonymous copy made in AH 895 (AD 1490)
Produced for Sultan Bayezid II
Istanbul, Topkapı Palace Library, MS.A.1116

᪥

THIS text is a work on politics written by Taj al-Din Abu Muhammad 'Abdallah ibn 'Umar ibn Muhammad al-Sarakhsi al-Dimashqi, who died in 1242. It is written in a *ta'līq–dīvānī* reminiscent of the work of Muhammad al-Munshi al-Sultani.[1]

The outer covers are decorated with a pressure-moulded lobed pointed-oval centre-piece. The light-tan leather inner covers are blind-tooled with a tiny whorl rosette in the centre, while the border is diminutive, with an s-tool cable between fillets.

Text block 87 folios, 217 × 133 mm, the text area, 123 × 70 mm, set within a gold frame, with black outlines and an outer black guard strip, and containing 7 lines of *ta'līq* script in black ink, with details in gold; a thin gold frame occupies the margins on three sides and was presumably intended to contain the glosses, but these are written haphazardly, either in the margin or within the text frame.

Paper Medium-thick, polished, hard Oriental laid paper with about five laid lines to the centimetre, running at right angles to the spine; the paper, which was once cream, is badly stained brown.

Illumination On folio 1a there is a plain-edged illuminated roundel: the gold field bears the dedication to Sultan Bayezid in white *thulth*, while the border has an ultramarine ground, with two strands of arabesque rinceaux overlapping to form cartouches with silvery-gold grounds. On folio 1b there is a head-piece with a *basmalah* in white *muhaqqaq-thulth* against a gold ground, set within a cusped frame with orange outlines. The colouring, though restricted, provides a rich effect, and the illumination is finely executed.

Sewing Signatures of sixes, in sewing pattern A, using a pink two-ply, s-twist cotton in the centre and a fine, two-ply, z-twist white silk top and bottom; the headband is in brown and white.

Documentation It bears impressions of the seals of Bayezid II and Ahmed III and a note giving the title of the work in Sultan Bayezid's hand on folio 1a.

Published Karatay 1962–9, no.6967.

36

Sūrat al-an'ām

Anonymous and undated copy, perhaps of the 1480s
Istanbul, Topkapı Palace Library, MS.B.29

᪥

THIS small volume contains the text of the sixth *sūrah* of the Koran. From the 16th century onwards the Ottomans frequently made independent copies of this *sūrah*, but the tradition seems to have begun during the reign of Bayezid II, for there are no Ottoman examples identified from the earlier part of the 15th century, whereas there are 18 copies by Şeyh Hamdullah in the Topkapı Palace Library alone.[1] This seems to bear out the claim that Şeyh Hamdullah attracted Bayezid's attention by sending him specimens of the *Awrād* (sections of the Koran used for supererogatory prayers) and *Sūrat al-an'ām*.[2] Why this *sūrah* became so popular during Bayezid's reign remains to be established.

Text block 27 folios, 210 × 140 mm, with a text area, 120 × 76 mm, set within a gold frame, outlined in black, with blue and black outer guard stripes, and containing 9 lines of *naskh*, which are in the style of Şeyh Hamdullah, in black ink.

Illumination There is a somewhat crudely executed illuminated head-piece on folio 1b.

Paper Polished, cream, medium thick, laid Oriental paper, with about seven laid lines to the centimetre, running parallel to the spine.

Sewing Signatures of both tens and eights, using a two-ply, z-twist white silk in sewing pattern A; the headband is red and blue.

Documentation There is no seal of Bayezid II.

35 Outer cover

37

A single-volume Koran

Copy made by Şeyh Hamdullah and
completed during the middle ten days of Rajab 899 (16–26 April 1494)
Istanbul, Museum of Turkish and Islamic Arts, MS.402

❧

THIS is one of the most famous of all Ottoman Korans, as much for its binding as for its script and illumination. The binding is remarkable for the depth and clarity of its moulding, the panels on the outer covers being sunk to a depth of just over two millimetres. The floral and arabesque scrolls that occupy the sunken areas are in high relief of about one millimetre.

Together with cat.38, cat.40 and cat.41 it marks the triumph of pressure-moulding as the principal technique for the finishing of Ottoman bindings. Pressure-moulding was also used for the doublures of these manuscripts, and filigree work, which had been standard on the doublures of bindings produced for Mehmed II, was henceforth relegated to a secondary role in Ottoman court binding.

The outer covers are of burgundy leather, and most of the surface has been sunk, leaving only the spandrels between the centre-piece and the corner panels and the border frames raised. The contrast in depth is accentuated by the contrast in textures. The raised areas have been highly burnished, while the sunken areas have been worked with minute rows of dense stippling, which mostly runs parallel, in a horizontal direction. The density of the stippling creates a colour contrast, as the light diffuses quite differently on the glazed and stippled areas. The edge of the stamped areas has a concave bevel a little below the top surface of the binding.

The same stamps have been used for the front and back outer covers. The lobed pointed-oval centre-pieces contain arabesque leaves, rosettes and lotus palmettes disposed symmetrically on two axes. The composition is reminiscent of one used in the 1460s and 1470s, as, for example, on cat.11. The sunken borders are, however, unusually wide – 26 millimetres – and they are set between raised bands decorated with small-scale s-tool cabling. In a departure from the style of borders used during Mehmed II's reign, they are divided into lobed roundels linked by an arched frame, and there is a device of paired arabesque leaves set inside and between each roundel.

The floral elements – lotus flowers and rosettes –

are identical in their form and detailing to those in the illumination, and the open and free-flowing composition of the centre-piece contrasts with the tightly controlled division of the sunken borders.

The fore-edge section of the flap has an appropriate pressure-moulded Koranic inscription (LVI, 77–9): 'God hath said that this is indeed a Koran most honourable, in a Book well-guarded, which none shall touch but those who are clean'. The flap has similar decoration to the covers, executed according to the same principles. The panels were not so deeply pressure-moulded, nor were the raised areas as highly burnished, but emphasis is provided by a light-blue and gold outline that has been added to the concave contours of the composition.

The olive-brown leather doublures, like the outer covers, have lobed centre- and corner-pieces and a wide border divided into long cartouches with lobed ends. One difference, however, is that the motifs used on the doublures do not include arabesque leaves.

Text block 265 folios, 334 × 230 mm, the text area, 202 × 119 mm, is set within a gold frame, with a thin outer black guard stripe, and containing 14 lines of fully vocalized *naskh* in black ink, and details in red. There is a *du'ā* in Arabic on folios 260a–262a written in *naskh*; a *fālnāmah* (*fāl-i kalām-i majīd*) in Persian, written in two columns of *nasta'līq* on folios 262a–264b; and a further text in Persian in one column of *nasta'līq* on folios 265a–b.
Paper Polished, cream Oriental laid paper with about seven laid lines to the centimetre, running parallel to the spine, and no visible chain lines.
Illumination The volume is extensively illuminated throughout, for the most part in the Turcoman-inspired style of Bayezid's period, in which two tones of silvery gold, as well as ultramarine, orange, emerald green, lilac, pink and yellow were used.[1]
Sewing The sewing is modern.
Documentation An elaborate *waqf* notice, with the impression of the seal of Mahmud I.
Published Arseven n.d., fig.707; Çığ 1971, pls IV–V; Istanbul 1983, no.E.12; Washington 1991, no.81.

37 Back cover

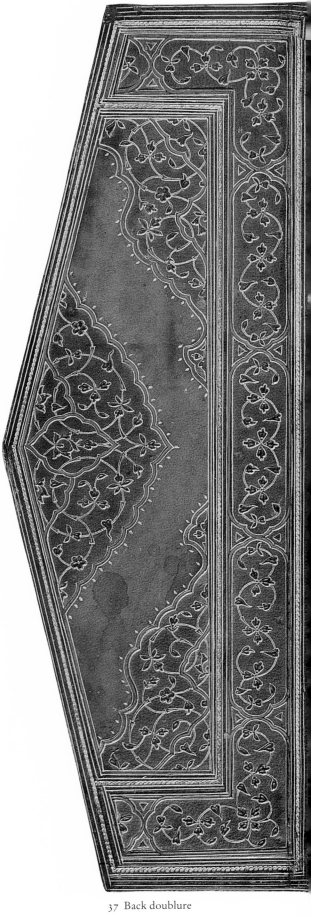

37 Outer face of flap

37 Back doublure

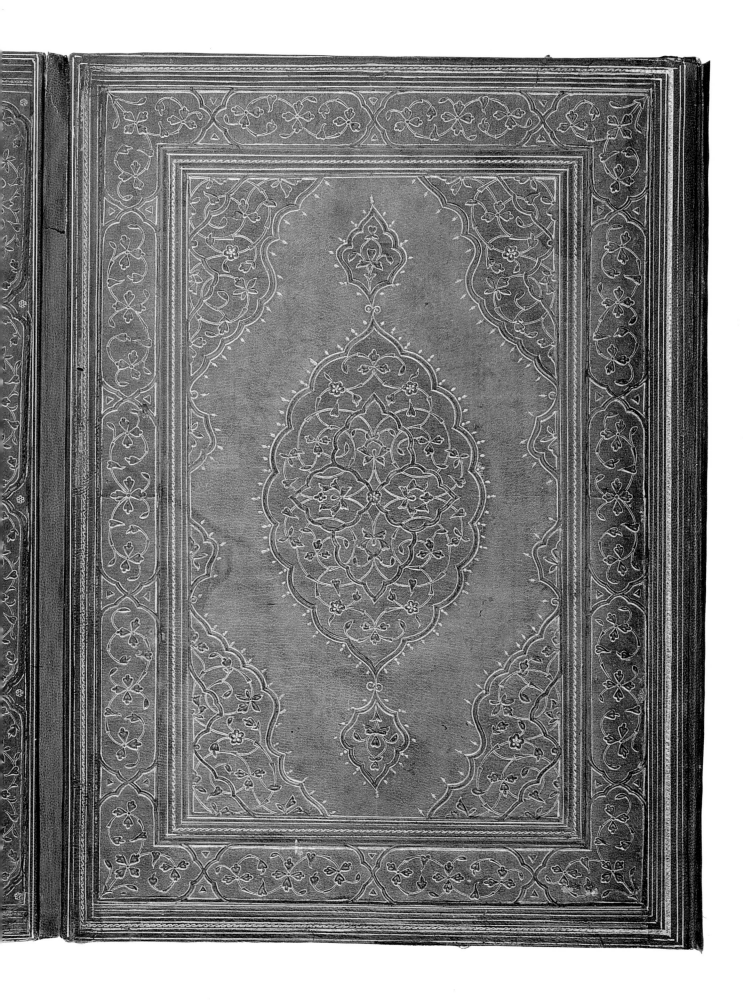

38

Single-volume Koran

Copy made in Istanbul by Şeyh Hamdullah and
completed during the first ten days of Dhu'l-Hijjah 901 (11–20 August 1496)
Istanbul, Topkapı Palace Library, MS.E.H.72

❧

Ş EYH Hamdullah was the most famous and in-
fluential Ottoman calligrapher of the late 15th
and early 16th centuries, and he is recorded to have
written a total of 47 Korans. The finest surviving
copies transcribed by him all date from the reign
of Bayezid II (1481–1512), although it is not always
made explicit that they were produced for the Sultan
(cf. cat.37, cat.40–41). This particular copy does not
bear a dedication, but in the colophon Hamdullah
describes himself as 'scribe of the Sultan' (kātib al-
sulṭān). What is more, its modern call number (E.H.72)
shows that it was transferred to the Topkapı Palace
Library from the Emanet Hazinesi, 'the treasury
for holy relics', and it may be that the Koran was com-
missioned for this treasury. Such a circumstance
would explain why it was never impressed with the
seal of Bayezid II, which seems to have been applied
only to those books in his personal library.

The colour contrast between the outer faces of the
binding and the doublures recalls that used in bind-
ings produced for Mehmed II. The outer covers are
of mid- to dark-brown leather, the doublures, a deep
burgundy. In other respects, however, the binding
is quite different. In the first place deep pressure-
moulding was used for both the outer and inner
covers; secondly, the floral motifs employed are ex-
tremely close, in type, proportions and detailing (in
particular, through the use of a hollow shaped like
the eye of a needle), to those used in the double-page
of illumination on folios 1a –2b, which is in a style
characteristic of Bayezid's reign.

The outer covers are stamped with the same com-
position of a lobed pointed-oval centre-piece with
pendant escutcheons, lobed corner-pieces, and a
broad border. The design in the centre-pieces is an
arabesque and floral composition, symmetrical on
two axes. The general principles are, therefore, those
employed for cat.37, but the effect is different. This
is because the filler motifs have been increased in
size and reduced in number; and they have not been
outlined in gold. The binding thus gains in visual
flow what it loses in emphasis. The difference can
be summarized by the borders: on cat.37 they are

divided into compartments by a series of heavily
accented frames, here they are filled by a single-
stem floral meander scroll.

The pressure-moulding is blind, against a densely
stippled ground, so that the sunken areas appear
much darker than the raised main field. Gilding is
restricted to the outlines and the narrow raised bor-
ders, which are decorated with cabling, and to the
group of four gold dots in the middle of the centre-
piece. The burgundy doublures are more colourful
than the outer covers. Gilding has been used not only
for the outlines to the centre- and corner-pieces, but
for the ground of the escutcheon pendants and the
central areas of the centre- and corner-pieces, while
blue has been used to highlight the contours of the
sunken panels (figure 82). As on cat.37 the motifs
on the doublures are exclusively floral.

The device of a long cartouche set above and
below with a pair of four-lobed roundels, which
occurs in the centre-piece, was developed from sim-
ilar compositions in Iranian bookbinding: a related
motif occurs, for example, on a Turcoman binding of
the 1470s (figure 81).[1] The transition from the main
field to the sunken planes of the centre- and corner-
pieces was achieved in two stages, a fairly wide con-
cave indent, followed by a shallow bevel. The hinge
of the envelope flap has a pressure-moulded Koranic
inscription (LVI, 79–80).

Text block 337 folios, 280 × 186 mm, the text area,
165 × 90 mm, is set within a gold frame, with black
outlines, and an outer black guard stripe, and con-
taining 14 lines of vocalized naskh in black ink, with
reading marks in light blue.
Paper Thin Oriental laid paper with about seven
laid lines to the centimetre, running at right angles
to the spine.
Illumination The volume is extensively illuminated
throughout.[2]
Sewing Rebound in the late 18th or early 19th cen-
tury, with a new flyleaf in burgundy and gold.
Published Çığ 1971, pl.VI; Karatay 1962–9, no.798;
Washington 1987, p.45, fig.7, p.305, cat.7.

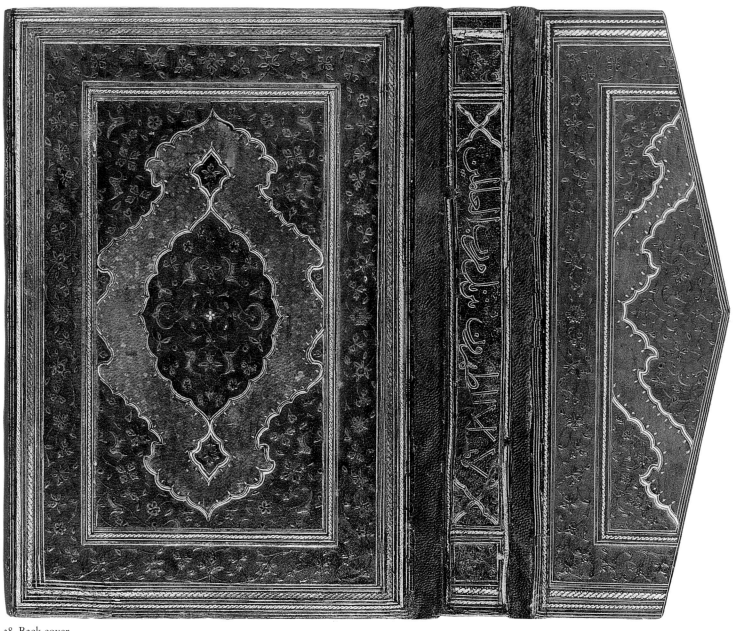

38 Back cover

39

Tuḥaf al-asāṭīn of Ibrahim al-Halabi

Anonymous copy made in Istanbul in AH 906 (AD 1500)
Produced for Sultan Bayezid II
Istanbul, Topkapı Palace Library, MS.A.1498

❧

THIS work on mysticism was dedicated to Sultan Bayezid. Its binding provides a modest contrast to the prestige covers of the Korans written by Şeyh Hamdullah (cat.37–8, 40–1), which were the finest bindings produced during Sultan Bayezid's reign. It nevertheless illustrates two standard features of the period: the use of pressure-moulding, with bevelled and concave transitions between the main field and the sunken panels; and the reduced size of all the decorative elements, from the corner- and centre-pieces to the decorative details and narrow borders.

The outer covers are in a light-burgundy leather, and they have been pressure-moulded with small centre- and corner-pieces. The centre-piece is in the form of a lobed oval with pendants, while the corner-pieces are cusped but not indented. They all enclose a design of arabesques against a parti-coloured blue and gold ground that is tightly stippled in parallel horizontal rows. The blue ground creates the effect of subsidiary centre- and corner-pieces. The edging to the sunken panels consists of three small zones: a concave zone highlighted in blue, set between two tiny bevelled edges tooled in gold. The diminutive s-tool border is tooled in blue between blind fillets.

Both the outer covers and the doublures were given additional interest by increasing the colour range.

The doublure is in a light tan with a filigree centre-piece in the form of a cusped cruciform motif, with the filigree in a light-red, or lake, colour, against a gold ground. The centre-piece is outlined in black; the border of fillets is blind-tooled, except for the innermost, which is black.

For a work by the son of this author, see *figure* 80.

Text block 194 folios, 262 × 177 mm, the text area, 180 × 117 mm, is set within a gold frame with black outlines, with an outer guard stripe in blue, and containing 15 lines of unvocalized *naskh* in black ink, with details in red, blue and gold.
Paper Polished, cream Oriental paper, which is turning brown with foxing.
Illumination None.
Documentation It bears an impression of the seal of Sultan Bayezid II on folio 194b.
Sewing Signatures of tens, in sewing pattern A, using a two-ply, z-twist pink silk; headbands in a chevron pattern of pink and blue silk.
Published Karatay 1962–9, no.5181.[1]

39 Back cover

39 Back doublure

40

Single-volume Koran

Copy made by Şeyh Hamdullah in AH 909 (AD 1503–4)
and illuminated by Hasan ibn 'Abdallah
Istanbul, Topkapı Palace Library, MS.A.5

❧

THE register of the Sultan's acts of beneficence for the *hijrī* year 909 shows that on 29 Rajab (17 January 1504) Şeyh Hamdullah received the sum of 7,000 *akçe*, together with a coat of rich stuff.[1] It is highly likely that this 'act of beneficence' was in fact payment by Bayezid II for this Koran.

The outer covers are of black leather with deep pressure-moulded panels in the form of a lobed pointed-oval centre-piece, with pendant escutcheons, indented corner-pieces, and a segmented border, the segments linked by four-lobed roundels. The sunken panels are just over 1 mm deep and have a double contour. This contour consists of a curved bevel and a shallow indent outside it which slopes towards the bevel, and it has the effect of creating a gentle transition from the main field to the sunken panels.

All the sunken panels are filled with relatively small-scale arabesque scrollwork set against the most minutely stippled ground, with the stippling arranged in parallel horizontal lines. The contours of the sunken panels, and the raised frames on either side of the border, are gilded. The raised frames are decorated, the inner one with a striated s-tool of the type that appears on bindings produced towards the end of Mehmed II's reign. The outer has been worked with a striated guilloche band more typical of bindings of the 18th century and later; indeed, it is possible that this frame has been reworked. The hinge of the envelope flap has a pressure-moulded quotation from the Koran (LVI, 77–9). The doublures are in a mid-burgundy leather, with a snuffed grain. They have a comparable composition to the front covers, but the decorative infill is floral and asymmetrical, whereas that on the front covers is arabesque and symmetrical on two axes.

The illumination is especially fine, with the text of the Koran framed at the beginning and end by double pages of illumination. The opening pages are illustrated here, while the illumination on folios 371b–372b takes the form of two rectangles with gold borders, which contain a cusped roundel centre-piece with pendants and corner-pieces.

The centre-piece on 371b has the dedication to Bayezid II in white *thulth* against a gold ground; this states that the Koran was written 'to be read by' (*bi-rasm tilāwat*) the Sultan. That on folio 372a has a prayer followed by, 'The gold-work and decoration were accomplished by the hand of the feeble worshipper who is one of the slaves of that Sultan – May God make his reign last for ever!'; then, in the bottom pendant, the name Hasan ibn 'Abdallah. Hasan appears to have been the principal illuminator to collaborate with Şeyh Hamdullah, for he worked on at least three extant Korans, ranging in date from 1499 to 1508–9.

Text block 377 folios, 321 × 230 mm, the text area, 200 × 129 mm, set within a broad, 2 mm gold frame, outlined in black, with the outer guard stripe in black, and the inner in thin gold with black outlines, and containing 11 lines of vocalized *naskh* in black ink, with details in red.

Paper Polished, cream, hard Oriental laid paper, with about eight laid lines to the centimetre, running at right angles to the spine.

Illumination In addition to the features described above there are varied forms of rosettes or interlaced roundels in gold for the verse markers.

The *sūrah* headings are rectangles fully enclosed within the text frame; they often have a gold ground, and the *sūrah* title is written in white within a cartouche with cusped ends and a gold or ultramarine ground; if it is in gold, it is of a different tone to the gold used for the rest of the rectangle.

On folios 372b–374a there is a divination of the Koran (*fālnāmah*) in three columns of 15 lines of *nasta'līq*, with a beautifully illuminated panel at the end that has an ultramarine ground and gold escutcheons. On folios 374b–377b there is a prayer in Arabic in 11 lines of *naskh*; this was added during the reign of Mehmed IV.

Sewing The sewing and headbands are new.

Documentation Impressions of the seal of Bayezid II on the first and last folios have been gilded over.

Published Karatay 1962–9, no.800; Derman 1976, fig.22; Çağman 1983, no.E.16.

40 Back cover

40 Back doublure

41

Single-volume Koran

Copy made by Şeyh Hamdullah
Completed on 14 Safar 905 (14 September 1499)
Istanbul, Topkapı Palace Library, MS.E.H.71

❧

THE outer covers, which are decorated with the same stamps back and front, are in a dark burgundy-brown leather, with a snuffed levant grain. They are deeply pressure-moulded, and the transition from the main surface to the sunken area has a concave bevel. The main field is glazed, while the sunken panels are stippled with horizontal lines of minute dots, which were probably part of the intaglio die rather than the product of subsequent tooling. The composition consists of a lobed oval centre-piece with escutcheon finials, and lobed and indented corner-pieces. The wide border has a meander scroll of arabesque leaves and rosettes.

The doublures are in olive-brown levant-grain leather with a similar composition to the front covers, but the filling of the centre-piece is exclusively floral and lacks the symmetry along two axes. Instead, it is filled with sweeping floral rinceaux, a central rosette, and a small cloud-like motif as the base element from which two of the rinceaux spring. As on the front covers, gold has been used to outline the main design elements and the guard-borders. The borders of the outer covers consist of an elaborate guilloche, those on the inner covers, of a narrow s-tool cable.

The envelope flap has a composition that echoes that of the main covers; the fore-edge section has a pressure-moulded Koranic inscription (LVI, 77–80).

The volume opens with a double-page of illumination (folios 1b–2a), whose gold ground is set with a central cusped roundel and other figures in ultramarine; the design can also be read as pairs of quasi-rectangular cartouches set obliquely at 45 and 315 degrees and arranged in four vertical rows, a composition that is reminiscent of that used for cat.41. The gold fields are filled with floral scrolls and 'Chinese' cloud bands, and the colouring shows an intense contrast between the ultramarine and the gold, whereas the other colours – orange, light blue, lilac, pink and a pale emerald green – are lightly applied.[1] The text is fully illuminated with markers for various divisions.[2]

The text of the Koran ends on folio 343b and is followed by a colophon on the same page, in the script of the same type and size as the main text. The scribe signs himself *Ḥamd Allāh al-maʿrūf bi-ibn al-Shaykh bi-sinn al-shaykhūkhah* ('Hamdullah, known as Ibn al-Shaykh, in his old age'). The last line of the colophon, which includes the date, is in a script closer to *thulth*. The colophon page is followed by a double page of illumination (folios 343b–344a), with a lobed roundel in gold as the centre-piece and cusped and indented corner pieces. The roundel, which has a feathery border in blue and tear-shaped finials, is blank. The illumination has an unusually spacious and airy character, due to the lightness of the colouring – predominantly white, silvery gold and blue – and the white field, even though this is filled with gold floral scrollwork and gold cloud-bands.

Text block 351 folios, 333 × 226 mm, with a text area, 216 × 133 mm, set within a gold frame outlined in black and between two narrow frames in a slightly more orange gold, and containing 12 lines of vocalized *naskh* in black ink. Folios 344b–347a have a prayer in Arabic to be read on concluding the Koran; it was written in the same vocalized script as the main text, in a single column. Folios 347b–350a contain a divinatory text, a *fālnāmah*, in Persian, written in *taʿlīq* in two columns; it is in black ink, but red was used for the first appearance of each subsequent letter of the alphabet. Folios 350b–351a carry a Persian text in *nastaʿlīq*, written in black and red ink in a single column. All these sections appear to be contemporary with the main text.

Paper Medium-thin, polished, cream Oriental laid paper, with seven or eight faint laid lines to the centimetre, running at right angles to the spine; no chain lines are visible, but there are dark floccular inclusions.

Illumination Discussed above.

Sewing Sewing pattern A, with thin, two-ply, z-twist, z-spun, tightly twisted yellow silk; the headbands have a chevron pattern in yellow and blue silk.

Documentation There are no seals or ownership notes; like cat.38 the manuscript was previously kept in the Emanet Hazinesi.

Published Arseven, n.d., fig.657; Karatay 1962–9, no.799; Istanbul 1983, pp.113–14, cat.no.E.14.

41 Back cover

41 Outer face of flap 41 Back doublure

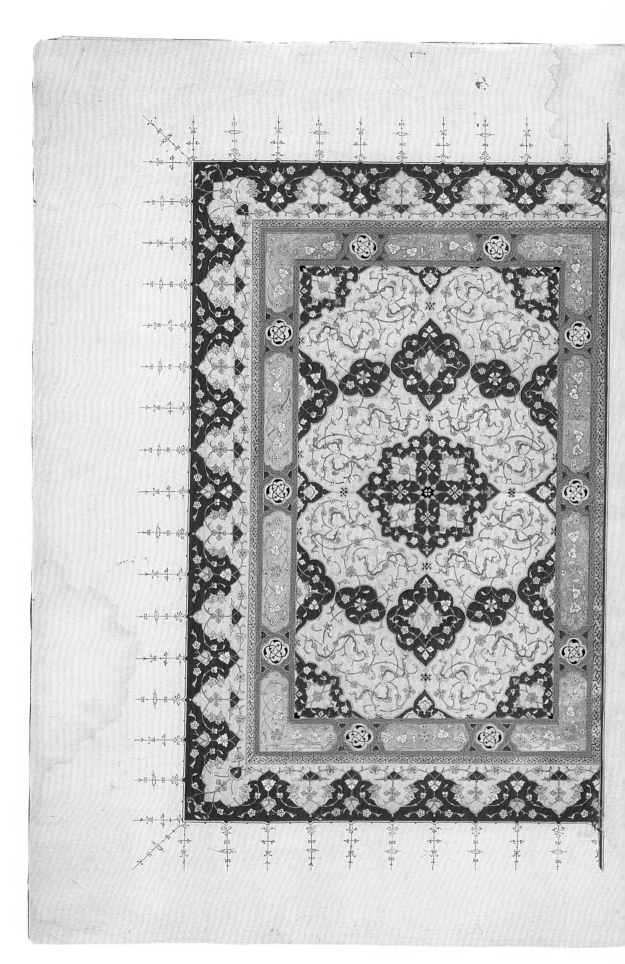

41 Folios 1b–2a

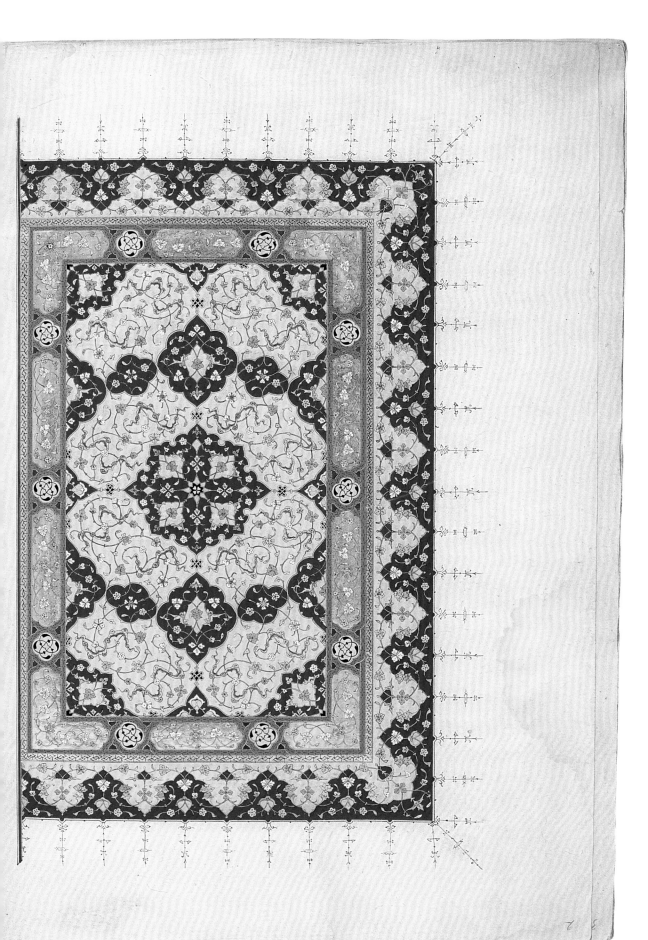

85 Rubbing from back doublure
Istanbul, Topkapı Palace Library, MS.A.2062
(actual size)

Appendix One

STRUCTURAL FEATURES OF THE OTTOMAN BOOK

The materials and procedures used to produce the text blocks and bindings of manuscripts in the medieval Islamic world have been ably and fully discussed by Gulnar Bosch and Guy Petherbridge,[1] and it would be redundant to repeat their account here. For artefactual evidence, however, they relied largely on manuscripts and bindings produced in the Arab world, so that not all of their observations apply to manuscripts produced in 15th-century Turkey. The following is a brief description of some of the characteristics that distinguish these Ottoman manuscripts from the model outlined by Bosch and Petherbridge.

Paper and Sizing

All the Islamic manuscripts examined in the course of this study were written on paper of Near Eastern manufacture. The choice of paper was deliberate, because European paper – readily identified through its watermarks and mostly of North Italian manufacture – was not only available in Istanbul but was used for chancery documents,[2] as well as for Greek manuscripts produced at the court of Mehmed II.[3]

There has been no detailed study of the Oriental papers used by the Ottomans in the 15th century. They were mostly of the laid variety, although in a few instances, such as cat.33, a wove paper was used. The predominant type of paper used in Istanbul in the second half of the 15th century had seven or eight laid lines to the centimetre, with no visible chain lines.

It is not certain where the papers used in Ottoman manuscripts of the 15th century were made. Whether there was a working paper mill in Istanbul, at the site known as Kağıdhane ('paper mill') in the 15th century, or whether this mill only began, as Franz Babinger has argued, in the 18th century, remains to be decided.[4]

A different type of paper, with chain lines grouped in threes, seems to have been used in Amasya, judging by two manuscripts – cat.32 and Topkapı Palace Library, MS.B.382 – that were copied there in 1477 and 1477–8 respectively. They are written on paper. The author of a study of Hebrew manuscripts has claimed that this type was being produced by 1210 at the latest, and that it became the most common form of paper in the Near East until the advent of European paper.[5] If this is the case, it is remarkable how little appears to have

been used in Istanbul in the second half of the 15th century (an exception is cat.18). It is not known where the type was produced, but we cannot rule out Amasya as a possible source, since the endowment inscription for the mosque of Bayezid Pasha in Amasya, dated AH 820 (AD 1417), refers to the donation of property 'near Kağıdhane', which suggests that there was a paper mill there from an early period.[6]

Whatever its origin, the paper was invariably sized and burnished. Generally, the paper used for manuscripts from the 1450s was less highly burnished than that employed later in the century. No scientific analyses have been carried out into the types of sizing used in Ottoman manuscripts, but to the ordinary touch it would appear that the paper used from the 1460s was more 'hard-sized' than paper used on Arab manuscripts. The Arab tradition was to size with vegetable starch – according to Ibn Badis, writing in the 11th century, the practice was to use equal quantities of rice starch and chalk.[7] In the Iranian tradition, at least from the 15th century, the paper was sized with a mixture of starch and glue.[8] According to the recent study by Kâğıtçı, the glue was sometimes made from animal substances, such as albumen and isinglass.[9] Isinglass sours quickly in hot weather, but this disadvantage must have been outweighed by its effect.[10] It would be worth investigating whether the change in the surface character of the paper used by Ottomans in the second half of the 15th century was connected to a change in the materials used for sizing.[11]

A notable feature of many manuscripts from Bayezid's reign, such as cat.35 and cat.39, is that the paper has stained brown, and there seems to have been serious acid migration from the ink, which is surrounded by a brown leach. Whether this was due to differences in the paper or the ink, or both, is another question that deserves investigating.[12]

Gathering

The Ottomans always used flexible sewing. In the second half of the 15th century they favoured a gathering of five sheets folded once – the quinternion. This is best seen from a study of manuscripts with dedications to Mehmed II. Out of 59 for which there is information,[13] just over 70%, or 42 manuscripts, have quinternions; only 11 have quaternions. A few have exceptional gatherings:

two use sexternions (one in conjunction with quinternions); one uses 14s; and another 20s; and two use ternions.

Craftsmen from different regions of the Muslim world doubtless brought with them differing techniques, and, although they might adapt their decorative styles to the latest fashions, they often betrayed themselves in the less regarded areas, such as the routine procedures of manufacture. Thus, idiosyncratic gatherings may be related to the preferences of individual scribes. Ternions, for example, only occur in two manuscripts, both of which are signed by Sayyid Muhammad al-Munshi al-Sultani, the Iranian scribe who started to work for Mehmed after 1473.[14] By contrast, the gatherings of 20s occur in a manuscript from early in Mehmed's reign, which was copied by an Egyptian scribe in 1455–6.[15]

Sewing was another area where *émigré* binders may have let habit triumph over local practice. In the second half of the 15th century it became standard to sew the signatures at six sewing stations with a two-ply z-twist silk. The Ottomans would appear to have been influenced in this by 15th-century practice in Iran, but as yet there are no detailed codicological surveys on which to base the comparison. According to Bosch and Petherbridge, it was standard for Islamic manuscripts to be sewn at two sewing stations only, but this observation, based largely on the evidence of medieval Arab manuscripts, has no relevance to the Ottoman tradition in the 15th century.

The Ottomans used two principal sewing patterns, referred to in the catalogue as pattern A and B. The most common was pattern A, in which there are four sewing stations, with the thread passing over the tail and head of the text block (*figure 86*). Pattern B consists of two central pairs of stations, and a further station at top and bottom, with the thread again passing over the text block (*figure 87*). Pattern A was standard, and it is possible that pattern B occurs only in manuscripts that have been restored.

The standard thread was silk. Silk thread, according to Edith Diehl, cannot be as firmly sewn as linen thread, and it tends to produce a book with sections that sag.[16] The criticism, though voiced in reference to books bound in the European manner, seems valid for Ottoman manuscripts of the 15th century as the thread has often broken, and, even

when intact, sections have sagged. The adoption of silk may, though, have been in response to a change in paper, for, with the move to Iranian papers that were generally thinner and harder-sized than the Syro-Egyptian papers, silk sewing was more appropriate than sewing with linen. This was because the Islamic binder attempted to achieve a text block that was of even thickness from fore edge to spine, without the spine 'swell' that characterized so many western medieval and Byzantine manuscripts. In order to reduce swell the Islamic binder would beat the text block. In the words of al-Sufyani, a bookbinder who wrote a treatise on the subject in Fez in 1619: 'If there are many quires so that it appears thick where it is sewn, then pound it where the thread is with a mallet on a slab until the thickened

86 *top* Sewing pattern A
at four stations
87 *bottom* Sewing pattern B
at six stations

thread is thinned out'.[17] With beating, the linen sewing threads would tend to sink and settle into the softer, more bulky Arab papers. The thinner and harder-sized Iranian papers, by contrast, would not have proved so accommodating, and the binder may therefore have sought a thinner type of thread: silk was the obvious choice.[18]

There has been no study of when silk came to be used for sewing the quires of Islamic manuscripts, but it was standard in Iranian and Ottoman books from the 15th century. A manuscript rebound in velvet covers under the Ottomans in the late 15th century (Appendix 3, no.23) throws a little light on the change.

The manuscript is a copy of Ibn Sina's *Qānūn fi'l-ṭibb*, completed in AH 723 (AD 1323), and the

colouring and style of the illumination suggest that it was produced in Hamadan. Although the manuscript is large in size (40.7 × 28.2 cm), it was originally sewn at only two sewing stations with a z-twist thread, which is probably linen. When it was rebound under the Ottomans, extra sewing stations were added above and below the original central pair, using cream z-twist silk.

The sewing was usually in a single colour of thread, of which red or white were the commonest. The same colour threads tended to be used for the headbands and for sewing the quires. There are 48 manuscripts with dedications to Mehmed II that have remains of their original headbands, and from these it appears that there was no dominant colour scheme. Red silk, usually in combination with one other colour, was the favourite, having been used in 31 instances.[19] The combination of blue and white occurs six times. Single colours were also occasionally used: cream occurs on its own ten times; yellow, only once.

Stencils and Pressure-moulding

The most important change to affect the finishing of bindings in the second half of the 15th century was the move from tooling to stamping. Until the 1450s it was common for Ottoman bindings to have patterns built up from unit-tools. During the 1450s the use of tooling with the aid of stencils became more common, and in the 1460s and 1470s this technique reached its apogee, with the use of stencils prepared by court designers; after the stencil had been used on one of the covers it was usually reversed for use on the other (*figures* 51–2).

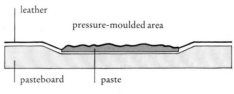

88 Section through cover

In the mid-1470s pressure-moulding was introduced, and by Bayezid's reign it had become the standard technique for Ottoman bindings, as we have seen in Chapters 2 and 3. Stamping introduced a sculptural effect to leather bindings. The degree of relief achieved by tooling was relatively slight, whereas in stamped bindings the ground of the centre- or corner-piece was sunk to a depth of between 0.5 and 1 mm, and in one exceptional item, cat.37, to a depth of 2 mm. The relief motifs did not rise to the level of the main field, so that

they were generally protected from abrasion.

The height of the relief motifs was regulated by the depth of the intaglio in the stamp, but the stamp could not be sunk deep into the leather merely with pressure. Instead, the technique was to cut out an outline of the centre- and corner-piece stamps from several layers of pasteboarding. These cut pasteboards would then be glued to an uncut sheet of pasteboard, a generous layer of paste applied to the bottom of the voided areas, and the leather pressed into the recesses (*figure* 88).[20] The stamp was applied into the recess; according to al-Sufyani, the binder tapped it gently a number of times with a mallet.[21] More consistent pressure was almost certainly necessary for the deep and distinct relief achieved in the extra bindings of Bayezid's reign (cat.37–38, 40–41), and a press may have been used. Either way, the paste was pushed up into the intaglio areas of the stamp to create the relief motifs.[22]

The stamps at this early stage were almost certainly made of hardened leather, metal stamps only becoming common later. To judge from the Persian specimens in the Victoria & Albert Museum, the stamps were about one centimetre thick overall, with three or four layers of leather, each layer being a little under 1 millimetre thick.[23] The remainder of the stamp appears to be made of paper. The best leather for the purpose is said to have been camel skin, and it appears that, once the glue had fully dried, the block of leather was crushed with an implement known as a *muṣta* to produce a result almost as hard as wood.[24] The design was cut into the block with the design reversed and in intaglio, using a bookbinder's curved knife known as a *nevregân*.[25] An important implication of the use of leather stamps was that the blocking was done cold, and that the covers had to be finished when the leather was still damp.

There is no conclusive evidence from the 15th century of gold-tooling or gold-stamping, a technique which would have called for the design to be blinded in, wiped with glair, overlaid with gold leaf and then worked a second time with a heated tool or stamp into which the design had been cut in positive.[26] At this period, most gold seems to have been applied as paint. Al-Sufyani described making liquid gold, insisting that only fish-glue should be used as an adhesive when gold is applied to leather.[27] To produce a sheen, the gold, he said, should be rubbed with an oyster shell or something comparable.[28] Gold leaf also appears to have been used on occasion, but it was not applied with heated stamps.[29]

Appendix Two

TABBY BINDINGS

The use of textiles on Islamic bindings is recorded as early as the 10th century AD in Iraq.[1] In AD 1174 Saladin sent the Zangid ruler Nur al-Din several Korans by famous calligraphers, presumably from the Fatimid library in Cairo; one was bound in a pistachio-coloured silk, another in blue silk.[2] The earliest surviving examples, however, date only from the 13th century.

Textiles tended to be employed in one of two ways. In some examples, which date from the 13th to the 15th century and are mostly of Mamluk origin, they were used as a ground for leather filigree corner- and centre-pieces.[3] Alternatively, cloth was used for the doublures. This second procedure was also employed on Mamluk bindings from the second half of the 14th century,[4] and there is at least one instance of this practice on an Ottoman manuscript produced for Mehmed II, probably in the 1440s or 1450s.[5]

It was under Mehmed II, too, that textiles began to be used with regularity for the outer covers of bindings. Between about 1460 and the early 1470s a sizeable number of manuscripts were provided with bindings faced with tabby textile. The following is a list of the known examples, organized by the design and colouring of the cloths. From the mid-1470s velvet replaced tabby on Mehmed's textile bindings (see Appendix 3).

In the tabby group the covers were usually lined both inside and out with cloth, whereas velvet, being much thicker, could be used only for the outer covers, and the doublures were usually of leather. Taken together, these bindings provide important evidence for the history of textiles in 15th-century Turkey.

Unless otherwise stated, all the manuscripts cited below are from the Topkapı Palace Library, and all the manuscripts listed bear the seal of Bayezid II.

Type 1

Striped tabby of white cotton and blue silk. Very faint white bands run at right angles, creating a plaid effect.

1 Süleymaniye Library, MS. Turhan Valide 116
Text copied in the *medrese* of Murad II in Edirne by Dawud ibn Mawlana Ibrahim ibn Khwajah Dawud in AH 866 (AD 1462)

Dedicated to Mehmed II
White stripes 4mm wide,
blue stripes 5mm wide
Published Istanbul 1953, no.27

2 Süleymaniye Library, MS. Turhan Valide 48
Text copied in Edirne in Muharram 870 (September 1465)
Dedicated to Mehmed II
White stripes 2.5mm wide,
blue stripes 8mm wide
Published Istanbul 1953, no.22

Type 2

Striped tabby of white cotton and green and burgundy silk. Green stripes 3.5mm wide, burgundy stripes 4mm wide, and white stripes 3.5mm wide. Faint white bands, 2mm wide, run at right angles, creating a plaid effect. Of the six known manuscripts bound with this textile, three were copied in AH 869 (AD 1464–5).

3 Süleymaniye Library, MS. Şehid Ali Paşa 1240
Text copied by 'Abd al-Wasi' ibn Hasan al-Lahsawi, completed on 20 Dhu'l-Hijjah 869 (13 August 1465)
Dedicated to Mehmed II

4 Süleymaniye Library, MS. Ayasofya 2448
Text copied in AH 869 (AD 1464–5)
Dedicated to Mehmed II
Published Istanbul 1953, no.68; Tayanç 1953; Öz 1953, p.22

5 MS.A.3446
Text not dated
Dedicated to Mehmed II
Paper doublures

6 Süleymaniye Library, MS. Köprülü 857
Text not dated
Dedicated to Mehmed II
Published Ünver 1943, fig.38; Istanbul 1953, no.36; Tayanç 1953; Öz 1953, p.22; Baykal 1958, fig.1

7 MS.A.1297
Text copied in AH 869 (AD 1464–5)
Dedicated to Mehmed II
The textile covers have been overlaid with marbled paper, leaving only a small amount of the original material visible

8 MS.A.3237
Text copied in AH 626 (AD 1228–9)
No dedication to an Ottoman patron

Type 3

Striped tabby of deep-red and bright-blue silk. Red stripes 3.5mm wide, blue stripes 2mm wide. The blue stripe was woven with dark-blue, light-blue and white threads, with single white threads separating alternating groups of dark-blue and light-blue threads.

9 MS.A.3220
Text completed on 12 Rabi' al-Awwal 871 (22 October 1466)
Dedicated to Mehmed II
See above, cat.16

10 Süleymaniye Library, MS. Yeni Cami 335
Text not dated
Dedicated to Mehmed II
Textile on the doublures only; the exterior has been recovered with marbled paper
Published Istanbul 1953, no.31; Ünver 1943, fig. on p.33

Type 4

The exterior of all three manuscripts is faced with a check tabby of red and white silk, the white squares 1mm square. The doublures are faced with a black-and-white check, the white squares also 1mm square. As it is unlikely that the bolts of material lasted long, all three manuscripts were presumably bound at the about the same time.

11 MS.A.1741
Text not dated; dedicated to Mehmed II
The inner face of the flap is lined with plain leather

12 Süleymaniye Library, MS. Ayasofya 3620
Text not dated
Dedicated to Mehmed II
Published Ünver 1943, fig.37; Istanbul 1953, no.78; Öz 1953, p.21; Tayanç 1953

13 MS.A.3496
Text not dated
Dedicated to Mehmed II
The inner face of the flap is lined with plain leather

Type 5

Striped tabby of black silk and white cotton. Black stripes 8mm wide, white stripes 2.5mm wide.

14 MS.A.2251
Text not dated; dedicated to Mehmed II
The doublures are lined with paper pastedowns

Type 6

Silk tabby with alternating stripes of medium and light blue. Medium-blue stripes 2mm wide, light-blue stripes 1m wide.

15 MS.A.3296
Text copied by Yusuf ibn Ilyas in
Dhu'l-Hijjah 871 (July 1467)
Dedicated to Mehmed II
The same scribe was also responsible or
MS.Ayasofya 1930, which is dated AH 872
(AD 1467–8); see cat.14

Type 7

Striped tabby of burgundy-red, ultramarine and white silk. There are white stripes 2.5 mm wide alternating with red stripes 2 mm wide, edged with ultramarine stripes 0.5 mm wide. A subtle plaid effect has been produced where the warp stripes have been crossed by two different weft bands, the first formed by successive passes of white silk, 3mm wide, the second by six passes, alternately white and red.

16 Süleymaniye Library, MS.Turhan Valide 81
Text copied by the same scribe as no.1 above
and completed in Rabi' al-Akhir 871
(November–December 1466)
Dedicated to Mehmed II
Published Istanbul 1953, no.29

17 Süleymaniye Library, MS.Ayasofya 2480
Text copied in AH 869 (AD 1464–5)
Dedicated to Mehmed II
Published Istanbul 1953, cat.53; Tayanç 1953

18 MS.A.2149
Text not dated; dedicated to Mehmed II

19 MS.A.3445
Text not dated; no dedication; see cat.15

20 MS.A.3250
Text copied by Muhammad ibn Ibrahim al-Farisi
in AH 871 (AD 1466); no dedication

21 MS.A.3217
Text copied in AH 865 (AD 1460); no dedication

Type 8

Striped tabby of black silk and white cotton. The black stripes 3 mm wide, the white stripes 0.5 mm wide. A plaid effect was created by bands of bluish-white silk, 0.5 mm wide, running at right angles to the stripes.

22 MS.A.3377
Text completed in Rabi' al-Akhir 865
(January–February 1461)
Dedicated to Mehmed II; see above, cat.17

23 MS.A.3492
Text completed in Istanbul in
Muharram 879 (June–July 1474) by
Muhammad al-Badakhshi; no dedication
The inner face of the flap is lined with
plain leather

24 MS.A.2768
Text not dated; no dedication

Type 9

Striped tabby of red silk. Red stripes divided by tiny white lines. Red stripes 1mm wide, white lines 0.5mm wide.

25 MS.A.3233
Text not dated; no dedication

Type 10

Striped tabby of burgundy-red and white silk. Red stripes 3mm wide, white stripes 1 mm wide. White bands, also 1 mm wide, run at right angles, creating a plaid effect.

26 Süleymaniye Library, MS.Ayasofya 2445
Text copied in Konya in AH 710 (AD 1310–11)
No dedication to an Ottoman patron

Type 11

Striped tabby of green and white silk. Green stripes 3mm wide, white stripes 0.5mm wide.

27 MS.A.2634
Text not dated; no dedication

28 MS.A.3232
Text not dated; no dedication
The doublures are of Type 15

Type 12

Striped tabby of black and white silk. Alternating black and white stripes crossed by a band of black and white. Black stripes 5mm wide, white stripes 4mm wide, black-and-white band 8mm wide.

29 MS.A.3269
Text copied in AH 666 (AD 1267–8)
No dedication
The doublures are lined with paper

30 MS.A.2590
Text not dated; no dedication
The doublures are of paper

31 MS.A.3362
Text not dated; no dedication
The doublures are of paper

32 MS.A.3234
Text copied by 'Ali ibn al-Taqi in
AH 732 (AD 1332)
No dedication to an Ottoman patron
The doublures are of paper

Type 13

Striped tabby of black and white silk. Black stripes 3mm wide, white lines 0.5 mm wide.

33 MS.A.1866
Text copied by Muhammad ibn Ahmad ibn
Abu Bakr in AH 653 (AD 1255)
No dedication to an Ottoman patron
The doublures are of paper

Type 14

Striped tabby of black and white silk. Stripes 4mm wide

34 MS.A.3521
Text not dated; no dedication

The striped textile was used for the doublures; the outer covers were faced with a plain crimson velvet

Type 15

Striped tabby of dark red and white silk. Red stripe 2 mm wide, white stripe 0.5 mm.

35 Doublures of MS.A.3232
See above no.28

Velvet Bindings

by Zeren Tanindi

Ottoman manuscripts of the 15th century with velvet bindings usually measured about 25 × 16 cm, and they included books in horizontal, or *jung,* format (cat.23 and nos 21–3, 27, 30, and 33 below – the last five vary in size between 40 × 29 cm and 35 × 20 cm). The texts, almost all written in Arabic, were on subjects such as logic, philosophy, medicine and grammar. Some contain notices recording that they were copied in Qustanti-niyyah (Constantinople) between 1450 and 1492, and several bear dedications to Mehmed II (nos 2, 6, 22, 27–8 below; *cf.* Appendix 2, nos 5, 9, 19, 23). Even manuscripts without documentation can be attributed to Mehmed's reign on the basis of codicological features, including their paper and script (nos 3–5 below). Other manuscripts, however, were older copies, and some have colophons bearing dates between 1221 and 1365 (nos 23, 26, 29, 30–33, 35, 47 below). Nevertheless, it is evident from the manner of binding and similarities in the velvets that they were rebound in the second half of the 15th century.

There are four principal technical groups into which the velvet bindings can be divided.

Group 1

The first type is a claret-red velvet with a long pile (nos 1–3 below). The pattern was formed by voiding the pile to different lengths. It consists of a large, three-lobed medallion enclosing a central pomegranate, with four-lobed rosettes between the medallions; on the bindings the connecting bands cannot be distinguished clearly.

All three examples are fragments of the same textile.

1 MS.A.2460
Text not dated; no dedication
Doublures of silk with a pink
satin-weave ground (*cf.*nos 3–5)
Cat.27 above

2 MS.A.3438
Text dated Muharram 886 (March 1481)
No dedication
Doublures of silk with a golden-brown
satin-weave ground
Cat.28 above

3 MS.A.2022
Text not dated; no dedication
Doublures of silk, with a
pink satin-weave ground (*cf.* nos 1, 4, 5)

Group 2

The second technical group are 'pile on pile' velvets characterized by a dark-red colour and a long pile (nos 4–5 below). The pattern was formed by the gradated cutting of the pile to different lengths. The outlines of the pattern were voided to expose the satin-weave ground. As in the previous group, the basic pattern of the velvet consists of rows of large, lobed medallions enclosing pomegranates, which are flanked by rosettes.

A comparable 'pile on pile' velvet was used for one of the imperial kaftans in the Topkapı Palace Museum. The long pile of the madder-red velvet has been cut to different lengths to produce a pattern of large, six-lobed medallions joined by thick stems, with crown-like designs at the points where the stems meet.[1]

Both examples are fragments of the same textile.

4 MS.A.3236
Text dated Shawwal 885 (December 1480)
No dedication
Doublures of silk, with a pink satin-weave ground (*cf.* nos 1, 3, 5)
Cat.29 above

5 MS.A.1863
Text not dated; no dedication
Doublures of silk, with a pink satin-weave ground (*cf.* no.1, 3, 4)

Group 3

The third technical group consists of crimson velvet, voided and brocaded with gold and yellow-silver thread. The two known manuscripts in the group were both produced for Mehmed II, although the dedicatory inscription on one has been tampered with (cat.24–5, nos 6–7 below).[2]

Gold-brocaded velvets appear in the works of many 15th-century northern European and Italian painters, but there is no example precisely comparable to the textiles used on the Ottoman manuscripts. The outer garments worn by cardinals, chancellors and angels, and the coverings of cushions, seen in paintings of Jan van Eyck dated to the years 1436–9, are apparently of velvet. The basic design on this cloth consists of a large

lobed medallion on a thick stalk; the large blossom and rosettes that fill the medallion resemble those on the velvet bindings in Group 3.[3] In Hans Memling's *Adoration of the Magi* (1479) the black man standing on the right wears a garment made of cloth bearing a large medallion with intersecting lobes; the blossom on a long, thick stalk at the centre of the medallion appears to be an artichoke.[4] A similar pattern appears on Saint Donation's robe in Gerard David's *Canon Bernadinus de Salviatis and Three Saints (circa 1501)*,[5] on the covering of the throne in the same artist's *Madonna and Child (circa 1509)*,[6] and on a brocaded velvet hanging in a *Madonna and Child* attributed to Dieric Bouts (d.1475).[7]

In Mantegna's *Presentation in the Temple,* variously dated to the 1450s or 1460s, the Virgin's gold-brocaded robe bears large lobed medallions filled with a composite motif and small rosettes.[8] A more elaborate example, with a large, lobed medallion enclosing a thick-stemmed blossom that resembles an artichoke, can be seen in Mantegna's depiction of the court of Lodovico Gonzaga in frescos completed in 1474.[9] A gold-brocaded crimson velvet with large medallions is also worn by the angel on the right of Carlo Crivelli's Brera *Pietà*, which is datable to the 1490s, as well as on the length of cloth that hangs over the marble balustrade in the foreground.[10]

The design on a piece of brocade in the Metropolitan Museum of Art in New York, which has been dated to the second half of the 16th century, consists of staggered rows of lobed medallions connected by thick stems bearing rosettes, all woven in gold and blue thread on a red field.[11] The form of medallion and the interstitial motifs resemble those on the velvet binding of no.3 below.

An especially sumptuous brocaded velvet was used to make one of the imperial Ottoman kaftans in the collection of the Topkapı Palace Museum.[12] It is traditionally associated with Sultan Ahmed I (*reg.*1603–17), but such attributions should be treated with caution.[13] Another kaftan of heavily brocaded red velvet is traditionally said to have belonged to Sultan Mehmed IV (*reg.*1648–87).[14] There does not, however, appear to be any example in the Topkapı Palace, or indeed depicted in any European painting, that is precisely comparable to the voided and brocaded velvets used for cat.24 and cat.25.

6 MS.A.2005
Text dated 8 June 1476; dedicated to Mehmed II
Doublures of burgundy leather with
blind-tooled decoration
Cat.24 above

7 MS.A.1890
The dedication to Bayezid II has been written
over an original dedication to Mehmed II
Cat.25 above

Green Velvet

8 MS.A.3240
Text not dated; no dedication
Leather doublures with centre- and
corner-piece composition

Group 4

The majority of the velvet bindings belong
to a fourth type which has a variety of voided
ferronerie designs in light- or dark-red or green.
Numerous variants of ferronerie velvets similar
to those in Group 4 are found in European
museums, and most are attributed to 15th-
century Italy.[15] Those used on the bindings can
be divided into two main sub-types.

The patterns on the green velvets are simpler
than those on most of the red velvets, although
there are red velvet examples as well (see no.27
below).[16] Cat.26 illustrates the basic composition,
which consists of staggered rows of cinquefoil
medallions enclosing pomegranates or thistle
motifs. In some examples, such as no.11, the
central motif is flanked by rosettes.

The more elaborate designs, such as that used
for no.11, have paired stems framing the cinque-
foil medallion, and these are wrapped around by
spiralling leaves, with a large flower where the
stem meets the top of the lobed medallions
(no.29). The velvet bindings in the Süleymaniye
Library belong to this group. In other examples,
such as no.23, there are also leaves winding
around paired stems, but at the apex there are
elaborate pomegranate motifs, flanked upon
either side by other such motifs (nos 23–4).[17]

A ferronerie textile of this elaborate type,
but in black rather than red velvet, was used for
an altar frontal and was embroidered with the
initials of Beatrice d'Este; it can therefore be
attributed to 1491–7.[18]

A dating in the second half of the 15th cen-
tury is confirmed by the Ottoman manuscripts
in this group, which are dated to between 1474
and 1481.

The lobed-medallion design also occurs, on
both the garments and the cushion covers, in
Piero della Francesca's frescos in the church of
San Francesco in Arezzo (*circa* 1452–9), and on
the garments worn by Saint Augustine in Piero's
dispersed polyptych for the Augustinians of

Borgo San Sepolcro, which he painted between
1454 and 1469.[19] Large, lobed medallions in an
elaborate version of the ferronerie style occur
on the robes of the Virgin in Carlo Crivelli's
Coronation of the Virgin (1493).[20]

Comparable velvets to those used on the
manuscripts survive in the Topkapı Palace
Museum, either as bolts or garments.[21] A kaftan
whose velvet bears a ferronerie design, though
brocaded rather than voided, is associated with
Bayezid II's son, the bibliophile Prince Korkut
(1473–1513), and this dating accords well with
the other evidence for this textile type.[22]

There appear to be at least two structural sub-
groups, one with, the other without, a satin
ground. This difference requires further research
by textile specialists. Where no reference is
made to the nature of the ground, it is not
known to which sub-group the item belongs.

Red Velvet

9 MS.A.3195
Text copied and completed on 15 Ramadan 879
(23 January 1475) by Shams al-Din al-Qudsi
No dedication
Tan leather doublures with a centre-piece filled
with arabesque filigree
Velvet with non-satin ground

10 MS.A.1972
Text copied by 'Ali ibn Fathallah al-Ma'dani
al-Isfahani, not dated; no dedication
Plain leather doublures
The volume is almost identical in format and
binding to no.9
Velvet with non-satin ground

11 Süleymaniye Library, ms.Ayasofya 3696
Text completed in Dhu'l-Hijjah 882
(March–April 1478)
Copied in Constantinople by Ghiyath
al-Mujallid al-Isfahani
No dedication
Velvet with non-satin ground

12 Süleymaniye Library, ms.Ayasofya 3740
Text copied by Ibn al-Shaykh (Şeyh Hamdullah),
but not dated
Dedicated to Mehmed II
The velvet of this binding is close to that of no.11
Velvet with non-satin ground
Cat.23 above

13 MS.A.1953
Text not dated; no dedication
Light-tan doublures decorated with a pointed-
oval centre-piece with filigree arabesques

14 MS.A.2391
Text not dated; no dedication
Plain, dark-brown leather doublures

15 MS.A.3197
Text not dated; no dedication
Plain, light-tan leather doublures

16 MS.A.3151
Text not dated; no dedication
Doublures of mid-tan leather

17 MS.A.1864
Text not dated; no dedication
Plain, mid-tan leather doublures

18 MS.A.1986
Text not dated; no dedication
Doublures of mid-tan leather, with a pointed
oval centre-piece with filigree arabesques

19 MS.A.2480
Text not dated; no dedication
Plain, mid-tan leather doublures

20 MS.A.3135
Text not dated; no dedication
Plain, mid-tan leather doublures

21 MS.A.2163
Text not dated; no dedication
Plain, tan leather doublures
In a *jung* format

22 MS.A.3444
Text copied by Muhammad al-Badakhshi and
dated Safar 880 (6 June–4 July 1475)
No dedication
Doublures of mid-tan leather with a pointed-
oval centre-piece filled with knotwork
Probably satin-ground

23 MS.A.1939/1–2
Text dated 1323–5
No dedication to an Ottoman patron
Doublures of mid-tan leather with
tooled centre-piece
Probably satin-ground

24 MS.A.3247
No data available; perhaps a confusion with
no.26, below

25 Istanbul, Military Museum, inv.no.5209
Text not dated; dedicated to Mehmed II

26 MS.A.3257
Text dated Muharram 675 (June 1276)
Copied by Qasim ibn 'Ali ibn Fatik al-Hilli
No dedication
Undecorated leather doublures

27 MS.A.1973
Text dated Jumada I 880 (August 1475)
Copied in Istanbul by 'Abdallah al-Hindi
Doublures of mid-tan leather, with
a tooled oval centre-piece

28 MS.A.1953
Text dated Ramadan 882 (December 1478)
No dedication
Light tan leather doublures, with a
filigree centre-piece

29 MS.A.3401
Text dated Rabi' al-Awwal 667 (November 1268)
Copied by Ahmad ibn Muhammad ibn
Mahmud al-Khujandi
No dedication
Plain leather doublures

30 MS.A.2132
Text dated AH 623 (AD 1226)
Copied by Bahnam al-Mutatabbib

31 MS.A.3345
Text dated AH 727 (AD 1327)
Light-tan leather doublures, with a small
medallion centre-piece

32 MS.A.2653
Text dated 618 (1221)
Copied by Ahmad ibn Hamzah ibn
'Ata'allah ibn Musa
No dedication
Doublures of black leather with
gilded centre- and corner-pieces

33 MS.A.3455
Text not dated; no dedication
Plain leather doublures
In the *jung* format

34 MS.A.3238
Text not dated; no dedication
Plain leather doublures

35 MS.A.2492
Text dated AH 646 (AD 1248)
Copied by Mahmud ibn
Muhammad ibn Abi Bakr
No dedication
Plain leather doublures
The design differs in details from most of the
other velvets in this group

Green Velvet

36 MS.A.3266
Text not dated; no dedication
Leather doublures with a large oval centre-piece
filled by large-scale floral motifs
See above, cat. 26

37 MS.A.2775
Text not dated; no dedication
Plain leather doublures

38 MS.A.3456
Text not dated, but it may have been copied
in the 13th century
No dedication
Plain leather doublures

39 MS.A.3457
Text dated 1289
Copied by Ahmad ibn Muhammad ibn
'Abd al-Jalal
Plain leather doublures

40 MS.A.3155
Text not dated; no dedication
Plain leather doublures

41 MS.A.3253
Text not dated; no dedication
Plain leather doublures
Possibly copied by Muhammad al-Badakhshi

42 Süleymaniye Library, Ayasofya 2756
Text not dated; no dedication
Plain leather doublures

Type 5
Plain Crimson or Brown Velvets

Crimson Plain Velvet

43 Süleymaniye Library, MS.Fatih 3682
The manuscript appears to be Timurid, of the
period of Ibrahim Sultan
Doublures of burgundy leather

44 Süleymaniye Library, MS.Ayasofya 2415
Text dated AH 883 (AD 1478)
Dedicated to Mehmed II
Plain leather doublures

45 Süleymaniye Library, MS.Ayasofya 3367
Text not dated
Dedicated to Mehmed II
Published Raby 1983, p.19

46 Süleymaniye Library, MS.Ayasofya 2415
Text dated AH 883 (AD 1478)
Dedicated to Mehmed II
Plain leather doublures

47 MS.A.2085
Text dated AH 767 (AD 1365)
No dedication
Mamluk illumination
Doublures are paper pastedowns

48 MS.A.3521
Text undated; no dedication
Doublures lined with a tabby-weave cloth,
see Appendix 2, Type 14

Brown Plain Velvet

49 Süleymaniye Library, MS.Turhan Valide 265
Text not dated
Dedicated to Mehmed II
Published Istanbul 1953, no.74; Ünver 1952,
fig.4; Baylav 1953

The similarity between some of the composi-
tions on the velvet bindings and the textiles
depicted in the works of 15th-century European
painters, combined with the fact that the velvets
were used to cover the bindings of manuscripts
produced in the reign of Sultan Mehmed II, en-
ables us to date these textiles to the 15th century.

From documents in the Bursa court records
for the years 1484–5, published by Professor
Halil İnalcık, it is clear that in the intensive
commercial atmosphere that existed in the city
in the 15th century velvet was not only woven,
but merchants also brought European velvet
to sell on the Bursa market. These documents
confirm the presence of Venetian and Florentine
merchants in Bursa.[23] They show that one of
the Europeans had 25 garments made up in
Bursa from Venetian cloth and European gold
brocade; and that European merchants sold
velvet in the city.[24] Bursa, it emerges, had looms
that produced figured velvet,[25] as well as gold-
brocaded velvet.[26] One of the velvet-weavers
was a slave of Russian origin.[27] Evidently, in the
period before the establishment of the palace
ateliers in Istanbul, cloth required by the
Palace was woven in Bursa.[28] The textiles used
for bindings in the second half of the 15th
century may therefore have been woven in
Bursa employing original compositions,
whereas others were probably specimens
imported from Italy or other parts of Europe,
which served as models for textiles to be woven
in Bursa for the court.

In addition, two bindings faced with plain silks
may be included for the sake of completeness:

50 Süleymaniye Library, MS.Ayasofya 4157
Outer covers a green atlas silk woven with
a palmette-like flower in gold thread
Text dated 1506
Copied by Muhammad al-Arij
This manuscript does not bear the
seal impression of Bayezid II

51 Süleymaniye Library, MS.Esad Efendi 2494
Beige silk, unpatterned; z-twist.
Text dated 1478
Copied in 'Constantinople' by
Ghiyath al-Mujallid al-Isfahani

Appendix Four

A DYNASTY OF BINDERS

The names of several binders are recorded from the early centuries of Islam, but these records are sporadic and for the most part incidental. Skill in bookbinding rarely merited a mention on its own, but it was sometimes noted in the context of another profession – in the case, for example, of a librarian who was also active as a binder.[1] In most instances, moreover, we know nothing more than the names of these craftsmen, as the historical documentation is not supported by artefactual evidence. Conversely, we have examples of bindings that bear the name of a binder for whom there is no supporting historical information.[2] Bindings were only rarely inscribed with the name of the maker, although there are examples from Iran and Iraq in the early 14th century, and, in particular, from South Arabia in the 14th and 15th centuries.[3] In Anatolia the practice was so uncommon that only one signed binding, that made by Muhammad al-Qaramani (*figure 7*), is known. There are, however, a number of block-pressed doublures that have the name of the maker included in their design, such as that on a Bursa manuscript of the second quarter of the 15th century, which is inscribed, 'The work of the binder Haydar, the son of Turbeyi' (*figure 42*).[4] It is only in the case of calligraphers and illuminators who were also binders and who recorded their multiple roles in the manuscripts they made that we have a combination of written and artefactual evidence, but few calligrapher-binders are particularly informative in their colophons, and it requires several well-documented manuscripts before we can begin to piece together even the barest outline of an artist's career. The information gathered above on Ghiyath al-Din al-Mujallid is, then, a rare exception.[5]

Our knowledge of the period after 1500 is somewhat better, for from that date Ottoman archival sources begin to provide a more regular and detailed record of binders' names, and from the 16th century until well into the 18th century there survives sufficient information to enable us to trace the careers of the palace binders.[6] Like other artists, these bookbinders presented gifts to the sultan on feast days and received gifts in return. Thus in 1555–6 the head binder Mehmed Çelebi received 1,000 *akçe*,[7] and one of his brothers, Mustafa Çelebi, 700.[8] Information is also available about the payments or increases

that the binders received when they were working on particular projects, because an account of expenses was kept for every manuscript produced in the palace scriptorium, and many of these accounts have survived.[9] To date, though, there has been no systematic study of the pay of the palace artists, so that we have a plentiful supply of data but no idea of, for example, the working conditions and living standards of these men. In some instances there is documentation that makes it possible to link a craftsman with extant bindings, but this only occurs when there is an archival record that links the two, for it was not Ottoman practice for binders to sign their works.

There is one published archival reference to binders late in Mehmed II's reign, but the information is still scant even for the reign of Bayezid II. Fuller documentation begins with the earliest extant register of palace craftsmen, which is dated Rabi' al-Akhir 932 (15 January– 12 February 1526).[10] From this and subsequent documents it emerges that for more than a century the bindery was dominated by members of a single family, whose association with the court can be traced back to the reign of Bayezid II. Among the 585 artists listed in this document are six binders and two apprentices, and it is clear that four of the eight were brothers. Two of these, Mehmed and Hüseyin, were master craftsmen, and two, Hasan and Mustafa, apprentices. They were the sons of a master craftsman attached to the court called Ahmed. Ahmed himself, though, had died by 1526.

We can therefore propose the following reconstruction. Ahmed was active during the reign of Sultan Bayezid, as he made a present of his pupil Davud Çerkes, presumably a Circassian slave whom Ahmed had trained, to the Sultan. Ahmed is also recorded as having received 1,000 *akçe* from Bayezid on 15 March 1504. How much earlier in Bayezid's reign he became involved with the court is uncertain, but it is worth noting that there were artists still on the imperial payroll in 1526 who had probably been brought from Akkerman by Sultan Bayezid in 1484.[11] During the reign of Selim (1512–22) Ahmed's son Mehmed was enrolled on the palace register 'in recognition of his skill'.

It seems likely that Ahmed died shortly before

May 1518. We can deduce this from the following evidence. Since five of the eight binders recorded in 1526 were his dependants – four sons, and one pupil, Davud Çerkes – Ahmed evidently enjoyed some status in the bindery, and it seems likely that he was the head of the studio. As the head of the studio in 1526, Alaeddin Kule'i, is recorded as having been first enrolled on 14 May 1518,[12] and as, furthermore, three of Ahmed's other sons, Hüseyin, Hasan and Mustafa, were enrolled as apprentices exactly a month later, on 13 June 1518, we may assume that Ahmed had died recently and that the enrolment of his sons was in part an act of charity by the Sultan.

Ahmed played a literally seminal role in the history of the imperial bindery, for it was dominated by his family for most of the 16th century. At least five generations of his family, a total of 16 persons, are recorded in the payrolls of palace binders, his great-great-grandsons, Osman, Ahmed and Kasım, being the last to be recorded with certainty, in AH 1033 (AD 1622–23). His great-great-grandsons were relatively low-ranking members of the bindery in the 1620s, but their grandfather, Kara Mehmed, was chief steward of the binders at the time, a position in which he was first recorded in 1605 and last recorded in AH 1033 (AD 1623–24).[13] Indeed, members of Ahmed's family were the highest-paid court binders for most of the 16th century.

By April or May 1545 at the latest, Ahmed's son Mehmed had become the head of the court bindery, having been in the employ of the court for some 30 years. Although he continued as chief binder until at least 1566,[14] no extant binding can be attributed to him, but there does survive a page of paper-cut calligraphy that he produced in AH 961 (AD 1553–54).[15] In 1545 there were four master binders and seven apprentices under Mehmed. Mehmed was the highest paid binder, followed by his three brothers; this left only one master – Ahmed, son of Kâmil – who was not a member of Ahmed's dynasty, and he was the lowest paid. In 1558 Mehmed was still head of the atelier, followed by three of his brothers, and their apprentices; Ahmed, son of Kâmil, had meanwhile been assigned to the binders attached to the imperial council, but was still recorded as the fifth master binder.

Continuity in the Ottoman palace bindery was thus ensured by this family tradition and was supported by apprenticeship: each of the master binders in 1545 had one apprentice each, while Mehmed, as head binder, had three. The influence of Ahmed's dynasty was felt in root and branch.

Mehmed was succeeded as head of the bindery by his brother Mustafa,[16] and he in turn by Mehmed's son Süleyman. Ahmed's dynasty was famous enough to be recorded in the late 16th-century account of scribes and painters by Mustafa Âli, who singles out the work of Süleyman.[17] Âli also mentions Süleyman's uncles, Hüseyin and Mustafa, but not Hasan. Two of Süleyman's brothers, Kara Mehmed and Mahmud, were also binders, and Kara Mehmed, as we have seen, was chief steward in the early part of the 17th century.[18]

Although we cannot as yet identify any bindings as the work of Bayezid II's binder Ahmed, and we are therefore unable to assess his artistic influence, the fact that his sons were trained by him and in turn trained their sons and many of the imperial binders of the 16th century made for greater continuity of technique and aesthetic. By the mid-century Ahmed's dynasty enjoyed complete control over the court bindery.

89 The binder Ahmed and his descendants
with their known dates of
employment in the imperial bindery

Notes

Preface

For the quotation on p.vii, see Ettinghausen 1954, p.459.

1. Hobson 1989.
2. Ettinghausen 1954, pp.463–4.

Introduction

1. Roberts & Skeat 1983.
2. Chicago 1981, p.24; Déroche 1992, p.20.
3. Khan 1993, p.11.
4. Chicago 1981, p.56.
5. 'The Materials, Techniques and Structures of Islamic Bookmaking', in Chicago 1981, pp.23–84.
6. Chicago 1981, p.46.
7. It has been pointed out to us by Alison Ohta that Bosch and Petherbridge's model does not hold true even for Mamluk manuscripts. We eagerly await the completion of Alison's work on Mamluk bindings, which will fill the lacuna referred to above (p.9).
8. Adam 1890, 1892, 1904–5.
9. It is possible that a large group of similar manuscripts may have been rebound later, but here broader art-historical criteria have to be applied.
10. Aga-Oglu 1935; Gratzl 1938–9; Aslanapa 1979.
11. Crane 1993, pp.36–70.
12. The earliest evidence from Anatolia for this connection comes from the endowment deed (*waqfiyyah*) that Altun Baba had drawn up for his *medrese* in Konya, which he founded in 1202. He stipulated that a proportion of the income from the endowments should be set aside for the library set up within the *medrese* and that the books needed for teaching were to be purchased with this money (Turan 1947, p.202; Oral 1950, issue 1, p.5).
13. Dublin, Chester Beatty Library, MS.1466 (Arberry 1967, no.46; James 1980, no.69). According to David James (personal communication), the binding of this manuscript is original.
14. Konya, Mevlana Museum, MS.51 (Tanındı 1990a, pp.17–22).
15. The group consists of four copies of the *Maṣnavī* (Mevlana Museum, MSS 1177, 1113, 53, 54; Çetin 1961, pp.104, 10), a two-volume copy of the *Dīvān-i kabīr* (MSS 68, 69), and a single manuscript containing the *Rabābnāmah* and *Intihānāmah* of Sultan Veled (MS.74); see Tanındı, forthcoming.
16. Konya, Mevlana Museum, MS.69. Emir Satı is referred to in the dedication as Amir Sati al-Mawlawi ibn Husam al-Din Hasan. One of the copies of the *Maṣnavī* in the Mevlana Museum (MS.1177; Tanındı, forthcoming) and a copy of the *Rabābnāmah* and *Intihānāmah* of Sultan Veled in Vienna (Österreichische Nationalbibliothek, Cod.mixt.1594; Duda 1983, pp.219–21) were made for the same patron. The illuminator who worked on the books of Emir Satı was a contemporary of Ibrahim al-Amidi, who illuminated Korans for the Mamluk sultan Sha'ban 1 between 1369 and 1376 (James 1988, pp.197–214).
17. Konya, Mevlana Museum, MS.12 (Oral 1950, issue 1, pp.5–10; Tanındı 1991, pp.42–3).
18. *Cf.* the decoration on two Mamluk bindings, Topkapı Palace Library, MS.A.2471 (text completed in April 1336; Tanındı 1990b, fig.22) and MS.A.317 (text completed in February 1391; Tanındı 1991, fig.33). In the latter case the floral design is used only on the back cover.
19. The envelope flap of the binding has been lost.
20. See above, p.45.
21. Firstly, Süheyl Ünver identified *figure 2* as Afyon, Gedik Ahmet Paşa Library, MS.12, whereas it is from the Konya Koran (Mevlana Museum, MS.12). (We would like to thank the Director of the Gedik Ahmet Paşa Library for confirming that there is no such binding in the library.) Secondly, he identified *figure 3* as Süleymaniye Library, MS.Fatih 4962, claiming that it was written in Konya by the scholar known as Musannifek (on whom, see above, p.45).
22. Istanbul, Topkapı Palace Library, MS.A.2127 (Tanındı 1990b, figs 6–8). For the manuscript, see Çağman & Tanındı–Rogers 1986, pp.31–2.
23. It is thought that the inner covers of plain leather are later replacements.
24. *Cf.* Weisweiler 1962, fig.7 (text completed in 1337, attributed to Iran or Turkey); fig.11 (text completed, Cairo, 1446). For a binding that is probably Mamluk on a manuscript dated AH 793 (AD 1391), with outsize lotus sprays between the centre- and corner-pieces, see Tanındı 1990b, fig.33 (reproduced in colour, Tanındı 1985, p.28).
25. A stamp used on the border of the Dioscorides manuscript has the same design as those used on bindings from Bursa in the mid-15th century (see above *figure 40* c–e), but the stamps differ in size and minute detail, and it remains to be established how long this design of stamp was current.
26. Weisweiler 1962, fig.28.
27. Topkapı Palace Library, MS.A.110 (Tanındı 1990b, fig.15).
28. Weisweiler 1962, fig.50.
29. Gratzl (1928) claimed that the manuscript, which he saw when it was offered to the Staatsbibliothek in Munich in 1927, is dated AH 832 (AD 1428–9). The manuscript was not bought by the Munich library, but it had been acquired by the Staatsbibliothek in Berlin by 1930, the year of its acquisition record (MS.OR.OCT.3285; Weisweiler 1962, fig.22). Weisweiler, however, gives the date as AH 834, and we are grateful to Dr Hars Kurio for confirming that the date AH 832 does not occur in the manuscript; that one of the treatises (by Ahmad al-Ghazali) is dated AH 834; and that there is a barely readable note dated AH 846, a birth-notice dated AH 924, and an undated *waqf* inscription.
30. Weisweiler 1962, figs 55–6, for example, display further examples of this feature, but it is not certain where the manuscripts were produced.
31. Istanbul, Süleymaniye Library, MS.Ayasofya 284. The late Professor Ünver kindly allowed Julian Raby to photograph his rubbing of the binding, which was marked as 'From the personal library of Fatih' (*Fatihin hususi kütüphanesinden*), a claim that still requires confirmation.
32. For pre-Mamluk examples, see Weisweiler 1962, figs 3, 5. For Mamluk examples, see Weisweiler 1962, figs 2 (text completed in 1353) and 6 (text completed, Damascus, 1338).
33. Tanındı 1990b, fig.13.
34. Weisweiler 1962, figs 9 and 11 respectively. *Cf.* also Weisweiler 1962, figs 8 (13th century?), 12 (text completed, Hama, 1421); Haldane 1983, no.1 (text completed in 1401).
35. Tanındı 1990b, fig.14 (text completed in 1298–9); *cf.* Tanındı 1990b, fig.29.
36. Chicago 1981, no.10.
37. The roundels differed not only in their profile but also in their filling. See, for example, Tanındı 1990b, fig.26; Weisweiler 1962, figs 26, 31, 33, 34, 41, 44, 45, 49; James 1980, no.33.
38. Weisweiler 1962, fig.52 (text completed in Damascus, 1461–2). *Cf.* Chicago 1981, no.47.

39. Weisweiler 1962, fig.46.

40. For dispersed sections and bindings from this Koran, see James 1980, no.105; Ettinghausen 1954, p.469, fig.356; Haldane 1983, no.13.

41. Öhrnberg 1978.

42. Weisweiler 1962, fig.63. The pointed-oval centre-piece became a frequent motif on Mamluk doors in the second half of the 14th century (Allan 1984, pp.87–8).

43. On this motif, see pp.45–52 above.

44. Weisweiler 1962, figs 31, 33, 42, 52; Tanındı 1990b, fig.26.

45. Weisweiler 1962, figs 34, 46, 49; Tanındı 1990b, figs 27–28; Chicago 1981, nos 57–62. *Cf.* the following variants: Weisweiler 1962, fig.26; Tanındı 1990b, figs 2, 19; Chicago 1981, nos 64–5.

46. Weisweiler 1962, figs 41, 44–5, 51; Tanındı 1990b, fig.33 (*cf.* fig.22).

47. It is difficult to believe that such well-defined patterns could have been achieved using the method proposed by Bosch and Petherbridge (Chicago 1981, pp.65–6). It may be that heat was used in the process; *cf.* Adam 1904–5.

48. See Bayram 1982, fig.2, for example. The craftsman who produced this doublure inserted his name – Mahmud – into the strapwork design.

49. Gray 1985, pl.viia. The manuscript is James 1988, no.40, part 20 (Topkapı Palace Library, ms.e.h.245); see also James 1988, pp.92–100.

50. Ettinghausen 1954, p.473; see also Allan 1982, no.7 (p.25 above, note 31).

51. Bosch 1952, pp.105–8; Chicago 1981, pp.65–6. The designs used on the detached bindings in the collection of the Oriental Institute, Chicago, are discussed in detail in Bosch 1952, pp.160–70.

52. Chicago 1981, p.66.

53. More than half the bindings in the Chicago collection have block-pressed doublures (Bosch 1952, p.113). As the majority were acquired from Moritz, they are probably of Cairene origin, despite the wide-ranging provenances attributed to them in Chicago 1981.

54. See, for example, Tanındı 1990b, fig.24 (text completed in 1336–7); Haldane 1983, no.1 (text completed in 1401).

55. See, for example, Chicago 1981, no.40 (text completed in 1475).

56. Tanındı 1990b, fig.32. On the dating of this binding, see this chapter, note 59 below.

57. Hobson 1989, chapter 3, especially pp.45, 52.

58. Tanındı 1990b, fig.22.

59. Tanındı 1990b, fig.33. The associated manuscript (Topkapı Palace Library, ms.a.2129) is dated ah 778 (ad 1376–7), but it must have been rebound more than a century later, as there is a dedicatory roundel in the name of Sultan Qansuh al-Ghawri (*reg.* 1501–16).

60. Ibrahim 1962; Chicago 1981, no.19; Haldane 1983, no.19, which, it should be noted, is the precise same size as Haldane 1983, no.18.

61. The earliest appearance of the cloud-collar motif on the Mamluk bindings so far published is on a manuscript of 1444 (James 1980, no.39; published in colour in James 1987, pp.64–5).

62. Haldane 1983, no.24; Weisweiler 1962, fig.59, which was produced sometime before 1476, when Qa'itbay presented it to his *medrese.* A less elaborate variant of the four-lobed tool occurs on a binding of 1442 (Weisweiler 1962, fig.10).

63. Topkapı Palace Library, ms.a.247/2. The colophon is dated 23 Ramadan 867 (11 June 1463), and Qa'itbay later donated the manuscript to his mosque in the citadel of Cairo.

64. Chicago 1981, no.67. Note the photograph on p.185, which shows the rhomb-and-meander stamp and a square-format stamp with a merlon motif; the latter was also used for the doublures of the Qa'itbay manuscript of 1473 (*figure* 10).

65. Raby (1986, fig.13) mistakenly published this binding as Ottoman (*cf.* Haldane 1983, no.129), but this was before he came across the Qa'itbay manuscript in the Museum of Turkish and Islamic Arts (see note 66 below), and before he was sufficiently familiar with the bindings of Mehmed ii. This misattribution can, however, serve as a warning of the dangers of ascribing detached bindings without the control of bindings on well-documented manuscripts. *Cf.* also a detached envelope flap, Haldane 1983, no.48.

66. Istanbul, Museum of Turkish and Islamic Arts, ms.508.

67. Weisweiler 1962, fig.59, datable to 1468–76 and made for Sultan Qa'itbay; Topkapı Palace Library, ms.a.1452, made for Qansuh al-Ghawri.

68. In the later Middle Ages 'Iraq al-'Arab (southern Mesopotamia) and al-Jazirah (northern Mesopotamia, a region now divided between Syria, Turkey and Iraq) were ruled by the same dynasties and formed part of the same cultural sphere as the Iranian plateau, and so the production of centres such as Baghdad and Mosul are often subsumed within the term 'Iranian'.

69. Titley 1983, pp.44–61, 223–4; Lentz & Lowry 1989, p.119.

70. Istanbul, Museum of Turkish and Islamic Arts, ms.2046.

71. See, for example, Sakisian 1934b, fig.12; Aslanapa 1979, pl.xiv; Lentz & Lowry 1989, no.99, illustrated on pp.198–9, 295.

72. Binyon, Wilkinson & Gray 1933, p.185; Chicago 1981, p.70; Lentz & Lowry 1989, p.349, under no.99. Dust Muhammad's text has recently been retranslated by Thackston (1989, p.346), who rendered *munabbatkārī* as 'inlay'.

73. Wulff 1966, pp.35, 97, 129; chisels are called *tīgh-i* or *qalam-i munabbatkārī.*

74. See, for example, Loubier 1910, p.5; Kersten 1914; Chicago 1981, pp.69–70.

75. Brend 1989, p.236. *Cf.* Brend 1989, fig.8; Aslanapa 1979, figs 32–3.

76. One difference between the two bindings is the treatment of the pendant escutcheons. The date of the binding on a copy of the *Ẓafarnāmah* produced in Shiraz in 1405 (London, British Library, ms.or.2833; London 1976, no.549) remains to be established.

77. Aslanapa 1979, fig.32; Brend 1989, fig.10.

78. The earliest recorded example of a binding with human figures is on a *Dīvān* of Jahan Khatun dated 1437 (Aslanapa 1979, figs 37–8). The *Khamsah* dedicated to Mehmed ii is Topkapı Palace Library, ms.r.862; Stchoukine 1966, pp.17–18; Stchoukine 1969; and Soucek 1971, p.600, with information on the colophons on folios 40a, 218a, 302a, 408a and 416a.

79. For a Shirazi manuscript dedicated to Bayezid ii, see *figure 79.*

80. Stchoukine (1969, p.8) suggested that the Turcoman-style miniatures were added under Bayezid ii, but it is worth pointing out that the manuscript does not carry the seal of that sultan.

81. Museum of Turkish and Islamic Arts in Istanbul, ms.1906, formerly ms.1543 (Sakisian 1934b, figs 4–5; Aga-Oglu 1935, pl.iv; Aslanapa 1979, fig.43). As the text block of ms.1906 measures 265 ×145 mm and was therefore much larger than that of the *Khamsah* of 1442, which measures 180 ×130 mm, the binder extended the central panel with a wider border and inscriptional panels above and below the main field.

82. Brend 1989, fig.11, in colour.

83. Aga-Oglu 1935, pl.v; Grube 1974, fig.131; Brend 1989, p.238. We would like to thank Professor Grube for providing us with photographs of *figures* 14 and 15.

84. Binyon, Wilkinson & Gray 1933, p.184.

85. Lentz & Lowry 1989, fig.25.

86. Özergin 1974–5; Lentz & Lowry 1989, fig.51 and pp.364–5; Thackston 1989, pp.323–7; and O'Kane 1987, pp.40–41, 56, especially note 96, for doubts about the association with Baysunghur.

87. This is perhaps the Anthology now in the Berenson Collection: Gray 1961, pp.84–6; Lentz & Lowry 1989, fig.40.

88. The scriptorium was an actual place and not merely an administrative arrangement or college of artists, for the report refers to the *kutub-khānah kih jihat-i naqqāshān bunyād nihādah takmīl yāftah, naqqāshān va kātibān nuzūl kard* ('the scriptorium that was founded for the decorative artists has been completed, and the decorative artists and the scribes have moved in').

Chapter One

1. Aşık Paşa-zade, ed.Giese, p.40. The 'great church' was Hagia Sophia, later known as Sultan Orhan Camii and now a roofless ruin; the *imaret* has been identified with a building

excavated outside the Yenişehir Gate; but the site and character of the monastery-*medrese* are the subject of dispute (see Ayverdi 1966, p.160, for example). *Cf.* Erünsal 1988, p.4.

2. See Taşköprülü-zade, ed.Furat, p.7, for example.

3. See p.4 above.

4. Taşköprülü-zade, ed.Furat, p.25; Erünsal 1988, p.5 and n.11. Some of Molla Fenari's books have survived among the manuscripts in the Veliyüddin Efendi Library, which was founded in the mosque of Bayezid II in Istanbul in 1768–9 and whose holdings were transferred to the Beyazıt Public Library, now the Atatürk Library (Ünver 1946, p.3; Erünsal 1988, p.5, n.12).

5. Taşköprülü-zade, ed. Furat, p.27–8; Erünsal 1988, p.6.

6. Eyice 1962–3, pp.4, 22–3.

7. Eyice 1962–3, p.24.

8. Aşık Paşa-zade, ed. Giese, p.40.

9. For example, Demiriz 1979, figs 306–16, 401–13.

10. See, for example the list of books donated by Umur Bey, the son of Timurtaş Pasha, to his father's *imaret* in Bursa (p.39 above).

11. Topkapı Palace Library, MS.A.167.

12. Aubin 1957, p.78; Tekindağ 1961, p.103; Ben Cheheb 1971; Aka 1991, p.29; Tanındı, in preparation.

13. The binding has been lined with paper, presumably during restoration.

14. Repp 1986, p.84.

15. Kuran 1968, p.115.

16. Denny 1979.

17. Demiriz 1979, fig.361; Öney 1987, p.79.

18. Taeschner 1932, p.144.

19. The carver of the wooden doors to the tomb, 'Ali ibn Hajji Ahmad Tabrizi, seems to have been a native of the same city (Taeschner 1932, p.147).

20. For the ceilings, see Demiriz 1979, figs 271–2.

21. Taeschner 1932, pp.143, 146–7.

22. The name actually reads, 'Ali ibn Ilyas 'Ali, but the second 'Ali seems to be a repetition made in error or to fill out the line. Firstly, it was very unusual for a man to have two personal names in this period. Secondly, it was common for the deprecatory tag placed before the name in a signature to rhyme with the name itself (*cf. bu ez'afü'l-halk inde'llah ve'n-nâs Mercümek Ahmed ibn-i İlyâs*; Mercümek Ahmed, ed. Gökyay, p.3), and in this case the tag (*afqar al-nās*, 'the most needy of mankind') rhymes with Ilyas, but not with 'Ali. And thirdly, 'Ali's most famous descendant, the writer Lami'i, referred to his grandfather as 'Ali al-Naqqash ibn Ilyas (Flemming 1986) [Editor].

23. Taeschner 1932, pp.143–4; Demiriz 1979, fig.295.

24. Taeschner 1932, pp.166–7; Flemming 1986.

25. Taeschner 1932, *loc.cit.*; Taşköprülü-zade,

ed. Furat, p.437. Timur did not visit Bursa in person but sent his grandson Muhammad Sultan to plunder the city.

26. Sümer 1983, unnumbered plates.

27. Bertrandon de La Broquière, ed. Schéfer, p.219.

28. Aşık Çelebi made a similar claim for his great-grandfather, Seyyid Natta', who was one of the two men carried off from Bursa with Molla Fenari. Seyyid Natta' was a Baghdadi dervish whose trade was the manufacture of the *nat'*, the leather mat used as a table. According to Aşık Çelebi (ed. Meredith Owens, folio 182b), the Ottomans had previously used the metal *sīnī* and only began to employ the *nat'* after Seyyid Natta' presented one to Sultan Murad II [Editor].

29. See above, p.16.

30. Ettinghausen 1954, pp.472–3.

31. Ettinghausen dated them to the 12th century, but one has figures typical of the metalwork of Is'ird (now Siirt in Turkey) in the mid-13th century (Allan 1982, no.7).

32. Museum of Fine Arts, Boston, inv.no.31.374; Ettinghausen 1954, fig.359. The other mould, in two parts, is in the Oriental Institute, Chicago (inv.no.32.151; Ettinghausen 1954, p.473). A leather fragment in the Victoria & Albert Museum, London, which has been published as part of a detached binding and attributed to Egypt in the 14th or 15th century (Haldane 1983, no.14.), may also illustrate the connection between saddlery and bookbinding. The fragment is relatively large, measuring 264 × 203 mm, and is decorated with tooled designs in blind and in gilt that may once have been enhanced with blue. (No blue is visible to the eye, although Haldane reported traces of blue pigment.) The patterns employed – panels of geometric strapwork filled with knot-work and chrysanthemum-like rosettes – can be related to Mamluk illumination (*cf.* James 1988, fig.29, and Lings 1976, pl.78, for example), as well as to Mamluk bindings ranging in date from perhaps as early as the late 13th century (Tanındı 1990b, fig.13, which is attached to a text completed in 1287–8) to the 1440s (Weisweiler 1962, fig.10, whose accompanying text is dated 1442). But the shape of the fragment and the curious juxtaposition of the fields of decoration, together with the fact that one of these, a wide, composite band, is tapered, suggest that it was never part of a binding at all. As the upper edges of the piece are pierced by nail holes, it may once have been pinned to a wooden form, such as the tree of a saddle [Editor].

33. Erünsal 1988, pp.7–8.

34. Süheyl Ünver identified a number of books with the Sultan's ownership recorded in them; Erünsal 1988, p.8.

35. Bursa, İnebey Library, MS.Haraçcıoğlu 1324; Tanındı 1990–91a, p.147, fig.20, pl.ivd.

36. Süleymaniye Library, MS.Süleymaniye 1009;

the binding is damaged but may be compared to those on two Ottoman manuscripts in the Topkapı Palace Library, MS.A.3428, dated 1462, and MS.A.3441, dated 1464 (*figure 45*).

37. Istanbul, Topkapı Palace Library, MS.R.93. Karatay (1961a, no.90) states first that this manuscript is an autograph copy and then that the author died in AH 864 (AD 1459), five years before it was transcribed.

38. Two of the few exceptions are a Koran copied in Edirne in 1452 by a scribe who bore the surname 'al-Hijazi' (see below, Cat.9, note 1) and the illustrated *Dilsūznāmah* now in Oxford (MS.Ouseley 133; Stchoukine 1967, pp.47–50; Çağman 1974–5, pp.333–4; Grube 1987, pp.187–202.)

39. On Konya, see above, p.45; on Amasya, see above, p.48.

40. MS.Morgan 500; see Ettinghausen 1954, p.468, fig.344.

41. Ettinghausen 1954, pp.464–5, fig.345, which reproduces Sakisian 1937, fig.1.

42. Topkapı Palace Library, MS.A.3437. *Cf.* Süleymaniye Library, MS.Ayasofya 2639, a copy of the *Risālah fī'l-hay'ah* of the imperial astronomer, 'Ali Qushchi, which may also have been made for Mehmed II.

43. Raby 1983, figs 2, 4, 13, 14, 16, 17, 19.

44. There are several Mamluk examples in Weisweiler 1962 (figs 58, 60, 63, 69), as well as two examples on Anatolian manuscripts copied in 1280 and 1312 (figs 54, 28), and an Iranian example on a manuscript dated 1459 (fig.57).

45. Stöcklein 1914–15, where the motif is referred to as the 'dschang'. If Stöcklein's theory is correct, the binding on a manuscript copied in Baghdad in 1205 (Weisweiler 1962, fig.37) must have been added some time after the text was written, for it has everlasting knots as corner-pieces.

46. Bursa, İnebey Library, MS.Haraçcıoğlu 640; see Tanındı 1990–91a, pp.146–7, fig.18.

47. Topkapı Palace Library, MS.G.i.24; Raby 1983, p.17, p.27, note 63, fig.11.

48. Raby 1983, figs 3, 6, 8, 11,14.

49. Topkapı Palace Library, MS.A.2131.

50. Topkapı Palace Library, MS.R.475. On this scribe, see also cat.22, and pp.70–1.

51. James 1992b, no.21, and pp.88–9.

52. Süleymaniye Library, MS.Fatih 5004; see above, p.45. *Cf.* also Weisweiler 1962, fig.43.

53. Latifi, ed. Ahmed Cevdet, p.60. Latifi's translator into German offered a different interpretation of the second half of this passage: 'Aber wenn er freilich auch selbst nur selten dichtete, so fand doch diese Kunst in seiner Regierung reissenden Absatz [d.i. kam in ihr zur eigentlichen Blüte.]' (pp.45–6) [Editor].

54. Sehi Bey, ed. Kut, folios 12b–13a (pp.94–5). This picture of Murad is confirmed by a contemporary, Bertrandon de La Broquière: 'la chose

en quoy il prent le plus grant plaisir, c'est en boire et aime gens qui boivent bien et m'a l'en dit qu'il boit tresbien x ou xII grondilz de vin qui peuvent bien estre vI ou vII quartes' (ed. Schéfer, p.183).

55. Latifi, ed. Ahmed Cevdet, *loc.cit. Cf.* Erünsal 1985, p.749; Erünsal 1988, p.8.

56. Mercümek Ahmed, ed. Gökyay, pp.3–4, amended after Birnbaum 1981, p.6. A number of other translations dedicated to Murad II are listed by Uzunçarşılı (1961, pp.539–42).

57. Ünver 1952a, pp.301–2, figs 6–10.

58. Süleymaniye Library, MS.Hamidiye 1082 mükerrer; Istanbul 1953, no.16; Ünver, *loc. cit.*

59. Konya, Mevlana Museum, MS.2524; Gölpınarlı 1971, pp.424–7. This binding has some affiliations with those produced in Iran in the previous century: the covers on the 30-part Koran of the Emperor Öljäytü (Hamadan, 1313), for example (Ettinghausen 1954, fig.346).

60. Gratzl 1924, pp.13–14, pls vIII–x.

61. Gratzl (1938–9, pp.1977–8, note 5) attributed the binding to eastern Iran, an attribution repeated by Pedersen (1984, fig.22). In the accompanying listing the binding is described as 'probably of Mesopotamian origin' (Gratzl 1938–9, p.1991).

62. Chester Beatty Library, MS.1508. Regemorter 1961, pls 23, 24; Arberry 1967, no.104. *Cf.* a binding on a Koran in Cairo (Ibrahim 1962, pl.2); the binding on another manuscript in the Chester Beatty Library, also made for Sultan Qa'itbay (Regemorter 1961, pl.20); and a binding in Munich (Kirchner 1955, fig.348).

63. Chicago 1981, no.25 (also published by Hobson 1989, figs 29, 30). Compare especially the swastika pattern in the border of the doublure (Hobson 1989, fig.30) with that on the back doublure of the Bursa Koran (cat.1).

64. Topkapı Palace Library, MS.Y.438. Parts I, II, 13–17, 20, 22 and 24 survive. See also cat.9.

65. On Murad's repeated attempts to retire from the throne, see İnalcık 1954, pp.55–67.

66. For a brief account of Umur Bey's family, see Uzunçarşılı 1961, pp.573–6. *Cf.* also Babinger 1934; Tekindağ 1974.

67. Ayverdi 1972, p.337; Erünsal 1985, p.751; Erünsal 1988, pp.9–10.

68. On the mosque, see Kuran 1968, pp.48–9; Ayverdi 1972, pp.337–44, figs 605–9.

69. Ayverdi 1972, p.344. The most likely explanation for this gift is that Erhundişah was Umur Bey's wife.

70. 'I cannot say what function the smaller room … served. … I can only say that the smaller room was probably not part of the prayer area because there is no *mihrab* in it.' (Kuran 1968, p.48).

71. Ayverdi 1972, p.337, 339; Erünsal 1985, pp.752–3; Erünsal 1988, p.11.

72. Erünsal (1988, *loc.cit.*) gives the date of this inscription as Jumada'l-Akhir 859, but the text

itself gives 30 Muharram 859 (20 January 1455) as the date when the deed was drawn up, and Jumada'l-Akhir 865 (14 March–11 April 1461) as the date when the inscription was made (see Ayverdi 1977, p.340).

73. Yüksel 1984, pp.141–2; Erünsal 1985, p.752; Erünsal 1988, p.10.

74. Yüksel 1984, pp.136–40. Yüksel used the version on folio 329 of the manuscript (İnebey Library, Bursa, MS.Ulu Cami 436; *figure 37*), but this is defective: it accounts for only 58 of the 60 volumes. A complete version is to be found on folio 1b of the same manuscript. The books donated by Umur Bey were unusual in that they included only three works in Arabic, and none in Persian, but numerous translations into Turkish. The libray of Umur Bey included a six-volume copy of the *Siyar-i Nabi* by Darir, a biography of the Prophet in Turkish presented to the Mamluk sultan Barquq in 1388. Darir later returned to Anatolia, to Karaman, and, given Umur Bey's interest in promoting the translation of pious works into Turkish, he may have acquired an autograph of the work, pehaps through his father who was then resident in Kütahya as *beylerbeyi* of Anatolia. The library also contains a copy of another Turkish work by Darir, his *Futūḥ al-Shām*, which the poet wrote after moving from Karaman to Syria, and which he presented to the Mamluk governor of Aleppo in 1395. Perhaps Ibn al-Jazari, who passed through Aleppo on his way to Bursa in 1396, acquired these works and took them with him to Turkey where they later passed into the hands of Umur Bey or his father. See Tanındı 1984c, p.27.

75. Yüksel 1984, p.143.

76. His grave lies under a dome, which rests on a square brick structure open on four sides (Ayverdi 1977, pp.344–5, figs 610–14).

77. See above, p.11.

78. An almost identical design occurs on the doublures of MS.Haraçcıoğlu 640 in the İnebey Library, Bursa.

79. Tanındı 1990–91a, p.146, figs 16, 17.

80. Weisweiler 1962, fig.50. See also a binding mistakenly published as 'North Africa/Egypt, 15th century' (Haldane 1983, no.51).

81. İnebey Library, MS. Haraçcioglu 640; Tanındı 1990–91a, pp.146–7, fig.18.

82. James 1988, no.61. For the bindings, see Ettinghausen 1954, figs 351, 353, 354.

83. The same design also appears on the back cover of the Konya Koran of 1313–14 (*figure 2*). There is a rosette in the centre of the star, and the polygons within the strapwork are filled with tools similar to those used on cat.5.

84. Ettinghausen 1954, fig.352. *Cf.* also cat.5.

85. The same frame surrounds the medallion on the front cover of cat.3, but the centre was treated quite differently.

86. MS.72; James 1988, no.45. For the binding, see Ettinghausen 1954, fig.346. Despite the evident parallels between the Bursa bindings and Iranian work of the previous century, we should not ignore the possibility of a Mamluk component in the 'Bursa style'. The s-overlap border of MS.Haraçcıoğlu 640, for example, appears to be derived from Mamluk work; *cf.* MS.A.317 in the Topkapı Palace Library, a Mamluk manuscript of AH793 (AD1391), for example.

87. Weisweiler 1962, fig.44.

88. The work in question is a commentary (*sharḥ*) on the *Lubb al-lubāb* ('Pith of piths') of al-Isfara'ini.

89. Rawson 1984, pp.132–3.

90. A surviving example of an Iranian cloud collar is in the Kremlin Armouries in Moscow (Lentz & Lowry 1989, no.116). For the patterns, see Lentz & Lowry 1989, nos 90, 95–7, 114, 115.

91. For this method of working see above, pp.13–19.

92. Rawson 1984, pp.156–63.

93. Chester Beatty Library, Dublin, MS.114; for the binding, see Brend 1989, fig.5. For a companion volume, see Lentz & Lowry 1989, no.16.

94. Lentz & Lowry 1989, pp.116–19.

95. Topkapı Palace Library, MS.H.796; Aslanapa 1979, fig.32; Brend 1989, fig.10.

96. The motif was in use on Mamluk bindings by the mid-15th century (see Introduction, note 61).

97. Topkapı Palace Library, MS.A.3419.

98. Filigree flowers were also used – in brown against a gold field – in the small medallions at the centre of the doublures, which are of red leather.

99. The other example is on MS.R.1919 in Topkapı Palace Library, a small Ottoman manuscript from the first half of the 15th century, which contains a copy of the *Ṣad kalimah-i 'Alī*. *Cf.* also Sarre 1923, pl.ix, for an item identified as 'Egyptian, 14th century'; it was, however, acquired in Istanbul.

100. İnebey Library, Bursa, MS.Haraçcıoğlu 1324; Tanındı 1990–91a, p.147, fig.20, pl.ivd. *Cf.* Topkapı Palace Library, MSS A.3449, H.1417.

101. Museum of Turkish and Islamic Arts, Bursa, MS.11; Tanındı 1990–91a, p.149 and fig.30.

102. Topkapı Palace Library, MSS A.3428 and A.3441.

103. Topkapı Palace Library, MSS A.20 and A.1691.

104. The use of gold and blue is attested in Iran by the 1380s (Ettinghausen 1954, p.467, and note 17).

105. Chester Beatty Library, Dublin, MS.405; Minorsky 1958, pp.7–8.

106. Topkapı Palace Library, MS.A.3449. This manuscript is undated, but the cloud-collar cartouche on the outer covers is of the same type as that on MS.Haraçcıoğlu 1324 (*figure 41*),

which was copied in 1452, and the doublures are the same as on cat.4, volume VIII, which was donated to the library of Umur Bey in 1453. These features suggest that MS.A.3449 was produced *circa* 1452.

107. *Cf.* Millet Library, Istanbul, MS.Feyzullah Efendi 489, dated Shiraz, 1429 (Sakisian 1934b, fig.1); and Topkapı Palace Library, MS.A.645, dated 1430–31.

Chapter Two

1. Raby 1987b; Washington 1991, no.107.
2. Raby 1980.
3. Raby 1987b.
4. Raby 1983, p.15.
5. For at least one Byzantine manuscript saved from the sack of the city by Mehmed, see Babinger 1956; Raby 1987a, p.298.
6. Patrinelis 1966, p.98, line 255.
7. A copy was also made of a Greek translation of the *Liber Insularum Archipelagi*; Raby 1987a, pp.303–4.
8. Raby 1987a.
9. Restle 1981.
10. Raby 1987c, p.189.
11. Tursun Bey, ed. İnalcık & Murphey, folio 56a, lines 9–12; ed. Tulum, p.70.
12. Repp 1972; Repp 1986, especially Chapter 2.
13. Erünsal 1988, pp.15 *ff.*, especially pp.25–6; *cf.* Cunbur 1985, pp.714–5.
14. Ünver 1952b.
15. Süleymaniye Library, MS.Damad İbrahim 822. For doubts about the authenticity of the date, see Ünver 1952b. On folio 1a there is a note recording its donation by Mehmed. The librarian Mustafa has added that he found that some pages were missing and made good the loss with difficulty. Mehmed was not the only benefactor of this library: the scholar and author Musannifek, for example, made a donation of his books. See Erünsal 1988, pp.197–8.
16. Baykal 1958, p.77; Erünsal 1988, p.16.
17. See Introduction, pp.12–17.
18. Blue was sometimes used as a subsidiary ground colour, as, for example on cat.21.
19. One of the earliest examples of a centre-piece with knotted hearts is Topkapı Palace Library, MS.A.1411, which was copied in Bosnia in 1463.
20. See Brend 1989, fig.5 for the earliest use of this style of corner-piece.
21. Istanbul, Millet Library, MS.Feyzullah 1360; see Sakisian 1927b, p.141, figs 6–7; Istanbul 1953, no.71. *Cf.* Sakisian 1927b, p.150, on the rarity of purely arabesque designs on Ottoman bindings.
22. The arabesque design of the pointed-oval centre-piece is similar to that of the centre-piece on the doublure of cat.11.
23. Süleymaniye Library, MSS Turhan Valide 210, (Ritter 1937, p.281; Istanbul 1953, no.51) and Damad İbrahim 826 (Istanbul 1953, no.52;

Ünver n.d., no.7). (See Chapter 2, Table 2, nos 9 and 12). The illuminated panels in the latter manuscript, which would normally have contained the dedication to Mehmed II, have been gilded over.
24. Süleymaniye Library, MSS Damad Ibrahim 826 and Laleli 1246M, respectively.
25. Istanbul, Nuruosmaniye Library, MS.3571; Ünver 1946, pl.36; Ünver 1952b; Baylâv 1953, p.58.
26. See above, p.15.
27. MS.F.1423; Ünver 1958.
28. Ünver 1958, p.10, 12, 15.
29. See above, p.100.
30. Raby 1981, p.47.
31. Ünver 1958, p.34.
32. Ünver 1958, p.47; for domed ceilings of the period, see Ünver & Pakalın 1945. An alternative possibility is that it was a design for a leather table mat (see above, Chapter 1, note 28).
33. Necipoğlu 1990, p.138.
34. Ünver 1958, pp.35, 51, 53.
35. Istanbul, Süleymaniye Library, MS.Damad İbrahim 826, for which see this chapter, note 23.
36. For metalwork, see Raby 1982; for ceramics, see Atasoy & Raby 1989, pp.76–81; for woodwork, see Raby 1986, as well as the *minbars* in the mosque of İvaz Bey in Manisa, which can be dated to 1484 (Yüksel 1983, p.347) and in the Hatuniye Mosque, Manisa, which was made in AH 896 (AD 1490–1; Oral 1962, pp.75–6).
37. Atasoy & Raby 1989, figs 64–5.
38. Raby 1982, fig.6; Çağman 1983, no.E.21; Washington 1991, no.80.
39. Ünver 1946, pl.32.
40. *Cf.* cat.11, though the centre-piece is linked to the frame by a roundel.
41. For manuscripts of this size dedicated to Mehmed II, see for example, Topkapı Palace Library MSS.A.1417 and A.3220; and Süleymaniye Library, MS.Turhan Valide 219.
42. The second manuscript is Süleymaniye Library, MS.Turhan Valide 238. The centre-piece on the outer covers of MS.Şehzade Mehmed 28 is comparable in size and design to that used on cat.11; this is not dated, but its doublure compares to the outer cover of *figure* 61.
43. Gantzhorn 1990, pp.298–307, provides a convenient coverage in colour.
44. Raby 1986, p.178.
45. Istanbul, Süleymaniye Library MS.Fatih 2571M (Istanbul 1953, no.39; Tayanç 1953; Ünver 1948, pp.41–51; Ünver n.d., fig.20; see also cat.17). The manuscript is dedicated to Mehmed II, but is not dated. The centre-piece of its outer cover is identical to that on Istanbul, Süleymaniye Library, MS.Turhan Valide 238; *cf.* this chapter, note 42.
46. Raby 1986, fig.2.
47. Respectively, Canova 1964, pp.93–4 and Franses & Pinner 1981.

48. *Cf.* Ruppersberg 1983, who suggests a similar date but ascribes a Turcoman origin to the design.
49. Uzunçarşılı 1986, p.57; Aslanapa 1986, p.70.
50. Barkan 1953–4, p.311; Barkan 1979, p.326; Aslanapa 1986, p.71.
51. Adam 1904–5, p.184.
52. Peçevi 1283, I, p.446.
53. Ünver 1958, p.8.
54. Ünver 1954; Nadir 1986, p.37, no.6; Christie's, London, 24 April 1990, lot 152.
55. Topkapı Palace Library, MS.A.1411.
56. Süleymaniye Library, MS.Ayasofya 2383. See above, p.71, Table 2, no.21. For Edirne, see this chapter, note 94.
57. Çağman 1989, p.36; Fisher & Fisher 1985.
58. Necipoğlu 1991, p.48, p.271, note 71.
59. Mango 1959, pp.154–69; Çağman 1989.
60. Ahmed Refik 1335–7, p.7. We would like to thank Professor Gülru Necipoğlu for kindly providing us with a photocopy of the original document (Başbakanlık Arşivi, Kamil Kepeci 7154, pp.2–3, 38–9, 70–1).
61. *Cf.* Ünver 1956; Ayverdi 1972, 85*ff.*, 405*ff.*, 417*ff.*, 435*ff.*; Gasparini 1985.
62. Lentz & Lowry 1989, p.364; Thackston 1989, p.325.
63. Çağman 1989, p.39; Necipoğlu 1991, p.241.
64. Meredith-Owens 1969, p.18.
65. See above, p.22–23.
66. Lentz & Lowry 1989, no.38, and p.205.
67. Süleymaniye Library, MS.Fatih 2571M. On this manuscript, see above, this chapter, note 45.
68. For other Timurid examples of flora with frilled edges, see Lentz & Lowry 1989, nos 106, 112, illustrated on p.205 and p.210 respectively.
69. Flora of this type occur on a copy of the *Maşnavī* produced in 1461 in Isfahan, but the main motif is an animal combat (Aga-Oglu 1935, pl.21; Grube 1974, fig.133; Sakisian 1937, p.215, 219).
70. Istanbul, Süleymaniye Library, MS.Ayasofya 4172. He was ruler of the province of Fars from AH 838, and of Transoxiana from AH 854–5.
71. The doublures have floral decoration in filigree against a blue ground. A particularly close comparison can be made with an Ottoman binding (Süleymaniye Library, MS.Ayasofya 3877). This manuscript is not dedicated to Mehmed II, but it is of his period.
72. *Cf.* also Süleymaniye Library, MS.Ayasofya 1864, but the text it encloses lacks any obvious clues as to its date, provenance or patron.
73. Süleymaniye Library, MS.Şehzade Mehmed 16, whose text is dated 13 June 1452, was copied by Muhammad ibn Shahinshah. It has many features that link it with the cloud-collar group of the 1450s.
74. Süleymaniye Library, MS.Fatih 3645. In the illumination, the gold is a dullish orange, more in the Mamluk than the Turcoman manner. The

doublures are very simple – plain light burgundy with fillet borders.

75. It bears the seal of Bayezid II, which indicates that it was once in the imperial library.

76. *Cf.* Zayn al-'Abidin ibn Muhammad, who was also a calligrapher and illuminator (Bosch 1952, p.36; Aga-Oglu 1935, p.16, pl.XVII; Sakisian 1937, p.224, fig.4; Gratzl 1938–9, p.1991; Ünver 1958, p.15). For Mamluk examples, see Bosch 1952, p.37.

77. Süleymaniye Library, MS.Ayasofya 3626.

78. The deficiencies are obvious in the uneven placement and sizing of the tiny rays that edge the centre- and corner-pieces of the outer covers.

79. See above, cat.11.

80. Süleymaniye Library, MS.Turhan Valide 210 (text completed in 1466); Topkapı Palace Library, MS.R.706 (text completed in 1464; see Çığ 1971, pl.1; doubts have been expressed about the authenticity of this binding, which has been much reproduced); and Topkapı Palace Library, MS.A.3195 (text completed in 1475).

81. See Chapter 2, Table 2, no.2.

82. Topkapı Palace Library, MS.A.1996. See below, cat.23, note 4.

83. Istanbul, Topkapı Palace Library, MS.A.2829.

84. Süleymaniye Library, MS Süleymaniye 353.

85. Süleymaniye Library, MS.Şehzade Mehmed 101; *cf.* Weisweiler 1962, fig.11.

86. Zorzi 1987, especially pp.59–61, 77–85.

87. The lists given in Istanbul 1953, Tayanç 1953 and Öz 1953 are for the most part repetitive and are often unreliable.

88. See above, Chapter 1, note 42.

89. For despatches in the Milan archives, see *Monumenta Hungariae Historica, Acta Extera,* IV, 1875, pp.356–7, 369–75.

90. The scribe states in the colophon that he completed the text on the *mawlūd sayyid al-kāyinat.*

91. Kritoboulos, trans. Riggs, p.14; ed. Grecu, p.43.

92. Raby 1987c. A similar chronology can be observed in the production of Greek manuscripts at Mehmed's court (Raby 1983).

93. See the introduction to Appendix 2.

94. At least one Fatih-style leather binding (Süleymaniye, MS.Ayasofya 686) was certainly produced in Edirne. This an autograph of a work by Molla Gurani and may well date from the year the work was composed, AH 874 (AD 1469–70). It is worth noting, however, that it was not finished to quite the same high standard as many of the other Fatih-style bindings.

95. Appendix 3, nos 2, 4, 6, 9, 11, 22, 27, 46.

96. Appendix 3, no.50, lacks Bayezid's seal, but the manuscript lies outside the main tradition.

97. This cannot be because red velvet was not worn at Bayezid's court: in November 1503, for example, the Mamluk ambassador was given

an outfit (*came*) made of pile-on-pile Italian crimson velvet. Rogers 1987; Barkan 1979, p.181, item 193; Tezcan & Delibaş–Rogers 1986, p.16.

98. Topkapı Palace Museum, inv.no.13/10 (Atasoy 1992, p.112).

99. Çağman 1983, no.E.9.

100. Appendix 2, no.23.

101. Arat 1936–9, p.303; Woods 1976, pp.128–9.

102. The velvets were not specially woven for the bindings, but they may have been taken from samplers. Establishing their origin is still a problem. We must wait for the major publication on the subject being prepared by Nurhan Atasoy, Walter Denny and Louise Mackie.

103. Bertrandon de La Broquière, ed.Schéfer, p.176.

104. *Monumenta Hungariae Historica, Acta Extera,* IV/2,1877, pp.239–44 (doc.170).

105. Diehl 1946, I, p.113; *cf.* Hobson 1989, p.18. On the Corvinian examples, see Csontosi 1878, nos 1, 4–11, 18.

106. Tezcan & Delibaş–Rogers 1986, p.20.

107. Çağman 1983, no.E.124; *cf.* Çağman 1983, no.E.181.

108. On the manuscript, see Çağman & Tanındı–Rogers 1986, nos 173–5. For another example of a textile binding of the 18th century, see Baltimore 1957, no.91.

109. For Iranian examples, see manuscripts such as Topkapı Palace Library, MS.R.862 (see above, Introduction, note 78), R.866, R.855, R.1547 (*figure 74* and cat.19, notes 2 and 4).

110. Süleymaniye Library, MS.Ayasofya 3839. Two further examples of this style of illumination can be found in cat.23 and in Süleymaniye Library, MS.Ayasofya 3958 (Table 3, no.2).

111. A matt, silvery gold for the border; an orange and lustrous gold for the ground of the inscription; and a sprinkled brown and matt gold for the plaited border.

112. Ahmad ibn 'Abdallah al-Hijazi came to Turkey from Shiraz and copied a Koran in Edirne in 1452 (see above, Chapter 1, note 38).

113. *Cf.* Süleymaniye Library, MSS Damad İbrahim 1066/1–2, which has different colouring again, and MS.Ayasofya 3870, whose illuminator did not, however, opt for the smaller borders.

114. See above, Chapter 3, pp.91–2.

115. See above, this chapter, note 92.

116. Tansel 1953, p.323.

117. Busse 1959, pp.151–3, no.2.

118. Richard 1989; Nadir 1986.

119. Mokri 1973.

120. Richard 1989.

121. See p.76, Table 3. He signs himself Ghiyath al-Mujallid al-Isfahani (nos 2, 4–6); Ghiyath al-Din al-Mujallid (no.3); and Ghiyath al-Din al-Mujallid al-Isfahani (no.7). For no.8, see this chapter, note 123.

122. We are grateful to Tim Stanley and Dr Julie

Meisami for their help with this translation. See also Ünver 1958, p.27.

123. *'alā yad al-'abd al-faqīr Ghiyāth al-Mutaṭabbib – aṣlaha Allāh sha'nahu abadan – al-shahīr bi-Mujallid.* The book in question is Süleymaniye Library, MS.Ayasofya 3557.

124. Ünver (1958, p.15) was wrong in stating that it is the *Dīvān* of Qabuli.

125. Süleymaniye Library, MS.Ayasofya 3696, copied in Istanbul in AH 882 (AD 1477–8); MS.Esad Efendi 2494, copied in Istanbul in AH 883 (AD 1478–9); MS.Ayasofya 3557, undated.

126. Levey 1962.

127. Kappert 1976, pp.64–5. The manuscript was reproduced in facsimile by Ertaylan 1948.

128. These books are small to medium in size, ranging in height from some 170 mm to 260 mm.

129. Ertaylan 1948; Ayverdi 1953, pp.51–52, fig.31.

130. The paper is yellow, of an unpolished, probably European, type.

131. Topkapı Palace Library, MS.A.2633.

132. Tansel 1953, pp.294–5; Woods 1976, p.129, p.270, note 107.

133. The pressure-moulding on the binding of MS.Ayasofya 3557 is not very deep. *Cf.*above, pp.92 *ff.*

134. Ünver (1958, p.15, note 8) for a partial, and sometimes incorrect, list of works by Ghiyath.

135. Ünver 1958, p.39.

136. Appendix 3, no.11.

137. *Cf.* Soucek 1988, pp.7–13, for an Aqqoyunlu panel-stamped binding datable to 1478.

138. Topkapı Palace Library, MS.A.2062.

139. Süleymaniye Library, MS.Ayasofya 3839. The outer covers are in very poor condition.

140. Topkapı Palace Library, MS.A.3228.

141. The binding exhibits an unusual use of a thickish s-tool for the border. *Cf.* MS.Ayasofya 3895, which is also dated AH 886 (AD 1481–2).

142. For a related Timurid or Turcoman drawing, see Istanbul, Topkapı Palace Library, H.2153.

143. Topkapı Palace Library, MS.A.1921.

144. *Cf.* respectively, Babinger 1966 and Jacobs 1937; Jacobs 1949, p.29.

145. Babinger 1966.

146. Werner 1966, p.257.

147. Raby 1987a.

148. Raby 1983, pp.23–24; Raby 1987a, p.302.

149. Jacobs 1949, p.25.

150. Karabacek 1918, pp.16–21; Babinger 1951; Raby 1987a, p.303.

151. Ünver 1952b; Baylâv 1953, pp.57–58.

152. For the latter, Istanbul, Köprülü Library, MS.894. See also cat.15. Among the manuscripts with frontispiece dedications to Mehmed is a copy of the dispute between Nasr al-Din Tusi and Imam Razi on the sections on logic in Ibn Sina's *Isharāt,* (Istanbul, Topkapı Palace Library,

MS.A.3446. There is possibly a duplication in Karatay's catalogue between MSS A.3446 and A.3466). On 23 August 1467 a copy was completed for Mehmed of Nasr al-Din Tusi's commentary on the *Ishārāt*. (Istanbul, Süleymaniye Library, MS.Şehzade Mehmed 67). See also cat.16. Incidentally, much of the responsibility for transcribing such philosophical works was given to 'Ali ibn Fathallah al-Ma'dani al-Isfahani.

153. Repp 1986, especially pp.68–71.

154. Halasi-Kun 1987–92.

155. On the date of the debate, see Repp 1986, pp.134–5. On Hocazade's treatise, Türker 1956.

156. No copy of Ibn Rushd's work copied for Mehmed has so far been identified.

157. Rosenthal 1958, p.14.

158. Raby 1983, pp.17–20.

159. Raby 1983, p.23.

160. However, a copy of Suhrawardi's *Al-mashāri' wa'l-muṭārahāt* was written for him in October 1466 (Table 2, no.9), and Sadr al-Din Qunawi's *Miftah al-Ghayb* (Table 2, no.13) in 1467.

161. Adapted from Kritoboulos, trans. Riggs, p.14. For the Greek, Kritoboulos, ed. Grecu, p.43. On Mehmed and pseudo-Aristotle's *Secretum Secretorum*, see Jacobs 1949, p.22, and Ryan 1982, pp.119–20.

Chapter Three

1. E.g. Venice, Museo Correr, MS.Cicogna 1971; on the manuscript, see And 1989.

2. Çavuşoğlu 1971, p.57.

3. Yüksel 1983, pp.160–61, 234.

4. Yüksel 1983, p.136.

5. Kappert 1976, p.9.

6. Kappert 1976, pp.47–8; see also Kissling 1953, pp.250–51.

7. Baylâv 1953; Huard & Grmek 1960.

8. See above, pp.28–9, for Bursa, and pp.8, 45, for Konya. On other Amasya manuscripts, see pp.48–9 above. A further example, copied in Amasya in AH 892 (AD 1486–87), is MS.Damad İbrahim 748 in the Süleymaniye Library; it was rebound in the 19th century.

9. See above, p.13.

10. Sakisian 1934b, fig.6; Aslanapa 1979, figs 36.

11. Sakisian 1934b, figs 3, 8–11; Aslanapa 1979, figs 34, 39–41; Brend 1989, figs 11–12; Lentz & Lowry 1989, no.40, pp.121, 191. A celebrated example close in date to the Amasya binding is the filigree doublure of a *Maṣnavī* written for Sultan Husayn Bayqara in Herat in 1482 (Sakisian 1934b, fig.12; Lentz & Lowry 1989, no.99, pp.198–9; Brend 1989, fig.14.)

12. Rawson 1984, p.169. On the continuity of the animal combat theme in Islamic art, see Ettinghausen & Hartner 1964.

13. Lentz & Lowry 1989, no.105, illustrated on p.204. *Cf.* also a drawing in which monkeys grasp a crane by its legs (Grube 1961, fig.15).

14. Two tools – one in the form of a swastika, with arms radiating from a rhomb, the other in the form of a rhomb crossed by diagonal lines – provide a further link between the Amasya binding and the earlier group, although the tools used on the Bursa Koran are much bigger. The tool in the form of rhomb crossed by diagonal lines occurs, though, on a binding from Iran dated 1436 (*figure 4*), and on bindings made for the Mamluk sultan Qa'itbay in 1462–3 and 1473 (*figures 10, 11*). On the Mamluk examples it is found in combination with a swastika-like tool, but this differs from the Ottoman version in that there is no central square or rhomb.

15. Topkapı Palace Library, MS.A.3314. The dedication is set in a gilded roundel on folio 1a.

16. Sakisian 1937, pp.213*ff*. Aga-Oglu 1935, pl.XVIII.

17. Pope & Ackerman 1938–9, pl.940b; Schroeder 1942, p.38; Arberry 1967, no.185, pl.10; James 1980, no.71; Lings 1976, pl.89 (in colour).

18. Munich 1910, pl.19; Martin 1912, p.102, pls 264–7, where he says that the manuscript was in the Ayasofya Library; Marteau & Vever 1913, no.30.

19. Schroeder 1942, p.38. *Cf.* James 1992a, no.29. Ettinghausen 1938–9, pl.940b, discusses it under the mid-15th century, but the caption carries a date of the late 14th or early 15th century.

20. Lentz & Lowry 1989, pp.78–79, cat.no.20.

21. For published examples, see Ünver 1946, pls 33–4, 36; Baylâv 1953, figs 45, 50, 63a, 67a–b, 74; Raby 1983, fig.43. For Jalairid and Timurid prototypes, see Lentz & Lowry 1989, pp.72–73, 82–83.

22. Rogers 1983, no.11.

23. Munich 1910, pl.19; Pope & Ackerman 1938–9, pl.959.

24. *Cf.* also Grube 1974, p.259, fig.129.

25. The miniatures are on folios 160a and 279b, respectively. We are grateful to Eleanor Sims for providing us with a copy of her unpublished study of these miniatures.

26. Topkapı Palace Library, MS.H.781. See Togan 1963, pp.27–29; Stchoukine 1968; Grube 1975, no.68; Çağman & Tanındı-Rogers 1986, p.90, no.90, with an Aqqoyunlu attribution; Çağman 1987; Lentz & Lowry 1989, no.32. Brend (1989, figs 45–6) has claimed that the manuscript was completed in Tabriz for Uzun Hasan (*reg.*1466–78), but it contains no documentation to support this. It bears the seal of Bayezid on the first and last pages. The sewing and headbands are modern.

27. Uzunçarşılı 1975, pp.474–5.

28. Kissling 1953, pp.244–5.

29. Thuasne 1892, p.26, note; Gibb 1902, II, p.72. There is an undated copy of the *Dīvān*, with a binding in the style of Ghiyath al-Din, in Bursa, İnebey Library, MS.Haraçci 913. For a manuscript copied for Cem Sultan in Bursa in 1470, see Istanbul, Topkapı Palace Library, MS.R.1704.

30. Süleymaniye Library, MS.Ayasofya 4009.

31. *Min kutub aqarr al-'ubbād Jam ibn Muhammad ibn Murād – ghafara Allāh lahu wa li-jamī' al-mu'minīn fī kull al-bilād.*

32. The animals, where they occur, are usually birds, but on folios 1b–12a there are rabbits and deer painted in opaque watercolours. There is a close likeness between the pointed oval on the covers of this manuscript and that on the doublures of cat.33.

33. See above, pp.71–6.

34. Kissling 1953, pp.241–2; Martin 1972.

35. Thanks largely to the efforts of Pir Ilyas of Amasya and Zakarya al-Khalwati.

36. Kissling 1953, p.246.

37. Kissling 1953, p.247. According to Taşköprülü-zade, Çelebi Efendi was a master of the black arts (*sihr*) and of magic squares ('*ilm al-awfāq*; Martin 1972, pp.281–2), but see Kissling (1953, p.248) on the legendary character of his account. Yusuf Sinan derived much of his information from his father, Yakub Efendi, who was himself a leading member of the brotherhood (Kissling 1953, pp.262, 265, 267).

38. Kissling 1953, pp.250–1; Babinger 1951, p.260, note 4, p.262.

39. Kissling 1953, p.250.

40. Yüksel 1983, p.23.

41. Prince Ahmed's education was entrusted by Bayezid in part to a member of the Halveti brotherhood (Kissling 1953, p.250).

42. One of the three threatened with execution by Mehmed was the calligrapher 'Abd al-Rahim Hatami ibn 'Ali ibn Mu'ayyad ibn al-Shaykh Pir 'Ali, according to Ayverdi 1953, pp.7–8.

43. Thuasne 1892, p.28.

44. Babinger 1952, especially p.11.

45. See, for example, Topkapı Palace Library, MSS.A.3314 (*figure 75*), A.3317, A.3328, A.3481, A.3487, A.3495, A.3501, R.1713.

46. Mirim Çelebi was the great-grandson of 'Ali Qushchi, the astronomer who had been an associate of the Timurid prince Ulughbeg and who came to Istanbul in the reign of Mehmed II; continuing this tradition, Mirim Çelebi wrote a Persian commentary on Ulughbeg's *Zīj* (Kappert 1976, p.49).

47. Erünsal 1980.

48. Rogers in Rogers & Ward 1988, pp.120–24, especially 123–24.

49. Erünsal 1980, p.218.

50. Respectively, Barkan 1979, pp.332, 339, 343, 346.

51. Barkan 1979, p.351 and 359. This presumably refers to the *Sulaymānnāmah* composed by Firdawsi of Bursa, known as Firdawsi the Long. A copy of this work dating from the reign of

Bayezid is in the Chester Beatty Library, Dublin (MS.406; see Minorsky 1958, pp.9–10, MS.406; Washington 1991, no.94).

52. Respectively, Barkan 1979, p.354, 356, 338.

53. Respectively, Barkan 1979, pp.334, 356, 340.

54. Barkan 1979, p.347; cf. p.377.

55. Barkan 1979, p.337.

56. Barkan 1979, p.350. One of the rare recorded instances of the purchase of an old manuscript by a member of the Ottoman dynasty was when Mustafa, a son of Süleyman the Magnificent and governor in Amasya between 1541 and 1553, acquired a copy of the *'Ajā'ib al-makhlūqāt* ('Wonders of creation') by the cosmographer Abu Yahya al-Qazwini from an Arab merchant from Mecca (Kappert 1976, p.109).

57. Topkapı Palace Library, MS.A.3563; Stchoukine 1971. The first Turkish translation of this text was made by Amasyalı İbrahim Çelebi in 1487. See Tanındı, in press A.

58. James 1992b, pp.144–9.

59. Akimushkin & Ivanov 1976, p.50; Çağman & Tanındı–Rogers 1986, p.88; James 1992b, p.145.

60. Togan 1963, p.36, suggested it was given by Husayn Bayqara.

61. Barkan 1953–4, p.309. The dating is based on a reference (also on p.309) to Kemal Reis, who was called to Istanbul 'to enter [the Sultan's] service as a mariner' in AH 900 (1494–5AD), according to his nephew Piri Reis, and died in a storm in 1511 (S. Soucek 1992, p.40). Incidentally, Kemal Reis was mentioned as receiving an *in'ām* on 5 Dhu'l-Qa'dah 909 (Barkan 1979, p.367).

62. Barkan 1979, p.329.

63. Barkan 1953–4, p.309.

64. Barkan 1953–4, p.310. Both the designers and the bookbinders were registered as *ehl-i hiref*, but two other groups under those who received a monthly salary were paid rates of about 2,000 *akçe*: the 19 swordsmiths and the 44 bowmakers, although both of these groups included an unspecified number of apprentices (Barkan 1953–4, p.309).

65. See, however, Atıl 1987, fig.15.

66. They were paid a total of 762,336 *akçe* a year.

67. Barkan 1953–4, p.313. In this document those receiving a monthly salary included 21 master craftsmen. The total number of craftsmen may have fallen because some masters had been registered under different headings.

68. Nevertheless, it was Selim who, through conquest more than enrolment, laid the foundations for the expansion of the *ehl-i hiref* in the early part of Süleyman's reign. A register of 1526 (Barkan 1979) lists artists who had joined the roster during the reign of Selim, but the numbers were not high compared to those who entered at the beginning of Süleyman's reign or who had been brought from Tabriz following Selim's capture of the city in 1514 (Barkan 1979, p.24).

Many of the latter eventually found their way on to the roster of court craftsmen, with the result that when a comprehensive listing of craftsmen was drawn up for the period 1 July–26 September 1527, they totalled 585 (Meriç 1953; Barkan 1979, pp.26–65). For a listing of the artists recorded in various registers in the first half of the 16th century, see Atıl 1987, appendix 3, pp.289–99.

69. Topkapı Palace Library, MS.A.3444.

70. Topkapı Palace Library, MS.A.3492.

71. Topkapı Palace Library, MS.A.3444.

72. Süleymaniye Library, MS.Turhan Valide 197.

73. Topkapı Palace Library, MS.R.984, in which he calls himself 'al-Husayni'.

74. Barkan 1979, p.298. On the *imaret* of Emir Sultan, see Ayverdi 1972, pp.282–8.

75. Barkan 1979, p.299.

76. Barkan 1979, p.335. Muhammad al-Badakhshi is probably to be identified with the Mevlana Seyyid Müneccim who was given 7,000 *akçe* and a robe of honour on 4 Sha'ban 909 (Barkan 1979, p.341, entry no.280), and who was given money and robes for bringing an almanac to the Sultan on 13 Shawwal 909 (Barkan 1979, p.362).

77. The names of three scribes, Kasım, Musliheddin and Şemseddin, are known from the mosques that they founded during Bayezid's reign, but they are not specifically described as royal copyists (Yüksel 1983, p.272). For four scribes involved in the building of Prince Ahmed's tomb in 1514, see Yüksel 1983, p.423; for Katib Bali Mehmed, a confidential secretary in the palace, see Yüksel 1983, p.272; and for Abdürrahim Katib, who was listed as *müteferrik-i ehl-i hiref* in 1526, with the comment that his father came from Iran, and that he had been one of the imperial scribes in time of Mehmed II, see Uzunçarşılı 1986, p.64.

78. Barkan 1979, p.95.

79. Ahmed Refik 1335–7, p.7.

80. Barkan 1979, p.351.

81. Barkan 1979, p.358. The calligrapher and binder Ali Yetim used the synonym Alaeddin; he was born in Aydın, learnt calligraphy in Tire, and became a cadı. He is said to have died in AH 920 (AD 1514), at the age of 100 (Ayverdi 1953, p.21; cf. also Derman 1970, p.281), and, if he is to be identified with the Alaeddin in the *in'ām* register, he would have been 90 years old at the time. For Ahmed see Appendix 4.

82. A binder who was presumably active in Bayezid's reign was the father of the calligrapher Mücellid-zade Mahmud, who died in 1544 (Derman 1970, p.282; Rado, n.d., p.67), but where the father was a binder is not known. The signed binding discussed by James (1992b, no.22) is an earlier binding subsequently added to the manuscript.

83. Süleymaniye Library, MS.Ayasofya 4150.

84. Topkapı Palace Library, MS.A.607, of *circa*

1510, has burgundy doublures, and Süleymaniye Library, MS.Ayasofya 4206, of *circa* 1500, has a black exterior with arabesque and floral decoration worked in blind and light-red doublures with filigree centre-pieces, but there was increased use of colour in that the ground to the filigree was green, as well as gold and blue.

85. Cf. also Süleymaniye Library, MS.Turhan Valide 196, dated AH 896 (AD 1490–1).

86. See, for example, Topkapı Palace Library, MS.A.1743, which is a simple production, dated Muharram 908 (7 July–5 August 1502).

87. Topkapı Palace Library MS.A.1329.

88. See, for example, Topkapı Palace Library, MS.A. 2633, dated 1475. Cf. Süleymaniye Library, MS.Turhan Valide196; Topkapı Palace Library, MSS A.607, A.1840, R.984. For an Aqqoyunlu version dated 1478, see Chester Beatty Library, MS.401 (Regemorter 1961, pl.41).

89. Gratzl 1938–9, p.1983.

90. Aslanapa 1979, p.65.

91. For the manuscript of 1459, see Gratzl 1938–9, p.1991; Aslanapa 1979, fig.49. For that of 1476, see Aslanapa 1979, fig 55. For that of 1478, Dublin, Chester Beatty Library MS.331, see Regemorter 1961, pl.31; for the manuscript, see Arberry and others 1962, p.80. For the manuscript of 1482, a *Masnavī* produced for Sultan Husayn Bayqara in Herat, see Aslanapa 1979, pls XIII–XIV. For the manuscript of 1485, see Aslanapa 1979, p.65, fig.31 (not 'Illustrations 54–5' as the caption reads). See also Baltimore 1957, no.82, for a manuscript of 1484. Whether Aslanapa 1979, plate XV, really is a binding contemporary with the manuscript of AH 867 (AD 1463) is questionable.

92. See, for example, Aslanapa 1979, pl.XI.

93. Süleymaniye Library, MS.Ayasofya 4206. See, however, cat.8.

94. Topkapı Palace Library MS.EH.1511. It would appear that the covers have been reversed in a restoration, so that the filigree doublures have been used for the outer covers. Once again, the earliest Ottoman example of the style dates from the latter part of Mehmed's reign; see the binding of a manuscript that is dated 1475 (Topkapı Palace Library, MS.A.2633). The same device occurs on the filigree doublure of the *Khamsah* made for 'Ismat al-Dunya (*figure 78*).

95. His patronymic suggests he was a convert to Islam, and he states in an inscription in cat.41 that he was one of the slaves of the sultan. See also Istanbul, University Library, MS.A.6662, dated AH 914 (AD 1508–9; Atasoy 1992, pp.139, 143). In general, see Mahir 1990.

96. Adam (1904–5, p.19) suggested the shiny gold was leaf, the matt, powdered gold, but his experiments at duplicating the effect were, he admitted, unsuccessful.

97. For illustrations in colour, see Frankfurt

1985, II, no.1/53; Lings 1976, figs 92–3.

98. Barkan 1979, pp.69–70; Atıl 1987, p.288.

99. Ayverdi (1953, pp. 25–38) has suggested that he was born in 1426 or earlier.

100. Celâl 1948, p.7. One of the Şeyh's pupils was the bibliophile Prince Korkut, who copied the only Koran known to have been produced by an Ottoman prince (Ayverdi 1953, p.42). Korkut's Koran, which is now lost, was in a moderate *naskh* hand. See also Rado, n.d., pp.56–7; Erünsal 1988, p.36.

101. Ayverdi 1953, pp.29, 49. However, when Bayezid wanted one of the members of his court, Kasım Kâtib, to study under Hamdullah, he arranged special leave for him (Uzunçarşılı 1986, p.64). It is possible that this is the Kasım referred to by Rado (n.d., p.73).

102. The villages were Sarıgazi and Akbaba (Celâl 1948, p.15, without references).

103. Derman 1970, p.271. In the *Kanunname* of Mehmed II it was stipulated that the senior tutor should receive a daily income of 60 *akçe*, and the second tutor, 30 (Kappert 1976, p.47).

104. Uzunçarşılı 1949, p.606.

105. Celâl 1948, p.8; Ayverdi 1953, p.29.

106. Celâl 1948, pp.10–11.

107. Celâl 1948, p.11.

108. The Koran has been published repeatedly, but the colophon has never been reproduced: Welch 1972–8, II, p.35, MS.5; Lings & Safadi 1976, no.129; Welch & Welch 1982, pp.27–8. In another colophon, where he described himself as being 80 years old, with grey hair, he calls himself 'the scribe of Sultan Bayezid' (Celâl 1948, p.11). This is presumably the same colophon as that quoted in Arabic by Ayverdi 1953, p.31, although there he said he was in his eighties. See also cat.38, above.

109. Barkan 1979, p.338.

110. Hamdullah's pupil, Ahmad ibn Khwajah Yahya (Sibek-zade), for example, received a good reward for a Koran he presented to Bayezid in AH 908 (AD 1502), and which was placed in the Sultan's tomb after his death (Ayverdi 1953, p.16; Müstakim-zade, ed. İbnü'l-Emin Mahmud Kemal, p.92).

111. Mustafa Âli, ed.Tietze, I, pp.60–1.

112. Celâl (1948, p.9) does not say for how long.

113. Ateş [1974], pp.91–2.

114. Huart 1908, p. 109; Celâl 1948, p.10; Ayverdi 1953, p.30.

115. The seven pupils were Hamdullah's son Mustafa Dede, who died in 1538; his son-in-law Şükrullah, who died in 1543; his cousin, Muhyiddin ibn Celâl (*cf.*Barkan 1979, p.337); Muhyiddin's brother, Mehmed Cemal (Kappert 1976, p.51); another relation, Abdullah Çelebi of Amasya; Nefes-zade, according to his own *tezkire*; and Ahmed Karahisari (*cf.* Uzunçarşılı 1949, p.607). Mustafa Âli (ed. İbnü'l-Emin Mahmud Kemal, p.25) omitted Şükrullah, whom

he considered a pupil of Hamdullah's son, and gave seventh place to Şerbetçi-zade İbrahim Çelebi, but according to Müstakim-zade (ed. İbnü'l-Emin Mahmud Kemal, p.226) Şükrullah was both Hamdullah's son-in-law and his pupil.

116. *Cf.* Kappert 1976, p.168, note 237. The other manuscript is Topkapı Palace Library, MS.A.1996 (Ayverdi 1953, p.33, figs 15–16).

117. Müstakim-zade, ed. İbnü'l-Emin Mahmud Kemal, p.185. On links between the Suhrawardis and the Halvetis, see Kappert 1976, p.52.

118. Ayverdi 1953, p.30.

119. Kissling 1953, pp.259–60, 281–2. The family was descended from Jamal al-Din Muhammad al-Aqsarayi, a leading scholar and shaykh under Murad I. Shaykh Jamal al-Din Ishaq al-Qaramani was a well-known calligrapher who served as a scribe to Mehmed II.

120. Derman 1970, p.271.

121. It is interesting that the court scribe Kâtib Muslihiddin (ibn Halil Tirger), who was clerk of the gatekeepers, was *emin* of the mosque of the Koca Mustafa Pasha (Yüksel 1983, p.272, 290).

122. There had been an attempt to set up a Halveti base in the city some 20 years earlier (Kissling 1953, p.245; Martin 1972, pp.280–81).

123. Kappert 1976, p.58.

124. The date is based on the building inscription (Kissling 1953, pp.251–54, 256 *ff.*). The inscription over the main gate is said to have been written (and presumably composed) by the historian İdris Bitlisi (Rado, n.d., p.55). The church, which had been restored in about 1284, is now known as the mosque of Koca Mustafa Pasha (Yüksel 1983, pp.273 *ff.*).

125. Kissling 1953, p.254.

126. Celâl 1948, p.11; Ayverdi 1953, p.30.

127. Derman 1970, p.269. There are some accounts of differences with Selim.

128. Ayverdi 1953, p.30; Derman 1970, p.269, especially note 1 on the date of the encounter with Süleyman. Süleyman's more benevolent attitude towards the Halvetis in the early part of his reign perhaps owed something to his mother's connections with the movement (Kissling 1953, p.259).

129. Kissling 1953, p.253, 256.

130. Kissling 1953, p.257; Martin 1972, p.283. Selim claimed to need the marble in the converted Byzantine church for the Marble Pavilion that he was building on the sea shore by the Topkapı Palace, but this was a simple pretext. On the Marble Pavilion, see Necipoğlu 1991, pp.220–6.

131. Necipoğlu 1991, p.134: Topkapı Palace Archives, D.4. For a discussion of the porcelains referred to in these early Treasury register, see Raby & Yücel 1986, pp.77–81.

132. Öz 1940, facsimile no.21; Rogers 1987; Necipoğlu 1991, p.135.

133. It may have been at this time that the loose-leaf drawings in the Sultan's collection were inserted into albums (Raby 1981, p.47).

134. By 1564 the Turkish, Persian and Arabic manuscripts were kept in separate cabinets in the second hall of the Inner Treasury, called the *divanhane* (Necipoğlu 1991, p.137).

135. We are grateful to Dr Filiz Çağman of the Topkapı Palace Library for this information. The original is in the Oriental Collection of the Library of the Hungarian Academy of Sciences (MS.F.59).

136. Ünver 1952a. On the seal, Umur 1980, p.120.

137. Leroy 1967.

138. Grube 1978, fig.1.

139. See also, for example, Topkapı Palace Library, MS.A.3381.

140. Süleymaniye Library, MS.Ayasofya 981.

141. Barkan, 1953–4, p.308; Erünsal 1988, p.31.

142. Barkan 1979, p.327. He was the scribe of Topkapı Palace Library, MS.A.607, which was probably written in 1510. He gives his name as Khidr ibn Mahmud ibn 'Umar al-'Utufi.

143. Necipoğlu 1991, p.137.

144. Cunbur 1985, pp.720–24.

145. Cunbur 1985; Erünsal 1988.

146. Erünsal 1988, p.31.

147. The complex included a *medrese*, one of whose five staff members was a librarian (*ḥāfiẓ-ı kutub*) (Cunbur 1985, p.716; Erünsal 1988, pp.31–32). Bayezid probably also set up a library at his complexes in Amasya and Istanbul (Erünsal 1988, pp.32–33).

148. Erünsal 1988, pp.33–36. Whether there was a library set up by Koca Mustafa Pasha is uncertain (Erünsal 1988, p.34).

149. Uzunçarşılı 1986, pp.28 and 2, respectively; *cf.* p.70 for a gift of 1,500 *akçe* Ahmed received from the Sultan. See also, Atıl 1987, pp.291, 298. A manuscript of exceptional quality dedicated to Firuz Ağa is in the Library of Congress, Washington DC. It was perhaps copied by Şeyh Hamdullah and has a lacquer binding comparable to that on an item in the Chester Beatty Library (MS A.4199). See Sims, forthcoming; James 1981, pl.2.

150. The only documentary evidence from the early part of Bayezid's reign indicates that there was some continuity in the staff of the bookbinders; it relates to the binder Sinan, who was recorded among the *mütefferika* under Mehmed in 1478, and who was probably Bayezid's senior binder in 1489–90. See above, p.60.

151. On Bayezid's attitude to figurative art, see Raby 1987c, p.185, and note 87.

152. That is not to say that bookbinding designs under Bayezid were not worked out on paper first, nor to deny that there was a relationship between the motifs used on the bindings and in illumination.

153. Cf. Sakisian 1927a, 1927b, 1927c, who believed, however, that there was no Turkish style of binding, even by the beginnning of the 16th century (see especially 1927b, p.142).

154. See, for example, Atıl 1987, figs 16–17, 27; Tanındı 1993, p.425.

155. In general, Sakisian 1927a; cf.Atıl 1987, fig.27.

156. Baltimore 1957, no.89.

157. Topkapı Palace Library, MS.E.H.282. The scribe Fazlullah is known to have received 500 akçes from Bayezid in 1505, and to have written two copies of the Sūrat al-an'ām in 1506–7 (Karatay 1962–9, nos 806–7).

158. Arnold & Grohmann 1929, p.115.

159. Sakisian 1927a, p.282. On this market in the second half of the 16th century, see Löwenklau cited by Babinger 1931b, p.135, 139. According to Kilisli Muallim Rifat, at the end of the 19th century the illuminators and binders had shops in a row running from the Sabuncu Han (Nefes-zade İbrahim, ed.Kilisli Muallim Rifat 1939, p.75).

Catalogue 1

1. Another manuscript with a comparable binding is in Munich; see figs.31–33 above.

2. Regemorter 1961, pls 23, 24.

3. Arberry 1967, no.104.

4. Oriental Institute, inv.no.A12168 (Sarre 1923, pls 4–5; Chicago 1981, no.25).

5. Regemorter 1961, pl.20.

6. Similar devices occur on two 15th-century bindings in the Topkapı Palace Library, MSS A.2069 and A.645, but they were not common in this period.

Catalogue 2

1. It is possible that all the blind tooling on these covers was originally coloured blue.

2. Topkapı Palace Library, MS.A.2471, dated 1336, and MS.A.317, dated 1391 (Tanındı 1990b, figs.22, 33).

3. James 1992b, no.20.

4. See Çağman 1983, p.107. Cf. Çağman 1974–5, pp.344–5; Demiriz 1982, p.926, and cat.4 below.

5. This type of band was often used in the illumination produced in Shiraz in the first half of the 15th century, such as an undated Koran in the Mevlana Museum, Konya (MS.8, p.1 and 817; see Oral 1950, issue 14, pp.10–12; Enderlein 1991, pp.18–19; P. Soucek 1992, pp.117–9). The manuscript was donated by Sultan Selim II to the shrine of Mawlana Jalal al-Din Rumi, and its binding is decorated with a classical centre-and-corner scheme that can be dated to the second half of the 16th century, but the type of naskh in which it was copied and the style of illumination suggests that the manuscript was produced in an Ottoman atelier in Bursa or Edirne in the first half of the 15th century.

Catalogue 3

1. On the original text, see Kâtip Çelebi, ed. Yaltkaya & Bilge, II, columns 1540–41.

2. Yüksel 1984, pp.141–2, 146.

3. Yüksel's reading (1984, p.146) should be amended to wa-lā ya'ṭūhu li-aḥad qabl akhdh al-thaman minhu on the basis of the facsimile (p.141).

4. Bursalı Mehmed Tahir 1333, II, pp.13–14.

5. Öney 1987, p.58.

6. Öney 1987, pp.31, 32.

7. Tanındı 1990b, p.127.

8. James 1988, p.125, note on fig.83.

Catalogue 4

1. Anawati 1965.

2. The sigla of volumes II, IV and VI indicate that they entered the İnebey Library from the Great Mosque (Ulu Cami) of Bursa, while a seal impression in volume VIII (MS.Genel 931) shows that it entered the library from the Eşrefzâde Sufi lodge (dergâh).

3. Volume III, folio 229b. The two notices in volume VIII differ slightly. In the version on folio 1a, Abdurrahman son of Hasan Fakıh and Sinan son of Ahmed are accorded the title mawlānā ('our lord'), which indicates that they were members of the religious hierarchy. In the version on folio 203b, the name of the first witness is given as 'Abd al-Raḥmān ibn Ḥasan Faqih al-Qaraḥiṣārī.

4. This composition has similarities with the designs on two examples of Iznik blue-and-white ware that have been dated to the end of the 15th century (Atasoy & Raby 1989, figs 86, 287).

5. Knotted bands were employed in the hexagons on 15th- and early 16th-century Ushak carpets (Yetkin 1974, pp.18, 21), as well as on early 16th-century tiles (Carswell 1982, p.82; Atasoy & Raby 1989, figs 102–3). The infinite pattern of three-lobed half roundels formed from knotted bands is also reminiscent of an Ushak-type carpet that has been dated to the 17th century (Yetkin 1974, p.60).

6. Topkapı Palace Library MS.Y.438 (cf. figure 35).

7. Topkapı Palace Library MS.A.3449 (figure 38).

8. Topkapı Palace Library MS.A.2069.

Catalogue 5

1. Süleymaniye Library, MS.Muhtelit 1277, folios 31a–59a, which is in Persian; Nuruosmaniye Library, MS.3080, which, like all the other known examples, is in Turkish. This timespan is certainly too short, as the genre has been studied almost exclusively by historians attempting to trace the development of Ottoman historiography, who would have excluded later almanacs because they lack the chronological lists. For an almanac presented to Bayezid II in

1504 by Muhammad al-Badakhshi, in his role of court astrologer, see Chapter 3, note 76.

2. Ménage 1964, pp.14–17.

3. For the complete contents of a 15th-century Ottoman almanac (Chester Beatty Library, MS.402), see Minorsky 1958, pp.3–6.

4. Inv.no.6626. Unpublished.

Catalogue 6

1. Browne 1928, p.132.

2. The flyleaf note reads, Dīvān-i 'Irāqī, ṣāḥibuhu al-Sulṭān Bāyazīd bin Muḥammad Khān khullida mulkuhu ('The Dīvān of 'Iraqi, whose owner is Sultan Bayezid, son of Mehmed Khan – May his reign be made eternal!').

Catalogue 8

1. Dunlop 1960; cf. cat.23.

2. See above, pp.13–15.

3. Topkapı Palace Library, MS.H.781. See above, pp.85–6, for further discussion.

Catalogue 9

1. Konya, Mevlana Museum, MS.7; Ayverdi 1953, p.13–15, figs 3, 4; Oral 1950, issue 13. This scribe came to Edirne from Shiraz in 1441–2; Thackston 1989, pp.330–2.

2. Topkapı Palace Library, MS.Y.438. Parts I, II, 13–17, 20, 22 and 24 survive.

Catalogue 10

1. A similar style of arabesques and interlace ocurs in a manuscript of 1469–70 in the Süleymaniye Library, MS.Fatih 4080.

Catalogue 11

1. Süleymaniye Library, MS.Şehzade Mehmed 28.

2. Süleymaniye Library, MS.Turhan Valide 238 (Tayanç 1953; Istanbul 1953, no.15). The first volume of this work is in the Österreichische Nationalbibliothek, Vienna (MS.A.F.14/1; Flügel 1865–7, no.783) and is dated AH 871 (AD 1466).

3. Topkapı Palace Library, MS.A.1706. Another product of the same binder is attached to MS.A.3282.

4. With the words Hādhā sharḥ Kitāb Sībawayh li'l-fāḍil Abī Sa'īd al-Sayrafī raḥimahu Allāh 'This is the commentary on the Book of Sibawayh by the learned Abu Sa'id al-Sayrafi – May God have mercy upon him'.

5. Millet Library, MS.Feyzullah 1359, which also has a dedication to Mehmed II (Sakisian 1927b, fig.6; Ünver 1946, pls 34–5).

6. Süleymaniye Library, MS.Damad İbrahim 826 (see above, Chapter 2, note 23).

7. Sakisian 1927b, fig.7.

8. These motifs are evidently the work of the same illuminator as the decoration in Süleymaniye Library, MS.Fatih 2571M, for which see above, Chapter 2, note 45.

Catalogue 12

1. Rosenthal 1971, columns 723b–724a.

2. The central section of the centre-piece is similar to that of *figure 63* (see cat.11, note 8); the remaining parts of the centre-pieces differ, however.

3. See above, p.56.

Catalogue 13

1. Topkapı Palace Library, MS.E.H.2878; Çağman 1983, no.E.10.

2. Istanbul, Süleymaniye Library, MS.Şehzade Mehmed 67. The text is Nasr al-Din Tusi's commentary on Ibn Sina's *Ishārāt*, and this copy bears a dedication frontispiece to Mehmed II (Istanbul 1953, no.56; Tayanç 1953).

Catalogue 14–17

1. For the scribe, Yusuf ibn Ilyas, see above, p.70, Table 2, nos 11 and 13. The text of no.13 is Sadr al-Din al-Qunawi's *Miftāḥ al-ghayb*.

2. On al-Sayyid al-Sharif, see p.20 above. Topkapı Palace Library, MS.A.3331, with a frontispiece dedication to Mehmed, contains two commentaries on the *Mulakhkhaṣ*, one by Kadı-zade Rumi (died after 1427), the other by al-Sayyid al-Sharif. Mehmed also commissioned Molla Sinan Pasha to write notes to the commentary by Kadı-zade Rumi (Topkapı Palace Library, MS.A.3299).

3. The phrase used is *bi-rasm muṭālaʿat*.

4. See above, Chapter 2, note 45.

5. Karatay is wrong in his division of the manuscript into three parts. The copy of the *Ḥikmat al-ishrāq* he has beginning on folio 220b is the third section of the *Kitāb al-mashāriʿ*.

Catalogue 18

1. Al-Iji's work appears to have been held in high esteem at Mehmed's court, for another copy was made for his library by Muhammad ibn al-Murad ibn Husam in 1463 (Topkapı Palace Library, MS.A.1635).

2. The parallels with a group of early 14th-century sutra boxes from China are particularly striking. See, for example, Lee & Ho 1968, no.285.

3. Gold-on-black decoration can be seen, for example, on MS.E.H.1636 in Topkapı Palace Library (Aslanapa 1979, fig.29) and on MS.1905 in the Museum of Turkish and Islamic Arts, Istanbul (Aslanapa 1979, pl.XIII).

Catalogue 19

1. Bağdatlı İsmail Paşa, ed. Yaltkaya & Bilge, I, column 546 (where the author's name is given as Abu'l-ʿAbbas Ahmad ibn ʿAli ibn Babah); Brockelmann 1937, p.586.

2. On the Shiraz style, see Soucek 1971, pp.268–82; P. Soucek 1992, pp.117–19.

3. Süleymaniye Library, MS.Turhan Valide 238,

and Vienna, Österreichische Nationalbibliothek, MS.A.F.14/1 (see cat.11, note 2).

4. An example is Topkapı Palace Library, MS.A.20, a copy of a work by Molla Gurani. Other works that contain illumination in this style are İnebey Library, MS.Haraççıoğlu 1324 (Bursa, 1452); Süleymaniye Library, MS.Süleymaniye 1009 (made for Mehmed II, Bursa, 1455–6); a calligraphic scroll presented to Mehmed, one section of which was signed by ʿAtaʾallah ibn Muhammad al-Tabrizi and dated January 1458 (see cat.13); Topkapı Palace Library, MS.R.93 (Bursa, 1464); an autograph copy of the *Fatḥ Mafātīḥ al-ghayb* of Muhammad ibn Qutb al-Din al-Izniqi, dated December 1469 (İnebey Library, MS.Hüseyin Çelebi 482); and an undated copy of a *Risālah fi ʿilm al-mūsīqī* (Topkapı Palace Library, MS.A.3449) which can be dated to the 1450s on the basis of its doublure (see above, cat.4).

Catalogue 20

1. Repp 1986, pp.132–3.

2. The only closely related binding with a similar use of gold and blue outlining is cat.19.

Catalogue 21

1. The only known Koran bearing a dedication to Mehmed II is in the Bruschettini Collection, Genoa: Sotheby's London 8 April 1985, lot 202; Grube 1982, no.171.

2. James 1992a, no.7; James 1988, pp.34–8.

Catalogue 22

1. On this scribe, see above, pp.70–1.

2. Richard 1989.

Catalogue 23

1. Lentz & Lowry 1989, no.103; Rogers 1983, nos 20, 41, 42.

2. The volume does not bear a frontispiece dedication to Mehmed II, but the Sultan is praised at length on folios 146a–b, without his name being mentioned. On the scribe, see Chapter 2, pp.70–1.

3. For further discussion on Şeyh Hamdullah, see above, Chapter 3.

4. Topkapı Palace Library, A.1996 (Baylâv 1953, fig.63–5; Öz 1953, fig.64; Baykal 1958, pls 3, 4; Binark 1965, pls on pp.183, 186; Çığ 1971, pl.III); see also *figure 66*.

Catalogue 24

1. Tanındı 1985, pp.31–2.

Catalogue 25

1. A comparable dedication panel can be seen in Süleymaniye Library, MS.Ayasofya 2480. This is a copy of Nasir al-Din Tusi's *Asās al-iqtibās,* which was made for Mehmed II in AH 869 (AD 1464–5). *Cf.* also Topkapı Palace Library,

MS.A.2082, which is dedicated to Mehmed but not dated.

2. The spandrels around the oval cartouche are filled with floral sprays in gold against a white ground and with touches of light emerald green and orange.

3. But MS.R.1127 in the same library has a note reading, *Oda'dan çıkan türkî* ('Turkish [book] that came out of the Chamber'), an impression of Bayezid's seal, and a note that may be in his hand.

4. *Cf.* Monnas 1991, figs 4, 8; neither of these, however, use voiding in addition to brocading.

Catalogue 28

1. Tanındı 1990b, p.109, figs.21–22.

2. For Chinese textiles being sent to Turkey, see Cleaves 1950.

3. Rawson 1984, pp.163–9.

4. Lane 1960, pl.13d; *cf.* Demiriz 1979, p.504; Atasoy & Raby 1989, figs 208, 445.

Catalogue 29

1. Topkapı Palace Library, MS.A.3267.

2. Topkapı Palace Library, MS.A.3183. On this scribe, see Chapter 2, pp.70–1.

Catalogue 30

1. Mackie 1984, pp.136–41; Wardwell 1988–9, pp.41–42.

2. Düsseldorf 1973, no.254.

Catalogue 32

1. Sakisian 1934b, figs 8–11; Grube 1969, fig.56; Aslanapa 1979, figs 30, 39, 40, 42, 48, 50. For this style of figurative binding, and related drawing in albums in Istanbul, see Grube 1969 and 1974.

2. See also the discussion on pp.11–17, 82–3.

3. Uzunçarşılı 1975, pp.474–5.

4. An early note on the frontispiece page gives the number of folios as 288.

5. The watermark is an anchor in a circle, surmounted by a star; the diameter of the circle is 35 mm, and the chain lines are 29–32 mm apart. *Cf.* Topkapı Palace Library, MSS A.167 and B.382; the latter is also by an Amasya author.

Catalogue 33

1. Browne 1928, p.132.

2. The landscape is arranged so that the baseline is next to the spine.

3. For these chinoiserie drawings and related bindings, see Grube 1969 and 1974.

4. See *figure 77* for a binding with an inscription on the spine stating that it was made for the library of Sultan Bayezid. For an Iranian binding with a similar style of inscription in *nastaʿliq*, see Marteau & Vever 1913, pl.XIX.

5. The filigree centre-piece bears a close resemblance to *figure 69*.

Catalogue 34
1. İnalcık 1962, pp.164–5.
2. On a possible link between the copyist of this manuscript and the Muhammad ibn Mahmud Rangi who copied a *Kalilah wa-Dimnah* in 1492, (Bursa, İnebey Library, ms.Hüseyin Çelebi 763) see Tanındı 1990–91a, p.147.

Catalogue 35
1. On this scribe, see above, pp.70–1.

Catalogue 36
1. See Karatay 1962–9, cat.nos 769–72, 774–85, 788, 793. There is only one copy attributed to 15th-century Iran in the Topkapı Palace Library (ms.e.h.282).

Catalogue 37
1. The first two pages of text (folios 2b–3a) are set within rectangular frames illuminated in a similar style. The markers for groups of ten verses are in the form of lotus flowers in gold, with details in blue and a variety of other colours, and the word *'ashr* ('ten') written in white *thulth*. The *ḥizb* markers (for sixtieths of the text) are in the form of roundels with six lobes in gold, and coloured, mostly ultramarine, centres. *Juz'* markers (for thirtieths of the text) are in the form of roundels with 12 curling green and blue lobes, with gold centres, the text written in white. The beginning of each *sūrah* is marked by a rectangular panel set within the text frame, the title of the *sūrah* being enclosed within a cartouche with cusped ends. The style varies from the Turcoman to the Shiraz traditions of illumination.

There is a catchword at the bottom of each right hand page. There are occasional *sajdah* markers, on folios 126b, 150a, for example, in the form of lobed tear-drops in gold, with blue centres. The colophon is written within a richly illuminated finispiece on folio 259b. All the edges of the text block have been sprinkled with gold.

Catalogue 38
1. Topkapı Palace Library, ms.e.h.1511.
2. The double page of illumination on folios 1b–2a has narrow panels with an ultramarine ground. Each is set with a rhomb-like centre-piece, escutcheon pendants and matching corner-pieces, which have a light emerald-green ground, decorated with gold arabesque leaves. The interstices are filled with a gold floral rinceau with orange and white details, yellow rosettes and three-lobed flowers. The double border consists of an inner gold border with a meander of cloud-bands, also in gold, and an outer segmented border of cartouches linked by four-lobed roundels; each long cartouche has a floral scroll in black, with a blue central rosette and yellow buds.

On folios 2b–3a the text is surrounded by a wide illuminated frame on the three outer sides. The frame has a gold ground, inset with triangles and arabesque escutcheons with ultramarine grounds. The titles are in cusped cartouches and were written in white *thulth* against a browner gold, with gold cloud-bands as a filler.

The verse markers take the form of gold rosettes within the text, whereas the roundels set in the margin to mark other divisions of the text are in gold and ultramarine, with the name of the division in white *thulth*. *Sūrah* titles were written in white or gold *thulth*, each within a cartouche with cusped ends, which was, in its turn, set within a rectangular panel whose width matched that of the text frame; most often the ground of the cartouche was gold and decorated with a floral and arabesque scroll, while the rest of the panel often has Shiraz-style foliage in gold against an ultramarine ground.

Catalogue 39
1. The first folio is now so badly damaged that the date given by Karatay, presumably taken from the prayer on folio 1b, is no longer complete.

Catalogue 40
1. Barkan 1979, p.338; see above, p.96.

Catalogue 41
1. The first two pages of text (folios 2b–3a) are set within an illuminated frame that is similar in design and colouring to the frontispiece. The text is set into *abrī* clouds against a ground cross-hatched in brown, with tiny sprays of leaves in a pale lilac-blue.
2. The markers for groups of five verses take the form of a stylized lotus bud; they contain a roundel in blue, framed by eight feathery leaves that grow upwards from a tiny clasp at the base. The symbols that mark each tenth verse are in the form of concave hexagons, with a concave-sided dodecagon at the centre, while those for *ḥizb*s are in the form of twelve-pointed rosettes. Tenth-verse and *ḥizb* markers have gold centres and mostly blue borders, while in the markers for five verses the colours are reversed. In all of these markers the writing is in white *thulth*.

The *juz'* markers are larger roundels with gold centres and ultramarine borders, filled with arabesques. *Sūrah* headings are set into rectangular panels within the text frame. The title is in white *thulth* and is inscribed within a cartouche with cusped ends of different outlines, usually against a gold ground.

Appendix One
1. Chicago 1981.
2. Babinger 1931a, p.130.
3. Raby 1983.

4. Babinger 1931b, p.134; Chicago 1981, p.33. The site was known by this name in the 16th century and by a comparable name in the late Byzantine period.
5. Beit-Arié 1981.
6. Babinger 1931b, p.133, note 5.
7. Baker 1991, p.31 notes that the presence of starch is not always proven in the earliest Arab papers; iodine testing often shows no starch, though this may be due to the degradation of the starch over the centuries. However, from the 12th century on 'starch is always present'.
8. Chicago 1981, p.35.
9. Chicago 1981, p.79, note 101.
10. Baker 1991, p.31 points out that the use of gelatin may have been restricted, as in the west, to winter months.
11. Chicago 1981, p.79
12. See also Topkapı Palace Library mss a.607 and a.1329.
13. Several others have been rebound at a later date or have been resewn recently.
14. Istanbul, Ayasofya 3839; and Istanbul, Topkapı Palace Library, ms.a.3267. On this scribe, see above pp.70–71.
15. Istanbul, Süleymaniye Library, ms.Süleymaniye 1009.
16. Diehl 1946, i, p.60, ii, p.118.
17. Levey 1962, p.52.
18. We are grateful to Don Baker for this observation.
19. Five are red/blue; five red/yellow; ten red/cream and eleven red/green.
20. Al-Sufyani refers to the paste as *al-nashā'*, which was wheat-starch paste (*cf.* Levey 1962, p.42, note 298). However, Arseven n.d., p.314, refers to the use of *siriş*; this was a vegetable paste made from the glutinous bulbs of the *Asphodelus ramosus* or the *Eremurus aucherianus* according to Wulff 1966, p.238. That *siriş* was used by the binders in Bayezid's court is proved by a document for its purchase dated to ad1490: Barkan 1979, p.95. See also, Chapter Three, above. Any excess paste al-Sufyani recommended pushing away to the left and right of the stamp with one's hand.
21. Ricard 1925, p.13, lines 8–10; Levey 1962, p.53.
22. Sakisian 1927a, p.278, note 5, *cf.* p.280, note 1; Arseven n.d., p.314, who describes the inlay of leather into the recessed panels; Çığ 1971.
23. Haldane 1983, pp.9, 14, and especially pp.190–5. I am grateful to Dr Anna Contadini for arranging for me to inspect these stamps. On leather stamps in general, see Çığ 1971, p.10, 13; Adam 1904–5, p.183. Arseven n.d., p.314–15; *cf.* Gratzl 1938–9, p.1982, note 7, on metal matrices.
24. Çığ 1971; *cf.* Adam 1890, p.192; Adam 1904–5, p.183.
25. Arseven n.d., p.315. Çığ 1971, p.11, has suggested that they were worked by seal-engravers.

26. Diehl 1946, II, pp.340–50.
27. *cf.* Gratzl 1938–9, pp.1978, note 2; 1982–83.
28. Levey 1962, p.54. See Adam 1890, p.192, who claims that the surface of the matrix was covered with a varnish, and that the powdered gold would adhere to the areas which had come into contact with the varnish; see also Adam 1904–5, IV, p.179.
29. Adam 1890, pp.193, 196.

Appendix Two
1. Karabacek 1913, p.48.
2. Karabacek 1913, p.37, who also refers to a Mamluk silk binding embroidered with hyacinth rubies and pearls that was made for a Koran in Damascus in AD 1335.
3. Tanındı 1985, p.28; Tanındı 1990b, p.106, 109–110, 113.
4. Chicago 1981, no.71; Tanındı 1985, pp.28, 29; Tanındı 1990b, p.113.
5. Topkapı Palace Library, MS.A.521.

Appendix Three
1. Topkapı Palace Museum, inv.no.13/1964. It is 80 cm in length. For a general discussion of these velvet bindings, see Tanındı, in press B.
2. Tanındı 1985, pp.31, 32.
3. Hughes & Faggin 1971, pls XXXV, XLIII, XLIX; Monnas 1991, pp.104–107.
4. Hammacher & Vandenbrande 1969, pl.136.
5. London, National Gallery, inv.no.1045. Dunkerton and others 1991, fig.58.
6. London, National Gallery, inv.no.1432.
7. London, National Gallery, inv.nos 2595.
8. Berlin, Staatliche Museen. Martindale & Garavaglia 1971, pl.VIII, and especially no.38 for a discussion of the dating.
9. Mantua, Palazzo Ducale, Camera degli Sposi. Martindale & Garavaglia 1971, pl.XLIV, figure standing in front of the pillar on the right.
10. Milan, Brera. Bovero 1974, pl.LXI.
11. Inv.no.52.20.18 (Atıl 1987, 146).
12. Inv.no.13/837 (Tezcan & Delibaş–Rogers

1986, no.31). The design consists of lobed medallions with large blossoms at their centres, connected by thick stems and crown-like motifs. The authors propose a 16th-century or 17th-century date, but the collar suggests that this kaftan may instead be much earlier.
13. Tezcan & Delibaş–Rogers 1986, p.47,
14. Inv.no.13/500 (Tezcan & Delibaş–Rogers 1986, no.49). It is decorated with vertical rows of large medallions on thick stems. Each medallion contains a blossom that resembles a pomegranate flower, and the spaces between the medallions are filled with flowers and leaves.
15. See, for example, those in the Musées Royaux des Arts Décoratifs in Brussels: Errera 1927, nos 160–82. *cf.* Markowsky 1976, no.34.
16. *Cf.* Errera 1927, nos 164–6.
17. *Cf.* Errera 1927, nos 169–74.
18. Santangelo 1964, p.53, pl.54.
19. Lisbon, Museu Nacional de Arte Antiga, no.33. Murray & De Vecchi 1970, pls XVIII, XXVI, XLVIII, LIV.
20. Milan, Brera. Bovero 1974, pl.LIX.
21. There are three lengths of red velvet, 65 cm wide, ranging from 2.5 to 4 m in length, that have a pattern which, although indistinct, is also based on lobed medallions. Topkapı Palace Museum, inv.nos 13/1916, 13/1918, 13/1472. I would like to thank Dr Hülye Tezcan for her help in identifying these materials.
22. Washington 1991, no.92; Çağman 1983, no.E.26.
23. İnalcık 1980–81, pp.78–79.
24. İnalcık 1980–81, p.76.
25. İnalcık 1980–81, pp.84, 89.
26. İnalcık 1980–81, p.75.
27. İnalcık 1980–81, p.89.
28. İnalcık 1980–81, pp.87, 89.

Appendix Four
1. Chicago 1981, p.12.
2. Chicago 1981, p.13.
3. Ettinghausen 1954; Gray 1985; Chicago 1981,

p.13; Tanındı 1990b, pp.114–5.
4. *Cf.* cat.4. See also Bayram 1982, fig.2; the binder gives his name as Mahmud.
5. For earlier artists, see Ettinghausen 1938–9, pp.1937–8, 1946. See also Chapter 2, p.61 and note 76.
6. Meriç 1954; Atıl 1987, pp.298–9.
7. Uzunçarşılı 1986, p.70.
8. Uzunçarşılı 1986, p.75. *Cf.* the activities of a binder called Ali in the same period: Uzunçarşılı 1986, p.68; Topkapı Palace Museum, Archives, D.10009.
9. See, for example, Barkan 1979, p.70; Başbakanlık Arşivi, Kepeci Classification, Ruus 239, p.243 (for the year AD 1581); Ruus 242, pp.10–11 (for the year AD 1581); Ruus 250, p.37 (for the year AD 1588); Anafarta 1969; Meriç 1953, p.71; Tanındı 1984c, pp.31–2, 41; Çağman, forthcoming.
10. Meriç 1954, pp.3–4; Uzunçarşılı 1986, pp.28–9.
11. Uzunçarşılı 1986, pp.29,.31.
12. Alaeddin was rewarded by Bayezid in 1504; see above, Chapter 3, notes 80, 81.
13. Meriç 1954, pp.6–10.
14. Meriç 1954, p.4; Atıl 1987, p.299. Although the latest dated register of court artists is from 1566, Mustafa Âli, writing in 1587, says that Mehmed was the chief binder during the reign of Selim II (1566–74; Mustafa Âli, ed.İbnü'l-Emin Mahmud Kemal, p.73).
15. Mehmed is known to have been responsible for the binding of a Koran (Topkapı Palace Library, MS.E.H.49), but the present binding is not original (Tanındı 1984a, p.21; Atıl 1987, p.299, and no.14). For the paper-cut work, see Karabacek 1913, p.45; it is a page in the 'Murad III' album in Vienna, with the signature, *Muḥammad Ṭāhir Mujallid al-Khāqānī.*
16. Atıl 1987, p.299.
17. Mehmed's son Süleyman joined the bindery on 6 Muharram 965 (29 October 1557; Atıl 1987, p.299).
18. Tanındı 1990–91b.

Bibliography

Adam 1890
P. Adam, *Der Bucheinband. Seine Technik und seine Geschichte*, Leipzig, 1890.

Adam 1892
—, 'Über türkisch-arabisch-persische Manuscripte und deren Einbände', *Monatschrift für Buch-binderei*, III, 1892, pp.13–14, 20–4, 33–8, 52–4.

Adam 1904–5
—, 'Über türkisch-arabisch-persische Manuscripte und deren Einbände', *Archiv für Buchbinderei*, 1904–5, IV, pp.141–3, 145–52, 161–8, 177–85; V, pp.3–10.

Aga-Oglu 1935
M. Aga-Oglu, *Persian Bookbindings of the Fifteenth Century*, Ann Arbor, 1935.

Ahmed Refik 1335–7
Ahmed Refik, 'Fatih Devrine Ait Vesikalar', *Tarih-i Osmanî Encümeni Mecmuası*, LXII/49, 1335–7, pp.1–58.

Aka 1991
İ. Aka, *Timur ve Devleti*, Ankara, 1991.

Akimushkin & Ivanov 1976
O. Akimushkin and A. Ivanov, 'The Art of Illumination', in Gray, 1979, pp.35–57.

Alexandrescu Dersca 1942
M. M. Alexandrescu Dersca, *La campagne de Timur en Anatolie (1402)*, Bucharest, 1942.

Allan 1982
J. W. Allan, *Islamic Metalwork. The Nuhad Es-Said Collection*, London, 1982.

Allan 1984
—, 'Sha'bān, Barqūq, and the Decline of the Mamluk Metalworking Industry', *Muqarnas*, II, 1984, pp.85–94.

Anafarta 1969
N. Anafarta, *Hünername Minyatürleri ve Sanatçıları*, Istanbul, 1969.

Anawati 1965
G. C. Anawati, 'Fakhr al-Dīn al-Rāzī', *Encyclopaedia of Islam*, second edition, II, Leiden, 1965, pp.751–5.

And 1989
Metin And, '17. Yüzyıl Türk Çarşı Ressamlarının Padişah Portreleri', *Türkyemiz*, no.19, June 1989, pp.4–13.

Arat 1936–9
R. R. Arat, 'Fatih Sultan Mehmed'in Yarlığı', *Türkiyat Mecmuası*, 6, 1936–9, pp.285–322.

Arberry 1967
A. J. Arberry, *The Koran Illuminated. A Handlist of Korans in the Chester Beatty Library*, Dublin, 1967.

Arberry and others 1962
A. J. Arberry and others, *The Chester Beatty Library. Catalogue of Persian Manuscripts and Miniatures*, III, Dublin, 1962.

Arnold & Grohmann 1929
Sir T. W. Arnold and A. Grohmann, *The Islamic Book*, Paris, 1929.

Arseven, n.d.
C. E. Arseven, *Les arts décoratifs turcs*, [Ankara], n.d.

Aşık Çelebi
Aşık Çelebi, *Meşā'ir üş-Şu'arā*', edited by G. M. Meredith-Owens, London, 1971.

Aşık Paşa-zade
Die altosmanische Chronik des 'Āšikpašazāde, edited by F. Giese, Leipzig, 1929.

Aslanapa 1979
O. Aslanapa, 'The Art of Bookbindings', in Gray, 1979, pp.59–91.

Aslanapa 1986
—, 'Early Ottoman Carpets', in Pinner & Denny 1986, pp.67–71.

Atasoy 1992
N. Atasoy, *Splendors of the Ottoman Sultans*, Memphis, Tennessee, 1992.

Atasoy & Raby 1989
N. Atasoy and J. Raby, *Iznik. The Pottery of Ottoman Turkey*, London, 1989.

Ateş [1974]
İ. Ateş, *Ok Meydanı ve Okçuluk Tarihi*, Istanbul, [1974].

Atıl 1981
E. Atıl, *Kalila wa Dimna. Fables from a Fourteenth-Century Arabic Manuscript*, Washington, DC, 1981.

Atıl 1987
—, *The Age of Süleyman the Magnificent*, National Gallery of Art, Washington, DC, 1987.

Atsız 1957
Ç. N. Atsız, 'Fatih Sultan Mehmed'e Sunulmuş Tarihî Bir Takvim', *İstanbul Enstitüsü Dergisi*, III, 1957, pp.17–23.

Aubin 1957
J. Aubin, 'Le Mécénat timouride à Chiraz', *Studia Islamica*, VIII, 1957, pp.71-88.

Ayverdi 1953
E. H. Ayverdi, *Fâtih Devri Hattatları ve Hat Sanatı*, Istanbul, 1953.

Ayverdi 1966
—, *İstanbul Mi'marî Çağının Menşe'i. Osmanlı Mi'marîsinin İlk Devri*, Istanbul, 1966.

Ayverdi 1972
—, *Osmanlı Mi'mârîsinde Çelebi ve II. Sultan Murad Devri, 806–855 (1403–1451)*, Istanbul, 1972.

Babinger 1931a
F. Babinger, 'Papierhandel und Papierbereitung in der Levante', *Wochenblatt für Papier-fabrikation*, LXII, 1931, pp.1215–9; reprinted in Babinger 1962–76, II, pp.127–131.

Babinger 1931b
—, 'Appunti sulle Cartiere e sull' Importazione di Carta nell'Impero Ottoman spezialmente da Venezia', *Oriente Moderno*, XI, 1931, pp.406–15; reprinted in Babinger 1962–76, II, pp.133–41.

Babinger 1934
—, 'Tīmūrtāsh', *Encyclopaedia of Islām*, first edition, IV, Leiden and London, 1934, pp.782–4.

Babinger 1951
—, 'Ja'qûb-Pascha, ein Leibarzt Mehmed's II.', *Rivista degli Studi Orientali*, XXVI, 1951, pp.87–113; reprinted in Babinger 1962–76, II, pp.240–62.

Babinger 1952
—, *Vier Bauvorschläge Lionardo da Vinci's an Sultan Bajezid II. (1502/3)*, Nachrichten der Akademie der Wissenschaften in Göttingen, I, Philosophisch-historische Klasse, 1952, no.1, Göttingen, 1952.

Babinger 1956
—, *Reliquienschacher am Osmanenhof im XV. Jahrhundert. Zugleich ein Beitrag zur Geschichte der osmanischen Goldprägung unter Mehmed II., dem Eroberer*, Bayerische Akademie der Wissenschaften, Philosophisch-historische Klasse, Siztungsberichte, 1956, no.2, Munich, 1956.

Babinger 1962–76
—, *Aufsätze und Abhandlungen zur Geschichte Südosteuropas und der Levante*, 3 volumes, Munich, 1962–76.

Babinger 1966
—, 'Maometto il Conquistatore e gli Umanisti d'Italia', *Venezia e l'Oriente fra il Tardo Medio*

Evo e Rinascimento, Florence, 1966, pp.433–49; reprinted in Babinger 1962–76, III, pp.291–307.

Bağdatlı İsmail Paşa
Bağdatlı İsmail Paşa, *İḍāḥ al-maknūn fi'l-dhayl 'alā Kashf al-ẓunūn*, edited by Ş.Yaltkaya and K.R.Bilge, 2 volumes, Istanbul, 1945.

Baker 1991
D.Baker, 'Arab Papermaking', *The Paper Conservator*, XV, 1991, pp.28–35.

Baltimore 1957
The History of Bookbinding 525–1950 AD, Walters Art Gallery, Baltimore, 1957.

Barkan 1953–4
Ö.L.Barkan, 'H.933–934 (M.1527–28) Mali Yılına Ait Bir Bütçe Örneği', *İstanbul Üniversitesi İktisat Fakültesi Mecmuası*, XV, 1953–4, pp.251–329.

Barkan 1979
—, 'İstanbul Saraylarına Ait Muhasebe Defterleri', *Belgeler*, IX/13, 1979, pp.1–380.

Baykal 1958
İ.Baykal, 'Fatih Sultan Mehmed'in Hususi Kütüphanesi ve Kitapları', *Vakıflar Dergisi*, IV, Ankara, 1958, pp.77–9.

Baylâv 1953
N.Baylâv, *Fâtih Sultan Mehmed Devrinde Te'lif, Terceme ve İstinsah Edilen Tıb Eserleri ile İlâçlar*, Istanbul, 1953.

Bayram 1982
S.Bayram, 'XIV. Asırda Tezhiplenmiş Beylik Dönemine Ait Üç Kur'an Cüzü', *Vakıflar Dergisi*, XVI, 1982, pp.143–54.

Beit-Arié 1981
M.Beit-Arié, *Hebrew Codicology. Tentative Typology of Technical Practices Employed in Hebrew Dated Medieval Manuscripts*, Jerusalem, 1981.

Ben Cheheb 1971
M.Ben Cheheb, 'Ibn al-Djazarī', *Encyclopaedia of Islam*, second edition, III, Leiden and London, 1971, p.753.

Bertrandon de La Broquière
Voyage d'Outremer de Bertrandon de La Broquière, edited by Ch.Schéfer, Paris, 1892.

Binark 1965
İ.Binark, 'Türk Kitapçılık Tarihinde Cilt San'atı', *Türk Kültürü*, III/36, 1965, pp.985–96.

Binyon, Wilkinson & Gray 1933
L.Binyon, J.V.S.Wilkinson and B.Gray, *Persian Miniature Painting*, Oxford, 1933.

Birnbaum 1981
E.Birnbaum, *The Book of Advice by King Kā'us ibn Iskandar*, [Cambridge, Massachusetts], 1981.

Bosch 1952
G.K.Bosch, *Islamic Bookbindings: Twelfth to Seventeenth Centuries*, Ph.D. dissertation, University of Chicago, 1952.

Bovero 1974
A.Bovero, *L'opera completa del Crivelli*, Milan, 1974.

Brend 1989
B.Brend, 'The Arts of the Book', in *The Arts of Persia*, edited by R.W.Ferrier, New Haven and London, 1989.

Brockelmann 1937
C.Brockelmann, *Geschichte der arabischen Literatur*, erster Supplementband, Leiden, 1937.

Browne 1928
E.G.Browne, *A Literary History of Persia*, 4 volumes, Cambridge, 1928.

Bursalı Mehmed Tahir 1333
Bursalı Mehmed Tahir, *Osmanlı Müellifleri*, 3 volumes, Istanbul, 1333.

Busse 1959
H.Busse, *Untersuchungen zum islamischen Kanzleiwesen an Hand turkmenischer und safawadischer Urkunden*, Cairo, 1959.

Çağman 1974–5
F.Çağman, 'Sultan Mehmet II. Dönemine Ait Bir Minyatürlü Yazma. Külliyat-ı Kâtibî', *Sanat Tarihi Yıllığı*, VI, 1974–5, pp.333–46.

Çağman 1983
—, 'Ottoman Art', *The Anatolian Civilisations*, III, Topkapı Palace Museum, Istanbul, 1983, pp.97–315.

Çağman 1987
—, 'Altın Hazine Matarası', *Topkapı Sarayı Müzesi Yıllığı*, II, 1987, pp.85–122.

Çağman 1989
—, 'Saray Nakkaşhanesinin Yeri Üzerine Düşünceler', *Sanat Tarihinde Doğudan Batıya. Ünsal Yücel Anısına Sempozyum Bildirileri*, Istanbul, 1989, pp.35–46.

Çağman, forthcoming
F.Çağman, 'The Ahmed Karahisari Qur'an in the Topkapı Palace Library in Istanbul', forthcoming.

Çağman & Tanındı–Rogers 1986
F.Çağman and Z.Tanındı, *The Topkapı Saray Museum. The Albums and Illustrated Manuscripts*, translated, expanded and edited by J.M.Rogers, London, 1986.

Canova 1964
G.Canova, *Paris Bordon*, Venice, 1964.

Carswell 1982
J.Carswell, 'Ceramics', in Petsopoulos 1982, pp.73–96.

Çavuşoğlu 1971
M.Çavuşoğlu, *Necâtî Bey Dîvânı'nın Tahlili*, Istanbul, 1971.

Celâl 1948
M.Celâl, *Şeyh Hamdullah*, Istanbul, 1948.

Çetin 1961
N.Çetin, 'Mesnevi'nin Konya Kütüphanelerindeki Eski Yazmaları', *Şarkiyat Mecmuası*, IV, 1961, pp.98–117.

Chicago 1981
G.Bosch, J.Carswell and G.Petherbridge, *Islamic Bindings and Bookmaking*, Oriental Institute, University of Chicago, 1981.

Çığ 1971
K.Çığ, *Türk Kitap Kapları*, Istanbul, 1971.

Cleaves 1950
F.W.Cleaves, 'The Sino-Mongolian Edict of 1453 in the Topkapı Sarayı Müzesi', *Harvard Journal of Asiatic Studies*, XIII, 1950, pp.431–46.

Crane 1993
H.Crane, 'Notes on Saldjūq Architectural Patronage in Thirteenth Century Anatolia', *Journal of the Economic and Social History of the Orient*, XXXVI, 1993, pp.1–57.

Csontosi 1878
J.Csontosi, *XXXV Handschriften (Geschenk des Sultans Abdul Hamid II.)*, Budapest, 1878.

Cunbur 1985
M.Cunbur, 'Kütüphane Vakfiyelerinden Notlar', *Erdem*, I/3, 1985, pp.711–43.

Demiriz 1979
Y.Demiriz, *Osmanlı Mimarisi'nde Süsleme*, I, *Erken Devir (1300–1453)*, Istanbul, 1979.

Demiriz 1982
—, 'Anadolu Türk Sanatında Süsleme ve Küçük Sanatlar', *Anadolu Uygarlıkları Ansiklopedisi*, V, 1982, pp.881–928.

Denny 1979
W.B.Denny, 'The Origins of the Designs of Ottoman Court Carpets', *Hali*, no.2, 1979, pp.6–11.

Derman 1970
U.Derman, 'Kanunî Devrinde Yazı San'atımız', *Kanunî Armağanı*, Ankara, 1970, pp.269–89.

Déroche 1992
F.Déroche, *The Abbasid Tradition. Qur'ans of the 8th to 10th Centuries*, The Nasser D.Khalili Collection of Islamic Art, I, London, 1992.

Diehl 1946
E.Diehl, *Bookbinding. Its Background and Technique*, 2 volumes, New York and Toronto, 1946.

Duda 1983
D.Duda, *Islamische Handschriften*, I, *Persische Handschriften*, Österreichische Akademie der Wissenschaften, Phil.-hist. Klasse, Denkschriften, CLXVII, Vienna, 1983.

Dunlop 1960
D.M.Dunlop, 'al-Balkhī', *Encyclopaedia of Islam*, second edition, II, Leiden, 1960, p.1003.

Dunkerton and others 1991
J.Dunkerton, S.Foister, D.Gordon, and N.Penny, *Giotto to Dürer. Early Renaissance Painting in the National Gallery*, New Haven and London, 1991.

Düsseldorf 1973
Islamische Keramik, Düsseldorf, 1973.

Enderlein 1991
V.Enderlein, *Die Miniaturen der Berliner Baisongur-Handschrift*, Berlin, 1991.

Errera 1927
I.Errera, *Catalogue d'étoffes anciennes et modernes*, Musées Royaux du Cinquantenaire, third edition, Brussels, 1927.

Ertaylan 1948
İ.H.Ertaylan, *Külliyyât-i Divan-i Kabulî*, Istanbul, 1948.

Erünsal 1980
İ.Erünsal, 'Türk Edebiyatı Tarihine Kaynak Olarak Arşivlerin Değeri', *Türkiyat Mecmuası*, XIX, 1980, pp.213–22.

Erünsal 1983
—, *The Life and Works of Tâcî-zâde Ca'fer Çelebi, with a critical edition of his Dîvân*, Istanbul, 1983.

Erünsal 1985
—, 'Medieval Ottoman Libraries' *Erdem*, I, 1985, pp.745–54.

Erünsal 1988
—, *Türk Kütüphaneleri Tarihi*, II, *Kuruluştan Tanzimat'a Kadar Osmanlı Vakıf Kütüphaneleri*, Ankara, 1988.

Ettinghausen 1938–9
R.Ettinghausen, 'Manuscript Illumination', in Pope & Ackerman 1938–9, III, pp.1937–74.

Ettinghausen 1954
—, 'On the Covers of the Morgan *Manâfi'* Manuscript and Other Early Persian Bookbindings', *Studies in Art and Literature for Bella da Costa Greene*, edited by D.Miner, Princeton, 1954, pp.459–73.

Ettinghausen & Hartner 1964
R.Ettinghausen and W.Hartner, 'The Conquering Lion. The Life Cycle of a Symbol', *Oriens*, XVII, 1964, pp.161–71.

Eyice 1962–3
S.Eyice, 'İlk Osmanlı Devrinin Dinî-İçtimaî Bir Müessesesi. Zaviyeler ve Zaviyeli-cami', *İstanbul Üniversitesi İktisat Fakültesi Mecmuası*, XXIII, 1962–3, pp.3–80.

Fatih Vakfiyeleri, 1938
Fatih Mehmed II Vakfiyeleri, Ankara, 1938.

Fisher & Fisher 1985
A.W.Fisher and C.G.Fisher, 'A Note on the Location of the Royal Ottoman Ateliers', *Muqarnas*, III, 1985, pp.118–20.

Flemming 1986
B.Flemming, 'Lāmi'ī', *Encyclopaedia of Islam*, second edition, V, Leiden, 1986, p.649–51.

Flügel 1865–7
Gustav Flügel, *Die arabischen, persischen und türkischen Handschriften der k.k. Hofbibliothek zu Wien*, 3 volumes, Vienna, 1865–7.

Frankfurt 1985
Türkische Kunst und Kultur aus osmanischer Zeit, 2 volumes, Museum für Kunsthandwerk, Frankfurt, published Recklinghausen, 1985.

Franses & Pinner 1981
[Editorial by M.Franses and R.Pinner], 'Portraits of King Henry VIII, *Hali*, 3, no.3, 1981, pp.176–81.

Gantzhorn 1990
V.Gantzhorn, *Der christlich-orientalische Teppich*, Cologne, 1990.

Gasparini 1985
E.Gasparini, *Le pitture murali della Muradiye di Edirne*, Padua, 1985.

Gibb 1902
E.J.W.Gibb, *A History of Ottoman Poetry*, edited by E.G.Browne, II, London, 1902; reprinted 1965.

Gölpınarlı 1971
A.Gölpınarlı, *Mevlana Müzesi Yazmalar Kataloğu*, II, Ankara, 1971.

Gottlieb 1910
T.Gottlieb, *K.K.Hofbibliothek. Bucheinbände. Auswahl von technisch und geschichtlich bemerkenswerten Stücken*, Vienna, 1910.

Gratzl 1924
E.Gratzl, *Islamische Bucheinbände des 14. bis 19. Jahrhundertrs*, Leipzig, 1924.

Gratzl 1928
—, 'Eine frühe Buchbinderinschrift aus Kleinasien', *Jahrbuch der Einbandkunst*, II, 1928, pp.60–62.

Gratzl 1938–9
—, 'Book Covers', in Pope & Ackerman 1938–9, pp.1975–94.

Gray 1961
B.Gray, *Persian Painting*, Geneva, 1961.

Gray 1979
—, editor, *The Arts of the Book in Central Asia*, London, 1979.

Gray 1985
—, 'The Monumental Qur'ans of the Il-Khanid and Mamluk Ateliers of the First Quarter of the Fourteenth Century (Eighth Century H.)', *Rivista degli Studi Orientali*, LIX, 1985, pp.135–46.

Grube 1961
E.J.Grube, 'A School of Turkish Miniature Painting', *First International Congress of Turkish Arts, Ankara, 1959*, Ankara 1961, pp.176–209.

Grube 1969
—, 'Herat, Tabriz, Istanbul. The Development of a Pictorial Style', *Paintings from Islamic Lands*, edited by R.Pinder-Wilson, Oxford, 1969, pp.85–109.

Grube 1974
—, 'Notes on the Decorative Arts in the Timurid Period', *Gururājamañjarikā. Studi in onore de Giuseppe Tucci*, I, 1974, pp.233–79.

Grube 1975
—, *Miniature islamiche nella collezione del Topkapı Sarayı Istanbul*, Padua, 1975.

Grube 1978
—, *Persian Painting in the Fourteenth Century. A Research Report*, Annali dell'Istituto Orientale di Napoli, XXXVIII, supplement no.17, 1978.

Grube 1982
—, 'Painting', in Petsopoulos 1982, pp.193–212.

Grube 1987
—, 'The Date of the Venice *Iskandar-Nama*', *Islamic Art*, II, 1987, pp.187–202.

Halasi-Kun 1987–92
T.Halasi-Kun, 'Gennadios' Confession of Faith', *Archivum Ottomanicum*, 12, 1987–92, pp.5–103.

Haldane 1983
D.Haldane, *Islamic Bookbindings*, Victoria & Albert Museum, London, 1983.

Hammacher & Vandenbrande 1969
A.M.Hammacher and R.H.Vandenbrande, *The Book of Art. Flemish and Dutch Art*, Milan, 1969.

Harrison 1924
T.Harrison, 'A Persian Binding of the 15th Century', *Burlington Magazine*, XLIV, 1924, pp.31–5.

Hobson 1989
A.Hobson, *Humanists and Bookbinders*, Cambridge, 1989.

Huard & Grmek 1960
P.Huard and M.D.Grmek, *Le premier manuscrit chirurgical turc rédigé par Charaf ed-Din (1465)*, Paris, 1960.

Huart 1908
Cl.Huart, *Les Calligraphes et les Miniaturistes de l'Orient Musulman*, Paris, 1908.

Hughes & Faggin 1971
R.Hughes and G.T.Faggin, *The Complete Paintings of the Van Eycks*, London, 1971.

Ibrahim 1962
'Abd al-Latif Ibrahim, 'Jilda muṣḥaf bi-Dār al-Kutub al-Miṣriyya', *Bulletin of the Faculty of Arts*, Cairo University, XX, 1962, pp.81–107.

Imber 1990
C.Imber, *The Ottoman Empire, 1300–1481*, Istanbul, 1990.

İnalcık 1954
H.İnalcık, *Fatih Devri Üzerinde Tetkikler ve Vesikalar*, I, Ankara, 1954.

İnalcık 1962
—, 'The Rise of Ottoman Historiography', *Historians of the Middle East*, edited by B.Lewis and P.M.Holt, Oxford, 1962, pp.152–67.

İnalcık 1980–81
—, 'Osmanlı İdare, Sosyal ve Ekonomik Tarihiyle İlgili Belgeler. Bursa Kadı Sicillerinden Seçmeler', *Belgeler*, X, 1980–81.

Istanbul 1953
İstanbul Kütüphanelerinde Fatih'in Hususî Kütüphanesine ve Fatih Çağı Müelliflerine Ait Eserler, Istanbul, 1953.

Jacobs 1937
E.Jacobs, 'Büchergeschenke für Sultan Mehemmed II.', *Festschrift für Georg Leyh*, Leipzig, 1937, pp.20–26.

Jacobs 1949
—, 'Mehemmed II., der Eroberer, seine Beziehungen zur Renaissance und seine Büchersammlung', *Oriens*, 2, 1949, pp.6–30.

James 1980
D.James, *Qur'ans and Bindings from the Chester Beatty Library*, London, 1980.

James 1981
—, 'Lacquer items in the Chester Beatty Library', *Lacquerwork in Asia and Beyond*, Colloquies in Art & Archaeology in Asia, XI, 1981, pp.318–22.

James 1987
—, *Masterpieces of the Holy Quranic Manuscripts. Selections from the Islamic World*, Kuwait, 1987.

James 1988
—, *Qur'āns of the Mamlūks*, London, 1988.

James 1992a
—, *The Master Scribes. Qur'ans of the 11th to 14th Centuries*, The Nasser D.Khalili Collection of Islamic Art, II, London, 1992.

James 1992b
—, *After Timur. Qur'ans of the 15th and 16th Centuries*, The Nasser D.Khalili Collection of Islamic Art, III, London, 1992.

Kappert 1976
P. Kappert, *Die osmanischen Prinzen und ihre Residenz Amasya im 15. und 16. Jahrhundert*, Istanbul, 1976.

Karabacek 1913
J. von Karabacek, *Zur orientalischen Altertumskunde, IV. Muhammedanische Kunststudien*, Kaiserliche Akademie der Wissenschaften in Wien, Philosophisch-historische, Klasse, Sitzungsberichte, CLXXII/1, Vienna, 1913.

Karabacek 1918
—, *Abendländische Künstler zu Konstantinopel im XV. und XVI. Jahrhundert*, I, Kaiserliche Akademie der Wissenschaften in Wien, Denkschriften, LXIII, Vienna, 1918.

Karatay 1961a
F. E. Karatay, *Topkapı Sarayı Müzesi Kütüphanesi. Farsça Yazmalar Kataloğu*, Istanbul, 1961.

Karatay 1961b
—, *Topkapı Sarayı Müzesi Kütüphanesi. Türkçe Yazmalar Kataloğu*, 2 volumes, Istanbul, 1961.

Karatay 1962–9
—, *Topkapı Sarayı Müzesi Kütüphanesi. Arapça Yazmalar Kataloğu*, 4 volumes, Istanbul, 1962–9.

Kâtip Çelebi, ed. Yaltkaya & Bilge
Kâtip Çelebi, *Keşf-el-zunun*, edited by S.Yaltkaya and R.Bilge, 2 volumes, Istanbul, 1941–3.

Keddie 1972
N.R.Keddie, editor, *Scholars, Saints, and Sufis. Muslim Religious Institutions in the Middle East since 1500*, Berkeley, 1972.

Kersten 1914
P. Kersten, 'Die Durchbrucharbeit', *Archiv für Buchbinderei*, XIV, 1914, pp.8–11.

Khan 1993
G. Khan, *Bills, Letters and Deeds. Arabic Papyri of the 7th to 11th Centuries*, The Nasser D.Khalili Collection of Islamic Art, VI, London, 1993.

Kirchner 1955
J. Kirchner, *Bilderatlas zum Buchwesen*, I, Stuttgart, 1955.

Kissling 1953
H. J. Kissling, 'Aus der Geschichte des Chalvetijje-Ordens', *Zeitschrift der Deutschen Morgenländischen Gesellschaft*, CIII, 1953, pp.233–89.

Kritoboulos, trans. Riggs
Kritoboulos, *History of Mehmed the Conqueror*, translated by C.T. Riggs, Princeton, 1954.

Kritoboulos, ed.Grecu
Kritoboulos, *Critobul din Imbros, in domnia lui Mahomed al II-lea, anii 1451–1467*, edited by V.Grecu, Scriptores Byzantini, IV, Bucharest, 1963.

Kuran 1968
A. Kuran, *The Mosque in Early Ottoman Architecture*, Chicago and London, 1968.

Lane 1960
A. Lane, *Guide to the Collection of Tiles in the Victoria & Albert Museum*, London, 1960.

Latifi
Tezkire-i Latīfī, edited by Aḥmed Cevdet, Istanbul, 1314; translated into German as *Latifi's Tezkere*, Tübingen, 1950.

Lee & Ho 1968
S. E. Lee and W.-K. Ho, *Chinese Art under the Mongols. The Yüan Dynasty (1279–1368)*, Cleveland Museum of Art, 1968.

Leiden 1986
Treasures from Turkey, Leiden, 1986.

Lentz & Lowry 1989
T. Lentz and G.Lowry, *Timur and the Princely Vision. Persian Art and Culture in the Fifteenth Century*, Los Angeles County Museum of Art and the Arthur M. Sackler Gallery, Washington, DC, 1989.

Leroy 1967
J. Leroy, 'Une évangéliaire arabe de la Bibliothèque Topqapi Sarayı à décor byzantine et islamique', *Syria*, XLIV, 1967, pp.119–30.

Levey 1962
M. Levey, 'Mediaeval Arabic Bookmaking and its Relation to Early Chemistry and Pharmacology', *Transactions of the American Philosophical Society*, new series, LII/4, Philadelphia, 1962.

Lings 1976
M. Lings, *The Qur'anic Art of Calligraphy and Illumination*, London, 1976.

Lings & Safadi 1976
M. Lings & Y. Safadi, *The Qur'an*, British Library, London, 1976.

London 1976
The Arts of Islam, Hayward Gallery, London, 1976.

Loubier 1910
J. Loubier, 'Orientalische Einbandkunst', *Archiv für Buchbinderei*, X, 1910, pp.33–43.

Mackie 1984
L.Mackie, 'Toward an Understanding of Mamluk Silks. National and International Considerations', *Muqarnas*, II, 1984, pp.127–46.

Mackie 1989
—, 'A Piece of the Puzzle. A 14th–15th Century Persian Carpet Fragment Revealed', *Hali*, no.47, October 1989, pp.16–23.

Mahir 1987
B. Mahir, 'Osmanlı Sanatında Saz Uslubundan Anlaşılan', *Topkapı Sarayı Müzesi. Yıllık*, II, 1987, pp.123–40.

Mahir 1990
—, 'II. Bayezid Dönemi Nakkaşhanesinin Osmanlı Tezhip Sanatına Katkıları', *Türkiyemiz*, no.60, February 1990, pp.4–13.

Mango 1959
C. Mango, *The Brazen House. A Study of the Vestibule of the Imperial Palace of Constantinople*, Copenhagen, 1959.

Markowsky 1976
B. Markowsky, *Kunstgewerbe Museum der Stadt Köln. Europäische Seidengewebe des 13.–18. Jahrhunderts*, Cologne, 1976.

Marteau & Vever 1913
G. Marteau and H. Vever, *Miniatures persanes … exposées au Musée des Arts Décoratifs, Juin–Octobre 1912*, Paris, 1913.

Martin 1912
F. R. Martin, *The Miniature Painting and Painters of Persia, India and Turkey from the 8th to the 18th Century*, London, 1912.

Martin 1972
B. G. Martin, 'A Short History of the Khalwati Order of Dervishes', in Keddie 1972, pp.275–305.

Martindale & Garavaglia 1971
A. Martindale and N. Garavaglia, *The Complete Paintings of Mantegna*, London, 1971.

Ménage 1964
V. L. Ménage, *Neshrī's History of the Ottomans. The Sources and Development of the Text*, Oxford, 1964.

Mercümek Ahmed
Kaykā'us ibn Iskandar, *Qābūsnāmah*, translated by Mercümek Ahmed, edited by O. Ş.Gökyay, Istanbul, 1944.

Meredith-Owens 1969
G.M.Meredith-Owens, *Turkish Miniatures*, London, 1969.

Meriç 1953
R.M.Meriç, *Türk Nakış Sanatı Tarihi Araştırmaları, I, Vesikalar*, Ankara, 1953.

Meriç 1954
—, *Türk Cild Sanatı Tarihi Araştırmaları, I, Vesikalar*, Ankara, 1954.

Milan 1971
Brera Milan, Great Museums of the World, Verona, 1971.

Minorsky 1958
V. Minorsky, *The Chester Beatty Library. A Catalogue of the Turkish Manuscripts and Miniatures*, Dublin, 1958.

Mokri 1973
Mohammad Mokri, 'Un Farmân de Sultân Ḥusayn Bâyqarâ recommandant la protection d'une ambassade ottomane en Khorasân en 879/1474', *Turcica*, V, 1973, pp.68–79.

Monnas 1991
L. Monnas, 'Silk Fabrics in Paintings by Jan Van Eyck', *Hali*, no.13, December 1991, pp.103–113.

Mouradja d'Ohsson
I. de Mouradja d'Ohsson, *Tableau Général de l'Empire Othoman*, Paris, 2 volumes, 1787–90.

Munich 1910
F. Sarre and F. R. Martin, editors, *Meisterwerke Muhammedanischer Kunst*, 2 volumes, Munich, 1910.

Murray & De Vecchi 1970
P. Murray and P. De Vecchi, *The Complete Paintings of Piero della Francesca*, London, 1970.

Mustafa Âli, ed. İbnü'l-Emin Mahmud Kemal
Mustafa Âli, *Menakıb-ı Hünerverân*, edited by İbnü'l-Emin Mahmud Kemal, Istanbul, 1926.

Mustafa Âli, ed. Tietze
Muṣṭafā 'Ālī's Counsel for Sultans of 1581, edited by Andreas Tietze, I, Vienna, 1979.

Müstakim-zade, ed.İbnü'l-Emin Mahmud Kemal
Müstakim-zade, *Tuhfe-i Hattatin*, edited by İbnü'l-Emin Mahmud Kemal, Istanbul, 1928.

Nadir 1986
A. Nadir, editor, *Osmanlı Padişah Fermanları/ Imperial Ottoman Fermans*, London, 1986.

Necipoğlu 1990
G. Necipoğlu, 'From International Timurid to Ottoman. A Change of Taste in Sixteenth-century Tiles', *Muqarnas*, VII, 1990, pp.136–70.

Necipoğlu 1991
—, *Architecture, Ceremonial, and Power. The Topkapı Palace in the Fifteenth and Sixteenth Centuries*, Cambridge, Massachusetts, and London, 1991.

Nefes-zade, ed. Kilisli Muallim Rifat
Nefes-zade İbrahim, *Gülzar-ı Savab*, edited by Kilisli Muallim Rifat, Istanbul, 1939.

Neşri, ed. Unat & Köymen
Neşri, *Kitab-ı Cihan-nümâ*, edited by F. R. Unat and M. A. Köymen, 2 volumes, Ankara, 1949–57.

Öhrnberg 1978
K. Öhrnberg, 'A Qur'ān Manuscript in Helsinki', *Studia Orientalia*, LI/3, 1978, pp.3–10.

O'Kane 1987
B. O'Kane, *Timurid Architecture in Khurasan*, Costa Mesa, California, 1987.

Öney 1987
G. Öney, *Islam Mimarisinde Çini*, Istanbul, 1987.

Oral 1950
M. Z. Oral, 'Kitap Kitabeleri', *Anıt*, 1950, issue 1, pp.5–10; issue 13, pp.4–6; issue 14, pp.10–12.

Oral 1962
—, 'Anadolu'da San'at Değeri Olan Ahşap Minberler, Kitabeleri ve Tarihçeleri', *Vakıflar Dergisi*, V, 1962, pp.23–77.

Öz 1940
T. Öz, *Topkapı Sarayı Müzesi. Arşiv Kılavuzu*, II, 1940.

Öz 1946–51
—, *Türk Kumaş ve Kadifeleri*, 2 volumes, Istanbul, 1946–51.

Öz 1953
—, *Topkapı Sarayında Fatih Sultan Mehmet II.ye Ait Eserler*, Ankara, 1953.

Özergin 1974–5
M. K. Özergin, 'Temürlü Sanatına Ait Eski Bir Belge. Tebrizli Ca'fer'in Bir Arzı', *Sanat Tarihi Yıllığı*, VI, 1974–5, pp.471–58.

Patrinelis 1966
Chr. Patrinelis, ὁ Θεόδωρος Ἀγαλλιανὸς …, Thessalonica, 1966.

Pedersen 1984
J. Pedersen, *The Arabic Book*, edited by Robert Hillenbrand, Princeton, N.J., 1984.

Petsopoulos 1982
Y. Petsopoulos, editor, *Tulips, Arabesques and Turbans. Decorative Arts from the Ottoman Empire*, London, 1982.

Pinner & Denny 1986
R. Pinner and W. B. Denny, editors, *Oriental Carpet and Textile Studies*, II, *Carpets of the Mediterranean Countries 1400–1600*, London, 1986.

Pope & Ackerman 1938–9
A. U. Pope and P. Ackerman, editors, *A Survey of Persian Art from prehistoric times to the present*, 6 volumes, Oxford, 1938–9.

Raby 1980
J. Raby, 'Cyriacus of Ancona and the Ottoman Sultan Mehmed II', *Journal of the Warburg and Courtauld Institutes*, XLIII, 1980, pp.242–6

Raby 1981
—, 'Mehmed II Fatih and the Fatih Album', *Islamic Art*, I, 1981, pp.42–9.

Raby 1982
—, 'Silver and Gold', in J. Raby and J. Allan, 'Ottoman Metalwork', in Petsopoulos 1982, pp.17–33.

Raby 1983
—, 'Mehmed the Conqueror's Greek Scriptorium', *Dumbarton Oaks Papers*, XXXVII, 1983, pp.15–34.

Raby 1986
—, 'Court and Export, Part 2. The Uşak Carpets,' in Pinner & Denny 1986, pp.177–87.

Raby 1987a
—, 'East & West in Mehmed the Conqueror's Library', *Bulletin du bibliophile*, 3, 1987, pp.296–318.

Raby 1987b
—, 'Mehmed the Conqueror and the Byzantine Rider of the Augustaion', *Topkapı Sarayı Yıllığı*, 2, 1987, pp.141–52.

Raby 1987c
—, 'Pride and Prejudice. Mehmed the Con-queror and the Italian Portrait Medal', *The Renaissance Medal*, edited by J. G. Pollard, National Gallery of Art, Washington, DC, 1987, pp.171–94.

Raby & Yücel 1986
J. Raby and Ü. Yücel, 'The Earliest Treasury Registers', in R. Krahl, *Chinese Ceramics in the Topkapı Saray Museum, Istanbul. A Complete Catalogue*, edited by J. Ayers, I, London, 1986, pp.77–81.

Rado, n.d.
Ş. Rado, *Türk Hattatları*, Istanbul, no date.

Rawson 1984
J. Rawson, *Chinese Ornament. The Lotus and the Dragon*, British Museum, London 1984.

Raymond 1922
A. Raymond, *Vieilles faiences turques*, Berlin, 1922.

Regemorter 1961
B. van Regemorter, *Some Oriental Bindings in the Chester Beatty Library*, Dublin, 1961.

Repp 1972
R. Repp, 'Some Observations on the Development of the Ottoman Learned Hierarchy', in Keddie 1972, pp.17–46.

Repp 1986
—, *The Müfti of Istanbul. A Study in the Development of the Ottoman Learned Hierarchy*, London, 1986.

Restle 1981
M. Restle, 'Bauplanung und Baugesinnung unter Mehmed II. Fâtih', *Pantheon*, 39, 1981, pp.361–7.

Richard 1989
F. Richard, 'Dīvānī ou ta'līq? Un calligraphe au service de Mehmet II, Sayyidī Mohammad Monšī', *Les manuscrits du Moyen-Orient. Essais de codicologie et de paléographie*, edited by F. Déroche, Istanbul and Paris, 1989, pp.89–93.

Ritter 1937
H. Ritter, 'Philologika IX', *Der Islam*, 24, 1937. pp.270–86.

Roberts & Skeat 1983
C. H. Roberts and T. C. Skeat, *The Birth of the Codex*, London, 1983.

Robinson and others 1988
B. W. Robinson and others, *Islamic Art in the Keir Collection*, London, 1988.

Rogers 1983
M. Rogers, *Islamic Art and Design, 1500–1700*, London, 1983.

Rogers 1987
—, 'An Ottoman Palace Inventory of the Reign of Bayezid II', *Proceedings of CIEPO*, Cambridge, 1984, edited by

J.-L. Bacqué-Grammont and E. van Donzel, Istanbul, 1987, pp.40–53.

Rogers & Ward 1988
J. M. Rogers and R. Ward, *Süleyman the Magnificent*, British Museum, London, 1988.

Rosenthal 1958
E. I. J. Rosenthal, *Political Thought in Medieval Islam. An Introductory Outline*, Cambridge, 1958.

Rosenthal 1971
F. Rosenthal, 'Ibn al-Athīr', *Encyclopaedia of Islam*, second edition, III, Leiden, 1971, pp.723–5.

Ruppersberg 1983
J. Ruppersberg, 'Ein Teppichmuster für eine türkmenische Fürstentochter', *Heimtex*, 1983, pp.74–92.

Ryan 1982
W. F. Ryan, 'The *Secretum Secretorum* and the Muscovite Autocracy', *Pseudo-Aristotle. The Secret of Secrets. Sources and Influences*, edited by W. F. Ryan and C. B. Schmitt, Warburg Institute Surveys, IX, London, 1982.

Sakisian 1921
A. Sakisian, 'L'école de miniature à Hérat au XVᵉ siècle', *La Renaissance de l'Art Français*, IV, 1921, pp.146–50 and pp.293–7.

Sakisian 1923
—, 'La reliure persane du XIVᵉ au XVIIᵉ siècle', *Actes du Congrès d'histoire de l'art, Paris, 1921*, I, 1923, pp.343–8 and pl.18.

Sakisian 1927a
—, 'La reliure turque du XVᵉ au XIXᵉ siècle', *Revue de l'Art Ancien et Moderne*, LI, 1927, pp.277–84.

Sakisian 1927b
—, 'La reliure turque du XVᵉ au XIXᵉ siècle', *Revue de l'Art Ancien et Moderne*, LII, 1927, pp.141–54.

Sakisian 1927c
—, 'La reliure turque du XVᵉ au XIXᵉ siècle', *Revue de l'Art Ancien et Moderne*, LII, 1927, pp.286–98.

Sakisian 1929
—, *La miniature persane du XIIᵉ au XIIIᵉ siècle*, Paris and Brussels, 1929.

Sakisian 1934a
—, 'La reliure dans la Perse occidentale, sous les Mongols, au XIVᵉ et au début du XVᵉ siècle', *Ars Islamica*, I, 1934, pp.80–91.

Sakisian 1934b
—, 'La reliure persane au XVᵉ siècle sous les Timourides', *Revue de l'Art Ancien et Moderne*, LXVI, 1934, pp.145–68.

Sakisian 1935
—, 'Les tapis de Perse à la lumière des arts du livre', *Artibus Asiae*, V, 1935, pp.9–22.

Sakisian 1937
—, 'La reliure persane au XVᵉ siècle, sous les Turcomans', *Artibus Asiae*, VII, 1937, pp.210–23.

Sakisian 1939
—, 'Thèmes et motifs d'enluminure et de décoration arméniennes et musulmans', *Ars Islamica*, VI, 1939, pp.66–87.

Santangelo 1964
A. Santangelo, *The Development of Italian Textile Design from the 12th to the 18th Century*, London, 1964.

Sarre 1923
F. Sarre, *Islamic Bookbindings*, translated by F. D. O'Byrne, Berlin, 1923.

Schroeder 1942
E. Schroeder, *Persian Miniatures in the Fogg Museum*, Cambridge, Massachusetts, 1942.

Sehi Bey, ed. Kut
Heşt Bihişt. The Tezkire of Sehī Beg, edited by G. Kut, [Cambridge, Massachusetts,] 1978.

Seyyid Lokman, trans. Artemel
Seyyid Lokman, *Kiyâfetü'l-İnsâniyye fî Şemâili'l-'Osmâniyye*, translated by S. Artemel, Ankara, 1987.

Sims, forthcoming
E. Sims, 'An Illuminated Manuscript Copied by Shaykh Hamdullah in the Library of Congress, Washington DC'.

Soucek 1971
P. Soucek, *Illustrated Manuscripts of Nizami's Khamseh, 1386–1482*, Ph.D. dissertation, New York University, 1971.

Soucek 1988
—, 'The New York Public Library *Makhzan al-Asrār* and its Importance', *Ars Orientalis*, 18, 1988, pp.1–37.

P. Soucek 1992
—, 'The Manuscripts of Iskandar Sultan: Structure and Content', *Timurid Art and Culture. Iran and Central Asia in the Fifteenth Century*, Leiden, Cologne and New York, 1992.

S. Soucek 1992
S. Soucek, *Piri Reis and Turkish Mapmaking after Columbus, with a facsimile reproduction of the Khalili Portolan Atlas*, London, 1992.

Stchoukine 1965
I. Stchoukine, 'Une *Khamseh* de Niẓāmī illustrée à Yazd entre 1442 et 1444', *Arts Asiatiques*, XII, 1965, pp.3–20.

Stchoukine 1966
—, *Peinture turque d'après les manuscrits illustrés*, Iᵉʳᵉ partie, Paris, 1966.

Stchoukine 1967
—, 'Miniatures turques du temps de Mohammad II', *Arts Asiatiques*, XV, 1967, pp.47–50.

Stchoukine 1968
—, 'Une *Khamseh* de Niẓāmī de la fin du règne de Shāh Rokh', *Arts Asiatiques*, XVII, 1968, pp.45–58.

Stchoukine 1969
—, 'Un manuscrit illustré de la bibliothèque de Mohammed II Fatih', *Arts Asiatiques*, XIX, 1969, pp.3–13.

Stchoukine 1971
—, 'Un manuscrit illustré de la bibliothèque de Bāyazīd II', *Arts Asiatiques*, XXIV, 1971, pp.9–22.

Stöcklein 1914–15
H. Stöcklein, 'Orientalische Waffen aus der Residenz-Büchsenkammer im Ethno-graphischen Museum München', *Münchner Jahrbuch der Bildenden Kunst*, 1914–15, pp.106–44.

al-Sufyani, ed. Ricard
Sinā'at tasfīr al-kutub wa-ḥill al-dhahab, edited by P. Ricard, Paris, 1925.

Sümer 1983
F. Sümer, *Türklerde Atçılık ve Binicilik*, Istanbul, 1983.

Taeschner 1932
F. Taeschner, 'Beiträge zur frühosmanischen Epigraphik und Archäologie', *Der Islam*, XX, 1932, pp.109–86.

Tanındı 1984a
Z. Tanındı, 'İslam Sanatında Cilt ve Ustaları', *Yeni Boyut*, III/23, May 1984, pp.9–12.

Tanındı 1984b
—, 'Rugani Türk Kitap Kalıplarının Erken Örnekleri', *Kemal Çığ'a Armağan*, Istanbul, 1984, pp.223–53.

Tanındı 1984c
— *İslam Tasvir Sanatında Hz. Muhammed'in Hayatı. Siyer-i Nebi*, Istanbul, 1984.

Tanındı 1985
—, 'Cilt Sanatında Kumaş', *Sanat Dünyamız*, no.32, 1985, pp.27–35.

Tanındı 1986
—, '13–14. Yüzyılda Yazılmış Kur'an'ların Kanuni Döneminde Yenilenmesi', *Topkapı Sarayı Müzesi. Yıllık*, I, 1986, pp.140–52.

Tanındı 1990a
—, '1278 Tarihli En Eski Mesnevi'nin Tezhipleri', *Kültür ve Sanat*, no.8, 1990, pp.17–22.

Tanındı 1990b
—, 'Topkapı Sarayı Müzesi Kütüphanesi'nde Ortaçağ İslam Ciltleri', *Topkapı Sarayı Müzesi. Yıllık*, IV, 1990, pp.102–49.

Tanındı 1990–91a
—, '15th-century Ottoman Manuscripts and Bindings in Bursa Libraries', *Islamic Art*, IV, 1990–1, pp.143–74.

Tanındı 1990–91b
—, 'Manuscript Production in the Ottoman Palace Workshop', *Manuscripts of the Middle East*, V, 1990–1, pp.67–98.

Tanındı 1991
—, 'Karamanlı Beyliği'nde Kitap Sanatı', *Kültür ve Sanat*, no.12, December 1991, pp.42–4.

Tanındı 1993
—, 'Türk Tezhip, Miniyatür ve Cilt Sanatı', *Başlangıcından Bugüne Türk Sanatı*, Ankara, 1993.

Tanındı, in preparation
—, 'Göçer Bir Bilginin Kitabı: Bir Tezhip Üslubu ve Bu Üslubu Titreşimleri'.

Tanındı, in press A
—, '*Mihr-i Müşteri* Minyatürlerinin
İkonoğrafik Çözümlemesi', *Güner İnal'a
Armağan*, Ankara.

Tanındı, in press B
—, 'Kadife Ciltler', *Dokuzuncu Milletlerarası
Türk Sanatları Kongresi, 23–27 Eylül*,
İstanbul 1991.

Tanındı, forthcoming
—, 'The Art of the Book in 14th-century
Anatolia: Satı al-Mavlavi and his Patronage'.

Tansel 1953
S. Tansel, *Osmanlı Kaynaklarına Göre Fatih
Sultan Mehmed'in Siyasî ve Askerî Faaliyeti*,
Ankara, 1953.

Taşköprülü-zade
Taşköprülü-zade Ahmed Efendi, *Al-shaqā'iq
al-nu'māniyyah*, edited by A.S. Furat, Istanbul,
1985.

Tayanç 1953
M.M.Tayanç, *Fatih. Güzel San'atlar*, Istanbul,
1953.

Tekindağ 1959
M.C.Ş.Tekindağ, 'Bayezid II.'nin Tahta
Çıkışı Sırasında İstanbul'da Vukua Gelen
Hâdiseler Üzerine Notlar', *Tarih Dergisi*, X,
1959, pp.85–96.

Tekindağ 1961
—, *Berkok Devrinde Memluk Sultanlığı*,
Istanbul, 1961.

Tekindağ 1974
—, 'Timurtaş', *İslâm Ansiklopedisi*, XII/1,
Istanbul, 1974, pp.372–4.

Tezcan & Delibaş–Rogers 1986
H. Tezcan and S. Delibaş, *The Topkapı Saray
Museum. Costumes, Embroideries and Other
Textiles*, translated, expanded and edited by
J.M.Rogers, London, 1986.

Thackston 1989
W. M.Thackston, *A Century of Princes.
Sources on Timurid History and Art*,
Cambridge, Massachusetts, 1989.

Thuasne 1892
Thuasne, *Djem-Sultan. Fils de Mohammed II
frère de Baezid II (1459–1495)*, Paris, 1892.

Tibbetts 1992
G.R.Tibbetts, 'The Balkhī School of
Geographers', *The History of Cartography*,
II/1, edited by J.B. Harley and D. Woodward,
Chicago and London, 1992, pp.108–36.

Titley 1983
N. Titley, *Persian Miniature Painting*,
London, 1983.

Togan 1963
Z. V. Togan, *On the Miniatures in Istanbul
Libraries*, Istanbul, 1963.

Turan 1947
O. Turan, 'Selçuklu Devri Vakfiyeleri, I.
Şemsettin Altun-Aba Vakfiyesi ve Hayatı',
Belleten, XI, 1947, pp.202–10.

Turan 1954
—, *İstanbul'un Fethinden Önce Yazılmış
Tarihî Takvimler*, Ankara, 1954; reprinted 1984.

Türker 1956
M. Türker, *Üç Tehafut Bakımından Felsefe ve
Din Muhasebeti*, Ankara, 1956.

Tursun Beg, ed. İnalcık & Murphey
Tursun Beg, *The History of Mehmed the Con-
queror*, edited and translated by H. İnalcık and
R. Murphey, Minneapolis and Chicago, 1978.

Tursun Bey, ed. Tulum
Tursun Bey, *Târîh-i Ebü'l-Feth*, edited by
M.Tulum, Istanbul, 1977.

Umur 1980
S. Umur, *Osmanlı Padişahlar Tuğraları*,
Istanbul, 1980.

Ünver 1946
—, *İstanbul Üniversitesi Tarihine Başlangıç.
Fatih Külliyesi ve Zamanı İlim Hayatı*,
Istanbul, 1946.

Ünver 1948
—, *İlim ve Sanat Bakımından Fatih Devri
Notları*, I, Istanbul, 1948.

Ünver 1952a
—, 'İkinci Selim'e Kadar Osmanlı Hüküm-
darlarının Hususî Kütüphaneler Hakkında',
IV. Türk Tarih Kongresi, 1948, Ankara, 1952,
pp.294–312.

Ünver 1952b
—, 'Fatih Sultan Mehmed'in Hususi
Kütüphanesinde Bilhassa Kendisi için
Yazdırılmış İbni Sina Eserleri Hakkında',
İstanbul Üniversitesi Tip Fakültesi Mecmuası,
15/3, 1952, pp.1,194–1,205.

Ünver 1954
—, 'Baba Nakkaş', *Fatih ve İstanbul*, II,
1954, pp.7–12, 169–88.

Ünver 1956
—, 'Edirne'de Şah Melek Paşa Camii
Nakışları', *Vakıflar Dergisi*, 3, 1956, pp.27–30.

Ünver 1958
—, *Fatih Devri Saray Nakışhanesi ve Baba
Nakkaş Çalışmaları*, Istanbul, 1958.

Ünver, n.d.
—, *50 Türk Motifi*, Istanbul, no date.

Ünver & Pakalın 1945
S. Ünver and M.Z. Pakalın, *Bursa'da Fatih'in
Oğulları Mustafa ve Sultan Cem ve Türbeleri*,
Bursa, 1945.

Uzunçarşılı 1949
İ.H.Uzunçarşılı, *Osmanlı Tarihi*, II,
first edition, Ankara, 1949.

Uzunçarşılı 1961
—, *Osmanlı Tarihi*, I, second printing,
Ankara, 1961.

Uzunçarşılı 1975
—, 'Fatih Sultan Mehmed'in Ölümü',
Belleten, XXXIX, 1975, pp.473–81.

Uzunçarşılı 1986
—, 'Osmanlı Saray'ında Ehl-i Hiref
(Sanatkârlar) Defteri', *Belgeler*, XI/15,
1981–6, pp.23–76.

Wardwell 1988–9
A.E.Wardwell, 'Panni Tartarici. Eastern
Islamic Silks Woven with Gold and Silver
(13th and 14th Centuries)', *Islamic Art*, III,
1988–9, pp.95–173.

Washington 1991
Circa 1492. Art in the Age of Exploration,
edited by J.A. Levenson, National Gallery of
Art, Washington, DC, 1991.

Weisweiler 1962
M.Weisweiler, *Der islamische Bucheinband des
Mittelalters*, Wiesbaden, 1962.

Welch 1972–8
A. Welch, *Collection of Islamic Art. Prince
Sadruddin Aga Khan*, 4 volumes, Geneva,
1972–8.

Welch & Welch 1982
A.Welch and S.C.Welch, *Arts of the Islamic
Book. The Collection of Prince Sadruddin Aga
Khan*, Ithaca and London, 1982.

Werner 1966
E. Werner, *Die Geburt einer Grossmacht – die
Osmanen (1300–1481)*, Berlin, 1966.

Woods 1976
J.E. Woods, *The Aqquyunlu. Clan,
Confederation, Empire*, Minneapolis and
Chicago, 1976.

Wulff 1966
H.E.Wulff, *The Traditional Crafts of
Persia*, Cambridge, Massachusetts, and
London, 1966.

Yetkin 1974
Ş. Yetkin, *Türk Halı Sanatı*, Istanbul, 1974.

Yüksel 1983
İ.A.Yüksel, *Osmanlı Mimârîsinde II Bâyezid,
Yavuz Selim Devri (886–926/1481–1520)*,
Istanbul, 1983.

Yüksel 1984
M.Yüksel, 'Kara Timurtaş Paşa Oğlu
Umur Bey'in Bursa'da Vakfettiği
Kitaplar ve Vakıf Kayıtları', *Türk Dünyası
Araştırmaları*, no.31, August 1984,
pp.134–47.

Zorzi 1987
M. Zorzi, *La Libreria di San Marco*,
Milan, 1987.

A.306	Karatay 1962–9, no.2851	A.2460	Karatay 1962–9, no.6927	A.3401	Karatay 1962–9, no.6782
A.317	Karatay 1962–9, no.2744	A.2471	Karatay 1962–9, no.8303	A.3419	Karatay 1962–9, no.6863
A.521	Karatay 1962–9, no.5399	A.2480	Karatay 1962–9, no.8312	A.3428	Karatay 1962–9, no.6812
A.542–9	Karatay 1962–9, no.2461	A.2492	Karatay 1962–9, no.8403	A.3437	Karatay 1962–9, no.6853
A.607	Karatay 1962–9, no.3103	A.2493	Karatay 1962–9, no.6943	A.3438	Karatay 1962–9, no. 6771
A.645	Karatay 1962–9, no.2704	A.2590	Karatay 1962–9, no.7569	A.3441	Karatay 1962–9, no.6813
A.1017	Karatay 1962–9, no.3434	A.2633	Karatay 1962–9, no.6931	A.3444	Karatay 1961a, no.931
A.1032	Karatay 1962–9, no.4048	A.2634	Karatay 1962–9, no.8561	A.3445	Karatay 1962–9, no.6666
A.1116	Karatay 1962–9, no.6967	A.2653	Karatay 1962–9, no.8363	A.3446	Karatay 1962–9, no.6768
A.1297	Karatay 1962–9, no.3313	A.2768	Karatay 1962–9, no.6568	A.3449	Karatay 1962–9, no.7428
A.1329	Karatay 1962–9, no.8671	A.2775	Karatay 1961a, no.313;	A.3455	Karatay 1962–9, no.8752
A.1357	Karatay 1961a, no.503		Karatay 1962–9, no.8735	A.3456	Karatay 1962–9, no.7006
A.1452	Karatay 1962–9, no.4718	A.2830	Karatay 1962–9, no.6524	A.3457	Karatay 1962–9, no.7008
A.1498	Karatay 1962–9, no.5181	A.3135	Karatay 1962–9, no.7033	A.3481	Karatay 1962–9, no.7122
A.1509	Karatay 1962–9, no.5034	A.3151	not recorded by Karatay	A.3487	Karatay 1962–9, no.7124
A.1635	Karatay 1962–9, no.8149	A.3155	Karatay 1962–9, no.6998	A.3492	Karatay 1962–9, no.7114
A.1636	Karatay 1962–9, no.7796	A.3183	Karatay 1962–9, no.6694	A.3495	Karatay 1962–9, no.7123
A.1672	Karatay 1962–9, no.8150	A.3195	Karatay 1962–9, no.6645	A.3496	Karatay 1962–9, no.6733
A.1691	Karatay 1962–69, no.8006	A.3197	Karatay 1962–9, no.6695	A.3501	Karatay 1962–9, no.7121
A.1706	Karatay 1961a, no.315	A.3210	Karatay 1962–9, no.8710	A.3521	Karatay 1962–9, no.5719
A.1741	Karatay 1962–9, no.4810	A.3213	Karatay 1962–9, no.6719	A.3563	Karatay 1961a, no.618
A.1743	Karatay 1962–9, no.4754	A.3217	Karatay 1962–9, no.6688	B.29	not recorded by Karatay
A.1840	Karatay 1962–9, no.4946	A.3220	Karatay 1962–9, no.6662	B.309	Karatay 1961b, no.1636
A.1863	Karatay 1962–9, no.4928	A.3232	Karatay 1962–9, no.6709	B.382	Karatay 1961b, no.2037
A.1864	not recorded in Karatay	A.3233	Karatay 1962–9, no.6730	E.H.71	Karatay 1962–9, no.799
A.1866	Karatay 1962–9, no.4732	A.3234	Karatay 1962–9, no.6757	E.H.72	Karatay 1962–9, no.798
A.1873	Karatay 1962–9, no.4928	A.3236	Karatay 1962–9, no.6701	E.H.245	Karatay 1962–9, no.195
A.1890	Karatay 1962–9, no.4798	A.3237	Karatay 1962–9, no.6754	E.H.282	Karatay 1962–9, no.415
A.1939/1	Karatay 1962–9, no.7238	A.3238	Karatay 1962–9, no.7471	E.H.1511	Karatay 1961a, no.496
A.1939/2	Karatay 1962–9, no.7239	A.3240	Karatay 1962–9, no.6644	H.781	Karatay 1961a, no.404
A.1953	Karatay 1962–9, no.7226	A.3248	not recorded by Karatay	H.796	Karatay 1961a, no.887
A.1972	Karatay 1962–9, no.7273	A.3250	Karatay 1962–9, no.6674	H.1123	not recorded by Karatay
A.1973	Karatay 1962–9, no.7230	A.3253	Karatay 1962–9, no.6744	H.1417	Karatay 1961a, no.155
A.1996	Karatay 1962–69, no.7199	A.3257	Karatay 1962–9, no.6715	H.1511	Karatay 1961a, no.496
A.2005	Karatay 1961a, no.273	A.3266	Karatay 1962–9, no.6690	R.93	Karatay 1961a, no.90
A.2022	Karatay 1962–9, no.8713	A.3267	Karatay 1962–9, no.6696	R.475	Karatay 1961a, no.65
A.2069	Karatay 1962–9, no.7283	A.3269	not recorded by Karatay	R.862	Karatay 1961a, no.402
A.2082	Karatay 1962–9, no.6642	A.3278	Karatay 1962–9, no.6649	R.855	Karatay 1961a, no.406
A.2085	Karatay 1962–9, no.7339	A.3279	Karatay 1962–9, no.6721	R.866	Karatay 1961a, no.40
A.2097	Karatay 1962–9, no.7286	A.3282	Karatay 1962–9, no.6729	R.880	Karatay 1961a, no.475
A.2127	Karatay 1962–9, no.7191	A.3296	Karatay 1962–9, no.7057	R.984	Karatay 1961a, no.579
A.2129	Karatay 1962–9, no.7408	A.3299	Karatay 1962–9, no.7074	R.1127	Karatay 1961b, no.577
A.2131	Karatay 1962–9, no.7197	A.3314	Karatay 1962–9, no.7093	R.1547	Karatay 1961a, no.335
A.2132	Karatay 1962–9, no.7300	A.3317	Karatay 1962–9, no.7081	R.1704	Karatay 1961b, no.1608
A.2149	Karatay 1962–9, no.7673	A.3328	Karatay 1962–9, no.7095	R.1713	Karatay 1962–9, no.7126
A.2163	Karatay 1962–9, no.7659	A.3331	Karatay 1962–9, no.7075	R.1726	Karatay 1961a, no.279
A.2177	Karatay 1962–9, no.7761	A.3345	Karatay 1962–9, no.6543	R.1919	not recorded by Karatay
A.2251	Karatay 1962–9, no.7812	A.3362	Karatay 1962–9, no.6643	R.1986	Karatay 1961a, no.904
A.2254	Karatay 1962–9, no.7814	A.3377	Karatay 1962–9, no.6693	Y.830	Karatay 1961a, no.246
A.2391	Karatay 1962–9, no.8406	A.3381	Karatay 1962–9, no.6860	Y.438	Karatay 1962–9, no.722

Index

BINDERS, SCRIBES, ILLUMINATORS AND DESIGNERS